Francis Haskell

Rediscoveries in Art: Some Aspects of Taste, Fashion and Collecting in England and France

THE WRIGHTSMAN LECTURES
Cornell University Press

D1160926

Francis Haskell

REDISCOVERIES IN ART

Some Aspects of Taste, Fashion and Collecting
in England and France

*THE WRIGHTSMAN LECTURES delivered under the
auspices of the New York University Institute of Fine Arts*

Cornell University Press Ithaca, New York

This is the seventh volume of the Wrightsman Lectures,
which are delivered annually under the auspices of the
New York University Institute of Fine Arts

© 1976 by Phaidon Press Limited, Littlegate House, St. Ebbe's Street, Oxford

All rights reserved. Except for brief quotations in a review,
this book, or parts thereof, must not be reproduced in any
form without permission in writing from the publisher. For
information address Cornell University Press, 124 Roberts Place,
Ithaca, New York 14850

First published 1976 by Cornell University Press

First printing, Cornell Paperbacks, 1980, with some revisions

International Standard Book Number 0-8014-9187-8 (paper)
Library of Congress Catalog Card Number 75-21656

Printed and bound in Great Britain by
Morrison & Gibb Limited, London and Edinburgh

Contents

For Ellis Waterhouse

Preface

WHEN I RECEIVED my flattering invitation from the Institute of Fine Arts in New York to give the Wrightsman Lectures in 1973, I decided that the occasion called for a subject of potentially wide general interest, and that the History of Taste might qualify in this respect. But large subjects demand large books; and five lectures even stretched to their absolute limits (as my long-suffering, patient, and generous audience will remember all too well) can barely scratch the surface of the problems involved in even the briefest survey of the material suggested by my title. I tried to get round the difficulty by using in my sub-title those invaluable words 'aspects of', and I have used them again in this book. But on re-reading these lectures I have nevertheless been alarmed not only by the inevitable cutting of many corners, but also by numerous straight omissions of real importance. Of some of these I am acutely aware; many more, no doubt, are due to ignorance or neglect.

To remedy these and other defects at all adequately would involve recasting the material so fundamentally that every trace of the original lectures would vanish. After much thought I have rejected this course, and have instead decided to publish them more or less as delivered – more or less, because each one has been considerably extended by the inclusion of material that I had omitted so as not to overrun too drastically the time at my disposal. In addition, I have begun with an Introduction which is intended to explain some of the principles I have adopted in the book itself, and I have relied heavily on the notes. Many of these consist of no more than the references which are required of any book aspiring to reasonable standards of scholarship. But others are very much longer, and are designed almost as a commentary on the text – containing points that would indeed certainly have been included in the text had I decided to write a full-scale book on my chosen subject. I am especially pleased therefore that the publishers have agreed to their being printed on the relevant pages rather than at the end of each chapter. I have also introduced some further information in the captions to the illustrations.

Although I refer to 'chapters', and although I have somewhat tidied my text, I have not tried too hard to conceal the fact that this book originated as a series of lectures: the personal pronoun occurs much more frequently than would otherwise be desirable, and the attempts at dramatic openings and thrilling curtain drops betray, rather tawdrily, the stagy derivations of the whole project. But once again such rhetorical devices could only have been eliminated by a complete redrafting of the material, and I am particularly anxious to think of this book as opening rather than closing a series of problems; as tentative and, by the very nature of its theme, ephemeral in value.

The kindness and hospitality of Mr and Mrs Wrightsman themselves, and of all the staff of the Institute of Fine Arts, are now proverbial, and I can only echo the gratitude expressed by my predecessors, and wonder again at the extreme skill with which an occasion I had anticipated with dread was turned into one that was actually enjoyable – at least for the lecturer.

I am grateful to H.M. the Queen for permission to reproduce pictures and documents

from the Royal Collection, and to the very helpful staffs of the many libraries in which I have worked: in particular, those of the Bodleian, Taylorian Institute and Ashmolean Museum in Oxford; of the National Gallery and (the indispensable) London Library in London; of the Cabinet des Estampes in Paris; and of the Kunsthistorisches Institut in Florence.

A reading many years ago of two articles – frequently referred to in this book – by Mr Stanley Meltzoff on the Rediscoveries of Vermeer and the Le Nain brothers greatly stimulated my own interest in some of the themes discussed in the following pages, and I was flattered that he chose to come and hear me plagiarize much of what he had written. And I have many other acknowledgements to make – so many, that the following list may seem pretentious in its length and designed to give the book more importance than it warrants. But, as will become very clear, I have constantly trespassed into fields in which I have no specialized knowledge, and the advice of the following friends, colleagues, and pupils has been invaluable to me: Joseph Alsop, Giles Barber, P. A. Bezodis, Hugh Brigstocke, Colin Clark, T. J. Clark, Howard Colvin, Claudine Decostre, Pamela Eyres, John Fleming, Celina Fox, Hugh Honour, T. L. Ingram, André Jammes, Otto Kurz, Tanya Ledger, Michael Levey, Christopher Lloyd, A. N. L. Munby, Léonie and Richard Ormond, Christopher Platt, Donald Posner, Alex Potts, David Robertson, Pierre Rosenberg, Aaron Scharf, Antoine Schnapper, Felice Stampfle, Daniel Ternois, Franco Venturi, David Wakefield, Christopher White, Jon and Linda Whiteley, John de Witt, Michael Wynne, Norman Ziff.

The Paul Mellon Centre for Studies in British Art has been very helpful with photography; and my wife has given me every possible support.

On the whole I have tried to indicate just where I have relied on individual assistance, but to this rule I must make one exception. Ellis Waterhouse has helped me so much that were I to acknowledge this adequately his name would have to appear on almost every page. I can only hope that by dedicating this book to him I can express something of what it owes to his constant encouragement.

F. H.

Oxford, Spring 1975

Preface to the Second Edition

THERE ARE SOME significant differences in content and presentation between this and the first edition of this book. Apart from correcting errors and bringing bibliographical references up to date, I have in a number of cases backed up with additional evidence arguments which may well have seemed inadequately supported. Moreover the placing of the illustrations within the text (which has necessarily involved the relegation of the notes to the end) will also, I hope, make some of my points easier to follow. Finally, I am particularly grateful to Dr Whiteley for helping me to track down the original picture (or a version of it) by Sebastian Vrancx (Plate 43) which was reproduced in Le Brun's collection of engravings as a Van der Weyden. I should also like to thank the owner for allowing me to reproduce it.

F. H.

Oxford, November 1979

Introduction

THE KING TALKED about his new building at Kew, 'and said he should have thought it impossible thirty years ago that he should ever encourage Gothic architecture' – George III's wry comment, made in the very opening years of the nineteenth century,[1] hints at what is one of the most central, dramatic, and even alarming issues raised by any consideration of the vagaries of artistic taste: the manner in which such changes, while appearing to be the outcome of a most intimate and personal choice, may in fact be predetermined by external circumstances against our very wills.

Nearly a hundred years later a brilliant French art historian watched the process at work with weary fatalism:[2] 'It is, then, as a result of a long, a very long, development that we have forgotten Albano so as to celebrate Botticelli. As you can see, there has been nothing capricious or surprising about this, and those who have been naïve enough to think that they discovered Botticelli have, in fact, despite themselves, merely been following a current which swept them along with it. What is more, this evolution is continuing. Without being prophets we can forecast in what direction it is moving, and name the idols it is preparing to resurrect. . . . The day is not far off when we will find ourselves enthusing over . . . those depressing Bolognese whom we loved yesterday and whom we will love again tomorrow.'

And yet, for obvious reasons, we are reluctant to admit that the process is inexorable. After all, not all the wisdom or proverbs of the ages have fully reconciled us to the obvious fact that even at any given moment tastes may differ, and to explain this we have had to call not only on individual whim, but also on ignorance, corruption and wickedness of every kind – and even physiognomical peculiarities: the artist Linnell, when painting the portrait of Sir Robert Peel, noticed that he 'had a broad lower part of the brow, and no reflective faculties, and remarked that he possessed "no second storey" to his head. This he considered the reason of Sir Robert's admiration for Dutch to the exclusion of almost all other art, because it is for the most part a simple transcription of the more physical aspects of nature, without any appeal to the higher imaginative and spiritual faculties of the mind.'[3] So much for certainly the most cultivated, and possibly the greatest, statesman of nineteenth-century England.

As time passes, however, these differences (and apparent defects) of taste that so disturbed Linnell are submerged into an even more disturbing similarity, so that the serious student of such matters can date the formation of an art collection (such as Sir Robert Peel's) with almost as much accuracy as he can date the pictures that go to make it up; Sir Robert's lack of a 'second storey' is forgotten, as we try to wonder why he, and virtually all his contemporaries, admired certain types of Dutch painting which had been of little interest a hundred years earlier, or neglected others which were to be passionately loved a hundred years later.

Critics, historians, connoisseurs, and dealers have in fact pondered over, deplored, welcomed, and frequently benefited from, changes of taste in the visual arts virtually since the arts came into being as recognized categories of the human scene, though frequent attempts

have been made to limit the scope of the problem raised by these changes. 'It must be remembered,' wrote one dealer, William Buchanan, in 1824,[4] 'that there is a fashion in masters, as there is in dress, or in anything else,' only to qualify this with the comment, 'the fact is, that everything in art which is excellent in itself will remain so, independent of fashion.' This qualification, which has been endlessly repeated, cannot easily be sustained.

Indeed, it is ironical that Buchanan should have made such a claim at the very time when the status of the *Apollo Belvedere*, the *Venus de' Medici*, Domenichino's *Last Communion of St Jerome* – all those exemplars of 'excellence', the eternal fame of which was axiomatic for him – was being slowly, but ruthlessly, undermined. Already Mme de Staël and Stendhal had sapped the foundations of an eternal, unchanging canon of beauty, though the tastes of both writers corresponded perfectly with those of Buchanan – and of Quatremère de Quincy, the last and most authoritative exponent of Ideal Beauty.[5] But there would be few lovers of the arts today who would deny that Piero della Francesca or Caravaggio or Vermeer or Watteau painted 'excellent' pictures, though their very names were certainly unfamiliar or distasteful to Buchanan or Quatremère or Stendhal. The argument that the finest artists have not been affected by changing tastes can be reduced in the last analysis to the proposition that for no extended periods since their lifetimes have Raphael, Titian, and Rubens not been considered great painters by the most influential sections of articulate opinion. We should be grateful for such stability, however limited.

Variations in artistic taste constitute not only a problem, but a disquieting one. Changing fashions in clothes – the comparison is frequent – are certainly worthy of the historian's attention, but they do not cause him the distress which (as I found from many people's reactions to the following lectures) can be aroused by our enforced acknowledgement that what is self-evidently of supreme importance to us can once have seemed insignificant, or even actively repugnant, to men whom we know from manifold evidence to have been fully as cultivated, often far more so, than ourselves. But it is still more disconcerting to project on to the future some of the lessons which we learn from our study of the past. Will a future generation be unmoved by Piero della Francesca or Vermeer? We are told that Time is the great judge. This is a statement which can neither be confirmed nor denied, but from the vantage point of today both these artists have been neglected for longer than they have been admired. Nor can it be assumed that once a painter has been recovered from oblivion he cannot, as it were, be lost again. In the middle years of the nineteenth century Ruskin spoke for wide sections of public opinion when he claimed that Orcagna was one of the three greatest of all Italian artists: even allowing for the superb qualities of the varying artists who made up the composite figure known by Ruskin under that name, most art lovers might now find the claim somewhat excessive. And what of the Francesco da Imola whose pictures we hear, on excellent authority,[6] 'were all the fashion in Rome' in about 1819? He is not to be found even in the history books. But claims of this kind may also seem meaningless, for the whole concept of trying to establish such hierarchies (the theme of much of my first chapter) now appears to be a somewhat futile one.

Futile – because of the very relativity of taste which seems to emerge from a study of the past. And yet it was just this relativity which nearly all the great 'rediscoverers' of the nineteenth century were so particularly anxious to avoid and which gives a stridency to their judgements that might otherwise be difficult to explain. It is, for instance, the realization that he is deliberately setting out to demolish one whole canon of orthodox taste that makes it so important for Ruskin to try to establish a new one. For him, as for most of the

other writers who will be noticed in the following chapters, Anarchy was as much the danger as Heresy.

That anarchy – a readiness to admire the arts of all periods and of all civilizations – is now with us, and has been justly celebrated as one of the most significant cultural achievements of our century. It would be futile to deny its benefits, but perverse not to recognize its drawbacks. The 'Whig interpretation' of the history of Taste has seen every new 'discovery' – of medieval or Oriental art, of the Mannerists or (as I write) of the nineteenth century Academics – as a victory for enlightenment: I would like to bear in mind, as a sort of unseen commentator on what is to follow, the man who continued to venerate Luini and Carlo Dolci long after more prominent connoisseurs had begun to rave about Fra Angelico and Memling.

The problem is also a disturbing one for another reason. I do not believe that variations of taste are to be found to a remotely comparable extent in the other arts: Dante, the 'metaphysical poets', Bach – the list of one-time neglected, and subsequently rediscovered, writers and composers is a formidable one, but it does not have about it that aspect of total mystery that confronts us when we contemplate the differing attitudes to many of those whom we now consider to have been among the supreme painters of our civilization.

Although architecture is the obvious exception to this broadest of generalizations (and I am very much aware that I should have paid much more attention to it than I have),[7] such a distinction between our responses to the various arts suggests – and experience confirms – that possession, and hence, by definition, financial interest plays a considerable role in the process under investigation. Simple conspiracy theories, which centre round cunning dealers who exploit an insecure and ignorant public, are too crude to account for highly complicated developments; but to ignore the elements of possession and monetary gain (which are irrelevant when discussing the fortunes of writers and composers) would be absurd. Nevertheless, I do not believe that very much of interest is to be learned about taste from those tables of fluctuating prices which are so popular today. So many unknown factors – about availability, authenticity, and condition, about the general economic background and attitudes to it – are involved that the evidence to be gleaned from auction prices is only rarely of much use: nor, it is often forgotten, do the activities of a few rich collectors provide the most valuable information about changing tastes.

Without doubt, the reversal of artistic values which occurred between about 1790 and about 1870 (the approximate time-span covered by this book) is the most vociferous of which we know. The eighteenth century was deeply – almost obsessively – concerned with the problem of Taste, and the possibility or otherwise of determining fixed canons whereby it could be established, but although changes were frequent and much discussed, they involved surprisingly little disturbance in a hierarchy that had been implicitly acknowledged ever since the fourth or fifth decades of the seventeenth century. In mid eighteenth-century France almost everyone admitted, usually with some dismay, that Dutch and Flemish cabinet pictures were more popular with most collectors than large-scale Italian paintings of the Renaissance or Baroque periods; but no one ever wrote (as Théophile Thoré was to do a hundred years later) that they were of higher moral – and hence aesthetic – quality. Buchanan, in fact, was looking back to a situation that had prevailed some generations before his own, when he claimed that the relatively minor masters were affected by changes in evaluation while the great peaks remained untouched. Reading the diatribes of eighteenth-century critics against the constant pursuit of novelty in taste

and the corrupting effects of fashion, it is sometimes difficult to understand what inspired such agitation. The antiquities in the Vatican Museum, the pictures of Raphael and Titian, Correggio, Guido Reni and Domenichino, Rubens, Poussin and Le Sueur – who was there to deny the absolute standards that they imposed, however aberrant contemporary art might be? But the revulsion against Baroque architecture soon gave a hint that revaluations were likely to be far more passionate than earlier changes in taste, at least since the dismissal of the Gothic in the fifteenth and sixteenth centuries.

Thereafter change was ruthless and complete. Antiquity continued to be admired for a time, but it was a different antiquity. Despite some violent controversies, the fame of the marbles from the Parthenon, newly arrived in London, soon began to eclipse that of the marbles from Rome, Naples, and Florence, newly arrived in Paris.[8] Quatremère de Quincy, the greatest theorist of the age, was to agree with Canova, the greatest sculptor, that 'toutes nos études sont à recommencer',[9] though in England moderate opinion characteristically tried to effect a compromise of the old kind: 'We should not, however, permit our raptures to outrun our discretion: there is no occasion to praise them [the Elgin marbles] at the expense of productions, with which to force a comparison seems as injudicious as unnecessary; and perhaps it would be prudent to suffer the fervour of our admiration to cool a little before we crown the brows, even of Theseus himself, with those wreaths which are to be plucked from the Torso, the Hercules and the Laocoon.'[10] But the time for statesmanlike compromise was over; even before the Revolution, jokes had been made in the studios about the *Apollo Belvedere*, that 'scraped turnip'.[11] Now such contempt spread in ever widening circles, and, before another generation was out, the authority of antiquity itself had been called into question. In 1836 the young Viollet-le-Duc was appalled to find a French student in Rome saying that 'he did not like antique statues, and note,' Viollet-le-Duc adds, in a revealing comment, 'he told me this while eating his soup, exactly as one might say "I do not like lettuce or cucumbers." '[12]

Nor could the vogue for the medieval be merely incorporated into an older scheme of values; like some relentless parasite it burrowed into, and finally destroyed, the tolerantly eclectic taste which had first greeted it with patronizing benevolence. At much the same time, it came to be felt that a true feeling for 'sincere' Dutch artists such as Hobbema necessarily involved a rejection of those who had betrayed the landscape of their native land such as Jan Both or Berchem. And more such changes could be recorded. By the middle of the nineteenth century many of the more articulate art lovers felt as self-assured and exclusive in their tastes as had been their predecessors of a hundred years earlier. But that assurance was misplaced. They did not fully appreciate that the very tools that they had used to overturn the values of the eighteenth century were now available for destroying their own new construct. Indeed, with hindsight, we can see that the real 'discoveries' that occurred between about 1790 and 1870 were not so much of Orcagna or Rembrandt, Vermeer or El Greco, Botticelli, Piero della Francesca, or Louis Le Nain, as of a multitude of contrasting qualities each apparently divorced from those associations (of religion or of a certain concept of art itself) that were once thought to be indissolubly linked to them.

In the following chapters I have therefore not tried to follow consistently the fortunes of individual artists or schools, though I have made much use of the valuable specialized studies of this topic that exist. I have instead tried to look at the phenomenon of changing taste from a varying set of approaches: the availability or otherwise to the collector or connoisseur of recognized masterpieces; the impact of contemporary art; the religious or

political loyalties that may condition certain aesthetic standpoints; the effects of public and private collections; the impression made by new techniques of reproduction and language in spreading fresh beliefs about art and artists.

This variety of approaches will be in inverse proportion to the depth with which I can pursue any single one of them. I will have to be excessively selective as well as excessively ambitious: one artist will have to stand for a dozen, and a single duke (perhaps even an earl) for the whole of Burke's Peerage; great writers will be omitted to give way to some anonymous hack who makes the single revealing comment that I need; drawing and sculpture will hardly be considered; and, above all, the whole vast German contribution to this theme will be neglected except in so far as it impinges on England and France. Nor will I show much more respect for chronology. Although I cover a period of about a century and although I have tried to indicate my own awareness of my topic developing in a particular direction during the course of that century, I have not hesitated to move backwards or forwards in the interests of clarifying the approaches I have outlined above.

It is partly for this reason that I have not carried the story up to our own times, except very rarely or by implication. Vast changes in taste occurred after 1870 – not least in the United States; but it seems to me that the process whereby we now automatically expect taste to change, and the range of our appreciation to broaden, was already by then apparent to the most acute observers of what had happened earlier.

Whatever the deficiencies of this particular book, the interest of the subject itself seems to me to be beyond doubt. Never has it been more movingly evoked than in what is often the most subtle, as well as the most elegiac, meditation on the whole theme, *William Wetmore Story and his friends*.[13] In that book Henry James repeatedly emphasizes that 'we like, in faded records, the very mistakes of taste, for they are what seems to bring us nearest to manners, and manners are, changing or unchanging, always most the peopled *scene*, the document to be consulted, the presented image and beguiling subject. . . . To live over people's lives is nothing unless we live over their perceptions, live over the growth, the change, the varying intensity of the same – since it was *by* these things they themselves lived.' *Mistakes* is a word we would hardly dare use today for differences – differences, moreover, that are no longer even that, for James's puzzlement that 'Robert Browning and his illustrious wife burnt incense, for instance, to Domenichino' reveals no awareness of the chance that, seventy years after he wrote, we ourselves might share again many of the Brownings' tastes; but the fascination of the topic remains as potent as ever – and as mysterious.

It is, however, the duty of the historian (though not of the novelist) to try to clear away mystery as effectively as he can. To conclude that variations of taste in the arts are, like pagan gods, so wholly arbitrary and capricious that they can merely be observed – and worshipped – is to abdicate responsibility at too early a stage. In the following chapters I have not tried to categorize those great changes in taste which are often familiar enough, but rather to examine a few test cases and assumptions, and to bring together in sometimes unexpected juxtaposition the results of other scholars' more detailed and specific researches.

1 Hierarchies and Subversion

IN 1841, after four years hard work, Paul Delaroche, the most popular French artist of the day, completed his huge semicircular mural in the apse of the Ecole des Beaux-Arts in Paris, the general effect of which can be most easily studied in a conveniently labelled reduction, now in the Walters Art Gallery, Baltimore (Plates 1, 2).

'In our memory,' wrote an English journal,[1] 'no picture in the grand style, by a living artist, has excited the same interest and the same admiration.' There is a vast amount of contemporary evidence to suggest that this was not an exaggeration, and if Baudelaire was soon to call it 'puerile and clumsy',[2] his was something of a lonely voice in the chorus of enthusiasm that greeted Delaroche's most ambitious undertaking. Ingres himself, fully aware no doubt of the debt that the conception owed to his own *Apotheosis of Homer* (Plate 3) of nearly a generation earlier, 'cordially embraced M. Delaroche and, measuring with his eye the vast extent of this glorious picture, said to his pupils "Voilà de la grande peinture!" '[3]

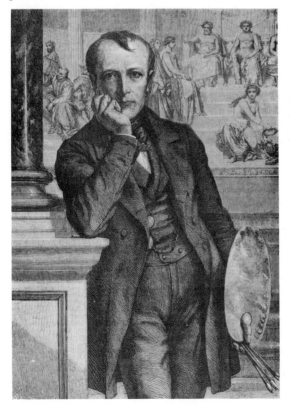

1 *Delaroche painting the Hemicycle. Magasin Pittoresque*, 1859, p. 116 (probably based on a waist-length self-portrait drawing — information kindly supplied by Mr Norman Ziff)

From the standpoint of this book, such general praise – and even the nature of the occasional criticism – is almost as significant as the work itself, which here needs only brief attention. Placed at the very core, so to speak, of the theory and practice of European art, the Hemicycle depicts 'the immortality held out to the greatest artists and the glory that will crown them',[4] and in carrying out this project Delaroche followed a fairly widespread practice of combining allegory and realistic portraiture. Seated on a marble throne in the centre (Plate 6) are the figures of Ictinus, Phidias, and Apelles, the foremost architect, sculptor, and painter of antiquity. Kneeling on the foreground before them is Glory and, to the left, the Arts of Greece and the Middle Ages, 'dreamy, melancholic, chastely draped' and, to the right, the Arts of Rome and the Renaissance, 'voluptuous, dazzling, sensual, and half-nude'. To the left and right of this supreme tribunal are grouped 'all the great artists of the thirteenth, fourteenth, fifteenth, sixteenth, and seventeenth centuries'.

Who are the painters included in this company, for it is with painters only that this book will be concerned? From left to right (Plate 5) we have portraits of the colourists: Correggio, Veronese, and – an elegant dandy in doublet and striped breeches – Antonello da Messina; then Murillo, a seated Van Eyck in brocade, and Titian, followed by Terborch, Rembrandt, and Van der Helst. Seated on the marble ramp, Rubens is immediately recognizable, with Velazquez peering out between him and Van Dyck, who all but con-

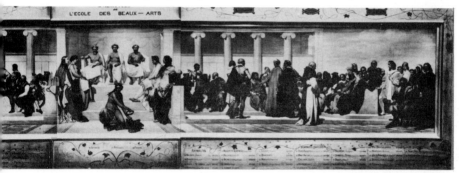

2 Delaroche: *Reduction of the Hemicycle painted for the Ecole des Beaux-Arts, Paris* (composite photograph). Walters Art Gallery, Baltimore

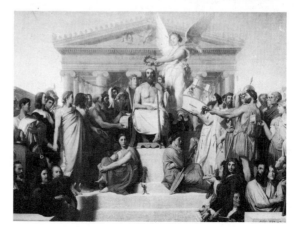

3 Ingres: *The Apotheosis of Homer.* Louvre, Paris

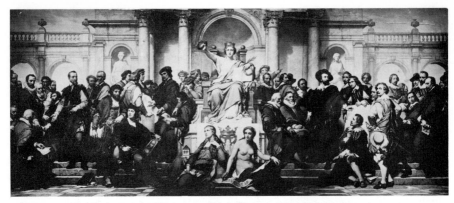

4 Nicaise de Keyser: *The Antwerp School of Painters.* Koninklijk Museum, Antwerp

ceals the sinister Caravaggio, placed (rather surprisingly) next to Bellini and the moustachio'd Giorgione.

A group of four within the columned, temple-like structure includes Ruisdael, Paul Potter, Claude Lorrain, and Gaspard Poussin, all landscape painters, and if we then turn to the other wing, and once again follow the figures inwards towards the centre (Plate 7), we find the artists celebrated chiefly for their draughtsmanship. We meet first Nicolas Poussin and Giotto, while almost hidden behind them are Cimabue in profile and Andrea del Sarto. Seated in sulky isolation is Michelangelo, and behind him stand Masaccio, Perugino and the rather effete and over-gracious Raphael. A glimpse only of Giulio Romano and Mantegna before we reach Fra Bartolommeo, portrayed here as a rather stout and cunning monk; then Domenichino engaged in a whispered conversation with the seated Leonardo da Vinci, followed by Dürer, Sebastiano del Piombo, and Orcagna; and so on to the last group of the immortal painters and engravers: Le Sueur, Holbein, Edelinck, Marcantonio Raimondi, and – most prominent of all – Fra Angelico.

Delaroche's Hemicycle was only one of very many such tributes to the Old Masters produced from about the middle of the eighteenth century to the end of the nineteenth, but it was the most famous and the most influential,[5] and we can find reminiscences of it all over Europe. In Belgium, for instance, a few years later, Nicaise de Keyser used it as the model for his mural in the Antwerp Museum glorifying the artists of that city (Plate 4), and we will shortly come across a more interesting and revealing instance of its impact in London.

The existence of such hierarchies of artists, and of paler reflections of them, often in the form of individual busts,[6] plaques, and so on, can present us with much fascinating evidence about the principal theme of this book: the history of taste. But it is evidence that is extraordinarily difficult to unravel.

I have referred to the general welcome given to Delaroche's mural. It was indeed very widely discussed, but in all the dozens of commentaries that followed its unveiling the one feature that is scarcely ever mentioned is the one feature that interests us – the choice of artists represented. True, a careless English observer was somewhat offended that among the architects 'Inigo Jones and Christopher Wren appear to us strangely forgotten',[7] whereas a French writer felt no qualms about the absence of Wren, and assumed that

Jones could only have been included to be 'polite to the English'.[8] Not unnaturally he thought that Alberti was more deserving of immortality, and he was a little distressed at the exclusion (which is indeed surprising) of Guido Reni, Guercino, the Carracci, Salvator Rosa, and Tintoretto. For the rest, we have discussions of the composition, the colour, the faithfulness or otherwise of the portraits, the use of allegory and so on, but little else.[9] Are we not entitled to assume that this silence is – like the dog that failed to bark in the Sherlock Holmes story – significant in itself: that Delaroche had in his choice of artists to be repre-

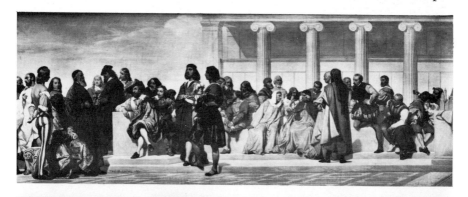

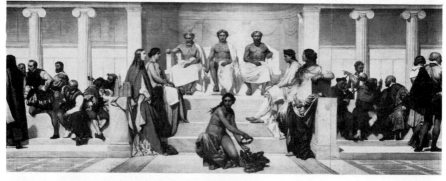

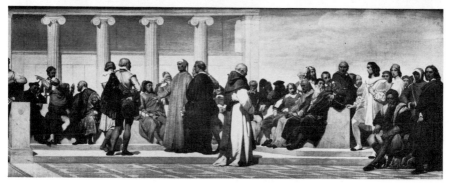

5–7 Delaroche: *Reduction of the Hemicycle*. Walters Art Gallery, Baltimore

sented satisfied the consensus of informed opinion?

That Delaroche was himself responsible for selecting the artists to be included may be surprising but seems almost certain. Like historians of the Renaissance searching in vain for a 'programme' for the Vatican Stanze or Giorgionesque *poesie*, the investigator of Delaroche's Hemicycle from this point of view will come away disappointed.

An early project had featured not only a different disposition of figures, but also a different choice of artists from that finally adopted. Instead of the forty painters eventually included, there were to be only thirty-six at this stage, and there would have been a relatively stronger French contingent with a breakthrough into the eighteenth century in order to include Delaroche's own great grandfather-in-law, Joseph Vernet. Among the very large number of careful studies for the completed work are some which were transcribed fairly directly, such as the *Poussin* (Plate 9), some which were fairly drastically revised, such as the distinctly unfortunate *Rembrandt* (Plate 10), and others which were

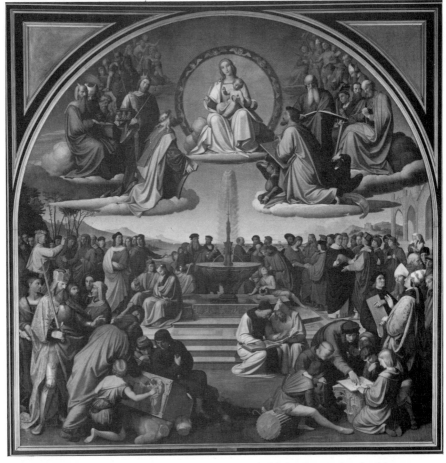

8 Overbeck: *The Triumph of Religion in the Arts*. Städelsches Kunstinstitut, Frankfurt

9–10 Delaroche: *Studies for the figures of Poussin and Rembrandt on Hemicycle*. Cabinet des Dessins, Louvre, Paris

totally rejected, though it is not always possible to be certain whether this was because they represent artists who were not inserted or because they were alternative portrayals of others who were. There also exist preliminary oil sketches at Nantes which show only fifty-eight figures in all, and there are many other variants, the study of which, though certainly of interest to the Delaroche scholar and even to our own enquiry, would take us into too much detail for this book. As we all know from the endlessly conflicting interpretations that have been made of Raphael's surviving drawings for the Stanze, such variety *proves* nothing: but there is strong reason to believe that although Delaroche probably took advice, the project as a whole was his own; and that, in the noisy and disputatious nineteenth century, we can take the absence of comment on his choice of protagonists to imply indifference or approval.

Such approval was certainly given to the most important offspring of the Hemicycle: the podium representing the Painters on the memorial raised in London to the memory of the Prince Consort (Plates 11, 12).

When submitting his designs to the Queen in 1863, the architect George Gilbert Scott accompanied them with some explanatory remarks to her secretary, in which he pointed out that, 'from the upper platform rises a podium, or continuous pedestal surrounded by sculptures in alto-rilievo, representing historical groups or series of the most eminent artists of all ages of the world; the four sides being devoted severally to Painting, Sculpture, Architecture, and Music. The figures are about seven

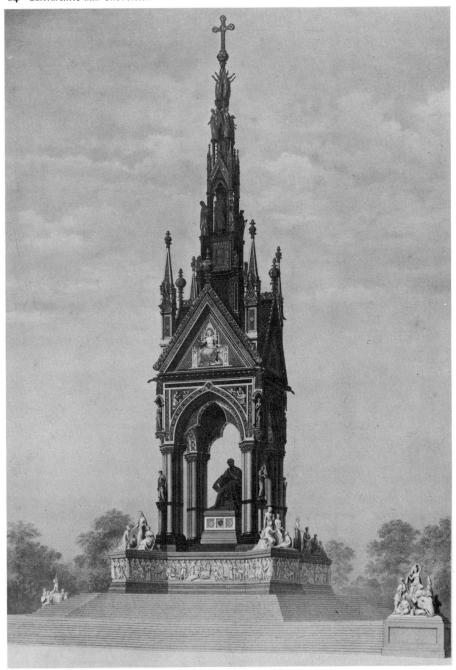

11 *The Monument to the Prince Consort.* Chromolithograph from *Handbook to the Prince Consort National Memorial*

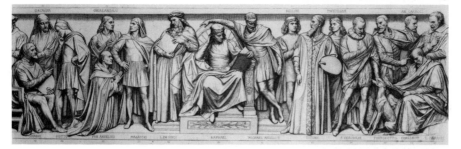

12 *The Painters:* detail of H. H. Armstead's east front of the podium of monument to the Prince
Consort. From *Handbook to the Prince Consort National Memorial*

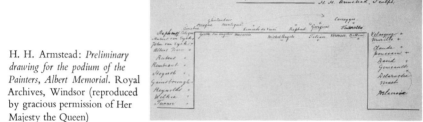

13 H. H. Armstead: *Preliminary
drawing for the podium of the
Painters, Albert Memorial.* Royal
Archives, Windsor (reproduced
by gracious permission of Her
Majesty the Queen)

feet high, and would be treated something after the manner of Delaroche's *Hémicycle
des Beaux-Arts.*[10]

In view of the fact that we are told that the Hemicycle was 'almost as well known in
England as in France, for it is one of the lions of Paris, which no Englishman ever fails to
visit',[11] the idea was hardly surprising, but once again – and this time with far more evi-
dence at our disposal – it does strike us as odd that the choice of figures to be portrayed was
clearly left to the sculptors themselves; and in the case of the Painters this was not the well
established Paul Delaroche, but the very little known Henry Hugh Armstead.[12] In the
Royal Archives at Windsor we can follow the construction of the Albert Memorial week
by week, day by day, almost stone by stone.[13] The experts send in their reports; the gran-
dees make known their views: 'If Viscount Palmerston were to make any suggestion on
the subject he would say that what would appear to him to be the most appropriate would
be an open Grecian Temple . . . with a statue of the Prince Consort of Heroic Size in the
centre upon a suitable pedestal'; the artists complain that they are not being paid; the
Archbishop of Canterbury thinks that King David as author of the Psalms might be more
suitable than Homer as the centre figure presiding over the poets; a surviving friend of
Goethe is called in to give advice about the poet's features; the Keeper of Antiquities at the
British Museum points out inaccuracies in the representation of Phidias; and, exercising
the most intense vigilance, seeing and approving every plan, every suggestion, is the Queen
herself. Everything, from the most detailed technical comment to the usual series of cranky
letters that accompany all such projects, has been meticulously preserved; and the one item
missing is any suggestion that instructions were given to the sculptor as to whom he
should represent on his podium. The proposals for forty-one painters came from him and
were apparently accepted without discussion. Once again we have a preliminary plan
(Plate 13) showing rather fewer names than were actually adopted (thirty-five, in fact) and

14 H. H. Armstead: *Portrait studies of Correggio for the figure on the Albert Memorial.* From a scrap book belonging to the sculptor, in the Library of the Royal Academy, London

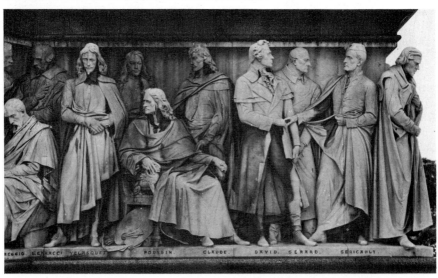

15 H. H. Armstead: *Podium of the Painters on the Albert Memorial* (detail)

once again we can find innumerable drawings and studies for the individual figures chosen[14] (Plate 14).

It is worth pondering for a moment on some of the differences that have occurred between 1837 and 1864, the starting dates of the two undertakings. Though including only the dead, Armstead has advanced boldly into the nineteenth century – English art would have fared badly indeed had he, like Delaroche, not ventured beyond the end of the seventeenth, and thus none of his five English artists features among the Immortals of the Hemicycle. But he has been generous to his French contemporaries (Plate 15). Delaroche himself is there of course, but it is gratifying to see that Delacroix is also represented, and it was perhaps something of a relief that Ingres died in 1867, after the preliminary plan but just in time to redress the balance on the podium itself.[15] Students of Victorian taste will be surprised to find that none of the modern Germans could be found a place: Overbeck lived a little too long, but Cornelius died in the same year as Ingres.

If we turn to the Old Masters in greater detail (Plate 16), we find one or two very strange differences: no Van Dyck on the Albert Memorial seems inexplicable, and makes one grudge the space occupied by Hubert van Eyck; Perugino, Giorgione, and Andrea del Sarto have all disappeared; the Carracci, on the other hand, have been reinstated, and so too has Tintoretto, who had at one time been scratched off the list of proposed artists. With the exception of Rembrandt, all the Dutch have been eliminated, and in this emphasis on the great Italian masters Armstead's podium looks back to one of the very first of all these celebratory tributes, Barry's mural in the Royal Society of Arts (Plates 17, 18) of the early 1780s. In this, although 'next to Van Dyck is Rubens, who with his hand on the shoulder of the modest and ingenious Le Sueur is pushing him forward amongst the artists of greater consequence', prominence is given not just to such obvious figures as

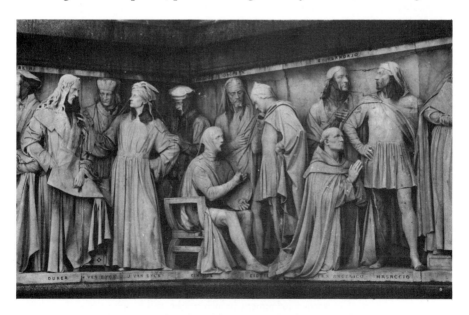

16 H. H. Armstead: *Podium of the Painters on the Albert Memorial* (detail)

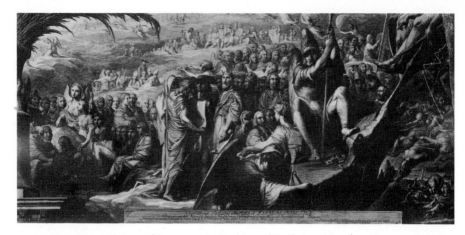

17 James Barry: *Elysium and Tartarus, or the Final State of Retribution*. Ashmolean Museum, Oxford.
(Engraving—not wholly precise— after the mural in the Royal Society of Arts, London)

Raphael, Michelangelo, Leonardo, and Domenichino, but also to Cimabue, Giotto, and
Masaccio.[16]

Armstead's podium was greeted with the same enthusiasm as had been Delaroche's
Hemicycle[17] – many critics thought it the most distinguished feature of the whole monu-
ment – and though there were a few reservations about some of the architects who had
been excluded,[18] there was a total lack of criticism as regards the choice of painters, and
no one seems to have thought of commenting on the changes in emphasis that we have
just been considering.

Anyone who has played the party game of being compelled to choose the forty best
painters in the history of Europe will know the agonies of inclusion and exclusion, the
heated discussions, the revaluations forced upon victim and challenger alike. Are we to
take the absence of comment on the choices made by Delaroche and Armstead for the
most important commissions of their respective periods and countries as indicating a
tolerant sympathy for the dilemmas in which they found themselves? No one who has
studied nineteenth-century criticism and polemics can seriously believe that.

Are we then to believe, as has already been suggested, that the broadly eclectic selections
that they made did – in each case – correspond exactly to the evaluation of earlier art made
by informed opinion at the time? Happy indeed would that informed opinion have been
had that been true! We shall see later that the search for a generally accepted taste in art,
such as (so it was assumed) had existed, misguided though it was, in the eighteenth century,
was a desperately serious one. But, of course, we know that this was not the case. Well
before the Hemicycle or the Albert Memorial, vigorous campaigns had been fought – and
apparently won – on behalf of artists who found no place on either monument, or against
others who were given prominent positions on both. Barely a painter is shown in either
work who had not aroused the most passionate feelings.

The silence that greeted so potentially controversial a settlement was a silence born either
of indifference, or of an acknowledgement (which might well be admitted today) that no
such hierarchy is seriously attainable, or – and this seems the most likely explanation – of a

desire not to disturb a *status quo* that appeared to be as satisfactory as could be achieved. The Hemicycle and the podium are significant partly because – like so much nineteenth-century art itself – they conceal rather than reveal a truth: like the Greek Revival railway station, or the suddenly launched 'medieval traditions' of the period, they suggest an element of stability and permanent value that was lacking in reality.

They are significant also because of the very breadth of tastes that were catered for. Such breadth probably came naturally to Delaroche and Armstead, whose own artistic allegiances were somewhat unsteady, and was popular also with authoritative patrons in France and England who were always anxious to avoid stirring up unnecessary controversy. But it also involved a much more fundamental and deeply felt issue. Serious nineteenth-century writers certainly envied the assured taste of their predecessors, but they ridiculed its supposed narrowness – a narrowness vividly expressed by the belligerent Ingres writing from Florence in 1822: 'The real thing to study is how to become *exclusive*, and that can be learned, if I dare so, by constantly frequenting only what is true beauty. How ludicrous and monstrous it is to love, with the same passion, Murillo, Velázquez and Raphael! Those who think in this way have never really been granted the supreme understanding of beauty!'[18a] Lady Eastlake, on the other hand, – one of the most articulate, representative, and influential figures of Victorian England – referred to her husband's 'catholicity of taste' as the 'true test of a real lover of art for its own sake', commenting that 'this catholicity . . . was a thing unheard of' in the early years of the nineteenth century. 'I could sit down with pleasure to copy almost any picture here from Teniers to the *Transfiguration*,' she reports him as having said on a visit to the Louvre in 1814;[19] and similarly the introduction to the very first number of the *Gazette des Beaux-Arts*, published in 1859, insisted that, although the maintenance of a hierarchy was essential, yet it should be acknowledged that beauty was to be found in the work of every kind of artist from Raphael to the minor eighteenth-century engraver Gravelot.

18 James Barry: *Elysium and Tartarus, or the Final State of Retribution.* Detail of the mural in the Royal Society of Arts, London

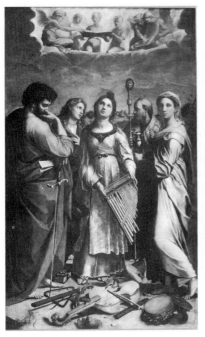
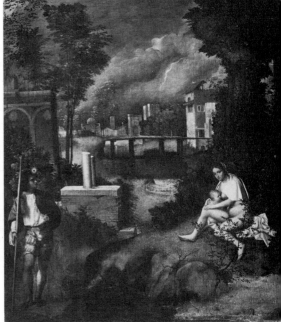

19 Raphael: *St Cecilia*. Pinacoteca, 20 Giorgione: *La Tempesta*. Accademia, Venice
 Bologna

The eclecticism affirmed by these public monuments was therefore calculated to appeal at least as much to the connoisseur as to the wider public. None the less, it inevitably obscured all the principal issues involved. For 'catholicity of taste' meant not what it said, but rather a readiness to appreciate what was, at any given time, generally considered to be somewhat beyond the average range of approval. Lady Eastlake's own *Journals* provide ample evidence of that. 'Modern Florentines,' she writes in 1858,[20] 'are so degenerate that they think far more of a Carlo Dolci, or a Sassoferrato, than they do of their really great masters . . . Botticelli, Ghirlandajo, Filippo and Filippino Lippi.' Yet how amazed she would have been had one dared to tell her that, whatever else her taste was, it was cetainly no more 'catholic' than that of Horace Walpole, who nearly a hundred years earlier had claimed in a famous, much derided, and perhaps deliberately provocative outburst:[21] 'There is little to be said of the Florentine School, as there was little variety in the Masters; and except Andrea del Sarto, and the two Zucchero's, their names are scarce known out of Tuscany. Their Drawing was hard, and their Colouring gawdy and gothic . . . In short, in my opinion, all the qualities of a perfect Painter, never met but in RAPHAEL, GUIDO and ANNIBAL CARACCI.'

In fact, many nineteenth-century critics were vaguely haunted by the innate contradiction of trying to build up a new and exclusive hierarchy on the basis of a supposed 'catholicity of taste', but few of them had the arrogant self-confidence of Ruskin, who, at the age of twenty-six, could write from Bologna with cheerful candour:[22] 'So much the worse for Raffaelle. I have been a long time hesitating, but I have given him up to-day, before

the St. Cecilia. I shall knock him down, and put up Perugino in his niche.' (Plates 19, 21).

The nineteenth century, as we all know, witnessed much 'knocking down and putting up'[23] – a startling series of revaluations of the art of the past that have radically affected our appreciation and understanding to this day: whole schools, such as the early Flemish and Italian, seventeenth-century Spanish and eighteenth-century French, were, at different times, in different places, and in the eyes of different publics, restored to favour; while others, such as the Italian Baroque and the Italianate Dutch, were rejected as valueless and even pernicious;[24] and within those schools and others, individual artists were elevated to dizzy heights or degraded to the lowest abyss: Botticelli and El Greco, Vermeer, Hals, Watteau, Goya, and Piero della Francesca are only a few who are not found enjoying the conversation of their confrères in the Ecole des Beaux-Arts or on the Albert Memorial. A sudden attribution or discovery could change the whole character of a painter's reputation, as was the case with Giorgione's *Tempesta* (Plate 20): to us a marvellously familiar master-piece, but one that does not appear to have been seen, or at any rate mentioned, between

21 Perugino: *Virgin and Child with four Saints*. Pinacoteca, Bologna

1530 and 1855; at this date the picture by which Giorgione was known all over the world was a Titianesque portrait group now forgotten by all but the most assiduous art lovers (Plate 22).[25] Other artists, Orcagna perhaps most noticeably, but also Mazzolino, Francia, Luini, and Gaudenzio Ferrari, soared briefly like comets across the sky to sink, not indeed into contempt or oblivion, but into the history books rather than into the general consciousness. It would just have been possible to have been brought up believing that Annibale Carracci was a great artist, to live for many years dismissing him as a sterile eclectic, and to enjoy a ripe old age admiring his pictures once more.

'Knocking down . . . and putting up' – the practice was already an old one before Ruskin decided to undertake it with such enthusiasm. At some time during the last third of the seventeenth century the feeling developed that the age of very great painters was over – painters whose reputations would, like those of Raphael, Titian and Correggio, the Carracci, Poussin and Rubens, continue to grow and to solidify into eternity. Of course, artists such as Luca Giordano and Solimena, Carlo Maratta, Boucher and Tiepolo were to enjoy international successes at least as great as any of their predecessors, but the feeling

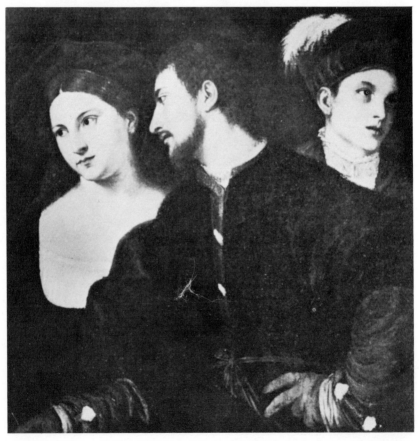

22 Follower of Titian: *Triple Portrait*. Duke of Northumberland collection, Alnwick

remained none the less; and these successes were, on the whole, short-lived. It was during this period too (between about 1680 and 1780) that we find the first really powerful indications of that radical divergence between critical esteem and public success that was later to prove of such overwhelming importance for European culture: only in England, with no golden age on which to look back, could the eighteenth century be seen as one of real advance in painting. Elsewhere Taste began to be contrasted with Fashion, the Old with the New, and the 'knocking down' process was already under way before the savage onslaught on contemporary art and the seventeenth-century Baroque masters that characterized so much critical opinion from the second half of the eighteenth century onwards, even eating into the reputation of the great Bolognese masters themselves.

Yet it was at much the same time that the 'putting up' process also began. As early as 1677 the subtle French critic Roger de Piles wrote, in a passage whose implications are not entirely clear though they are obviously of direct concern to our enquiry: 'Connoisseurs cause beautiful things to be appreciated wherever they are found. They dig them up [*ils les déterrent*] – if I may be allowed to use the expression – and sometimes succeed in giving fame to a picture which had been easily accessible for more than sixty years without anyone bothering to look at it because it had nothing particularly surprising about it.'[26] And later, throughout the eighteenth century, 'new' artists – a Teniers, a Cuyp, a Hobbema, or a Murillo – began to be added to the canon of what could be appreciated by a 'man of taste' – that figure of such importance for the period. To survey the creation of this canon would be just as rewarding as to watch over its disintegration, and indeed it may be claimed that the one process cannot be adequately studied without an understanding of the other. For, to a large extent, the breakdown of a hierarchy of values was implicit in the very breadth of taste that had been assumed by the middle of the eighteenth century, and it is sometimes difficult to see why this breakdown only came about rather later and in so drastic a fashion. If the same collector could rave over his Rubens sketch and his genre scene by Van Mieris (Plates 23, 26), what was it that put, let us say, Frans Hals and Jan van Eyck beyond the range of his highest sympathies?

In fact, Taste, however capricious, always depends on more than taste. Any aesthetic system, however loosely held together, is inextricably bound up with a whole series of forces, religious, political, nationalist, economic, intellectual, which may appear to bear only the remotest relation to art, but which may need to be violently disrupted before any change in perception becomes possible. Dealers and artists, historians and clergymen, politicians and collectors, may all at one time or another have different motives for wanting to change or to enforce the prevailing aesthetic hierarchy. Enforcement can indeed be just as dominant an urge as change. Again and again, in the last two hundred years, the attempt has been made to freeze Taste; and there can scarcely be any lover of art who does not sometimes experience a feeling of panic at the thought that the story to be outlined in the following pages is certainly not yet over and that our own values may not be eternal; who would not wish, in fact, like the fortunate Armstead, to carve into enduring stone the names of those artists (many of them so different from the ones chosen by him!) whom *we* hold sacred.

It is from this angle of conflicting forces and personalities that I wish to discuss a phenomenon whose general contours are familiar enough and whose details have been studied in many specialized monographs. I hope indeed that the frequent quotations included in this book will give some flavour of a continuous and complex debate rather than of an

23 Rubens: *The Assumption of the Virgin*.
 Royal Collection (reproduced by gracious
 permission of Her Majesty the Queen)

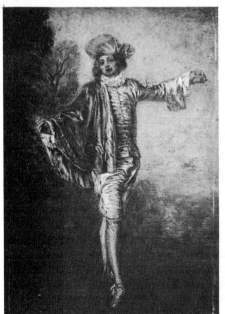
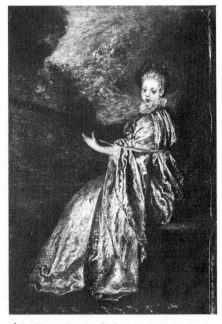

24–5 Watteau: *L'Indifférent* and *La Finette*. Louvre, Paris

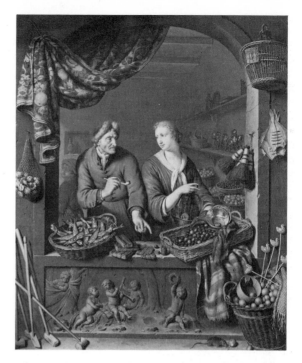

26 Willem van Mieris: *The fruiterer's shop*. Royal Collection (reproduced by gracious permission of Her Majesty the Queen)

uninterrupted series of 'enlightened' victories over obscurantism; and that the attention which is sometimes paid to the quirks of individuals may demonstrate that they too, as well as the wider processes of history, can play a significant role in promoting change. Indeed, it is these latter which have been all too summarily treated in what is intended to provide more of a specific diagnosis than a general theory.

As far as I know the first use in print of the word *Discoveries* in the sense that I am adopting it (in the slightly modified form demanded by translation) for the title of this book occurred in 1792. The author was Jean-Baptiste-Pierre Le Brun, and the painter in whose rediscovery he played a central role was the then virtually forgotten Vermeer. That Le Brun realized the novelty of what he was doing is proved by the fact that, having used the term, he immediately adds (in words strikingly similar to those of Roger de Piles a century and a quarter earlier) 'if I may be allowed the expression'.[27]

It is particularly convenient for us that Le Brun should be associated with this word, because in his own person he sums up so many of the influences that will be concerning us. Artist, historian, dealer, politician, a friend of the leading painters of the day, the survivor of revolution and tyranny – a brief discussion of his career will, like the overture of an opera, involve touching on many themes that will be developed at greater length in later chapters; the more so, as we will find Le Brun himself turning up again and again in different contexts.[28]

Born in 1748 under King Louis xv and dying in 1813 under the Emperor Napoleon, he was the last (and possibly the greatest) in a long and distinguished line of eighteenth-century French dealer-connoisseurs, and when in 1806, the year that Girodet's *Deluge* was causing a sensation at the Salon, we find him recommending two pictures by Watteau (Plates 24, 25) as 'being of delicate and brilliant colour . . . they recall the beautiful style of

Titian',[29] or two Chardins (Plates 27, 28) by claiming that they are 'of a harmony and colour worthy of Rembrandt',[30] it is difficult to know whether we should speak of a survival or revival of taste. Certainly such language *at such a date* (though by no means unique as regards Watteau) makes it clear that we are in touch not only with a very perceptive connoisseur, but also with a very astute dealer – and it must be stressed from the first that dealing plays a much larger role in the events that interest us here than is usually admitted.

Le Brun (Plate 29), who started life as an artist – his best work is, characteristically, his frontispiece for a sale catalogue (Plate 30) – and who in 1776 began an immensely complex marriage with the painter Elizabeth Vigée, is known to us as a man mainly through that most tendentious of sources – a disillusioned wife; a wife, moreover, who seems to have painted the portraits of just about everyone she met except that of her husband.[31] It is therefore hardly surprising that he has gone down to history as an unscrupulous gambler and womanizer. Before the Revolution he had built for himself and his wife a set of rooms in the garden adjoining their private house in the Rue de Cléry (Plate 31),[32] and there he kept his own collection, and displayed not only the immensely important Old Masters, over the sales of which he presided year by year, but also two exhibitions of modern painters in 1790 and 1792 at a time when the Academy was coming under increasing attack.[33] His interest in, and relations with, contemporary artists were indeed close and are of some relevance.[34]

With David they always seem to have been a little uneasy,[35] but for many years he commissioned works – some, doubtless, to be passed off as seventeenth-century originals – from

27–8 *Chardin's La petite fille aux cerises* and *Le jeune soldat*, destroyed during World War II.
Engravings by Cochin the elder. Fitzwilliam Museum, Cambridge

29 Jean-Baptiste-Pierre Le Brun:
Self-Portrait, 1796. Private collection

30 Jean-Baptiste-Pierre Le Brun:
*Frontispiece to the sale catalogue
of M. Poullain*, 1780

31 *Hôtel Lebrun, Paris*. Archives Nationales, Paris (photographed from
the plate in Gallet)

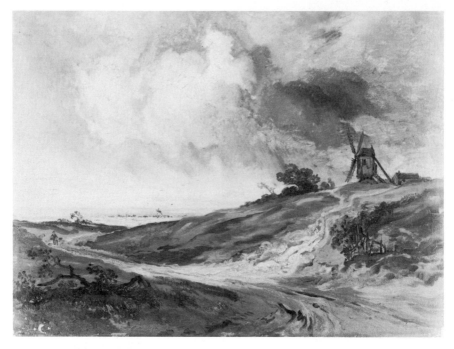

32 Georges Michel: *Landscape with a windmill*. Fitzwilliam Museum, Cambridge

the most Dutch of French landscape artists Georges Michel[36] (Plate 32), and it was in his rooms that were exhibited in 1803 the models for a monument to the recently killed General Desaix.[37] He did what he could to have recalled to France the attractive painter Louis Gauffier, then living as an exile in Italy[38] (Plate 33), and it was to him that Lucien Bonaparte turned for advice in 1800 when his brother Napoleon characteristically asked for a list to be drawn up of the ten best painters, sculptors, and architects in France.[39]

Yet although Le Brun always fell comfortably on his feet, he had to pass through some difficult moments. He had been too closely associated with royalty – buying extensively for the king and acting as keeper of pictures for both the Duc d'Orléans and the Comte d'Artois – to be altogether well placed when the Revolution broke out in full fury: nor was his position made any easier by the fact that his wife had been among the very first *émigrés*, leaving France as early as October 1789. Le Brun's vigorously worded pamphlet[40] explaining that her motives were entirely unpolitical and that she had merely gone on a study trip to Italy is one of the most fascinating documents illustrating his private life that have come down to us, and provides a vivid picture of the weekly receptions held by this fashionable couple just before the Revolution: the company of painters and musicians – Vernet, Hubert Robert, Delille, Piccini, Grétry, and others – a sort of '*lycée* ouvert à tous les talens, la gêne en était bannie', which gradually changed its character as the 'great' insisted on being invited.

This thrust at his former patrons was made, in desperate circumstances, when the whole nature of art collecting had already changed. Le Brun played a strident and controversial

role in the establishment of the Museum and the plunder necessary for it before Vivant-Denon took over, and indulged in venomous pamphleteering battles in this connection.[41] But though he must often have been in great danger, his only actual suffering was a pistol shot in the back fired by someone carelessly handling a loaded revolver.[42] With some moral courage he spoke up aggressively in favour of 'petits tableaux flamands connus sous le nom de curiosité' at a time when large-scale history painting was considered the only art worthy of a true revolutionary.[43]

Despite these ventures into public life and into modern art, Le Brun's main interests had always lain in dealing in the Old Masters and building up private collections. To do this he had travelled extensively all over Europe – by about 1802 he claimed in a letter to Napoleon to have made forty-three trips abroad to buy pictures[44] – and he continued to do so when the end of the Revolution made this possible again. But his involvement with the Museum

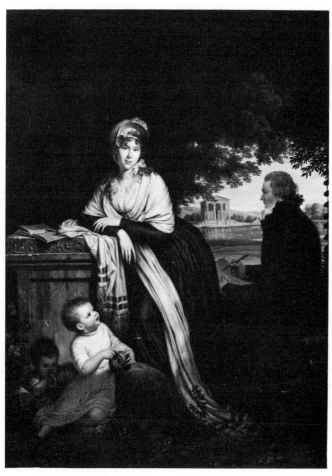

33 Louis Gauffier: *Self-portrait with his wife and children in Italy.*
Galleria d'Arte Moderna, Florence

and its politics is not altogether surprising, because he was used to making very big claims for the role of the dealer – bigger than any that had ever been made before – and the theme of the 'discovery' of forgotten artists from Holbein (Plate 34) to Ribera (Plate 35) or Louis Le Nain (Plate 36) runs constantly through all his claims – and he sold masterpieces by all of them.

We first hear him put the idea forward in 1783 – though in a somewhat different way. 'It is to dealers', he proclaims,[45] 'that we owe the "regeneration", if the expression be allowed, of a large number of pictures which had been profaned by the hand of Ignorance; and in this connection we will content ourselves with referring to the case of one who, when summoned to a house filled with pictures by the greatest masters, by chance went into a room somewhat apart and found that the main table in it was made up of one of Annibale Carracci's masterpieces which had been attached to a base solid enough to resist the ravages of time for a few years more.'

Le Brun is here referring to the rescue of a lost work by one of the most celebrated of Old Masters, but it was not long before he extended the term to the forgotten master himself. The passage appears in his finely illustrated corpus of Dutch, Flemish, and German masters, a glorified commemorative sale catalogue in three volumes on which Le Brun had been working for some twenty years and which had the misfortune to appear early in 1792. In the preface to this Le Brun explains that the artists with whom he was dealing were, alas, unable to contemplate the grandeur and ideal which had been the happy lot of the French through the magnificence of Louis XIV, and he goes on to attack at some length 'our politicians and moralists of the last few years who have been trying to diminish the

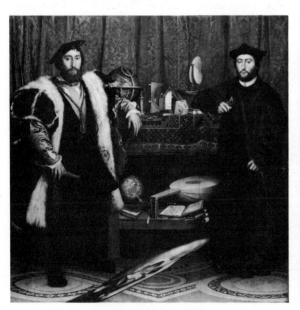

34 Holbein: *The Ambassadors*. National Gallery, London

35 Ribera: *The Holy Family with Saint Catherine*. Metropolitan Museum, New York

36 Louis Le Nain: *Le maréchal de forge*. Louvre, Paris

reputation of this monarch'. When the second volume appeared a few months later, this apologia for monarchy must have seemed somewhat out-of-date, to put it mildly, and his new preface begins: 'This book, which was undertaken many years ago, was handed over to the printer before the glorious epoch which has turned an enslaved into a free people. Begun under despotism, it is completed under the auspices of sacred equality and august freedom,' and he proceeds to explain away his previous references to Louis XIV.[46]

As Le Brun himself rightly proclaimed, the plan of his book was a new one, the artists being arranged neither alphabetically nor according to strict chronology, but in groups of pupils and followers around particular masters. With hindsight we can see that Le Brun was doing something whose implications were even more revolutionary than he himself probably realized. He was the first connoisseur to break with the prevailing habit of trying to attribute as many pictures as possible to the great and established names and to insist instead on the value of rarity and unfamiliarity. His whole book was designed to bring to light hitherto neglected artists such as Saenredam (Plates 37, 38), and was specifically intended to replace name snobbery by what was in effect another kind of snobbery – that of the unknown – which was to open up infinite possibilities for historians and collectors.

To reproduce for the first time ever, and to praise enthusiastically,[47] a painting by Vermeer (Plates 39, 40), an artist whose name had been almost wholly forgotten for more

38 Engraving after Saenredam:
Interior of the Church of St Bavo,
Haarlem, for Le Brun's *Galerie* . . .

39 Vermeer: *The Astronomer*. Baronne Edouard
de Rothschild collection, Paris (formerly
Le Brun collection)

40 Engraving after Vermeer: *The Astronomer*,
for Le Brun's *Galerie* . . .

41 Metsu: *The letter-writer*. Sir Alfred Beit collection, Russborough

than a century, and indeed to acknowledge that this 'très-grand peintre' is more or less unknown – this was a decisive step forward in the appreciation of art, whatever the commercial considerations that lay behind it. And while it is naturally true that Le Brun speaks well of nearly all the painters represented in his collection, his greatest warmth, on this as on other occasions, is reserved for Vermeer.

How soon did Le Brun decide to approach painting in this new and adventurous spirit? A comparison between Vermeer's *Geographer* and the engraving made for his book in 1784 may give us a clue. The one significant difference between them is the absence on the latter of the signature and date, IV MEER MDCLXVIIII. When we look at Le Brun's volumes we note that the signatures are never reproduced by his engravers, though I have found no other instance of one so prominent being omitted, and in many other cases he does discuss artists' signatures or monograms in his text. I am inclined to suspect that Le Brun, who can in fact only have known of the true authorship of this picture from the signature, may have had it eliminated from the engraving because he was at one time thinking of following the very course which he frequently imputes to rival dealers and which was usual enough at the time: that is, painting over the signature and suggesting that the artist was a more familiar and established master – probably Metsu (Plate 41) to whom he compares Vermeer on a number of occasions. And then, perhaps when publication was nearly ready, came that flash of genius, the consequences of which are with us to this day: someone we have never heard of can be 'un très-grand peintre'. . . .

Considerations of this kind continued to preoccupy Le Brun throughout his career. In 1807 and 1808 he travelled widely in Spain and Italy, and was immediately struck by what he saw of Spanish art: 'My admiration made me want to snatch from oblivion many famous masters who are unfamiliar to all who live outside Spain.'[48] The response was characteristic, though less so were the apparent inadequacies of Le Brun's connoisseurship when trying to tackle so new a field and his comparative lack of success in extracting many masterpieces from Spain.[49] None the less, the fact remains that already before the French generals had begun that systematic looting in Seville, Granada, and elsewhere which was eventually to lead to world-wide interest in Spanish art, Le Brun had brought back to Paris a series of pictures by (or attributed to) Velazquez, Claudio Coello, and Alonso Cano, as well as the inevitable Murillo, and that the illustrated sale catalogues he produced in connection with his exhibition of them contains some of the first illustrations of the work of these artists outside their native country.[50] Le Brun was always interested in reproductions, and it is when discussing those that were available of the pictures of Velazquez that he makes an early (though not the earliest) reference in French to 'Goya, peintre vivant'.[51]

But while it is true that Le Brun was one of the first of art lovers consciously to try to 'discover' neglected artists of the past, it must be emphasized that the spirit in which he did so was very different from that of a number of other investigators who, all over Europe, had been thinking along similar lines for at least a generation. Not for him the cult of the 'primitive', whether antique or medieval.[52] This lover of Northern art had nothing but contempt for the early Flemish painters, and his comments on a painting which he absurdly (almost perversely) attributed to Rogier van der Weyden (Plate 42)[53] – 'despite the praise of some writers I am unable to assign either great merit or great value to these productions'[54] – was characteristic of earlier attitudes rather than prophetic of new ones. On the other hand, at the height of the reaction against the Baroque, he writes with enthusiasm of

42 Engraving after 'van der Weyden': *Masked figures in a street*, for Le Brun's *Galerie* . . .

43 Sebastian Vrancx: *Patrician Family Going to a Carnival Reception*. Private collection, Brussels

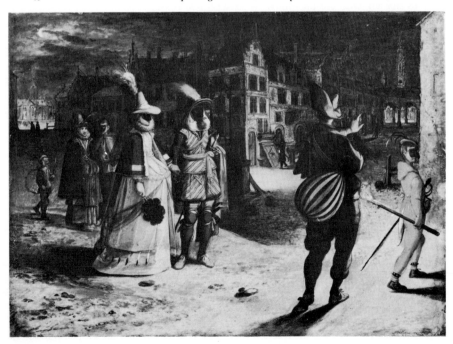

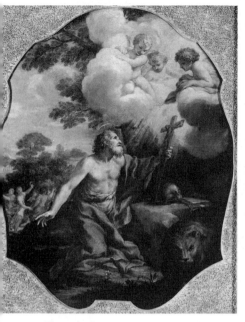

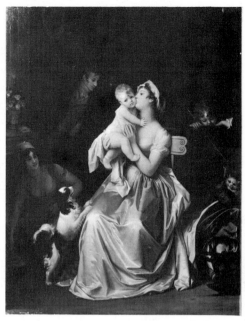

44 Pietro da Cortona: *St Jerome*. Detroit
 Institute of Arts

45 Marguerite Gérard: *Mother and child*.
 Pushkin Museum, Moscow

Pietro da Cortona, and complains that it is 'extraordinary that there are some people today who run down this master'[55] (which was a mild way of describing contemporary criticism of the artist), though, once again, the fact that he was trying to sell two pictures by Pietro (Plate 44) no doubt helped to condition his approach.

The interesting feature about Le Brun is that his really important and original appraisals were all made within a field of taste that was generally acceptable – and to a large extent this was responsible for their failure. Although he will always hold a decisive place in the history of pioneering connoisseurship, the immediate results of his projects to promote the study of, and love for, such unknown artists as Vermeer and many others were relatively insignificant.[56] The *Lady with a servant* (Plates 46, 47) which he rightly and enthusiastically published as a Vermeer[57] soon reverted to the more familiar Terborch, and although the *Geographer* rose in price, it attracted no further attention until the middle of the nineteenth century.

It has been suggested[58] that this failure to follow up Le Brun's greatest discovery was due to the fact that under the Revolution and Empire, the time was not yet ripe for the revival of interest in domestic genre: but this flies in the face of all surviving evidence, both of contemporary art (Plate 45) and of the collections of Old Masters being formed at this time (such as that of Talleyrand) often under the influence of Le Brun himself,[59] which were solidly based on Dutch genre pictures. The reason is a different one and it can be summed up in a question which may sound odd today but which would have been natural enough in 1800: Why buy a Vermeer when a Metsu is available? Similarly, there is much evidence to suggest that the nascent interest in early Italian art was driven underground by another

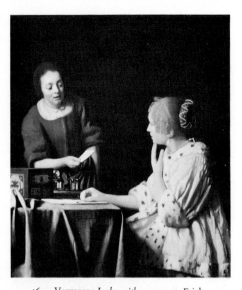

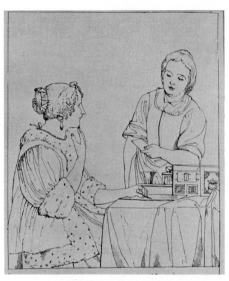

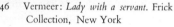

46 Vermeer: *Lady with a servant.* Frick
Collection, New York

47 Line engraving after Vermeer: *Lady with
a servant,* for Le Brun's *Recueil* . . .

question: Who wants a Masaccio or a Botticelli when a Guido Reni can be had for the asking?

The wars and invasions which followed the French Revolution and which extracted pictures from time-hallowed sanctuaries, far from accelerating the changes of taste which were under way during the last years of the *ancien régime,* played a significant part in halting them, or at least slowing them down.

2 Revolution and Reaction

IN MAY 1802 the great German critic Friedrich Schlegel, then aged thirty, came to Paris and in a series of enthusiastic letters notionally addressed to his friend Ludwig Tieck, which were soon published,[1] he described some of the pictures in the Louvre which he most admired. Among these were, above all, two paintings by Mantegna (Plate 48) – an artist who more than a generation earlier had astonished Goethe on his Italian journey[2] – which had entered the Museum only the previous year, though both had long been in France, and Memling's *Altarpiece of St Christopher* (Plate 49), which had been seized by the French armies from Bruges in 1794: 'The benevolent and kindly expression in the countenance of St Christopher, the luxuriant landscape, the symbolic deer, the simplicity and single-heartedness of the whole, remind us of the best efforts of the old German masters, more especially of Dürer.'

This response has come to symbolize what is generally considered to have been the impact on artistic taste of the Revolutionary and Napoleonic wars – convents and churches despoiled; hitherto neglected or despised pictures hung in the great Museum based largely on French loot; a new, radical reappraisal of the art of the past inspired by the immense social, national, religious, and political upheavals of the period.

In fact, of course, the problem is much more complex. Schlegel came to Paris by no means unprepared by his previous German experiences to look sympathetically at early art; he was moreover one of the extremely rare visitors to the Louvre to pay much attention to such pictures, which remained very few in number until a decade after his return to Germany, where his aesthetic responses were increasingly coloured by nationalism.[3] Moreover in Paris itself his more intense (but subsequently much less publicized) feelings were engaged by the standard masterpieces of the High Renaissance that attracted universal admiration at the time – Correggio, for instance, and the *Transfiguration*, 'the last and most wonderful work of Raphael' – though later they were to be despised by many who considered themselves to be the disciples of Schlegel. And although Schlegel goes out of his way to make a generalized attack on the Bolognese masters of the seventeenth century, he usually finds himself responding as warmly as the next man to individual works by them. It is the heightened language with which he evokes the art of the early Northern masters rather than any revolutionary concern to upset the *status quo* that gives significance to his comments – comments which aroused immediate response in Germany but left opinion in France and England virtually unaffected for at least a generation. The Revolutionary wars split the international community in matters of artistic taste as in so many other spheres.[4]

Indeed, the first impact occurred well before most people had even become fully aware of what was involved. In 1792, when Louis XVI was still king, though his future was already in doubt, Louis-Philippe-Joseph, head of the subsidiary Orleans branch of the royal family, hoping to gain the throne for himself and not realizing that the very institution of monarchy was at stake, sold his pictures in order to raise money for his intrigues.[5] His was probably the finest collection in private hands anywhere in the world at the time, and its disposal was certainly the most important event of its kind since the Estes had, in

48 Mantegna: *Parnassus*. Louvre, Paris

49 Memling: *St Christopher and two other Saints* (central panel of the Moreel triptych).
Musée des Beaux-Arts, Bruges

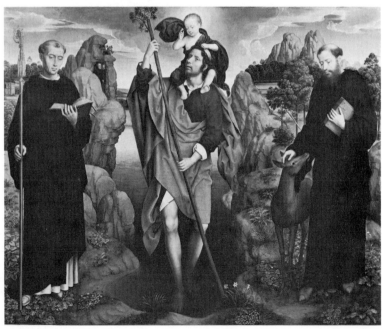

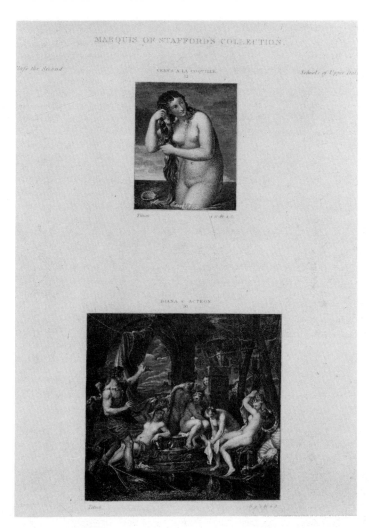

50 Titian: *Venus à la coquille*, and *Diana and Actaeon*. From Ottley:
Engravings . . . of Marquis of Stafford's Collection of Pictures, Vol II

1746, sold a hundred of their greatest masterpieces to the King of Saxony. The Orleans
pictures were of even higher quality (Plate 50), and after a number of complicated and
exciting adventures both the Italian and the Northern pictures (which had been disposed of
separately) reached England and were eventually bought by private treaty. The Italian and
French pictures were acquired by a syndicate of three noblemen, who kept what they con-
sidered to be the best for themselves, and sold the remainder, thus managing to make a
financial profit out of the whole transaction.

 For some months from the end of 1798 these paintings – the most significant ones in the
collection – were exhibited together in London before disappearing into various town and
country houses. Nothing of even remotely comparable quality and quantity had been seen

51 Domenichino: *The Persian Sibyl*. Wallace Collection, London

in England since the dispersal of Charles I's pictures a century and a half earlier; and it may be for this very reason that the general public seems to have been almost too dazed to have reacted with the enthusiasm that might have been expected: 'I am heartily sorry that you did not see these pictures,' wrote Mary Berry to a friend in March 1799,[6] less than three months after the opening of the exhibition, 'for they are by far the finest – indeed, the only real display of the excellency of the Italian schools of painting that I ever remember in this country. And then one sees them so comfortably, for there are fewer people go to the Lyceum than even to Pall Mall [the two places where the pictures were shown], for the pictures are all of a sort less understood and less tasted here: and besides, they are without frames; and besides, the Lyceum is out of the way; and besides, it is not near Dyde's and

Scribe's, nor Butler's, nor any of the great haberdashers for the women, nor Bond St. nor St. James' St. for the men.'[7]

But on a limited number of people the impact of the exhibition was unforgettable, and no one recorded it more vividly than William Hazlitt,[8] who – at the time to which he was referring – was still a budding painter: 'My first initiation into the mysteries of the art was at the Orleans Gallery: it was there that I formed my taste, such as it is: so that I am irreclaimably of the old school in painting. I was staggered when I saw the works there collected and looked at them with wondering and with longing eyes. A mist passed away from my sight: the scales fell off. A new sense came upon me, a new heaven and a new earth stood before me. . . . Old Time had unlocked his treasures, and Fame stood portress at the door. We had heard of the names of Titian, Raphael, Guido, Domenichino, the Carracci (Plates 51, 52) – but to see them face to face, to be in the same room with their deathless productions, was like breaking some mighty spell – was almost an effect of necromancy.'

The passage is as familiar as it is moving, but one point needs to be stressed: 'it was there that I formed my taste such as it is, so that I am irreclaimably of the old school in painting',

52 Annibale Carracci: *The Dead Christ Mourned* ('*The Three Maries*'). National Gallery, London

for the words imply that the values exemplified by the Orleans collection were already being challenged by December 1820 when Hazlitt wrote his article, though most people probably failed to realize this. The impact of the Orleans sale – and of many similar ones in London during this unsettled period – was dazzling in the possibilities it opened up, and entirely retrograde (if the word can be used without any pejorative connotations) as far as English taste was concerned. That the nobility and gentry could now decorate their houses in the same style as the aristocrats of Rome, Venice, and Genoa on whom they had called during their Grand Tours would have seemed unimaginable only ten years earlier. Suddenly it became possible – almost easy if the money was available – and as the meal was digested the appetite grew. Flocks of agents, dealers, unsuccessful artists, and adventurers of all kinds descended like vultures on Italy to take their pickings from the resident nobility, who were obliged to pay the swingeing fines imposed by the invading French armies. For more than a decade it seemed as if the whole of Europe from dukes and generals to monks and common thieves was involved in a single vast campaign of speculative art dealing. King George III noticed what was happening and commented sarcastically that all his noblemen were now picture dealers.[9]

Masterpiece after masterpiece arrived in London (Plate 53) in an apparently endless flow, and the process came to be looked on as natural. At the height of the blockade dealers, including French dealers, came to England with their stock and then returned to the Con-

53 Scarlett Davis: *Thirlestane House, Cheltenham, with pictures from Lord Northwick's collection.* Oscar and Peter Johnson Ltd, London

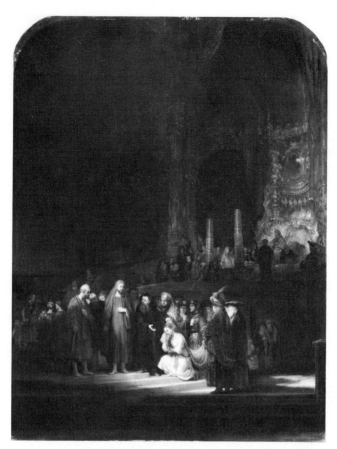

54 Rembrandt: *The woman taken in adultery*. National Gallery, London

tinent to renew it.[10] There was Lafontaine, for instance, a cold, reserved, silent man, himself a minor painter, who would look at a fine picture for fifteen minutes on end and then say no more than 'c'est zoli, c'est zoli'. When Bonaparte refused to pay enough for Rembrandt's *Woman taken in adultery* (Plate 54), which he offered him for the Musée Napoléon, he promptly took it to London and sold it there for five thousand guineas.[11]

The most authoritative account of what happened in these years was written in 1824 by William Buchanan, a Scottish lawyer who had been actively involved and who still had forty years to live, many of them devoted to dealing. His book is by far the frankest ever written by any dealer anywhere, and by printing many of the original documents and letters that passed between him and his agents Buchanan conveys much of the profitable excitement of the pursuit – bliss indeed was it to be a collector in that dawn, but to be a dealer was very heaven. However, a large number of private letters to and from him which have recently come to light make it clear that his account of both collectors and dealers is somewhat too bland.[12]

Taste, if the word implies discrimination, played little enough part in any of the compli-

55 J. H. Craig (engraved C. Picard): *The third Duke of Bridgewater*. Hope Collection, Ashmolean Museum, Oxford

56 Angelica Kauffmann: *The second Lord Berwick in Rome*. Attingham House, Shropshire

cated transactions involved, because for many years it was very difficult for anyone with enough money not to be able to buy some celebrated masterpiece. Indeed, this was the object of the whole operation. The artist James Irvine, Buchanan's collaborator who was living in Italy, wrote that he was 'repeating on a smaller scale what has been so profitably done by the purchasers of the Orleans collection. . . . With a few thousand pounds a few well-known first rate works might be procured, out of which you could pick one for yourself, and by the sale of the others reimburse all expenses,'[13] and he went out of his way to emphasize that he proposed buying 'no pictures but those of the highest beauty and celebrity'.[14] It was on the strength of taking advantage of these opportunities that the British aristocracy succeeded in building up for itself its reputation as a cultivated patriciate.

Who were these collectors? The ageing Duke of Bridgewater (Plate 55), who acquired the lion's share of the Orleans pictures and whose acute business sense was shown by his infinitely profitable ventures into coal mining and canal building, had not until now unpacked the antiquities which he had brought back from his Italian Grand Tour half a century earlier,[15] though it is true that his acquisition of the Orleans pictures did inspire in him a late-flowering passion for art which delighted his friends 'as it causes him to take the exercise of walking much about his galleries and rooms'.[16]

The second Lord Berwick (Plate 56), who bought what was possibly the single most

beautiful picture in the whole Orleans gallery, Titian's *Rape of Europa* (Plate 57), had on *his* Grand Tour only a few years earlier been so little interested in such matters that he had entrusted the entire question of furnishing his newly-built mansion of Attingham to his tutor and travelling companion, the Reverend E. D. Clarke, who wrote from Rome in 1792, 'he has left me to follow my own taste in painting and sculpture'.[17]

Indeed, of the men who from the mid 1790s onwards began hanging their galleries and reception rooms with some of the greatest masterpieces ever painted, a high proportion are new to the historian of English collections. Titians and Raphaels, Correggios, Rubenses, and Guidos joined the odd family portrait or hunting scene that until then had constituted the sum total of their artistic possessions. There were exceptions, of course: even before the Revolution, men like Sir Abraham Hume (Plate 58), later the author of the first monograph on Titian in the English language and himself the purchaser of one of the great

57 Titian: *The Rape of Europa*. Isabella Stewart Gardner Museum, Boston

58 P. C. Wonder: *Sir Abraham Hume (centre) with his son-in-law Lord Farnborough, and the Earl of Aberdeen*, 1826. Study for an unexecuted painting of Patrons and Lovers of Art. National Portrait Gallery, London

Titians from the Orleans collection (Plate 59) as well as many other masterpieces, had already shown an absorbed and discerning love of the arts,[18] as had William Beckford, Richard Payne Knight, and others; but on the whole, the figures who had played the most important cultural role in England during the last third of the eighteenth century were not involved. Perhaps lack of wall space was the only reason, perhaps the vast increase in prices – certainly the old aristocratic names were now joined by hugely rich bankers and merchants of Russian, Dutch, and German origin: John Julius Angerstein, the Hopes, the Barings.

Buchanan treated them all, old or new, with ironic contempt – in private. 'The old Earl of Wemyss' – 'the lecherous old dog' – 'has a particular rage for naked beauties, and plenty of the ready to purchase them with,' he wrote to his London agent in 1803, and the comedy of his attempts to sell a so-called Van Dyck *Venus* to this nobleman, who had in fact been buying fine pictures well before Buchanan's birth, throws a cruder, more realistic light on the art dealing of the day than has yet been made public.[19]

Buchanan's own qualifications for adopting such an attitude were non-existent. He had never been to Italy, and though he later took much pride in having imported Titian's 'celebrated' *Bacchus and Ariadne* (Plate 60) into England, he had in fact never heard of the picture when it was first proposed to him and had no idea what it looked like.[20] His sources

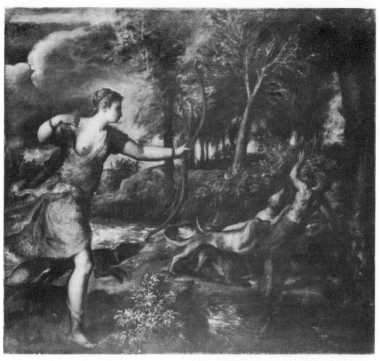

59 Titian: *The Death of Actaeon*. National Gallery, London

60 Titian: *Bacchus and Ariadne*. National Gallery, London

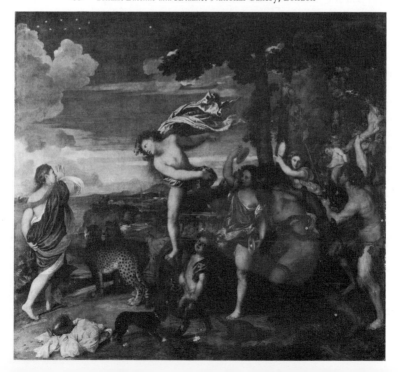

61 Botticelli: *Mystic Nativity*. National
Gallery, London

of original information were incredibly casual even by the standards of the time, and he relied more on travel books than on such prints as were available. But so rich were the spoils that none of this mattered, and he had all the other talents required of a successful dealer: the mixture of idealism and hardheadedness which prompted him to think of presenting to the nation some thirty or forty masterpieces, while at the same time grasping the fact that should the government turn down this opportunity to found a National Gallery – and it was pretty certain that they would – his gesture would certainly have raised the price of his pictures;[21] the curiosity about sources which made him rival Le Brun in his pursuit of marked sale catalogues and employ a 'spy' in Christie's;[22] the imaginative drive which led him to approach the American minister James Monroe with a suggestion that he might be interested in acquiring paintings for the newly created gallery at Philadelphia, despite the fact that 'the Americans like credit, and are damned paysters';[23] the coolness which, in 1804, urged him to arrange for the sale of his pictures 'before the attempt at Invasion takes place which [will] thin London of the Military Classes'.[24]

But, beyond all this, Buchanan realized the most important fact of all: that real power lay not with the collectors themselves, but with their advisers. Only Sir George Beaumont, he wrote, bought entirely on his own initiative.[25] The others relied on advice – advice that came from the artists, and it was therefore essential to bribe these. There was no awkwardness about the word which is used quite openly in the letters,[26] though it is appreciated that certain formalities had to be observed. [27] Benjamin West, the president of the Royal Academy, was the most important catch and presented the least difficulties – 'Doctor West, that learned, and enlightened *quack*, who has the address to make some folks believe that white, is black, and *au contraire*, Black, White', as Buchanan characteristically wrote of him,[28] whereas in the pages of his published book he records only that 'the late Mr. President West used often to remark to the proprietor [of Mr Day's collection of Italian pic-

tures] that after having visited his Rooms in Brook Street, where the collection then was, he used to march home as if he felt himself some inches taller'.[29]

Quite soon Buchanan was proposing – and usually with success – to subsidize most of the more influential figures in the Royal Academy.[30] This was more useful as a means of doing down rivals (about whom Buchanan tended to be somewhat paranoiac) than of puffing his own goods, most of which stood in little need of such treatment. It is true that, as we shall see in the next chapter, many years previously British artists had been among the pioneers in appreciating painters outside the canon of those accepted by orthodox taste. Thomas Patch and Reynolds, Flaxman and Romney had all shown interest in, sometimes even enthusiasm for, the primitives. Now, however, the sight of more conventional masterpieces hanging on the walls of English sale rooms quickly brought the Royal Academicians back to their more usual allegiances. Who, I asked rhetorically at the end of my last chapter, wants to buy a Botticelli when a Guido Reni can be had for the asking? It was a question that could have been put with much greater feeling by the artist-dealer William Young Ottley when in 1811 he was quite unable to sell Botticelli's *Mystic Nativity* (Plate 61) which he had bought from the Aldobrandini collection in Rome more than a decade earlier.[31]

The example of Ottley will have indicated that a few independent artists, dealers, and collectors continued to show an interest in more wayward developments,[32] but on the whole – for better or for worse – British taste generally, like that of Hazlitt's specifically, was 'irreclaimably of the old school in painting'.

Many Italians also did well out of their troubled times: the painter and dealer Vincenzo Cammuccini collaborated actively with his British opposite numbers, and in the process acquired such fine Renaissance masterpieces as the *Feast of the Gods* by Bellini and Titian (Plate 62);[33] while Teodoro Lechi from Brescia (Plate 63), who began his active life as a

62 Giovanni Bellini and
 Titian: *The Feast of the*
 Gods. National Gallery
 of Art, Washington

Jacobin and ended it as a hero of the Risorgimento, was, while campaigning for the French in 1798, offered as a present Raphael's *Marriage of the Virgin* (Plate 64) by the citizens of Città di Castello.[34] Another man who threw in his lot with the French and who was rewarded with a series of lucrative posts and exalted titles during the Napoleonic regime, the Marchese Gian Battista Costabili, of an old Ferrarese family, began to amass his superb collection of Old Masters in these years, concentrating largely on those that came from his native city (Plate 65).[35] Meanwhile Costabili's patron, the Viceroy of Italy, Eugène de Beauharnais, established picture galleries in Milan and Venice that had already reached international standards well before the return to Italy of those works of art that had been seized by the French.[36]

Indeed, by the standards of the time, the only people who had failed to take advantage

63 Appiani: *Teodoro Lechi*. F. Lechi collection, Brescia (photographed from plate in Lechi)

64 Raphael: *The Marriage of the Virgin.*
 Brera, Milan

65 Pisanello: *The Virgin and Child
 with Saints George and Anthony.*
 National Gallery, London

of the situation were the French themselves. No paradox is intended. From all over Italy, Germany, and the Low Countries, masterpieces were loaded on to ships and mules to be taken to Paris to be shown in the great Museum organized by Vivant-Denon: the *Apollo Belvedere* and Raphael's *Transfiguration*, Veronese's *Marriage at Cana* and the *Venus de' Medici.* The first great spoils were being added to the Louvre within a year of the Orleans collection being bundled out of the Palais Royal. But although nothing like this had ever been seen before, what is almost as astonishing is the meagreness, the almost negligible quality by conventional standards of the booty that fell into private hands.

On and off for nearly twenty years the French effectively dominated most of Italy. Artists, soldiers, and diplomats of all political opinions swarmed over the peninsula, many of them with specific instructions to seize masterpieces on behalf of the great centralized Museum in Paris and (indirectly) of the subsidiary galleries that were being created in leading provincial towns. Many of these agents were themselves collectors or were inspired to collect by the possibilities that seemed to open up before them: and yet if we compare what fell into their own hands with what was smuggled out to England, the differences are striking. So efficient was the control exerted by the authorities that remarkably little of what would, by prevailing standards, have been considered of serious quality failed to reach its official destination in Paris.

Pillage of private palaces and collections was nearly always strongly discouraged: the French commissioners entering Naples in 1799 were told to consider such collections as 'sacred'.[37] There were the odd, terrible exceptions, in Rome, Verona, and elsewhere, but they were comparatively rare; and outbursts of looting tended to concentrate on coins and medals, silver and furniture, always more vulnerable or appealing to soldiers in time of war than pictures[38] – though there must have been many more cases of theft than were ever fully recorded, as is demonstrated by a sad little occasion in April 1811 when Mme de Souza went on a shopping expedition along the *quais* with Cardinal Albani, then living in Paris, only to find him suddenly burst into tears when offered for sale a *Virgin* by Sassoferrato which had been looted from the Villa Albani.[39]

Even the English acknowledged that Italian private collections emerged relatively unscathed from direct French plunder, while pointing out that the masterpieces sold in London had been flushed out of Rome as a result of French penal taxation on the nobility.[40] Of course such taxation and similar pressures could act in the interests of the French themselves as much as of the English, but it is surprising how rarely this actually happened and how unsatisfactory the results usually were – though not always for lack of trying. We can take the case, for instance, of Charles-Jean-Marie Alquier, whose career is typical of many at this time: deputy, regicide, *commissaire aux armées*, diplomat in Spain and Italy, Baron of

the Empire, exile, and respectable veteran. During his years in Italy at the beginning of the century he did what he could to form a collection of masterpieces. His most celebrated acquisition was a so-called *Self-portrait* on canvas by Michelangelo, which (despite the enthusiasm of the painters Wicar and Ingres) proves to have been little more than a copy of a fairly well-established prototype probably by Jacopino del Conte; he also bought a 'Titian' *Self-portrait*, a small replica of Leonardo's *Virgin of the Rocks*, and other paintings of which the glamour of the putative authors is only matched by their actual insignificance.[41]

A somewhat more successful collector of very much the same type was Jean-Pierre Collot, another *commissaire* of the French armies in Italy, who when in Rome was able to rely on the advice of the most distinguished art historian in the city in choosing his pictures. Collot's post clearly gave him access to the greatest Roman palaces, but what he extracted from them was not very remarkable: a doubtful (though admittedly very famous) *Massacre of the Innocents* by Poussin from the Altieri, a doubtful Guido Reni from the Colonna, a still more doubtful Leonardo from the Barberini (Plate 66), and the usual 'Andrea del Sartos', 'Titians', and 'Baroccis'.[42]

It is instructive to match these rather dismal achievements with the fate of a picture of real significance which fell into private French hands during this period. When in 1799 General Clauzel, adjutant-general of the French army in Italy, was given as a present by the King of Sardinia Gerard Dou's *Dropsical Woman* (Plate 67), a painting that was for many years compared favourably with the most famous masterpieces of Raphael and

67 Dou: *Dropsical Woman.*
Louvre, Paris

56

68 Raphael: *An Allegory* (*'Vision of a Knight'*). National Gallery, London

69 Guercino: *Angels weeping over the Dead Christ*. National Gallery, London

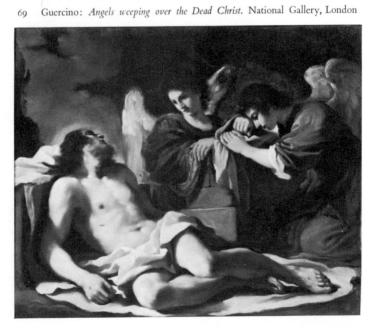

70 Canova: *Cardinal Fesch*. Gipsoteca, Possagno

71 Fabre: *Lucien Bonaparte*. Museo Napoleonico, Rome

Poussin, he evidently felt it prudent to offer so famous a work to the recently created Museum in Paris, where its arrival was greeted with the greatest enthusiasm.[43]

On other occasions, we actually find the French *commissaires* selling to their English enemies paintings by the most admired masters, such as Raphael's '*Vision of a Knight*' (Plate 68) and Guercino's *Angels weeping over the Dead Christ* (Plate 69), both of which emerged from Italian collections and reached London through French intermediaries.[44]

We shall see shortly that many very impressive collections of Italian paintings were being built up by Frenchmen in these years, but if we view them against the accepted taste of the time (the taste, that is, of the English purchasers of the Orleans collection and the French agents for the Musée Napoléon), they were – with two exceptions – negligible. The two exceptional collectors were both close relations of Napoleon himself – his uncle, Cardinal Fesch (Plate 70), and his younger brother, Lucien (Plate 71), with whom he quarrelled in 1803.

Although we can find out a good deal about the contents of the superb collections formed by both these men, it will not come altogether as a surprise to learn that, anxious though they were to publicize their pictures, they were also quite remarkably coy about their provenances, and the circumstances and dates at which they had acquired them: indeed, it is amazing to discover how many of what are now looked upon as world-famous masterpieces are recorded for the first time in their collections. We know that as early as 1803 Fesch owned 'great quantities [of pictures], good, bad and indifferent, chiefly small ones, and numbers standing against the walls not hung up',[45] but it seems rather unlikely, from the off-hand tones of the visiting English artist who tells us this, that he yet possessed

58

72 Raphael: *Altarpiece: The Crucified Christ with the Virgin,*
Saints and Angels. National Gallery, London

many of the extraordinary High Renaissance and Baroque masterpieces which later attrac-
ted such attention. Surprisingly enough these, such as Raphael's *Crucifixion* (Plate 72),
mostly seem to have been acquired *after* the downfall of Napoleon when Fesch was living
as an exile in Rome,[46] and consideration of his collection can best be postponed until a
later chapter.

Although we know more about the dates of Lucien's purchases,[47] to follow the intri-
cacies of his career as a collector would require more patience than can reasonably be
expected of any researcher. This strange and brilliant man, who made his brother's career
and then quarrelled with him, only to return to his side during the Hundred Days, spent
most of the war living in Italy and in England: he was as genuine and discriminating in his

love of art as he was devious in his dealings.[48] His saturnine good looks were recorded by most of the leading artists of the day, including Fabre, Canova, and – above all – Ingres, who also made of his family one of the most enchanted portrait drawings in the history of art.[49] Fortunately Lucien was as vain of his collections as he was of his appearance,[50] and the engravings he had made of many of his pictures (probably with a view to disposing of them during a period of financial difficulties) allow us not only to identify a significant number, but also to form an approximate idea of when he acquired them.[51] He surrounded himself with artistic advisers, and it was with the help of the painter Guillon Lethière that he bought large quantities of pictures on the occasion of his first mission abroad in 1801 when he was sent to Madrid: among these was the finest Velazquez to leave Spain since the Habsburg portraits which had been sent to Vienna in the seventeenth century (Plate 73).[52]

This was a good start, and Lucien maintained it with a series of remarkable purchases.

73 Velazquez: *Lady with a fan.* Wallace Collection, London

74 Studio of Raphael: *Madonna of the Candelabra*. Walters Art Gallery, Baltimore

We know that by 1812 he owned such beautiful pictures as Lotto's *Family group* (Plate 75), the earlier history of which is quite unknown, and that he had already acquired enormously famous paintings attributed to Raphael (Plate 74) and by Annibale Carracci (Plate 76). What is of particular interest in the context of this study is that Lucien should have obtained these pictures, not while holding some official post in the French army or diplomatic service, but, on the contrary, while living in Italy as a refugee from his all-powerful brother. The source from which he obtained some of his most famous masterpieces, such as Poussin's *Massacre of the Innocents* (Plate 77) and Sofonisba Anguisciola's *Game of Chess* (Plate 78), also throws considerable light on the limited nature of French collecting at this period.

Prince Vincenzo Giustiniani, heir to two renowned collections of antique marbles and (mainly) seventeenth-century paintings, was one of the many nobles in Rome to have suffered badly from the upheavals of war and revolution.[53] From the first years of the nineteenth century it was known that these collections were effectively for sale, and as early as 1804 Lucien had begun to purchase some of the best antiques and pictures, such as

75 Lotto: *Family group*. National Gallery, London

76 Annibale Carracci: *The Three Maries at the Tomb*. Hermitage. Leningrad

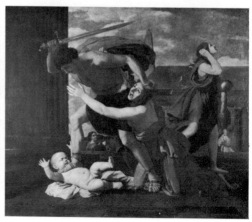

77 Poussin: *The Massacre of the Innocents*. Musée Condé, Chantilly

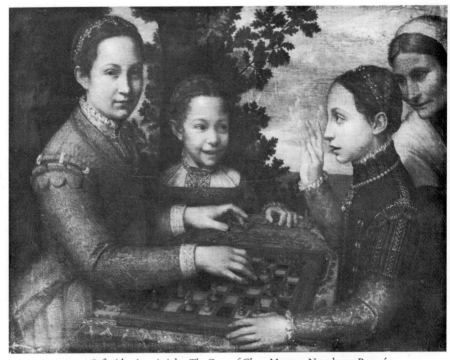

78 Sofonisba Anguisciola: *The Game of Chess*. Museum Narodowe, Poznań

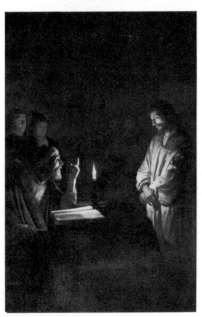

79 Honthorst: *Christ before the High Priest*.
National Gallery, London

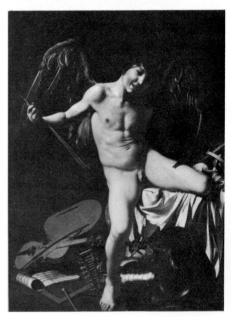

80 Caravaggio: *Amore Vincitore*. Staatliche
Museen, Berlin– Dahlem

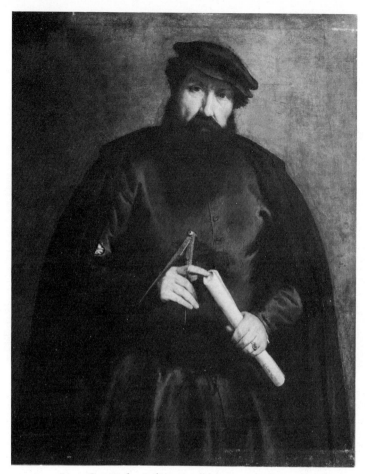

81 Lotto: *Portrait of an Architect*. Staatliche Museen, Berlin– Dahlem

Honthorst's *Christ before the High Priest* (Plate 79), to follow them up shortly afterwards with the paintings mentioned above.[54] Although Giustiniani managed to dispose of his sculptures quickly enough, it was not for some years that he was able to sell a hundred and fifty of his pictures to the Paris dealer Bonnemaison (who, as we have seen, kept his English clients throughout much of the war); and Bonnemaison was unable to sell any of them – despite the fact that they numbered pictures such as Caravaggio's *Amore Vincitore* (Plate 80) and Lotto's *Portrait of an Architect* (Plate 81), then attributed to Titian – until the King of Prussia took them off his hands in 1815.[55]

When William Buchanan paid his first visit to the Continent after the wars, he was astonished to find that 'no collection of real consequence appeared to have been formed by any individual during the whole period of the war'.[56] We have seen that from his own point of view of what constituted 'real consequence', Buchanan was hardly exaggerating, and that Fesch and Lucien Bonaparte were exceptional among the French in being able to acquire established Italian masterpieces, most of which were seized for the Louvre, only to

82 Michelangelo: *Taddei tondo*. Royal Academy, London

be dispersed by the time Buchanan arrived in Paris in 1817.[57] How much better, he must have reflected, he could have done with the opportunities available to his French rivals. How much better, he did in fact imply, he *had* done for English collectors even without those opportunities!

It was, of course, easier to buy in fields in which the government was not interested, such as very early and very late Italian art (to which we shall shortly turn); and even within the sphere of the High Renaissance we discover – with some surprise – that the Museum tended to neglect both sculpture and drawings.[58] It was here, therefore, that the acute French collector could achieve his outstanding successes. The most fanatical and treacherous of the artists of the period, Jean-Baptiste Wicar, who for many years acted as an agent in acquiring Italian art for the Museum in Paris and who, when the Empire collapsed, was among the most vociferous in demanding its restitution, was accused of stealing some seven pictures by well-known painters for his own collection;[59] but these cannot be traced, and what little we know of his pictures generally suggests that they were not of the highest

quality. It is, however, when we come to his sculptures and drawings (Plates 82, 83) that we find the true equivalents to the great masterpieces of Italian pictorial art that were reaching London in these very years.[60]

That it was lack of opportunity rather than any change of taste that inhibited French private collectors at this time is confirmed at a glance by the effects of the Spanish campaign, which were diametrically opposed to those of the Italian. Repeated attempts to select some of the finest pictures – both Spanish and foreign – from the royal and other collections in Madrid and elsewhere to enrich the Musée Napoléon were thwarted by delaying tactics, and by the fact that King Joseph, Napoleon's brother, was keen to keep them for himself; whereas individuals of all sorts, and French more than English, were able to acquire wonderful treasures of what we might call the conventional kind. The barest glimpse will be enough to point the contrast with Italy. Joseph himself, when forced to

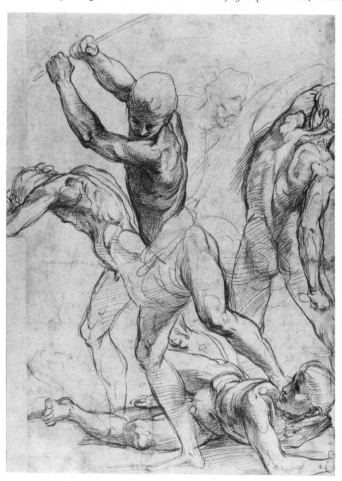

83 Raphael: *Combat of nude men* (preliminary drawing for
The School of Athens). Ashmolean Museum, Oxford

66

84 Raphael: *Madonna del Pesce*. Prado, Madrid

flee from Spain, took with him no less than five pictures attributed to Raphael (Plate 84), a magnificent Titian (Plate 85), and many other masterpieces. Murat, when military commander of Madrid, acquired some of the great Renaissance paintings from the collection of Godoy, the Prince of Peace, including Correggio's 'The School of Love' (Plate 86),[61] and in the free-for-all which prevailed during this terrible period the Danish minister in Madrid, Count Bourke, was particularly successful in his dealings and managed to obtain one of Raphael's most famous Madonnas (Plate 87) as well as four large paintings by Rubens from a convent near Madrid.[62]

In fact the list of all those individuals who did well out of the Spanish campaign is a long one,[63] and here I need only mention the most famous of them all, Marshal Soult.[64] Once

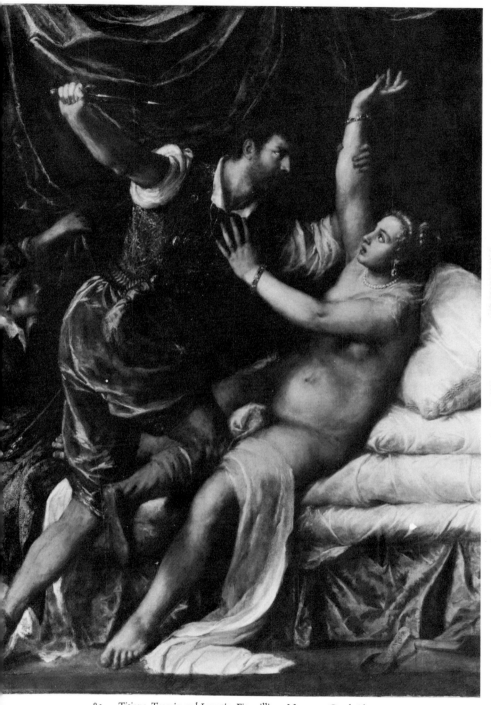

85 Titian: *Tarquin and Lucretia*. Fitzwilliam Museum, Cambridge

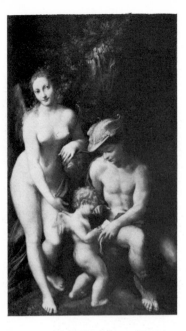

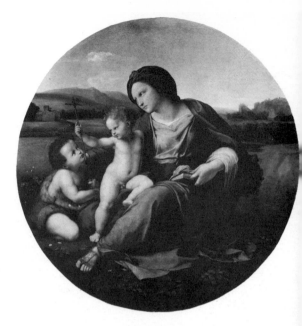

86 Correggio: *Mercury instructing Cupid before Venus* ('*The School of Love*'). National Gallery, London

87 Raphael: *Madonna Alba*. National Gallery of Art, Washington

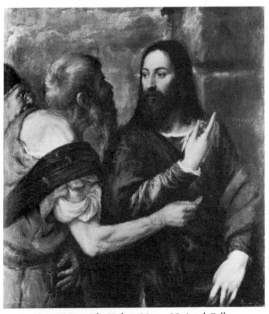

88 Titian: *The Tribute Money*. National Gallery, London

89 Van Dyck: *St Jerome*. Kunstverzameling Stichting Willem Van der Vorm, Rotterdam

90 Murillo: *Christ healing the Paralytic at the Pool of Bethesda*. National Gallery, London

again we find that his plunder included well-known works by established masters such as Titian (Plate 88) and Van Dyck (Plate 89), but he also obtained for himself one of the earliest extensive hauls of Spanish pictures to leave the country, and (in retrospect) it is this that makes him an important figure in the history of taste. The overwhelming majority of these – and the only ones to attract much attention at the time – were by Murillo (Plate 90), who was already established in the international Pantheon of great masters before the Revolution, and it was not very long before Soult was selling these for enormous sums to English collectors (Plate 93). It is, however, perfectly true that Soult was also happy to loot

works by less familiar and stranger-looking artists, such as Alonso Cano and Zurbarán (Plates 91, 92). But his methods of acquisition were so bizarre that it is unlikely that we can attribute his possession of these masterpieces to a precocious taste for out-of-the-way Spanish art.

Still less was there a demand for the unfamiliar from England. Buchanan's agent on the spot, the painter George Augustus Wallis, 'the English Poussin', saw the various changes that occurred in Spain and, so we are told in a phrase that throws considerable light on dealing at that time and others, 'its capital alternatively occupied by the French, the Spaniards, and the English: he remained at his post, and profited by these changes to acquire works of art for this country, endeavouring always, as a professional man and artist, to stand well with all parties'.[65] Whatever we may feel about Wallis's moral standpoint, his perception cannot be faulted. He singled out El Greco – indeed he was the first foreigner to do so – along with Alonso Cano, Zurbarán, and others of whom he had never heard as 'really first-rate men, whose works are quite unknown out of Spain. . . . This school is rich beyond idea, and its painters are all great colourists.'[66] The sudden shock of recognition still comes movingly to us down the ages – but Sir Thomas Lawrence thought nothing of Spanish painting (not even Murillo or Velazquez), and he urged Buchanan to stick instead to Titian, Rubens, Correggio, and Raphael.[67]

A general conclusion seems to be that the vast upheavals in Europe between 1793 and 1815 encouraged and, above all, enabled both the English and the French to acquire, either

91 Alonso Cano: *The Vision of St John the Evangelist*. Wallace Collection, London

92 Zurbarán: *St Lawrence*. Hermitage, Leningrad

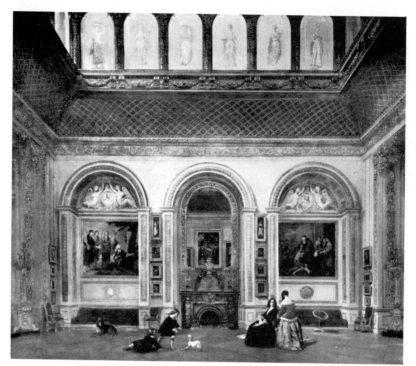

93 J. D. Wingfield: *Interior of Stafford House* (now Lancaster House), giving prominence to two of the Murillos (now in Ottawa and Washington) taken from the Caridad, Seville, by Marshal Soult in 1811–12, and eventually sold by him, after many abortive attempts, to the Duke of Sutherland in 1835. Oscar and Peter Johnson Ltd, London

privately or publicly and on a massive scale, pictures whose status had already been consecrated by centuries of praise. The budding interest in earlier – or remoter – art which had developed slowly but fairly steadily in the 1780s and early 90s was submerged by the sudden and unexpected availability of so many great and established masterpieces.

At least one man could appreciate this situation from personal experience. When Seroux d'Agincourt, the descendant of a French noble family, arrived in Italy in 1779 to embark on a great history of Italian art from its decline following the fall of the Roman Empire to its revival in the fifteenth and sixteenth centuries, he was rich, famous, and the friend and correspondent of artistic and scholarly Europe, able to employ dozens of copyists to help him in his gigantic undertaking, so that within ten years his manuscript was ready to be handed over to the publisher. But by then the Revolution had broken out, Seroux d'Agincourt (a *fermier-général*) was financially ruined, and no one was able, or sufficiently interested, to undertake the publication of so vast a book on so esoteric a subject – and it did not therefore begin to appear until 1811.[68]

It has recently been claimed (with a good deal of justification) that the 'rediscovery' of early Italian art had already been achieved by the Italians themselves well before the English, French, and Germans, to whom the credit is usually given for so gigantic a shift in taste.[69] It is certainly true that local historians, inspired by erudition and patriotism, had by the 1790s made virtually all the points that were to be elaborated, often with much greater

95 Engraving after Guido da Siena: *Madonna and Child enthroned*. Seroux d'Agincourt, Tome V, planche CVII

94 Guido da Siena: *Madonna and Child enthroned*. Palazzo Pubblico, Siena

rhetoric and much less learning, during the first half of the following century. But the researches of local historians then (and all too often now) tend to remain local, and whether or not Seroux d'Agincourt took full advantage of all those available to him, or matched in perception his almost exact contemporary, the Italian Luigi Lanzi, the fact remains that it was through his very extensively illustrated History, and those assistants associated with it, that the Italian 'primitives' became known to the rest of Europe.

Seroux d'Agincourt, the friend of Boucher and Fragonard, Voltaire and Mme Geoffrin, was no more likely to be enthusiastic about the art of the early masters than Gibbon, to whom he was consciously indebted,[70] was sympathetic to the controversies of the early Christians. Indeed, his book was partly designed as an erudite warning to illustrate the dangers to visual culture inherent in the collapse of civilization. Though he insisted on the crucial importance of personal observation in order to avoid 'empty theorizing' (*vaines discussions*) about the arts of the Dark and Middle Ages, his approach remained essentially (and rather simply) sociological. While going out of his way to escape from the nationalism of Vasari and other Italian art historians who had seen in the disintegration of classical values a direct result of the barbarian invasions, Seroux d'Agincourt (himself, after all, a descendant of those barbarians) looked rather to good and bad rulers of whatever race as the determining factors in conditioning aesthetic quality. Roman luxury had been more to blame for the fall in standards than foreign incursions. 'Enlightened despotism' remained the only hope – but in the 1780s for an ageing Frenchman living in Rome that hope was dimming. It is not therefore so strange to discover that his judgement of medieval art was essentially negative as to see that he could, from time to time, be genuinely fascinated by some apparently outlandish artefact of the Middle Ages, rendered even more outlandish in the engraving. We can take as an example his response to Guido da Siena's *Madonna and Child enthroned* (Plates 94, 95), whose fantastically early and obviously erroneous date of 1221 caused such excitement among those anxious to prove that artists had flourished out-

side Florence well before Cimabue and Giotto.[71] He may perhaps have surprised himself by his praise for the merits of the composition, the sweetness of the Child's face, the grace and nobility of the outlines, even the colour.[72] But he must have been still more surprised to find that he was surrounded by younger disciples who began to take his patronizing benevolence very much more seriously than he had ever intended.

In the history of taste it has frequently happened that economy, availability, fear of forgery and other considerations of the kind have stimulated collectors or students to explore fields generally considered to be of little interest: the vogue for Dutch and Flemish cabinet pictures (as opposed to Italian Renaissance history painting) in eighteenth-century France was at the time explained largely on these grounds. And now, three-quarters of a century later, it was mostly among diplomats associated with the French Legation in Rome, who – as we have seen – were singularly unsuccessful in obtaining 'conventional' masterpieces, that there gradually developed a strong feeling for the pictures that Seroux d'Agincourt had studied so assiduously, but in so detached a manner, for over a genera-tion.[73]

François Cacault, for instance, had spent some years in Italy before the Revolution[74] (which he greeted rather tepidly) and returned there to hold various diplomatic posts after it: his career culminated in the series of negotiations which led to the Concordat, but he was distrusted by Napoleon for giving too much support to the papal cause and recalled to France. Cacault's brother was a painter, and he himself, though of moderate means, seems to have been an obsessive collector. His sensibility had about it a tinge of the pre-Romantic, for between 1799 and 1804 he built for his large collection of pictures a special museum (Plate 96) in the wild countryside ('des rivières, des prairies, des bois, des montagnes, tels

96 Thiénon, Ch.: *Vue du Musée Cacault*. From *Voyage pittoresque dans le bocage de la Vendée . . .*, Paris 1817

97 Georges de La Tour: *St Joseph and the Angel*. Musée des Beaux-Arts, Nantes

sont les portiques du musée de M. Cacault')[75] near the little Breton town of Clisson, which had been closely associated with some of the more picturesque events of the Middle Ages and which, more recently, had been devastated by the wars of the Vendée. To this remote spot he attracted a host of modern artists and topographical painters in search of new sensations.[76]

But despite this choice of an unusual site, it was presumably a lack of opportunity to acquire 'conventional' pictures rather than a natural inclination that first led him, when already advanced in years,[77] to buy his early Italian pictures (Plate 98) – for which he certainly developed a real passion: a study of his possessions seems to reveal a sense of quality but no consistency of taste or interest in scholarship.[78] His two paintings by Georges de La Tour (Plates 97, 99), attributed by him to Murillo and Seghers, have revived interest in his collection, which included a Lancret as well as a Neri di Bicci, a Boucher as well as a Daddi.

98 Sano di Pietro: *St Francis of Assisi receiving the stigmata*. Musée des Beaux-Arts, Nantes

99 Georges de La Tour: *The hurdy-gurdy player*. Musée des Beaux-Arts, Nantes

100 *Unidentified pictures from Artaud de Montor collection attributed to 'Pierre Laurati'.* Artaud de Montor, *Peintres Primitifs*, plate 26

101 *Unidentified pictures from Artaud de Montor collection attributed to Dello and Uccello.* Artaud de Montor, *Peintres Primitifs*, plate 44

Such a centrifugal propulsion to the extremes of art was characteristic of much collecting at this period,[79] but everything suggests that François Cacault might have felt more at ease in the well-established centre.

But it was just this that was out of the question. Cacault's much younger colleague, Artaud de Montor, a political historian and secretary to the Legation, was perfectly open about all this. It was, he wrote,[80] no longer possible for a private citizen to build up a collection of genuine pictures by Raphael, Correggio, Titian, Giulio Romano, Andrea del

102 Rogier van der Weyden: *The Miraflores altarpiece.* Staatliche Museen, Berlin–Dahlem

103 Memling: *The Floreins altarpiece*. Louvre, Paris

Sarto, Carracci, and Domenichino, whereas a representative group of early pictures could be acquired cheaply enough (Plates 100, 101). They would then begin to reveal a whole series of unexpected beauties. The idea was by no means new, and Artaud acknowledged his debt to Seroux d'Agincourt, whose gigantic History only began to appear in print after the first edition of his own relatively slim brochure; but he and his friends gave the collection unprecedented publicity – there was not merely the catalogue bristling with references to controversies old and new, but also the fact that 'his gallery was open to artists who could study in it at leisure the pictures painted in Italy in the twelfth and thirteenth centuries: our most famous painters hurried there to examine them'.[81] Little can they have realized the nature of the road on which they had embarked.

I am aware that I have strongly stressed the 'determinist' elements affecting taste during these years, and that I have tried to suggest that the 'norm' for collectors was essentially one that had been established more than half a century earlier and had actually been reinforced by the impact of political and military upheavals. Departures from the 'norm' were mainly inspired by considerations of what was available, though there were of course some exceptions. It would, for instance, be interesting to know more about the personality of Général d'Armagnac who, even in a Spain teeming with Murillos, thought it worth while picking up altarpieces by Rogier van der Weyden (Plate 102) and Memling (Plate 103).[82]

Much more spectacular was the case of the English timber merchant Edward Solly, who

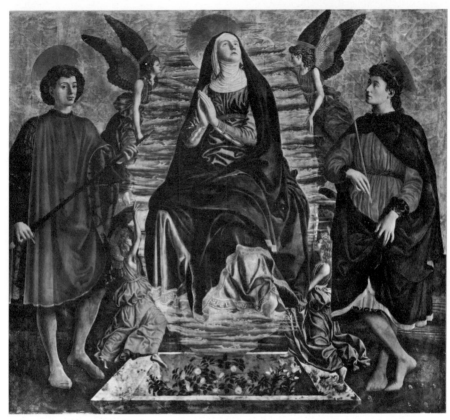

104 Andrea del Castagno: *The Assumption of the Virgin*. Staatliche Museen, Berlin–Dahlem

lived in Berlin throughout the Napoleonic wars and succeeded in making a vast fortune there.[83] Solly, whose passion for collecting seems to have dawned quite suddenly in about 1811, when he was thirty-five, was thus in a position to afford masterpieces of the High Renaissance of the same quality as those which we have seen flowing into London. To some extent he did indeed take traditional advantage of his opportunities – his Raphael *Madonna and Child* (though perhaps rather early for English and French taste of the time), his Moroni *Portrait of a Man*, above all his wonderful Titian *Self-portrait* (Plate 105): these, and a few more, would have been desirable additions to any contemporary English collection or, indeed, to the Musée Napoléon; but it has to be admitted that they must have been wholly submerged by the three thousand or so other paintings that Solly kept in his Berlin mansion. Botticelli and Cranach, Andrea del Castagno and Rogier van der Weyden (Plates 104, 106): it is doubtful whether more than half a dozen connoisseurs had even heard of the names of these artists, let alone wanted to buy – as Solly did on an unparalleled scale – masterpieces by them, their contemporaries, and even their predecessors.

Was Solly, whose astute business activities have been admirably chronicled in recent years but whose personality remains quite enigmatic, moved by a feeling for unconven-

tional beauty which in its scope and apparent depth was unique in his own day and which would make of him one of the great pioneers in the history of taste? Perhaps; but there are reasons to hesitate before being quite certain. He acquired the vast majority of his pictures – several hundred a year, many of them very large, over a period of a decade or so – through agents before he had ever had the chance to see them; he never travelled to Italy, where so many of them originated;[84] and almost his only recorded comments on art – made, admittedly, much later when he was living in England as a dealer – suggest an exclusive interest in the Italian Renaissance that was absolutely acceptable to conventional opinion and absolutely at variance with everything that had been distinctive about his own great collection, which had by then been sold.[85] Solly himself acknowledged that he would retain his pictures only after they had been 'approved by the committee at Berlin (for I purchased under the advice of the principal connoisseurs and professors of the art at Berlin)', and there is no doubt that for some years before selling his pictures in 1821 to the Prussian state he had been acquiring works – by the early German masters – which would be more acceptable to potential purchasers than the Italian fifteenth-century pictures which constituted the most unusual feature of his collection. Perhaps Solly was the first, and most successful, in a long line of millionaires to fall under the influence of German art historians, whose supremacy was dawning at this very time.

Certainly many of the 'principal connoisseurs and professors of the art at Berlin' and elsewhere in Germany were becoming enthusiastic about the quality of early Northern art. In Paris, Schlegel had spent much of his time with the two brothers Melchior and

105 Titian: *Self-portrait*. Staatliche Museen, Berlin–Dahlem

106 Cranach: *The Rest on the Flight into Egypt*. Staatliche Museen, Berlin–Dahlem

107 Memling: *The Seven Joys of the Virgin Mary* (detail: *The Adoration of the Magi*).
Alte Pinakothek, Munich

108 Stefan Lochner and workshop: *The Virgin
and Child in a rose garden*. Alte Pinakothek,
Munich

109 Gerard David: *The Deposition*. National Gallery, London

Sulpice Boisserée, and no sooner had they returned to their native Cologne than they started building up that great collection of German and Flemish primitives (Plates 107, 108) which, for a short time, fascinated Goethe, and soon the rest of Europe, both because of the scholarly interest of its curious contents, and because it demonstrated, for the first time in history, how an ideology (nationalism) and a religious belief (Roman Catholicism) could be given visual form through a private collection of Old Masters.

The implications of such an attitude to collecting[86] will be discussed in the next chapter, but here it needs to be emphasized that it was not long before other collectors, whose motives were by no means always the same as those of the Boisserée brothers, were following the path that they had pioneered. Solly was among these, and so too was another merchant, Karl Aders,[87] who settled in London, married an attractive wife, and displayed to an interested group of English writers and artists an impressive number of Northern pictures, the most prominent of which was a copy of Van Eyck's Ghent altarpiece – Solly having bought some of the original panels. The list of Aders' friends and acquaintances is very striking and includes Crabb Robinson, Coleridge, Wordsworth, Lamb, Landor, Flaxman, Lawrence, Linnell, Ward, Danby, Stothard, and Blake: virtually all of these recorded their fascination with his collection of Old Masters. Lamb went so far as to regret 'the admitting of a few Italian pictures', and even Sir George Beaumont and Samuel Rogers, whose taste was essentially (but not irreclaimably) of the old school in painting, were impressed by Aders' Bouts, Gerard Davids (Plate 109), and Memlings, which certainly played a significant role in encouraging the new fascination with German culture – an

important feature of English intellectual life in the early nineteenth century.

While some collectors broke away from earlier conventions through considerations of the market-place, and others through ideological commitment, the man whose activities were so largely the cause of both responses was himself perhaps the most remarkable pioneer of the whole period.

Dominique Vivant-Denon showed great flair in his acquisitions for the Musée Napoléon,[88] and although we need not go so far as fully to accept the claim of one writer,[89] perhaps inspired by Denon himself, that he had never taken advantage of his official position in order to enrich his own collection (which – so it was said – had been formed before his promotion and thereafter kept in storage for twenty years), it is true that he, like other Frenchmen of the time, had little to show in the way of major Renaissance or Baroque paintings. Like Wicar he owned drawings by the greatest and most renowned masters,[90] while his pictures were strongest in those very fields which attracted least attention from the average connoisseur of the early nineteenth century: fine works by Memling and Fra Angelico, the younger Bruegel (Plate 110), Fragonard, Domenico Tiepolo, and – above all – Watteau (Plate 111).[91]

Though he only became prominent during the Empire, Vivant-Denon was a man of the eighteenth century. Born in 1747, he was seventeen years younger than Seroux d'Agincourt (whom he had known before the Revolution)[92] and almost an exact contemporary

110 Engraving after unidentified Bruegel (the Younger?): *A Village Wedding* (in Vivant-Denon collection). *Monuments des arts*, IV, p. 242

111 Watteau: *Gilles*. Louvre, Paris

of François Cacault (who replaced him as Secretary of the French Embassy in Naples). Affable as well as ruthless, he lived a brilliant social life, and enjoyed the trust of Louis xv, Louis xvi, Robespierre, Napoleon, and Louis xviii: indeed, for a man who enjoyed such power and prestige he made surprisingly few enemies. He himself was a talented etcher, and travelled widely throughout Europe and Egypt. At some stage in his life he seems to have conceived the idea of writing a vast history of world art. Such a venture was characteristic of the encyclopedic ideas of the eighteenth century, but Denon's intention to base the work entirely on his own private possessions rather than on those he had accumulated for the State was original, recklessly ambitious, and impressive in its demonstration of the width of his interests. Inspired probably by tentative projects going as far back as 1795 and no doubt still more so by Seroux d'Agincourt and the French colony in Rome, he had by 1807 conceived the idea, which he was able to carry out a few years later, of buying for the Musée Napoléon a small but remarkable group of Italian 'primitives' in order to demonstrate the developments that led up to Renaissance painting.[93] For himself he ranged far

more widely. His arts and artefacts spanned most civilizations and epochs from China to Peru, from the archaic to the contemporary, and filled his six rooms on the Quai Malaquais.[94] There, after the wars, when he resumed collecting on a vast scale and began to commission the illustrations for his projected History, he would welcome English and other visitors, despite the tenacious indignation with which he had tried to thwart the English campaign to dismantle *his* Museum.[95] 'The apartments of the Baron Denon contain the most curious, varied and singular collections of art and antiquities, in the possession of any private person in Paris,' wrote one such visitor.[96]

Yet what makes Denon so remarkable a pioneer is not so much the scope of his collection or the intellectual interest he showed in its historical importance as the genuine feeling that he seems to have had even for those works which least conformed to conventional taste. In some unfinished notes on the formation of his collection, he once wrote[97] that since childhood he had devoted to the arts 'a cult rather than admiration', and that, 'I had no aim other than to satisfy my taste, no plans for economy other than to buy beautiful things. I have always thought that it was the acquisition of mediocrities that ruined the buyer.' Though he died before he was able to write his History,[98] it was his far-ranging search for 'beautiful things' and the enthusiasm for them that he was able to convey to even the most unexpected visitors – Frances Lady Shelley found the 'foot of a mummy of an Egyptian princess beautiful';[99] Thomas Dibdin 'could not get away from' what he took to be a portrait by Antonello da Messina[100] – that makes his attitude more typical of the nineteenth than of the eighteenth century. To a generation much younger than his own he was able to present not only the *Apollo Belvedere* and Raphael's *Transfiguration*, but also the temptations of youth and age, immaturity and decadence, simplicity and exoticism at each extreme of the conventional spectrum, and such revelations of beauty were soon to haunt artists and collectors of all kinds, and bring crashing down the edifice of Taste as it had once been conceived.

3 The Two Temptations

Established in the Via Gregoriana, surrounded by admirers and visiting foreigners to whom he would show the sights of Rome, Seroux d'Agincourt (Plate 112) liked to proclaim that it was his ambition to be the 'Winckelmann des temps de barbarie'.[1] He cannot have realized the implications of his aim. By resuscitating the study of antiquity Winckelmann had hoped not merely to contribute to scholarship and a more vital understanding of the art of the past but also to change the art of his contemporaries. This was just what d'Agincourt did not want to do, and by an absurd irony it was just in this field that he and his disciples made the greatest impression.

Our studies, now so cut off from the wider culture around us, so isolated in our learned journals or even in the splendid museums and exhibitions to which the public flocks as a temporary respite from the 'real world', once made a direct impact on that 'real world' – in the field of contemporary art, of religion, and of politics. A taste for one school or another could carry with it implications which are now hard to envisage, though a faint shadow of them perhaps remains in the passions which can still, very occasionally, be aroused by responses to the art of today. But in the nineteenth century the distinction between past and present was blurred, and every shift in the appreciation of the one was all too likely to affect the other – as Seroux d'Agincourt was alarmed to find: 'However useful

112 *Portrait of Seroux d'Agincourt*. Frontispiece to Vol. I of Seroux d'Agincourt: *Histoire . . .*

113 David: *Envois de Rome*, 1808, drawing. Ecole des Beaux-Arts, Paris (in addition to the two Ingres, the sketch shows paintings by Granger, Odevaere, and Boisselier)

114 Blondel: *La mort de Hyacinthe*. Musée Baron Martin, Gray (the picture was singled out by Le Breton as an indication that French art was recovering from its excessive 'primitivism' of a few years earlier)

some knowledge of the works of the earliest stages of the Renaissance may be for the History of Art, it would be dangerous to pursue our studies of them too far: above all, we must avoid the kind of enthusiasm felt by certain modern artists for these experiments, which are still too feeble from every point of view to serve as models.'[2] Particular anxiety on this score was inspired by the pictures sent to Paris from the French Academy in Rome in 1808,[3] which included two famous masterpieces by Ingres and which were thought to be unduly dependent on the example of early art (Plate 113). And although three years later the danger seemed to have been averted (Plate 114),[4] it was in fact recurrent during much of the nineteenth century.[5]

So much valuable work has been done in recent years[6] to investigate the longing felt in neo-classical studios to wipe the slate clean and return for inspiration to a pre-Renaissance, even a pre-Winckelmannian Greek world, that there is no need for me to do more than mention the point, and refer in passing to the 'primitifs' who were so scornful of the 'rococo' David, the German Nazarenes in Rome, and similar groups elsewhere. But we here are looking at the interaction of past and present from the opposite point of view, and because the issue has not been so seriously discussed, I wish to devote much of the present chapter to the proposition that it was the very indignation felt by many people for the oddities of modern art that was often projected back on to those Old Masters who did not belong to the established canon and who were held responsible for the aberrations of the

present.[7] The sins of the sons were visited on the fathers, and in fact it seems to me that the successful resuscitation (by what we may call the general consciousness) of hitherto neglected areas of the art of the past paradoxically depended on the assumption that this would *not* affect the practice of contemporary painting. Nor was this assumption always mistaken.

I want to try to demonstrate this by looking at the reactions to two virtually simultaneous revivals that took place in England and in France: those of early Italian, and of eighteenth-century French painting.

The wars ended, and English artists flocked to Italy again. For the next twenty years or so Rome and Venice were, for the last time, to resume their sway. Among those who went (at different times) were most of those who were to be the popular and successful artists of the 1830s and 40s, and to rule the art 'establishment' of the day – the very men against whom (or their followers) the Pre-Raphaelites were later to rebel as purveyors of 'slosh' – men such as Wilkie and Eastlake, Phillips, Uwins and Etty, whose taste had been formed on the Orleans collection, and whose patrons were indeed among the leading purchasers at the Orleans and similar sales; men who, none the less, paid only intermittent allegiance to the grand style as it had been advocated by Barry, Fuseli, and Haydon, but who felt more at home in the less demanding and more realistic field of slightly sentimentalized genre, often based on obviously Raphaelesque prototypes (Plate 115) – a real international style, very popular with the painters living at the French Academy in Rome. The harder, linear conventions of an earlier generation were abandoned in favour of the warmth and colour of Venetian, Dutch, and Flemish masters. And yet these were the very men who, in Italy, were – to our surprise, and their own – to rediscover yet again the 'Gothic' artists of medieval times. Phillips, the fashionable portrait painter (Plate 116) was later to sum up the results of his visit to Italy in 1825 with Hilton[8] and (on and off) with Wilkie – a study tour, made at the age of fifty-five, to help him prepare his lectures on the history of art to the students of the Royal Academy: 'We found that there were . . . important points relative to the art of painting of which we had previously attained but very imperfect ideas. . . . We were impressed with pleasure in beholding the propriety, indeed I may say the perfection of feeling and understanding that mingled with the imperfections to be found in the works of the early painters; those of the thirteenth and fourteenth centuries, the period of the resuscitation of art in Italy. We saw with surprise that the peculiar beauties of thought exhibited in those imperfect paintings had been far too lightly dwelt upon by writers on the subject; or had been touched with so little discrimination as to convey inadequate ideas of their value: whilst in some there were exaggerated praises of the skill

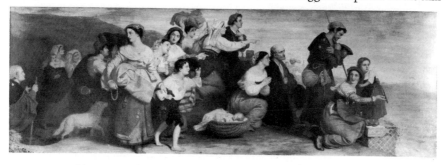

115 Eastlake: *Scene in the year of the Jubilee, or Anno Santo*. Lansdowne collection, Bowood

116 Phillips: *Portrait of Wilkie*. Tate Gallery, London

with which they were wrought.'[9] True, he warned his pupils not to imitate the earlier Italian masters 'as many students in Italy are now doing', but he proclaimed boldly that 'probably no painters have ever exceeded Cimabue and Giotto in the force of feeling'. The sentiment was not new[9a] – but never had it been expressed by someone whose art had so little in common with what he was praising.

At much the same time the popular artist Thomas Uwins discovered that 'Giotto and Cimabue, with a host of others of the same age, have left, scattered through the churches and convents of Italy, such thoughts as would be sufficient to inoculate any country with good taste, provided they were fairly published and circulated . . . I am sure that nothing would tend more to form the taste of the English school than the publication of such a collection . . .' Uwins perceptively pointed out that 'it was in this school, even more than the antique, that Flaxman studied', but, like Phillips, he felt that the Germans 'carry their admiration for early Italian painting rather too far, and in some cases imitate its oddities and peculiarities instead of its simplicity and grandeur'.[10]

117 *Interior of Campo Santo, Pisa.* From Carlo Lasinio: *Pitture a fresco del Campo Santo di Pisa.* Florence 1828

Or take Wilkie, visiting the Campo Santo in Pisa (Plates 117, 118), that Mecca for all those in search of new aesthetic emotions. The frescoes 'resembled in rudeness of colour, of drawing, of perspective, and even of composition, the drawings of the Chinese and Hindoos'.[11] A year later, in November 1826, he found himself in the Arena Chapel at Padua, deploring the fact that there were no prints in existence of Giotto's frescoes there, and asking, 'Should not the Academy get a few drawings made of them?' and, to set a

118 Carlo Lasinio: *Job and his comforters* (attributed to Giotto). *Pitture a fresco del Campo Santo di Pisa,* 1828, plate 2

119 Wilkie: *The blind fiddler*, 1806. Tate Gallery, London

120 Wilkie: *Cardinals, Priests and Roman Citizens washing the pilgrims' feet*, 1827. Glasgow Art Gallery

121 Wilkie: *Portrait sketch of Maria, Lady Callcott* (formerly
Mrs Graham). P. & D. Colnaghi & Co., London

good example, he sent a drawing of his own of a putative Giotto he had seen elsewhere.[12] Never was a conversion more rapid – or less effective. Travel on the Continent certainly inspired Wilkie, but hardly in the direction that might have been inferred from these comments: his style changed from Teniers and Ostade to Titian, Murillo and Velazquez (Plates 119, 120). Similarly, while the English public was said to be agog to know what would be the effect of an Italian tour between 1836 and 1838 on the work of William Collins, who had for many years enjoyed a huge success as a painter of vaguely Netherlandish genre scenes, no one – once curiosity was at last satisfied – could conceivably have guessed that 'the extraordinary frescoes in the Campo Santo particularly delighted and astonished him' (Plate 124).[13]

Giotto, and the primitives generally, constituted a very desirable medicine – but, like many desirable medicines, they were better taken by others.

But the lack of prints deplored by Wilkie was very soon to be remedied thanks to the initiative of a remarkable woman who deserves a prominent place in any account of nineteenth-century taste. The impoverished widow of a naval officer, Mrs Graham (Plate 121) had travelled all round the world making lively watercolours and writing spirited travel books.[14] Her response to art was exceptional in its range and perception, embracing

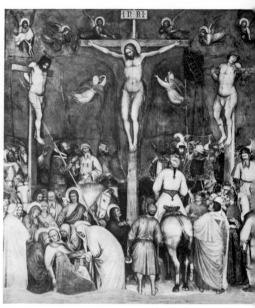

122 Sebastiano del Piombo: *Pietà*. Museo
Civico, Viterbo

123 Altichiero: *The Crucifixion*. Oratory of
St George, Padua

not only Memling and Lorenzetti, but also Altichiero (Plate 123) for 'his dignity amount-
ing to grandeur', Sebastiano del Piombo's *Pietà* (Plate 122), of which 'words cannot convey
an idea of the awful and reverential feelings' it inspired, a *Crucifixion* attributed to
Tintoretto, 'among the greatest dramatic pictures I have ever seen', and Caravaggio's
Beheading of John the Baptist, in which 'the composition, colour, and expression are all
terrible and highly dramatic'.[15]

In 1826 she married, *en secondes noces*, Augustus Wall Callcott, the most successful marine
painter in England (Plate 125). A year later, they went on a honeymoon to Italy, and there
she began her monograph on the Arena Chapel which, she stated in her preface to the
volume published in 1833, is 'likely to perish in a very few years . . . from the neglect into
which it has fallen'. The monograph was illustrated – and these were the first illustrations
of the chapel to appear anywhere – by her husband (Plates 126, 127), who was himself a
collector of Italian primitives.[16] These wood engravings were, he later explained, 'to be
looked upon as recollections rather than as facsimiles of the designs they are taken from',
but they were much admired by the German art historian Gustav Waagen, director of the
Berlin museum and always on the look-out for English interest in early Italian art.[17]

But Lady Callcott (as she later became) was important in other ways. Years before, she
and her first husband had taken under their wing the young painter Charles Lock Eastlake,
who was later to become director of the National Gallery in London, and the most influ-
ential figure in the English art establishment. As early as 1821 she began to launch him into
London society by writing, in a letter of introduction to the publisher John Murray,[18] that
he was 'a gentleman of as much modesty as real accomplishment . . . whose taste and
talents as an artist must one day place him very high among our native genius', and although
Eastlake soon returned to Italy to continue working as a painter there after his brief visit to

124 William Collins: *Cromer Sands*, 1846. 125 Callcott: *Dutch Sea Coast*. Tate Gallery,
 Tate Gallery, London London

England, it seems to me to be beyond doubt that much of the inspiration for his outstanding connoisseurship in the field of early Italian art derived from Lady Callcott's imaginative and continuing guidance.

The consequences were perhaps greater than she had anticipated. As the author of *Little Arthur's History of England*, one of the most successful best-sellers of the nineteenth century, Lady Callcott attracted considerable fame, and she and her husband formed a centre of social life in London. Though she became a permanent invalid, unable to write the book she had planned on Italian painting – 'But sickness has overcome my spirit of industry – Some more skilful hand must complete the design; and I have only, most gratefully, to say to my friends – Good night!'[19] – she would none the less continue to talk to her many visitors from the sofa, on which she was forced to recline, of the 'noble and pure spirit which, in the production of Italian art of the fourteenth and fifteenth centuries, appears through the yet coarse veil'.[20] After her death and that of her husband (in 1842 and 1844), their roles as joint arbiters of taste were at once assumed by her one-time protégé Eastlake, and his wife, the formidable Elizabeth Rigby, whose combined advocacy of the primitives

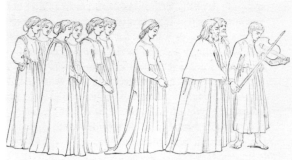

126–7 Callcott: *The Meeting of Joachim and Anne* and *The Virgin returns to Her House* (after Giotto).
 From Maria Callcott: *Description* . . .

128 Giotto: *The Ascension*. Arena Chapel, Padua

was far more persuasive than that of the Callcotts had been.[21] Thus, in the centre of the social and scholarly worlds of Regency and early Victorian London, there was no lack of respect for early art – as long as it did not affect contemporary production. I sometimes feel that before 1848 every painter in England had admired the works of the artists preceding Raphael – except those who were to become the Pre-Raphaelites.[22]

This attitude is not as surprising as it may appear at first sight. Though it is often claimed that artists always look to the past for precedents (and hence justification) for their own styles, this is by no means necessarily the case. Indeed, very frequently, an entirely alien art can be admired by a painter just because it offers an alternative, but not a threat, to his current practice. A very striking instance is provided by the revival of interest in Michelangelo that took place in the last three or four decades of the eighteenth century, when dissatisfaction with what was felt to be the flaccidity of contemporary art was intensifying.[23] It is often forgotten that this revival coincided chronologically with the first tentative reappraisals of the 'primitives',[24] and in fact I do not think that the two can legitimately be separated, for it was very often the same artists and theorists who admired both Michelangelo and the 'primitives' for almost the same reason: they shared an expressive vigour that was wholly foreign to the painting of the time. Sir Joshua Reynolds combined a reverence for Michelangelo quite untypical of the Academy[25] with a fresh appraisal of Masaccio which went far beyond the conventional respect due to a precursor;[26] Flaxman's enthusiasm for Michelangelo was expressed with hardly less eloquence and was fully as profound,[27] while his 'discovery' of Cimabue, Gaddi, Orcagna, and Giotto is astonishingly perceptive;[28] Romney made a sympathetic analogy between Cimabue and Masaccio on the one hand, and Michelangelo and Raphael on the other.[29] There are not many (completed) works[30] by any of these eighteenth-century artists to suggest such an attitude.

The most dramatic instance of this double reappraisal is provided by William Blake,

129 Botticelli: *Madonna and Child with St John the Baptist and St John the Evangelist*. Staatliche Museen, Berlin–Dahlem

who in later life was to rework the plate of one of his earliest engravings after a figure in Michelangelo's *Crucifixion of St Peter*, and to inscribe it with the words: 'This is one of the Gothic Artists who built the Cathedrals in what we call the Dark Ages wandering around in sheep skins and goat skins of whom the world was not worthy; such were the Christians in all Ages.'[31]

Observation (rather than psychoanalytical theory) suggests that children are at the same time crudely expressive and touchingly innocent. It was when a preference for the latter quality became firmly established in the nineteenth century that a total distinction was made between the 'primitives' and Michelangelo, and that the association of their styles began to seem almost blasphemous – to the partisans on each side. Thus Richard Duppa, author of the first English biography of Michelangelo, was in 1825 sufficiently irritated by the frescoes in the Campo Santo in Pisa to exclaim:[32] 'to examine those facts which cast a light upon the advancement or decline of our faculties in any branch of knowledge may be worth the investigation, but to class and systematize the debility of the middle ages is an attempt to give manly proportions to an homunculus. For those varied fancies or styles, I have no predilection,' while Ruskin's much later championship of primitive purity to the detriment of the 'captain of evil' is too familiar to need stressing.

Between such extremes of partisanship there was plenty of room for the artists of the first half of the nineteenth century to look, as did Wilkie,[33] for 'expression and sentiment' in the artists between Giotto and Michelangelo, while 'those that followed' (and, be it said, those on whom he personally based his style) 'seem to have allowed technicalities to get the better of them, until simplicity giving way to intricacy, they appear to have painted more for the artist and the connoisseur than for the untutored apprehensions of ordinary men'.

One contemporary artist occurs to these admirers of early art with marked frequency. Hilton in the Arena Chapel,[34] Lady Callcott in front of a Botticelli[35] (Plates 128, 129) both

found themselves irresistibly reminded of Thomas Stothard. The comparison has bewildered and amused modern writers, and it is difficult to be sure exactly what such sensitive observers had in mind: in view of the unfamiliarity of Blake, it seems most likely that Stothard's religious illustrations (Plate 130), which were widely known, probably struck contemporaries as combining innocence and mysticism in a uniquely primitive manner.

The comparison does, in any case, raise an interesting point. In 1815 Stothard had, like so many English artists, visited the Louvre before the collections there were broken up, but his reaction had been exceptional: 'Above all, I must confess,' he wrote in a letter from Paris,[36] 'I was well-instructed by viewing some Gothic pictures of no name, although their characteristic was excessive hardness with the most violent opposition of splendid colours: a thing, to my thinking, they had in common with Raphael's *Transfiguration*.' We shall see shortly that this association of Stothard with early Italian art had fascinating repercussions many years later; but, of course, this attractive minor artist by no means confined himself to one style. He was more at home in his pastiches of Flemish Baroque painting and of eighteenth-century French vignettes, and the frieze that he painted in the Advocates' Library in Edinburgh (Plate 131) was, in 1835, to shock the German artist and historian Passavant, the friend of the Nazarenes: 'Who would believe', he exclaimed indignantly,[37] 'that this fine artist who had imitated Rubens, and whose ambition had soared to the divine excellence of a Raphael, should degenerate at last to the manner of Watteau, whose style of subject he has condescended to imitate, though, it must be acknowledged, with better result? ... By this means, in my opinion, he has not only deteriorated from his own fine talents, but has to a degree poisoned the springs of art in England, by inducing young artists by his own example to abandon the higher excellencies, and study Watteau!'

To those who know the art of Stothard this outburst will seem rather high-pitched, to

130 Stothard (after): '*The Monarch Minstrel*'
 —*David with his harp* (c.1810?). Engraved
 by E. J. Portbury, and published in *Art*
 and Song edited by Robert Bell

131 Stothard: *Decoration of the Old Advocates'*
 Library, Edinburgh (detail)

132 Rossetti: *The Girlhood of the Virgin Mary*. Tate Gallery, London

put it mildly: nor, to most observers today, does the decoration of the Advocates' Library appear to have much more to do with Watteau than it does with Giotto or Botticelli. But, above all, Passavant seriously misjudged the state of English taste – Watteau had none of the wicked connotations for the English that he had for the Germans or even (as we shall see) for the French.[38] In one respect, however, the passage is of real significance: 'poisoned the springs of art in England . . . inducing young artists . . . to abandon the higher excellencies' – this was a cry that was to be echoed with a vengeance.

It is well known that the first pictures exhibited by the Pre-Raphaelites (Plate 132) were greeted with warmth and sympathy, and that it was only when the 'secret' initials P.R.B. were revealed and a general conspiracy seemed afoot that bitter hostility was unleashed.

What has been less explored is the impact that this hostility had not upon Rossetti, Millais and Holman Hunt, but on attitudes towards those early Italian artists who were thought to have been responsible for the formation and styles of the Brotherhood. We can watch, as in a slow-motion film, these attitudes develop and harden in the pages of the monthly *Art-Journal*, which was the most influential magazine of its kind in England and which had been formed (in 1839, with the title of *Art-Union*) especially to promote the interests of contemporary English artists against the claims of the Old Masters in general. The battle was an old one, as admirers of Hogarth well know, but the *Art-Journal* entered into it with pioneering zest. Its hero was Robert Vernon, an army contractor who made a fortune out of the Napoleonic wars, which he then spent on the works of modern English painters: these he presented to the nation. This type of self-made man, part profiteer, part patron, became increasingly familiar as the Victorian age progressed, and he could always be sure of a warm welcome in the pages of the *Art-Journal*, which was aggressively middle class in its social attitudes. The aristocracy was generally accused of being interested only in the Old Masters,[39] and every sort of device was used, from the most blatant appeals to commercialism and successful investment (appeals which retain their power to shock even in the world of today) to the most intimidating propaganda designed to terrify the newly rich with repeated (and, doubtless, often true) stories of the faking of Old Masters by unscrupulous dealers. If the price fetched by an Old Master was high, ridicule was poured on the purchaser for wasting his money; if low, he was derided for buying what could only be trash or a forgery. The enterprising collectors of the north country, their new mansions filled with Ettys and Landseers, were extolled, and their pictures were reproduced by all the new techniques becoming available; while the occasional inclusion of an article devoted to the more traditional and aristocratic type of collector subtly reinforced the pride of the newcomer to patronage.

But the *Art-Journal*'s patriotism was not limited exclusively to modern art. If London was going to have a National Gallery, it must of course be the best in the world:[40] foreign Old Masters were perhaps regrettable as rivals to the works of modern English artists, but as long as they existed, the English had better have as many as possible of the good ones. In 1844 the *Art-Journal* took up the cause of Gaudenzio Ferrari, who combined 'the simplicity of Raffaelle, the sweetness of Leonardo, the finish of Luini, the grandeur of Leonardo and the colour of Garofalo', and it strongly chided the National Gallery for turning down a Nativity by this master[41] (Plate 133). Its attitude to private collectors was more cautious. In the same year, it noted that 'some of our countrymen are now purchasing productions of the first epoch of Florentine art, as those of Beato Giovanni Angelico, Benozzo Gozzoli, Fra Filippo Lippi instead of those of Titian, Raffaelle and Correggio. This is probably the result of mere affectation; if it be a taste arising from study, much good may result from the fact.'[42] Three years later came the first hint of real danger. In 1847 there was a rumour that the National Gallery was thinking of buying the collection of early Italian painting which had been built up by the great dealer Woodburn, one of the most interesting pioneers in the collecting of early Italian art, and the *Journal* commented severely: 'We do not need antiquities and curiosities of the early Italian painters: they would only infect our school with a retrograding mania of disfiguring Art, and returning to the decrepit littleness of a period warped and tortured by monkish legends and prejudices.'[43]

When the Pre-Raphaelite storm finally broke, the *Art-Journal* unleashed a series of savage and undiscriminating attacks on all artists who had lived before Raphael, and continued

133 Gaudenzio Ferrari: *The Holy Family with a Donor*. John and Mable Ringling
Museum of Art, Sarasota

134 *The façade of the British Museum, with the pediment of The Progress of Civilization by Sir Richard Westmacott. From the Stationers' Almanack, 1852*

this sporadically for the next ten years, although as all contributors were anonymous and there are sometimes discrepancies in the tone of the articles, it is difficult to be certain that any specific editorial policy was adopted: a Botticelli is said to be 'flat and dry enough for the wildest enthusiast';[44] the beloved Fra Angelico himself is vapid and exemplifies monkish asceticism, deserving 'but a qualified sympathy for a mental condition which arose from inexperience and ignorance, at least as much as from the lofty causes attributed';[45] Orcagna is an 'overpraised terrorist';[46] and, 'with all our veneration of the antique, and our respect for the name of Giotto, we cannot, for the life of us, supply a satisfactory argument for . . . revivifying him from the sepulchre where he has lain for five centuries and a half'.[47]

All this venom was directly inspired by the danger to the modern English school – the fear (common in France and Germany half a century earlier) of retrogression rather than progress: 'The present generation are looking forward – not backward. The only advantage our painters will gain from studying the works of Giotto is to learn what to avoid, and this to one class will be something, *if they learn it.*'[48] What had been harmless when the most prominent artists of the day were Wilkie and his followers, became a menace in the generation of Rossetti and Holman Hunt, and some of the shrapnel even hit preceding admirers of the primitives. When in 1851 Mrs Bray published a life of her father-in-law, Thomas Stothard, whose own art had so strongly affected many people's attitudes to early Italian painting, she found it necessary to be cautious and to disown those who might be considered his spiritual heirs: 'Some of the paintings of the Middle Ages he considered possessed great merit. . . . Yet I am convinced, from the knowledge of Stothard's feelings in art, that he would have greatly disliked the present growing fashion among some of our young artists, of imitating the hard style and quaint attitudes and devices of the Gothic ages. Such . . . he would have assumed to be "affectations".'[49] Even Eastlake, soon to be director of the National Gallery and responsible for bringing to the museum more primitives than it had ever possessed, lost his nerve – prompted partly, no doubt, by his own apparent distaste for contemporary Pre-Raphaelites:[50] 'The taste' [for the early Florentine masters], he said in 1853,[51] 'is a modern one; how it has arisen would be, perhaps, a diffi-

cult enquiry; but I venture to predict that, as it at present exists, it will not endure. I think there is a great deal of fashion in it; a large proportion of those early pictures are full of affectation and grimace; and many persons who have, or fancy they have, a taste for those pictures are insensible to the essential elements of painting, such as beauty of arrangement, harmony of colouring, and natural action and expression.'

So great, however, was the prestige of Italian painting generally that there were various means by which even some of the less familiar masters could be accepted. One such was to imply that the term 'Pre-Raphaelite' was a misnomer: 'In fact,' wrote the *Art-Journal*,[52] 'they ought not to be compared to any Italians; since the Italians aimed at beauty, or at all events, where it was otherwise, at grace and dignity – of which our Pre-Raphaelites have no notion. From their astonishing awkwardness and hideousness of conception we should rather compare them with the more ungainly of the early Flemings . . . pre-Mabuses, pre-Van Eycks.'

It would seem reasonable to suggest, therefore, that far from helping the 'rediscovery' of early art, as is usually claimed, the appearance on the scene of the Pre-Raphaelites actually delayed this for a number of years in fairly wide (though, of course, not all) sections of the population. Any straying from the path of progress was dangerous, for Vasari's evolutionary views had been reinforced by scientific and technological evidence of advances in other fields. The danger was to be found everywhere. At a Select Committee in 1853, for instance, Richard Moncton Milnes asked Sir Richard Westmacott,[53] professor of sculpture at the Royal Academy, whether the introduction into the British Museum, on the pediment of which he had sculpted *The Progress of Civilization* (Plate 134), 'of works of earlier and oriental art, has had any effect upon the interest felt by the public with regard to the Elgin Marbles', and then, on being reassured with the answer 'none whatever, I should say', followed it up with a number of questions, the interest of which is so great that it is worth reproducing them at some length: 'Do you think there is no fear that introducing freely into the institution objects of more occasional and peculiar interest, such for instance as the sculptures from Nineveh (Plate 135) may deteriorate the public

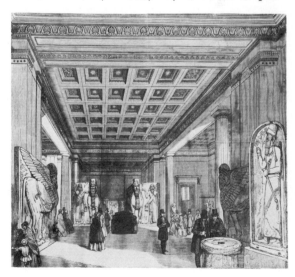

135 *The Nineveh Room in the British Museum.* From the *Illustrated London News*

taste, and less incline them than they otherwise would be to study works of great antiquity and great art?' To which Westmacott replied: 'I think it impossible that any artist can look at the Nineveh marbles as works for study, for such they certainly are not; they are works of prescriptive art, like works of Egyptian art. No man would think of studying Egyptian art.' Relentlessly Moncton Milnes pursued his interrogation: 'Do you think that the great interest works of that kind excite, those works being much more objects of curiosity than of art, exercises an injurious effect upon the public mind in matters of art?' 'I do not think they influence the public mind at all with respect to art,' answered Westmacott, only to be challenged again: 'Do you think as many persons attend and take an interest in the Elgin Marbles, when they are side by side with the Nineveh sculptures, as would take an interest in them if the Elgin Marbles were alone?' 'No,' was the reply, 'persons would look at the Nineveh Marbles and be thinking of their Bible at the time they were looking at them; they would consider them as very curious monuments of an age they feel highly interested in; but the interest in the Elgin Marbles arises from a distinct cause; from their excellence as works of art.' And then came the climax: 'Have not cases occurred in the intellectual history of many nations, in which the very free introduction of more barbarous specimens, such, for instance, as the Chinese, have had a very injurious effect upon taste in general?' 'I certainly think that the less people, as artists, look at objects of that kind the better.'

With hindsight we can see this as one of the most crucial artistic encounters of the century – a desperate attempt being made, in the interests of modern art, to preserve traditional and absolute standards of beauty from 'barbarian' contamination. But no one at the time could of course grasp its full implications. Four years later Eastlake found himself torn

136 Spinello Aretino: *Two haloed mourners* (fresco). National Gallery, London

137 Andrea del Verrocchio (ascribed to): *The Virgin and Child with two Angels*. National Gallery, London

138 Francia: *Altarpiece: The Virgin and Child with St Anne and other Saints.* National Gallery, London

between his two roles as president of the Royal Academy and director of the National Gallery, in which latter capacity he had recently bought a 'primitive' (Plate 136). His left hand knew what his right hand was doing, but did not altogether approve. 'I take occasion here to remark, that while it is desirable that a museum of pictures should in its completeness contain examples of every school and period, it by no means follows that all such examples are fit objects of study for young artists. A museum of sculpture, if worthy of the name, comprehends specimens of every school and age of antiquity; but it is not expected that students in sculpture should imitate archaic Greek bas-reliefs, Etruscan or Egyptian compositions.'[54]

Many years earlier Ottley had come up with one solution. If, he argued,[55] (and who would disagree?) Raphael was such a great painter, and the artists after him were so bad, did not this imply that Raphael's teachers must have been wonderful, and that he himself – or at least his contemporaries – may have been unsatisfactory? In other words, there were 'good' primitives, as well as bad. Even the *Art-Journal* was delighted when Eastlake bought for the National Gallery what was thought to be a Ghirlandaio (well known as the teacher of Michelangelo) (Plate 137), for he was 'an innovator in the right direction, and it is to him, and those like him, that we are indebted for the grand simplicity which characterised the art of the sixteenth century'.[56]

And though in terms of strict chronology, neither Francia nor Luini could be considered exactly as 'pre-Raphaelite', yet the relative unfamiliarity of their work in England caused them to be considered as such – but, literally, on the side of the angels. One writer, who was exceedingly anxious to get rid of the whole room of 'Orcagnic horrors' in the National Gallery, announced firmly that Francia (Plate 138) 'is the *cor cordium*, the heart of hearts of the real pre-Raphaelites: a softness and warmth of humanity above the conception of the

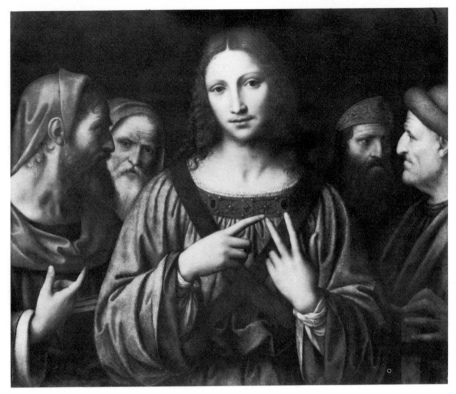

139 Luini: *Christ among the Doctors*. National Gallery, London

other seraphic painters, are here under the shadow of the Dove's wings,'[57] while another actually commended the preference for 'those early and purely Christian painters, till late long neglected but now fortunately exerting so salutary an influence upon the arts of modern Europe. . . . Luini we love as one of the tenderest of painters; living at the happy epoch when the earnest faith of early days yet unextinguished was most happily blended with the intellectual knowledge which Art, in its progress, had at length accumulated.' (Plate 139)[58]

Faith and progress – the vogue for painters who could exemplify these qualities was very great in the middle years of the nineteenth century, and was partly stimulated by the one English artist of the day who escapes from the categories to which I have already referred.

William Dyce had gone to Italy to study the Venetians, the Romans of the High Renaissance, and Poussin, but he also examined with far greater sympathy than any of his contemporaries the works not only of the German Nazarenes, but also of their sources who, as he at once saw, had nothing to do with the Cimabues, the Giottos and the Orcagnas, who were attracting all the attention. 'It is now perceived', he wrote in 1853,[59] 'that art had its *adolescence*, as well as its *infancy* and its *manhood*,' and he drew attention to 'such masters as Cima da Conegliano, Vittore Carpaccio, Marco Basaiti, Benozzo Gozzoli, Gian Bellini, Luca Signorelli, Domenico Ghirlandaio, Perugino, Pinturicchio', the quattrocento masters on whom his own work so clearly depended (Plates 140, 141). Dyce admired the Pre-Raphaelite Brotherhood and was, apparently, the first to point out their merits to

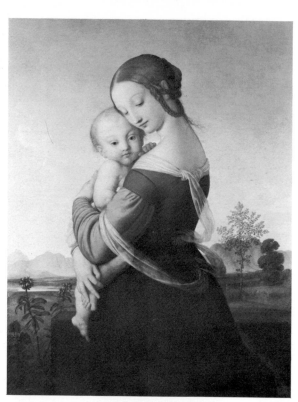

140 Dyce: *The Virgin and Child.*
Tate Gallery, London

141 Dyce: *The vision of Sir Galahad and his company* (preparatory drawing for a
mural in the Houses of Parliament). Aberdeen Art Gallery

142 Restout: *Saint Vincent de Paul appointed as almoner to the Sisters of the Visitation* (one of eleven pictures commissioned in 1729 by the Fathers of the Order of Saint Lazarus, deposited in the Musée des Monuments Français in 1795, and then transferred to the Paris churches of Saint-Nicolas-du-Chardonnet, and Saint- Marguerite —its present location)

Ruskin, but his own painting had far more support in authoritative circles – both royal and governmental – and the years between the mid 50s and the mid 60s marked the heyday of painters such as Luini, Francia, Garofalo and Gaudenzio Ferrari. They were not only useful as a stick with which to beat the flagging vitality of hard-edged Pre-Raphaelitism and thorough-going medievalists, for 'they show us that ugliness was not, in those days, deemed the outward sign of holiness',[60] but they also allowed concessions to be made to Pre-Raphaelite ideals by those who now saw that Pre-Raphaelitism had come – and almost gone – without doing too much harm.

Indeed, by about 1860, the danger to modern English painting was over, and the break between past and present seemed complete. Medieval art belonged to 'a world and an age that is now no more. In the noise and conflict of city life, in the midst of an art and an epoch wholly material and mechanical, it is salutary and refreshing to be taken back to men and times with whom we have so little in common.'[61] The phrases seem to echo consciously, or – more probably – unconsciously, others that had been written in 1847 before 'Orcagnic terrorism' had seemed to threaten the contemporary scene: 'Amid the din of railways, and the strife of politics, and the jarring tones of theological controversy, it is indeed refreshing to turn aside for a while, and, fanned by the breeze of a southern clime, to seek among marble palaces and cloistered aisles the traces of by-gone ages, and of master-spirits now passed into the solemn realities of eternity.'[62]

From now on the 'primitives' belonged to a closed world of pure art divorced from contemporary preoccupations, and when, as late as 1875, Frith, the most distinguished of the genre painters of early Victorian England, confessed[63] that he was 'sick of Messieurs Cimabue, Giotto and even Perugino . . . these pictures are curiosities, and not works of art at all in the true sense of the term', he was merely fighting a solitary war long after peace had been declared.

We can follow much the same sort of controversies in France over the revival of interest

in eighteenth-century art, and the parallel is a revealing one because contemporary styles were so different in both countries. As is well known, English taste during the first three decades of the nineteenth century was for loose, painterly brush strokes in style, and for genre, portraiture and landscape in subject matter. In the light of such preoccupations, not only was Watteau thoroughly congenial to all the leading British painters – Constable, Turner and Wilkie especially – but the very arbiter of taste, Sir George Beaumont, could actually encourage Wilkie to 'study Rembrandt, and Ostade, and Watteau'.[64] It is an exaggeration, but not a wholly distorting one, to say that in these decades Watteau plays something of the same sort of role for these, the most adventurous English painters of the period, as did the early Flemish and Italian artists for the more extreme followers of David and Ingres – with the two outstanding differences that in England no revival of interest in Watteau was really necessary, as he had never lacked admirers, and that his influence was supported rather than combated by 'official' opinion.

In France an interest in eighteenth-century art as a purely historical phenomenon began even before the eighteenth century was over. Almost from the first, the Museum, which opened in the middle of the Terror of 1793, included paintings by Watteau, Desportes, Lemoine, Santerre, and various members of the Van Loo family, though the only master of the century to be represented in some force was the recently dead Joseph Vernet – and all these artists were in any case swamped by painters more acceptable to revolutionary opinion.

Indeed, the Museum was at once beset by the same problems which (as we shall see) were later to become so pressing for all public galleries everywhere: was intrinsic excellence, educational example or historical interest to be the main criterion for admission? It was just because he avoided this issue that Alexandre Lenoir, the Museum's bitterest enemy, plays a role of some importance in this context.

Even after a hundred and fifty years Lenoir remains a controversial figure[65] – reckless and unscholarly, boastful and infinitely energetic, he set out to retain for a rival establishment of his own the artistic heritage of France over a long drawn out period during which he fought with equal fervour and stubbornness against revolutionary vandalism and the claims of legitimate owners. Though sometimes paying lip service to the principle that the function of a museum was to act as an educational centre for art students, and though occasionally consenting to the destruction 'of a hundred and eighty portraits of Nobles, Bishops and Prelates . . . in honour of Marat',[66] Lenoir seems to have been actuated above all by an obsessive and all embracing passion to preserve under his own authority every surviving vestige from the past at a time when the past was being annihilated as efficiently as possible.

His own taste was conventionally neo-classical,[67] and it is ironical that in retrospect his Musée des Monuments Français can be seen as having played a vital role in causing the disintegration of classical canons, for it was there that young painters went to study the medieval tombs and furnishings that were to inspire their 'troubadour' pictures, there too that the boy Michelet studied 'the eternal continuity of the nation'.[68] But in addition to the sculpture for which it was (and has remained) famous, the Musée des Monuments Français was for a number of years the depot in which were stored vast quantities of Lagrenées and Boullognes, Lafosses and Hallés – huge altarpieces (Plate 142) rescued by Lenoir from deconsecrated churches and then, after Napoleon's Concordat, redistributed almost at random to rot and gather dust amid general indifference. Thus Lenoir's terse receipts for these

pictures, and the occasional skirmish with the Museum over their destination, often constitute our final records of them until the intensive study of the last few years.

Another revealing glimpse of the historical approach to eighteenth-century art which developed during the Revolutionary period can be obtained by considering a curious episode that occurred in 1798. Early in that year Frederick Augustus Hervey, the Earl-Bishop of Bristol and Derry, that clergyman-peer and passionate patron of the arts whose wanderings through Europe baptized a dozen hotels with the name of Bristol, found himself in Venice, and, aware that the French were advancing rapidly on Rome, arranged to have sent a cargo of his latest acquisitions to Naples: 'pictures [by] Cimabue, Giotto, Guido da Siena, Marco di Siena, and all that old pedantry of painting which seemed to show the progress of art at its resurrection.'[69] Barely a fortnight later, the French arrived, and the bishop's remaining pictures were confiscated, while soon after he himself was interned for nine months. In October of that year a remarkable account of the whole episode was published in France.[70] Writing from Rome, its author pointed out that so generous had been the Earl-Bishop's patronage of living artists over a period of forty years that more than three hundred painters of different nationalities had written to ask the authorities not to disperse the collection, for 'his extensive accumulation of pictures, mostly painted by living artists and acquired in Italy over a period of many years, contained many feeble and bad pictures, but deserved none the less to be preserved as a monument to the taste of this century, unique of its kind'. How astonished the bishop must have been to learn that it was his modern pictures (now, alas, dispersed and mostly unrecorded), rather than his 'old pedantry of painting' that were coming to be considered of historical interest![71]

But a neutral historical attitude to the past was no more feasible in the realm of art than in any other area of human activity. We find the first symptoms of anxiety on 1 February 1795 when an anonymous letter was delivered to the Société Républicaine des Arts:[72] already, the writer complained, the public is admiring ill shaped, gilded vases on show in the Museum instead of 'the pure forms of the antique'. Don't remove them, he insists: keep anything that illustrates the history of art, however ridiculous – but at least publish a *catalogue raisonné* to tell people what to admire.

In painting, rather than in the applied arts, a *catalogue raisonné* of what people should admire began to appear not very long afterwards. Between 1803 and 1817 the artist and critic Landon produced an extremely impressive series of volumes, the *Vies et oeuvres des peintres les plus célèbres, recueil classique . . .*, which was designed to provide a fully illustrated corpus of history painting on a scale never before attempted. The overwhelming majority of painters represented were Italians of the sixteenth and seventeenth centuries; of the French, only Poussin, Le Sueur, Le Brun and Jouvenet were to be included.[73] But although Poussin and, to a somewhat lesser extent, Le Sueur remained famous, French history painting as a whole lost its appeal. David's pupils may, as legend goes, have flicked pellets of bread at Watteau's *Embarquement pour Cythère*, but it was Le Brun and Restout who were fatally damaged.[74]

Indeed, throughout the period of the Revolution, the Consulate and the Empire, collectors in France were buying small eighteenth-century pictures, and almost without exception, these collectors were themselves painters: men such as Bergeret, who has left us a vivid record of bidding for a Watteau under the Terror, but having to give up when the price went too high.[75] Very often, then and later under the Restoration, these painters were

143 Auguste: *Conversation dans un parc.*
Louvre, Paris

144 Daniel Saint: *Lady in a dress with a white shawl* (miniature). Wallace Collection, London

amateurs rather than professionals,[76] men such as M. Auguste who produced attractive pastiches (Plate 143), and later the Comte de Cypierre, who was to buy many master-pieces, partly on the advice of the young Théophile Thoré.[77] Or, when professionals, they tended to be miniature painters, such as Augustin, who died in 1832, or Daniel Saint[78] (Plate 144), whose sale in 1846 helped to make a wider public aware of the appeal of the eighteenth-century French *petits maîtres*; or the book illustrator Camille Rogier (Plate 145), a passionate admirer of Tiepolo and Guardi as well as of the French painters of the period.[79]

Dealers of course were active in advertising the qualities of eighteenth-century artists. Le Brun has already been discussed, and after his death the campaign was intermittently kept up by another dealer and print publisher, Gault de Saint-Germain, a prolific and polemical writer of considerable interest, who was, however, usually more keen to follow than to lead fashion. In his review of the Salon of 1819, he combined a scathing attack on Ingres and the dangers of medieval art with one of the earliest and most perceptive re-appraisals of Fragonard:[80] '. . . un homme de génie. Dans l'exécution fugitive de ses pensées on y reconnait ce goût léger de l'homme du monde dont l'éclat brillant et fleuri abonde en vices agréables. L'effet étincelant d'une lumière vive dans ses compositions était pour lui si séduisant qu'il l'appelait le coup du pistolet du clair obscur. Tant il y a que les restes de ses rêves sont encore charmans et que plusieurs se conserveront dans la curio-sité' – a passage which seems more sensitive than most of the later, and more highly publi-cized, writings on eighteenth-century art of the great poets and littérateurs who made up the Bohême of the Rue du Doyenné – Gérard de Nerval, Théophile Gautier, Arsène Hous-saye, Jules Janin and others; men who looked back nostalgically to a pre-Revolutionary

145 Camille Rogier: *Illustration to Act IV*
 of Dumas' "Kean". From *Le Monde*
 Dramatique. Bibliothèque Nationale, Paris

146 Delacroix: *Massacres de Scio*. Louvre, Paris

douceur de vivre, and who found in Watteau above all an artist who had faithfully portrayed the frivolous pastimes of an aristocratic, elegant and licentious society long-since submerged by vulgarity, commerce and political upheaval.

It is natural that those who are concerned with changes in taste should pay attention to these men; and to a few other sensitive collectors and critics, who consistently appreciated Watteau and other eighteenth-century painters. But the limitations of this development also need to be stressed: as late as 1846 Louis Viardot, husband of the great singer Pauline (Turgenev's mistress) and a well-informed and productive writer on the arts, had never even heard the names of Lemoine, Desportes, Pater – or Chardin.[81]

But Watteau and his followers had become widely known during the early years of the July Monarchy,[82] and, as in England with the medieval, so too in France with the rococo, it was just this growing fame that seemed to constitute a danger to modern art which must be stamped out. Small-scale pastiches, like those produced by Camille Roqueplan, Eugène Lami, Henry Monnier or Gavarni, caused no real concern, but as soon as the leading artists of the day appeared to be infected by the prevailing mania for eighteenth-century pictures hostility became intense. Well before the symptom can be detected by the historian of today (who has access to only a small fraction of the art of the early nineteenth century) the warning bells were sounded. As early as 1814 a critic found that the school of David was slowly 'abandoning the true principles of art, and sliding down the slippery slope into the errors from which it had so happily rid itself'.[83] Ten years later Stendhal was convinced that French painting was going back to the old ways of Boucher and Van

Loo,[84] and indeed it was the appearance of the Romantics that prompted the most formidable offensive directed not only against contemporary art but also against its supposed ancestor of the previous century. In article after article the fine critic Delécluze, who had himself been a pupil of David, thundered against innovations which, so it seemed to him, were in fact regressions to the past. Reviewing the famous Salon of 1824 he compared Delacroix's *Massacres de Scio* (Plate 146) with Watteau's *Embarquement pour Cythère* (Plate 147), and he continued: 'I do not know from what schools MM. Scheffer, Sigalon, Saint-Evre, Delacroix and Delaroche have emerged, but it is clear that the first four of these have completed their artistic education with an indifference for the antique which strongly resembles the contempt for it shown by those artists who lived between 1730 and 1780.'[85] These were *his* 'Orcagnic terrors', and he denounced Delacroix for having done his best to 'revive the false, mannered, and sloppy taste that prevailed in the French school in about 1772',[86] just as in 1829 the *Journal des Artistes*, which was also bitterly hostile to the Romantics, attacked both those members of the public who thought that freedom in the arts did not matter all that much and did not actually endanger the State, and those who claimed that 'there was good to be found, all things considered, in the work of Watteau and Boucher'.[87] The writer doubted not only their wisdom and taste but, rather more, their integrity. Watteau at least might be familiar to them; but Boucher? Virtually all his paintings and drawings had either disappeared or been totally forgotten. 'We will do them the honour to believe that, did they actually know him better, they would not take it upon themselves to pity him for the epigrams of which he is the target from time to time.'

Occasionally, writers tried the 'progressive' defence which we have encountered when

147 Watteau: *L'embarquement pour Cythère*. Louvre, Paris

looking at the reputations of Perugino or Ghirlandaio, the masters of Raphael and Michelangelo. Rather touchingly one dealer[88] in the early years of the nineteenth century said of the *Marriage of the Virgin* (Plate 148) by Carle van Loo – whose name was by then a byword for insults – that, had the artist only begun his career twenty years later, he would certainly have shared in the stylistic reform associated with Vien.

By the second half of the nineteenth century, however, French rococo was too popular to be used as a successful weapon with which to attack modern art, and for a short time in the 1870s Italian painters, such as Guardi and (above all) Tiepolo, were employed for the same purpose.

Like Watteau, Tiepolo had been 'discovered' essentially by artists, among whom Delacroix was said to have played a prominent part.[89] By the Second Empire he was generally accepted as a charming, though decadent, painter; but in 1876 Charles Blanc, the very influential critic, historian and one-time administrator, whose views were more conservative than he would readily have acknowledged, ended a sympathetic study of Tiepolo with the charge that he was 'un improvisateur laché et incorrect, un décorateur sans frein, sans mesure et sans convenance'. There can be little doubt that this was aimed at the Impressionists, who were just beginning to make converts, and when Paul Leroi (who was to write one of the first serious studies of Guardi two years later)[90] sprang to Tiepolo's defence, his article proved that he recognized the contemporary issues involved through his caustic comment that the art of Paul Baudry would have been very much more satisfactory, if that popular decorator *had* allowed himself to be more influenced by Tiepolo than by Raphael.[91]

In France, as in England, a taste for unorthodox art carried with it political, social and religious, as well as aesthetic, implications. If the cultivation of eighteenth-century painting had at one time suggested old allegiances to pre-Revolutionary society,[92] these had certainly been discarded in the most unexpected manner by the 1840s when the fashion was growing rapidly. It was in 1849, after the Revolution had toppled Louis-Philippe from his throne, that Delécluze exploded:[93] 'As for me, who have since 1830 been watching the ever-rising tide of the democratic ocean, I have still not been able to understand what can have caused the monstrous mixture of republican opinions and the revived taste for the works of Watteau and Boucher.... From 1789 until 1797 people were at least logical, and one could see that taste in art coincided with political opinions.... But by what is, I repeat, an incomprehensible paradox, it is our erstwhile proudest republicans who have, for the last twenty years, been furiously promoting the taste for the works of Watteau, Lancret, and Boucher.'

Delécluze was exaggerating, but he was not wholly wrong. By the late 1840s the revival of the rococo was closely (but not, of course, exclusively) associated with some strands of left-wing politics. In 1849, for instance, Henri Walferdin, a civil servant, eminent scientist, and radical deputy, presented to the Louvre *La leçon de musique* (Plate 149) from his collection of Fragonards (which was by far the finest in existence) on condition that it remained in the museum only as long as France remained a republic.[94]

The year before, while France was still, just, a monarchy, the general public had had its first chance to see how radically taste had changed in favour of the eighteenth century. The place was a gallery in a large shop, the Bazar Bonne-Nouvelle (Plate 150) in the street of the same name, and the exhibition held there might certainly be considered to have had opposition, if not specifically left-wing, implications.[95] It is true that Louis-Philippe lent

148 Carle van Loo: *The Marriage of the Virgin*. Musée Masséna, Nice (on loan from Louvre)

149 Fragonard: *La leçon de musique*. Louvre, Paris

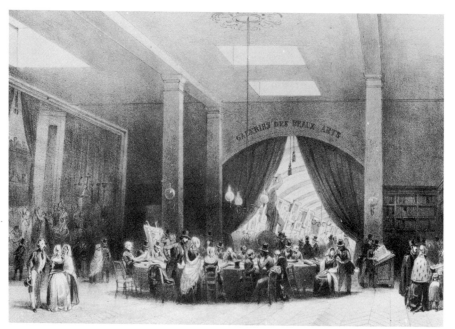

150 *Art gallery in the Bazar Bonne-Nouvelle*. Lithograph

151 Géricault: *Officier de chasseurs à cheval de* 152 Géricault: *Cuirassier blessé quittant le feu.*
Impériale chargeant. Louvre, Paris Louvre, Paris *la Garde*

153 Théodore Rousseau: *La Mare*. Musée Saint-Denis, Reims

154 Louis Le Nain: *La Charrette*. Louvre, Paris

two pictures, but they were by Géricault (Plates 151, 152), who had long been a favourite of the Left. Indeed, these two pictures which Michelet specially went to see,[96] were soon to be bought for the Louvre by the republican administration that came into being only a month after the opening of the exhibition. The most prominent contemporary artist to be included was Théodore Rousseau with four pictures (Plate 153),[97] and it was now that this painter, who for fifteen years had regularly been kept out of the Salons, first achieved widespread public recognition. Other pictures shown included *La Charrette* by Louis Le Nain (Plate 154) and *La Recureuse* (cf. Plate 156) by Chardin, who was enthusiastically singled out as a 'brutal realist' by at least one critic,[98] as well as pictures by Watteau, Fragonard (Plate 155), and Prud'hon (Plate 157).

It would be hard to find much in common between all these artists, and distinctions were, of course, made at the time. Greuze and Prud'hon had always been excluded from the general disapproval which had been the fate of so many eighteenth-century artists, but in the drawing rooms and studios, we are told in 1847,[99] Lemoine, Boucher and Fragonard would be equated with lies, whereas Watteau, Chardin and Joseph Vernet would be seen as having resisted the evil influences of their times.

On the whole, therefore, the issue was one of genre (or realism) against mythology, but – above all – to the left-wing nationalists, who welcomed the revolution of 1848, these artists all had the supreme advantage of constituting a French school which could be placed

on as high a level as those of Italy and the Low Countries to which (so it was claimed) they owed little, if anything. One of the earliest articles on Watteau had, in 1839, correctly but provocatively, opened with the phrase:[100] 'Antoine Watteau is barely French. . . . He breathed the same life-giving air as Rubens, Teniers, Van Dyck, and Metsu.' Only a few years later Watteau was to be held up as the very embodiment of the French spirit. The same problem faced Champfleury (who disliked most of the eighteenth-century painters partly because they drew too much attention away from his own rediscovery) when he came to consider the Le Nain brothers. In a sentence of inspired nonsense he wrote that they 'are simultaneously French and Spanish. . . . In their approach they are often Flemish, in their manner of painting Spanish . . . at the same time they are very French.'[101] His friend, Théophile Thoré, could be equally specious when trying to make the same sort of point. In a violent attack on supposed Italian influence on French painting, written in 1848, he tried to imply that Poussin's best picture must have been painted before he went to Rome, that Simon Vouet had seriously damaged French painting because of what he had learned in Italy, while 'Boucher and Fragonard retained their French spirit despite their studies in Italy'.[102] Meanwhile, yet another left-wing nationalist of this period, the great historian Michelet, contrasted Poussin, who had painted Italians, with Géricault, who had depicted only Frenchmen![103]

Much has been made of the rehabilitation of the Le Nain brothers by the new administration of the Louvre after 1848, but it was not their Realism that counted so much as their Frenchness – and a rather arbitrary selection of eighteenth-century masters was somehow

155 Fragonard: *Le voeu à l'amour*. Louvre, Paris

156 Chardin: *Le garçon cabaretier* (the same
composition— but not the same picture—as
that exhibited in 1848). Hunterian Museum,
University of Glasgow

157 Prud'hon: *Jeune zéphyr se balançant
au-dessus de l'eau*. Wallace
Collection, London

incorporated into this Front Populaire, leading to a distortion in our appreciation and understanding of French art that has remained with us to this day.[104]

Somewhat similarly, the assimilation of medieval art into English taste was as much bedevilled by religious (rather than political) issues as by those aesthetic considerations which I have already discussed: pure or monkish, rising above the superstition of the age or contributing to it? Endless arguments were deployed on both sides, and it was – during the first half of the nineteenth century – certainly difficult to express very warm feelings for early Italian art without committing oneself to other allegiances as well. The *Art-Journal* was, as usual, uncompromising.[105] Of the early Florentine painters in the Uffizi it could write, as late as 1858,[106] that 'the power of depicting moral beauty, or the sweet and amiable feelings of the heart, had not dawned on the pencils of these painters; and such ill-favoured purgatorial countenances, contrasted heterogeneously with gawdy colours and gilding, do not, we think, betoken a healthy state of feeling or imagination on their part. . . . A visit to San Marco strengthened the conviction that Fra Angelico has been praised with a singular absence of discrimination.' A year later Orcagna was belaboured for his 'loathsome, putrid piece of moralising in monkish art'.[107]

Certainly, the revival of interest in the 'primitives' had been closely associated with extreme Catholicism on the continent of Europe, as everyone in England well knew: first, the Germans; then Rio with his 'unctuous, incense-perfumed style',[108] and Montalembert,

in France.[109] Vigorous Anglican divines flocked to Italy to deride the 'idolatry' and 'Mariolatry' to be found in the churches, to make sure that sculptors had not neglected their duty by completing only those parts of their work that were visible to the public,[110] and to examine the frescoes in the catacombs for any light they might throw on the increasingly bitter disputes between modern 'Romanism' and the reformed Church of England.[111] From the artistic point of view Rome herself was not too dangerous – her classical heritage and Renaissance masterpieces were above controversy, and her Baroque could just be ignored or cited as evidence of her degeneracy:[112] 'It is the simple fact', wrote one clergyman with more dogmatism than accuracy,[113] 'that *there is not one single Gothic Church in Rome.* . . . Stained glass, – the glory of our English Cathedrals, – is simply *unknown.* The Churches are all of the debased Roman style, – like our own London City Churches; for which, by the way, it is clear that they afforded the miserable precedent.'

Yet elsewhere in Italy the situation was much more perilous. In 1848, for instance, the Reverend Hobart Seymour, a violent opponent of Catholicism, travelled to Rome, ostensibly to give an impartial survey of the religious scene there, in fact to denounce it with savage irony.[114] On the way, he found himself enraptured 'by the works of Giotto, Pinturicchio, Beato Angelico (Plate 158), Francia and the early works of Raphael', and in what reads like a religious equivalent to Tennyson's *Lotus Eaters* he felt impelled to warn others against the dangers he had overcome. He found them 'exquisitely passionless and motionless, . . . as if they could hear nothing but the music of the harps of heaven, as if they could see nothing but the holiness of the skies, and as if they could feel nothing but the happiness and peace of paradise. . . . There was a soft and sweet luxury of indolence in such a life, that might not unnaturally create such an ideal as this. . . . And such is the general and powerful effect of these pictures on my nature, that I never contemplate them without being drawn toward that kind of recluse and contemplative religion, which they seem designed to embody, and to be all the less fitted for that active and stirring benevolence, which is an essential of a living Christianity. . . . I had previously no idea – I could not conceive how painting could possibly exercise an influence almost magical, in alluring and seducing some persons to the church of Rome.'

But Seymour need not have been so anxious about the threat to his Protestant faith, for – in England – the Church of Rome was by no means unanimous in its attitudes towards Italian art. Some of its most important and influential figures spent many years of their lives in Rome, and – unlike the Anglicans – they were often keen to identify themselves with the Catholic Church as it had developed after the Reformation, and they were therefore reluctant to break with the Baroque art which seemed to be so closely associated with that development. Nicholas Wiseman, for instance, who in 1850 was created a cardinal and leader of the newly resurrected hierarchy in England, was, of all the ecclesiastical dignitaries in the country, probably the one most responsive to the visual arts.[115] He showed a deep and sensitive love of early Italian painting,[116] but he had been born in Seville and had preached for many years in the church of Gesù e Maria in Rome, which contains some of the most attractive masterpieces of Italian Baroque sculpture.[117] These early influences never wholly left him, and he wrote with enthusiasm of the 'superb shrine of gilt bronze' which constituted Bernini's *Cathedra Petri* in the apse of St Peter's.[118] The context was a controversy over the authenticity of relics, but if it is objected that Wiseman's aesthetic judgement was conditioned by his doctrinal attitude to these, I would reply that this was indeed surely the case – but that such conditioning does consistently play a larger part in

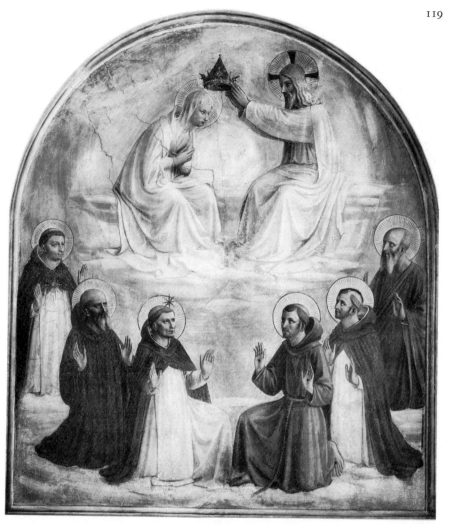

158 Fra Angelico: *The Coronation of the Virgin*. S. Marco, Florence

the formation of taste than is usually acknowledged.

Or again, there was Father Faber, one of the most spectacular converts of the century, who while still precariously within the Anglican fold, travelled around Europe in 1842 strongly disapproving of the 'tasteless ugliness' of Italian Baroque architecture[119] and dreading, just as much as the Reverend Seymour was to do a few years later, the enervating impact of early Italian art in Tuscany: 'I mused, and mused, and mused, pacing about in the thick clover [outside the Campo Santo in Pisa] till all my senses were wrapped in a delicious dream of art and history. . . . Now it happens that this voluptuous silent poetry which Italy engenders in so many, is just what I have been arming myself against before-hand, as effeminate, sensual, literary; not devotional, priestly, Catholic, Christian.'[120] After his reception into the Church of Rome, Faber returned to Italy with some of his followers

159 Simone Martini: *Saint
Augustine* (detail of
triptych). Fitzwilliam
Museum, Cambridge

160 Follower of Jan van Eyck:
The Virgin and Child.
Metropolitan Museum
of Art, New York

in 1846, and – in the revealing words of his biographer writing a quarter of a century later[121] – 'like most converts at that date, their taste was what is called Gothic, and they were consequently disposed to criticize unfavourably some of the ecclesiastical arrangements which came under their notice. Such dispositions, however, gradually disappeared under the influence of the edification which they received, and before they returned home their fastidiousness had given place to a hearty admiration of the material as well as the spiritual

161 Lanfranco: *The Miracle of the loaves and fishes.* National Gallery of Ireland, Dublin

developments in Italian piety.' Indeed it had. Although Faber made efforts to encourage the building of Gothic surroundings for himself and his fellow converts, the oratory in which they eventually settled was clearly inspired by the Italian Baroque fully as much in its altarpieces as in its architecture (Plate 163). Pugin described it as 'a place for the vilest debauchery, masquerades, &c. – one night a MASQUED BALL, next BENEDICTUS. . . . What a degradation for religion! Why, it is worse than the Socialists.'[122]

Pugin was indeed wholly intransigent in his advocacy of the Gothic, and detestation of Renaissance or Baroque in any form. Although he did 'not despair of St. Peter's being re-built in a better style',[123] he was more disconcerted by the frescoes of Gaulli: 'I attempted to say my prayers in the Gesù; I looked up, hoping to see something which would stimulate my devotion. But I saw only *legs* sprawling over me. I expected them to begin to kick me next, and rushed out.'[124] Pugin's intemperate attacks on 'the Italian taste that was rife among the Roman Catholics in England'[125] split the Catholic community, and the polemics that followed prove that any equation between the Roman Church and a love for medieval art would be absurdly over-simplified.[126] Indeed, it is worth pointing out that at the very moment when the National Gallery in London was making a belated, but triumphant, venture into the field of the 'primitives', in Dublin, the first acquisitions of the newly created National Gallery of Ireland were a series of large Baroque altarpieces (Plate 161).[127]

There is, however, some evidence to suggest that English High Church clergymen were much drawn to early Italian art. There was, for instance, the Reverend Fuller Russell, an enthusiastic Cambridge disciple of Pusey and Newman in Oxford.[128] Though never quite going so far as to join the Catholic church, he and his friends would hang their rooms with black velvet during Lent and dream of restoring the rich ecclesiastical vestments of the sixteenth century.[129] Behind the bare Georgian façade of his house in the London suburb of Enfield – a house in which he wrote books on the ancient glories of chivalry and knighthood[130] – 'the walls are so richly adorned with Italian specimens of the fourteenth century that the spectator feels as if transported into a chapel at Siena or Florence' (Plates 159, 162).[131]

162 Ugolino de Nerio: *The Deposition*. National Gallery, London

163 *The Oratory at King William Street* (with Baroque pictures). Watercolour, *c.* 1850.
Brompton Oratory, London

Or again, there was his somewhat younger contemporary at Cambridge, Alexander
James Beresford-Hope, a high Tory member of parliament and a devout Anglican with
passionate views about the merits of Gothic architecture, who was strongly drawn to the
Oxford Movement.[132] The younger son of Thomas Hope, one of the most ambitious pur-
chasers at the Orleans sale, he had been brought up amidst the best collection of Dutch
seventeenth-century pictures in England. But his own tastes were very different – though
equally extravagant. His house too reminded visitors of a chapel, crammed with wooden
altarpieces and crucifixes, bishops' croziers and censers, and a small collection of early
paintings, which culminated in a *Virgin and Child* then attributed to Van Eyck (Plate
160).[133] This was perhaps less alarming, because Northern artists had acquired certain
retrospective privileges as proto-Protestants, but it none the less provided evidence (as did
certain other collections of the 1840s and 50s) of a possible connection between extremism
in religious opinion and a certain kind of artistic taste.

It is against this background that we need to see the frantic attempts made by Ruskin to
reconcile his Low Church principles with a love of these very same artists, and also the
defensive (and revealing) comment made by the great Scottish historian, art lover, critic
and collector, James Dennistoun, that there was 'no compulsory connection' between 'the
present reaction in favour of Romanist views, prevalent in England among a class of per-
sons, many of whom are distinguished by high and cultivated intellect' and an admiration
for early Italian painting.[134]

An adequate study of the religious implications raised by the feeling for early Italian and
Northern art would have to investigate far more subtle nuances than are compatible with
this brief survey of the field as a whole. It is clear that different artists inspired different
allegiances, though it is surprising how often nineteenth-century commentators themselves

wrote about all painting dating from before the time of Raphael as if it formed one un-varying mass. The crucial, almost universal, association of childhood with religious sin-cerity requires to be discussed in a very wide context; here it need only be observed that, while this association may have involved a serious misunderstanding of the art, it did also imply the supremacy of a visual over an intellectual response to it. The well attested beliefs (or absence of them) of a Perugino, or the morals of a Sodoma might easily have landed these painters in a Victorian court of law – yet this, in no way, diminished clerical enthu-siasm for their pictures; just as the devout faith of a Michelangelo or a Bernini was useless in inspiring respect (even in Catholic countries) for a style of religious art that did not conform to a very definite concept of sincerity and innocence.

Indeed, it is somewhat ironical that when we next hear of a polemical association be-tween art and religion the context should be so very different – and yet so very similar. Writing some thirty years after Dennistoun, the other great British historian of Renais-sance Italy, John Addington Symonds, would have thought it ludicrous to feel inhibited in his love for Italian primitives by any fear of 'Romanist' contamination. Yet his attitude to art was not so alien to that of the committed writers of the 1840s as he himself probably thought. 'Perhaps,' he wrote in 1886 after an interesting but ferocious denunciation of the Baroque,[135] 'a generation will yet arise which shall take the Carracci and their scholars into favour, even as people of refinement in our own days find a charm in patches, powder, perukes, sedan chairs, patchouli, and other lumber from the age despised by Keats. . . . Whether the whirligig of time will bring about a revenge for the Eclectics yet remains to be seen. Taste is so capricious, or rather the conditions which create taste are so complex and inscrutable, that even this, which now seems impossible, may happen in the future. But a modest prediction can be hazarded that nothing short of the substitution of Catholi-cism for science and of Jesuitry for truth in the European mind will work a general revolu-tion in their favour.'

The impossible has happened – as always. But I hope to demonstrate in the next two chapters that the History of Art has been more effective than Catholicism (or even Jesuitry) in effecting the change of taste so feared by Symonds.

4 Taste and History

THE HISTORY OF TASTE in the Old Masters begins in the 1840s. By this provocative and demonstrably untrue statement I want to suggest that it was around then that we first find not merely (as in previous decades) the very exceptional collector or connoisseur exercising a conscious choice and responding to widely different artistic experiences, but a really significant number who, to a large extent, seem to have escaped the moulding of their tastes by the sort of external pressures that have been discussed in the last two chapters. The success in England of what we may call the 'Orleans generation' had stimulated a large number of wealthy men to buy pictures, and even after the exceptional circumstances of the Napoleonic wars, their purchases hardly declined in quality.[1] But of the aristocratic and mercantile dynasties which had amassed their treasures at the time of the French Revolution, only the banking family of the Barings sustained a highly developed interest in the Old Masters through several generations. Let us very briefly follow them down the years, as in some journalistic summary of a Galsworthy novel, for their collecting illustrates so clearly the points I wish to stress.[2]

There is, first, Sir Francis, the founder of the family fortunes (Plate 164), the 'first

164 Lawrence: *Sir Francis Baring and his business associates.* Lord Northbrook collection, on loan to the Guildhall Art Gallery, London

165 Lawrence: *Sir Thomas Baring and his family*. Lord Northbrook
collection, on loan to the Guildhall Art Gallery, London

merchant in Europe', Pitt's 'commercial oracle in the House of Commons', sociable and
living magnificently,[3] but refusing to buy at the Orleans sale because he insists on offering
£10,000 for the pictures he wants instead of 10,000 guineas – a proof, so Buchanan rather
curiously claims,[4] of the 'off-handed decision, and liberality, which always mark the
character of a British merchant'. Nevertheless, pictures are needed to furnish his houses, and
splendid Dutch paintings are accumulated (Plates 167, 168), almost, one feels, by accident.[5]

His sons, Thomas and Alexander, took their pictures much more seriously. Sir Thomas,
the elder (Plate 165), was something of a dealer, like most of his contemporaries in all

166 George Richmond: *Mr
Thomas Baring*. Lord
Northbrook collection

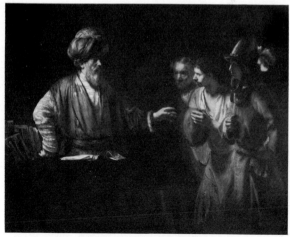

167 Rembrandt: *The Centurion Cornelius*.
Wallace Collection, London

168 Berchem: *Mountainous landscape with peasants driving cattle
and sheep*. Royal Collection (reproduced by gracious permission
of Her Majesty the Queen)

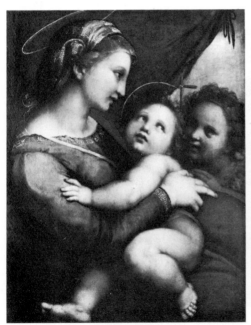

169 Raphael: *Madonna della Tenda*.
Alte Pinakothek, Munich

170 Guido Reni: *Ecce Homo*. Fitzwilliam
Museum, Cambridge

171 Sebastiano del Piombo: *Madonna and Child with Saints Joseph and John the Baptist and a donor.* National Gallery, London

172 Antonello da Messina: *St Jerome in his study.* National Gallery, London

ranks of society, and shocked English art lovers by selling Raphael's *Madonna della Tenda* (Plate 169) to the heir to the throne of Bavaria in 1814, scarcely a year after he had bought it.[6] He acquired many Dutch pictures to add to his father's collection, but then in the same year sold them all to the Prince Regent.[7] However, he made up for these sales by the lavishness with which he bought Italian and Spanish pictures, mainly from Le Brun at the height of the Napoleonic wars.[8] His great country house at Stratton, in which he would earnestly conduct religious discussions and disagree with the local vicar about the impropriety of hanging pictures in churches, reminded visitors of a museum,[9] and it is curious to visualize Sir Thomas reading the Bible 'in a plain and unaffected manner' to family and servants in a room hung with the most sumptuous of southern masterpieces (Plates 170, 171), though already there are indications of what is to come in the picture that he would proudly show off as a Dürer (Plate 172).

Sir Thomas's brother, Alexander, was said to have spent more than any man in England on pictures, many of them also bought from Le Brun, though in his case they were mainly Dutch and Flemish.[10]

It is, however, with the third generation of this enormously acquisitive family that we come across a truly independent and adventurous collector, who breaks with the more conventional purchases – splendid though they were – of his father, uncle and grandfather. Sir Thomas's son, Mr Thomas Baring (Plate 166), was as reticent and elusive as is the drawing of him compared to the flamboyant Lawrence portraits of his forebears. A Tory member of parliament, who turned down high office whenever it was offered to him, a bachelor who seems to have left behind no gossip or mark of any kind on those who met him, this enormously rich and capable banker devoted much of his life to the arts.[11] When he began buying in 1835, the pressure exerted by the *Art-Journal* and much public opinion

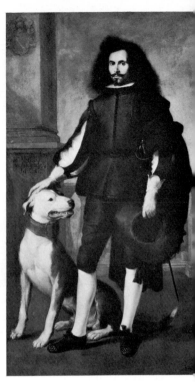

173 Steen: *The artist in fancy dress playing the lute.*
 Thyssen-Bornemisza Collection, Lugano

174 Murillo: *Don Andres de Andrade*
 y la Col. Metropolitan Museum,
 New York

to support the modern English school had a great effect on him,[12] but the old traditions died hard, and in 1846, in a transaction which (though on a smaller scale) recalls the purchase of the Orleans pictures fifty years earlier, he and two other collectors bought *en bloc* one hundred paintings from one of the most famous private collections in Holland, that of Baron Verstolk, and divided them among each other.[13] Baring kept forty-three, including masterpieces by Jan Steen (Plate 173), Cuyp and many others.

This was one of the last transactions of its kind to be carried out by an Englishman,[14] and two years later Baring bought, at valuation, the Italian, French, and Spanish pictures of his father, who had just died.[15] Until 1871 he continued to add to his collection, buying in almost every field from seventeenth-century Spanish to early Netherlandish (Plates 174, 176), becoming also one of the keenest English collectors of Watteau (Plate 175).

I have hurried in this absurdly simplified manner through the collecting habits of three generations of the Baring family because they illustrate so neatly the point with which I opened this chapter. By the 1840s and 1850s, in England and in France, taste could be extraordinarily fluid and receptive. Large-scale selling to Germany and the United States had not yet begun; and, in private houses much more than in museums, the favourites of eighteenth-century connoisseurs, such as Guido Reni, Claude and Wouwermans, could

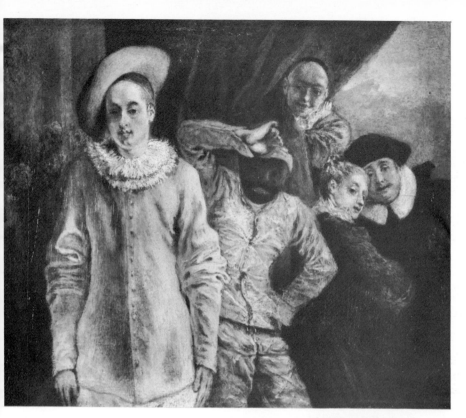

175 Watteau: *Harlequin, Pierrot and Scapin.*
James A. de Rothschild collection
(National Trust), Waddesdon Manor

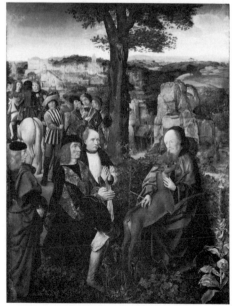

176 Master of Saint Giles: *St Giles and the hind.*
National Gallery, London

hang next to, and be admired with, newer claimants to attention, such as Flemish and Italian masters of the fifteenth century, or French of the eighteenth. Ruskin's daunting influence was already strong on some collectors, but not among that élite which is exemplified by Thomas Baring and his friends. Taste was not, as it had once been (and was to be again), based on a policy of systematic exclusion: on the contrary, it was more open than it ever had been, or would be again until more than a hundred years later.

The creation in the 1850s of a collectors' club, soon to be known as the Burlington Fine Arts' Club and to organize a remarkable series of exhibitions, provides some sort of acknowledgement of this state of affairs.[16] Connoisseurs from all social classes, from hereditary peers to *nouveaux-riches*, would meet to discuss their latest purchases; and a list of the early members makes it clear that these purchases were as liable to include medieval altarpieces as Tiepolo sketches, a Raphael as a Greuze. We have no adequate records of these informal meetings, but can only assume that among this élite of rich and cultivated men (and women) a new concept of Taste, to be based on principles far wider than any that had yet been established, was – in the most casual and untheoretical of spirits – being worked out.

These were the years when a much deplored eclecticism was a guiding factor in the creation of contemporary art, and when Free Trade was coming to be accepted as a solution to international problems, but whatever we think of the weirder architectural excesses of the period, it is impossible not to be impressed by the independence of judgement with which a number of outstanding connoisseurs in different parts of Europe began to revise, and ultimately to overthrow, the prejudices which still enclosed most Old Masters like so many prison walls.

Sometimes these very connoisseurs seem to have surprised themselves with their own insights. Pietro Selvatico, for instance, was born in Padua in 1803, and soon fell under the influence of the German Romantic writers and painters who idealized the art of the primitives. He travelled to Munich, earnestly read his Rio, and was closely associated with the Italian *Puristi*, who were directly inspired by the Nazarenes.[17] In his lectures to art students, which were published between 1852 and 1856, he pays the expected tributes to Giotto, to Fra Angelico, and to other heroes of the time, and then suddenly asks his pupils to allow him to devote some words to a Venetian painter, 'corrupt by education, but, through the power of his genius, a giant – I mean Giovanni Battista Tiepolo'. A giant – since that artist's death more than three-quarters of a century earlier, no one had written about him with such feeling, let alone lectured about him to art students (those tenderest of plants to historians of the time). It is true that Selvatico warns his audience against imitating Tiepolo, and shows some concern for the impurities of his style; but his four pages of panegyric reveal an informed enthusiasm which cannot have been due only to local patriotism and which must have amazed his listeners.[18]

Selvatico acknowledged as much: 'Many people will be surprised that I, who venerate the pure artists of the fourteenth century, should have given such abundant praise to the Baroque-infected (*imbarocchito*) Tiepolo' – but he emphasizes that there is no contradiction in his attitude. The imaginative fresco painter, like the gentle artists of the fourteenth century, was distinguished by spiritual expressiveness, and the truthful depiction of form. 'My praise merely demonstrates that I have no preconceived intention of excluding or denying merit to any style or school as long as the above-mentioned qualities are attained.'

The words could stand as a manifesto for those many art lovers who were determined to use their own eyes rather than rely on received opinion. Art had, until very recently,

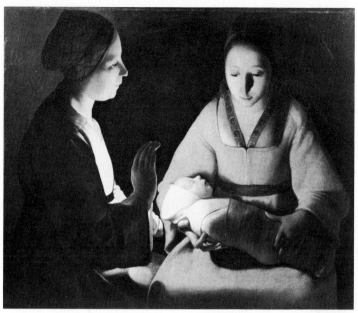

177　Georges de La Tour: *Le Nouveau-Né*. Musée des Beaux-Arts, Rennes

always been admired or despised in large categories: a whole school, a whole century, a whole nation rehabilitated, dismissed, or ignored; and, again and again, it proved difficult suddenly to look at an individual picture with fresh and unprejudiced eyes. But by 1856 even the *Art-Journal* was preaching (though not always practising) the virtues of an open mind:[19] 'One has no right to condemn a style of Art because it does not harmonise with our ideas nor pronounce it worthless because we are mentally or constitutionally unable to appreciate its excellence; and there is excellence even in the works of Watteau, Pater, Lancret, Boucher, and others of the same class.'

In his evidence to the Committee of Enquiry into the state of the National Gallery in 1853 (which provides a mine of information about contemporary attitudes to the 'inclusive' and 'exclusive' approaches to the past), Eastlake sensibly pointed out that 'there were always fine works by the early Florentine masters not only in galleries, but in churches and in public buildings in Italy, which were passed over',[20] and long before the historians or art journalists began to appreciate the merits of an open attitude towards the art of the past, there were large numbers of individuals throughout Europe who refused to 'pass over' what had, with only the smallest of efforts, always been accessible to those who cared to look. Among these I can here only touch briefly on some four or five men, chosen almost at random, and in no particular chronological order, among very many more of as much interest.

One of the most impressive insights in the history of nineteenth-century connoisseurship is provided by the French historian Hippolyte Taine who, when visiting the Rennes museum in 1863, was struck by 'an absolutely sublime Dutch picture, the *New-Born Child*, attributed to Le Nain' and wrote a rapturous account of this virtually unknown painting which, more than half a century later, was to be credited to Georges de La Tour and, soon after, to become one of the most beloved of European masterpieces (Plate 177).[21]

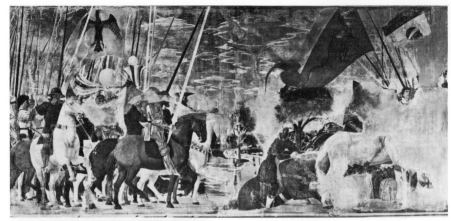

178 Piero della Francesca: *The Legend of the True Cross—The Victory of Constantine over Maxentius* (fresco). S. Francesco, Arezzo

179 Louis La Caze: *Self-portrait at the age of forty-five*. Musée des Beaux-Arts, Pau

Almost equally moving is the case of Lord Lindsay who, in 1847, published his highly influential (but, to us, almost unreadable) *Sketches of the History of Christian Art*, which, with a mixture of high emotion and arcane theology, argued the case for early Italian art and the need for its preservation.[22] 'Do not', however, he writes in his opening pages,[23] 'for a moment suppose me insensible to Classic Art – the memories of Greece and the Palatine are very dear to me – I cannot speak coldly of the Elgin Marbles, the Apollo, the Venus, the Dying Gladiator, the Niobe.' It was, no doubt, just this refusal to break with the classical taste of his ancestors that gave him his extraordinary understanding of Piero della Francesca's frescoes in Arezzo (Plate 178), about which he was one of the very first to speak with total conviction and enthusiasm: 'Coutts [his cousin] compared the impression to that made by the Elgin Marbles,[24] hosts only being in motion instead of subdividual figures . . . his style here is modern in all the excellencies, though without the modern flutter, and preserves throughout that graceful ease and repose which we have lost since the 16th century. They are masterly productions . . . masterly in every way. . . . And

yet he is totally unknown and unappreciated by modern historians!'[25]

Or we can turn to Paris, and glance briefly at the career of Louis La Caze (Plate 179), an amateur painter who studied under Girodet, and who practised for many years as a doctor, earning a notable reputation for courage and charity during the terrible cholera epidemic of 1832.[26] By then he had already begun to amass that extraordinary collection of pictures, the passion for which eventually absorbed his life to the exclusion of almost everything else.[27] Though he served on the juries of many a Salon, and was famous for his leniency, he appears to have had little liking for contemporary art: he owned no modern pictures, and we hear of him once gazing in silence at Ingres' *La Source*, only to comment eventually: 'The poor girl is suffering from scrofula; if I gave her a jab with my surgical scalpel the pus would come out. Let's go and look at Greuze.'[28]

Buttery (*beurré*) was the adjective with which he liked to praise his Chardins, and his main love was for the French eighteenth century. La Caze was a man of some means, but he liked to pick up bargains, and in his early days this was easy enough. However, it requires far greater judgement to buy cheap than expensive pictures, and what distinguished La Caze's collection from those of the many other connoisseurs who were soon indulging in much the same taste for eighteenth-century art is its consistently high quality. Except for Prud'hon, who was the particular favourite of his friend François Marcille,[29] virtually all the French eighteenth-century painters were represented by outstanding works, and sometimes by their masterpieces. It was he who bought Watteau's *Gilles* (Plate 111), which we last saw in Vivant-Denon's collection, and which had in the meantime belonged to another dilettante painter, M. de Cypierre. His Chardins and Fragonards included such famous works as *La Bénédicité* (Plate 180) and *Figure de Fantaisie* (Plate 181), but in this context he interests us for another reason – the very reason that aroused so much spiteful, patronizing (and jealous?) contempt in the Goncourt brothers when, in 1859, they went to call on him:[30] 'We were expecting to see a collection, a complete and instructive panorama of French art, a revelation of that French painting which is so little known – a Pantheon of the smallest and least known gods. Instead of which La Caze forces on us

180 Chardin: *La Bénédicité*. Louvre, Paris

181 Fragonard: *Figure de fantaisie*. Louvre, Paris

Rembrandts (Plate 182), Rubenses, Riberas (Plate 183), all sorts of large pictures, among which a few Watteaus, Chardins, and Lancrets are crushed and sound a completely false note. A terrible idea to make different schools devour each other in this way. Eclecticism is quite worthless – especially in a collection.'

Nothing can show more clearly how close was the association between nationalism (though by now it had lost all its radical connotations) and eighteenth-century French art at this time, and how bigoted were the Goncourt brothers in being unable to detect 'that affiliation, that family air, which is required if things are to be hung next to each other'. For La Caze understood better than they that (in the words of his friend Frédéric Reiset)[31] 'Watteau held up well next to Rubens; Velazquez harmonized perfectly with Rembrandt or Hals'. Indeed, in his determination to break away from the stereotyped conception of what constituted orthodox taste, La Caze proved to be among the first men in Paris to show an interest in Frans Hals[32] (Plate 184), and among the last to collect the work of Luca Giordano (Plate 185). His was a collection in which true consistency conflicted with convention and prejudice.[33]

Or again, there was the Baron Isidore Taylor, a naturalized French citizen born in Bruges of Irish descent, of whom when he died at the age of ninety, a friend wrote:[34] 'He was everything: soldier, painter, man of letters, playwright, theatrical administrator, *inspecteur-général des beaux-arts*, collector, bibliophile, traveller, diplomat, art missionary, archaeologist, a man of universal interests.' Such a summing-up conveys the breadth, but not the quality, of Taylor's activities.[35] He was author and editor of the most elegantly sumptuous

182 Rembrandt: *Bathsheba*. Louvre, Paris

183 Ribera: *The club-foot*. Louvre, Paris

184 Frans Hals: *La Bohémienne*.
Louvre, Paris

185 Luca Giordano: *The Marriage of the Virgin*.
Louvre, Paris

travel books of the century, to illustrate which he commissioned all the finest engravers of the time; he founded some half dozen mutual aid societies for writers, musicians, and artists; and, as director of the Comédie Française, it was he who was responsible for the famous first production of Victor Hugo's *Hernani* in 1831, which has entered the annals of theatrical history. But it is his approach to painting that interests us here. Sent by Louis-Philippe to Spain to acquire pictures for the royal collection (a project which will be discussed in the next chapter), Taylor showed by his choice of works – rather than by his writings – that he was among the first men outside Spain to appreciate the full genius of El Greco and Goya.[36] He also acquired for himself three pictures (all of them religious rather than the more acceptable portraits) attributed to El Greco, among the miscellaneous and scrappy collections he accumulated during his busy life: one can be glimpsed in a casual impression of his study in Paris[37] (Plates 186, 187).

In Britain, too, there were keen enthusiasts for Spanish art. By 1832 Richard Ford, doyen and greatest of scholars in the field,[38] could write from Seville: 'We are all crazy here about pictures, such buying and selling.'[39] But outside a small élite the general climate of opinion remained consistently hostile. As late as 1853, a member of the Committee of Enquiry looking into the affairs of the National Gallery could suggest, without fear of any serious opposition, that 'the Spanish school [is] generally looked upon as, more or less, a corruption of the lower Italian schools';[40] and when, in the same year, Louis-Philippe's collection, which had been assembled by Baron Taylor, was auctioned in London, the *Art-Journal* commented breezily:[41] 'The Spanish school of painting has few admirers in England; it has never been brought prominently before the collector, whose knowledge of its character is chiefly gathered from the few specimens of Murillo and Velazquez which are sparingly scattered throughout the country; of works of men less distinguished, he is, generally, in profound ignorance. Again, the majority of subjects introduced on the present occasion, was but little calculated to please an Englishman's eye, however popular

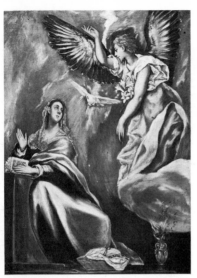

186 El Greco (and studio?): *The Annunciation.*
Szépművészeti Múzeum, Budapest

187 Unknown artist: *Drawing of the study of Baron
Taylor* (with El Greco's *Annunciation* at top right.
The identification of Plate 186 with the
Annunciation owned by Taylor cannot be regarded
as certain, but—as can be seen—the composition
appears to be the same). P. Grinke collection,
London

188 Goya: *Boys playing at see-saw*. Stirling Maxwell collection, Pollok House, Glasgow

they may be among those who originated them: saints and martyrs, attenuated, ghastly-looking monks and nuns, innocent of "damask cheeks", do not constitute the most pleasing pictures, and are certainly not those which our countrymen would choose wherewith to decorate their mansions: living flesh, smiling faces, and joyous sentiment, are much more in accordance with their tastes and feelings.'

Not everyone would have agreed. William Stirling M.P. (later Sir William Stirling-Maxwell), a genial and clubbable man of an old family, who inherited considerable wealth from his estates in the West Indies and his coal mines in Scotland, had by 1848, when aged only thirty, published three prolix, but highly instructive and entertaining, volumes on the 'Annals of the Artists in Spain'. Six years earlier he had bought four small Goyas in Seville[42] (Plate 188), and at the sales of Louis-Philippe and others in London he added considerably to his collection of Spanish painting by buying four El Grecos, as well as an assortment of pictures by Murillo, Zurbarán, Alonso Cano, and other masters, so that during the mid-Victorian period he owned the most important collection of Spanish art in Great Britain.[43] Yet his taste lacked the daring of Baron Taylor's and that of certain other connoisseurs in these years. His pretty, but relatively insignificant, Goyas did not encourage him to acquire any of the masterpieces by that artist that came on to the market at this time, such as, for instance, *The Forge*[44] (now in the Frick Collection), and his El Grecos were, with the exception of a small oil sketch,[45] all portraits of a kind which had long been familiar, and sometimes much admired, in Paris.

Indeed, Stirling-Maxwell's claims to have been a pioneering collector perhaps lie else-where. At the sale in 1853 of Thomas Butts, son of one of William Blake's keenest patrons,

189 G. B. Tiepolo: *Apotheosis of a Poet* (formerly Cheney collection).
National Gallery of Art, Washington

he bought – for derisory sums – a number of paintings and drawings by that artist (Plate 190), who was still so little appreciated that even ten years later a writer could add to the title of his biography of him the words 'Pictor Ignotus'.[46] Stirling-Maxwell was not the first to 'rediscover' Blake, whose works at that time still belonged almost exclusively to his surviving friends. In 1847 Dante Gabriel Rossetti had already been dazzled by an extensively illustrated notebook of the artist, which he at once bought,[47] and later he began to spread among his family and acquaintances[48] that somewhat unbalanced enthusiasm for him which already by 1876 had reached an extraordinary pitch.[49] But there does not appear to have been any link between Stirling-Maxwell and the Pre-Raphaelites at this time, and his discovery of Blake seems to have been the result entirely of his own intuition. Thus Stirling-Maxwell, who owned a wonderful library and many other fine pictures, occupies a significant place among those enterprising collectors who refused to allow their dominant allegiances to blind them to beauties of a far more recondite variety.

Let us look at one last collector of the period – Edward Cheney, an amateur watercolourist and patron of watercolourists;[50] a minor (though meticulous) scholar, and a still more minor (and less distinguished) romantic novelist; a man who spent most of his early life in Italy, a friend of the great, but also of historians and archivists,[51] although so strong and narrow were his political opinions that, in the words of a man who knew him well,[52] his 'very friendships were prejudices'. He belonged to 'that generation of Englishmen who regarded Italy as a museum created and preserved for their pleasure and edification, and which they were grateful to have sustained for their use by Austria or any other foreign power that could suppress the more vulgar influences of local politics and the disorders that might disturb the repose of ages and the solemnities of ancient faith'.

Cheney owned superb drawings and Rembrandt etchings,[53] but, above all, he was, during the 1840s, building up a collection of Venetian art which concentrated to a degree unknown at the time (or, indeed, since) on Tiepolo, by whom he owned a vast number of oil sketches (Plate 189), and several albums.[54] But there was no rigidity of taste about a collection which could also extend from Zurbarán to the primitives, and Cheney must

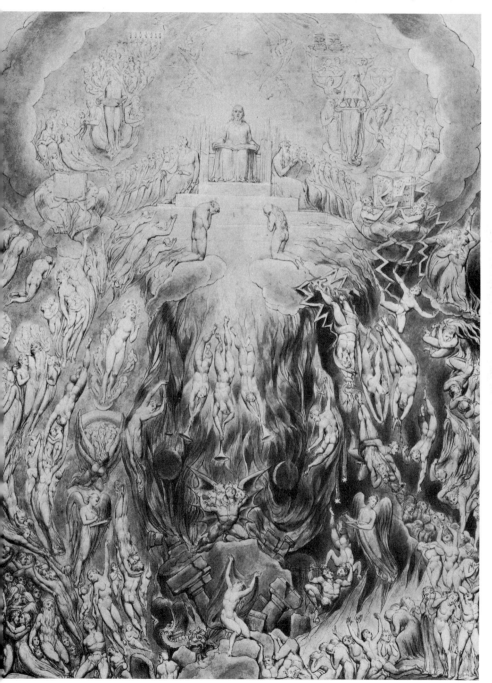

190 Blake: *A vision of the Last Judgement*. Stirling Maxwell collection, Pollok House, Glasgow

stand as my final representative of that brilliant generation – to whom a whole book could, and should, be devoted – so many of whose members valued quality, often of the most varied and novel kinds, more than notoriety, investment or sterile erudition.[55]

I am indeed reluctant to leave these cultivated and pioneering collectors, and many more whose names remain far less familiar, and who, like the ghostly figures beckoning to Virgil and Dante, seem to beg the scholar to tell the world of their activities. Their appeal to us must lie not in the fact that they bought pictures – a useful, but over-glamourized, hobby which has always met with far too much fawning adulation – as that, being very often uninterested in the written word, it was only through their collections that they could express their tastes, and these tastes can tell us something of great importance about which we would otherwise lack any information: of a silent resistance to the Goncourts' patronizing demands for consistency, to the hectoring of the *Art-Journal* for a crude form of utilitarianism, or to Ruskin's preaching about moral values. What, one wonders, did Ruskin say to Edward Cheney about his Tiepolos during the frequent calls he made to him in 'his beautiful rooms', while working on *The Stones of Venice*?[56]

But cursory though our look at these men has been, it will, I hope have indicated that the 1840s and 50s were the decisive years, in England and France, for the reappraisal of almost all the supremely great artists who are so conspicuously missing from Delaroche's Hemicycle and Armstead's Podium – reappraisals which, in almost every case, precede art-historical studies of the painters concerned. These years of feverish railway speculation, appalling famine, and political disturbances, were golden ones for the connoisseur – for the very reason that is generally used to disparage them. Frenzied propaganda to persuade the new rich to invest their money in contemporary pictures; a succession of forgery scandals much publicized by the *Art-Journal* and similar papers to frighten the public off so-called Old Masters, more than six and a half thousand of which entered England in

191 Mantegna: *The Agony in the Garden* (formerly Coningham collection). National Gallery, London

192 Matthieu Le Nain: *Le corps de garde* (formerly Pourtalès collection). Louvre, Paris

1838 alone;[57] a mistake by the National Gallery which was given much prominence in the press, and delighted the philistines[58] – all these had their effect. Modern art flourished as never before, and the market in Old Masters collapsed. But to deduce from this – as is done in all those many popular books which use price indexes as a guide to taste – that good pictures were not then truly appreciated is to subscribe to that most mistaken of beliefs that only the rich have taste.[59] Rarely, I believe, has there been such a constellation of gifted connoisseurs and collectors as during these years when collecting is said to have been in the doldrums. And, to reward and challenge their perspicacity, came a sudden bonus: the sale between 1841 and 1845 of the three thousand pictures which had been collected by Napoleon's uncle, Cardinal Fesch.[60]

There was much rubbish in this, the most gigantic sale that has ever been held: everyone acknowledged that, for it was known that the cardinal, first while serving in a secular capacity in Napoleon's armies, then as a diplomat, and finally as an exile in Rome, would often buy in bulk, acquiring twenty duds for the sake of the one picture he really wanted; the provenances were never revealed – too many people had an interest in keeping them secret; the original catalogue was a laughing stock,[61] the revised one full of irrelevant padding. In all this, the sale was in striking contrast to the dispersal of the Orleans pictures fifty years before, the only function with which it can legitimately be compared. For the number of masterpieces suddenly thrown on the market really was comparable: Raphael, Giorgione, Leonardo, Michelangelo, Rembrandt, Poussin, Watteau – the insatiable, and somewhat undiscriminating, cardinal owned great, and sometimes unrecognized, pictures by all these – as well as the most astonishing group of primitives ever assembled except by Edward Solly. Thus, the element of choice was really present, and to follow the dispersal of the collection to the ends of Europe would be an infinitely fascinating task – a real Baedeker's guide to Taste, throwing light on unknown, as well as world-famous, collectors: a masterpiece by Mantegna (Plate 191), acquired by a left-wing member of parliament for Brighton, who in the space of some seven or eight years builds up one of the finest collections of pictures in Europe;[62] a Matthieu Le Nain (Plate 192), entering one of

193　Sebastiano del Piombo:
The Visitation (fragment of
a detached fresco, formerly
Davenport-Bromley
collection). Duke of
Northumberland collection,
Alnwick

194　Delaroche: *Emile Pereire*.
Whereabouts unknown

the most distinguished, but also unfamiliar, collections in Paris;[63] fragments of a fresco by
Sebastiano del Piombo (Plate 193), being loaded off to the house of an English country
vicar.[64] After 1845 and the distribution of Fesch's pictures, the face of European collecting
had been changed for ever.[65]

Alterations in taste are often heralded by the small-scale collector or connoisseur, driven
to buying in a new field, sometimes because he is unable to indulge in what would be his
first choice, at others in pursuit of some obsessive cult. But alterations in taste can also be
registered at a slightly later stage by the speed with which they are reflected in the fashion-
able collections of the very rich. One could choose a number of such collectors in these
middle years of the nineteenth century – Rothschilds and Demidoffs, Holford and Pour-
talès – but perhaps the most interesting from our point of view are the Pereires, the history
of whose extraordinary gallery allows us to gauge, almost as on a thermometer, the exact
moment at which the new 'discovery' becomes absorbed into fashionable consciousness.

The two brothers Isaac and Emile Pereire (Plate 194), of Portuguese Jewish stock, had
been born in Bordeaux in the very first years of the nineteenth century.[66] Both had become

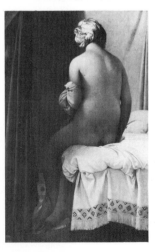

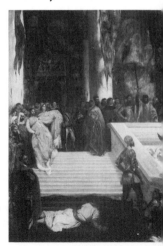

195　Ingres: *La baigneuse de
Valpinçon*. Louvre, Paris

196　Delacroix: *The Execution of
the Doge Marino Faliero*.
Wallace Collection, London

197 Ary Scheffer: *Margaret at the Fountain*. Wallace Collection, London

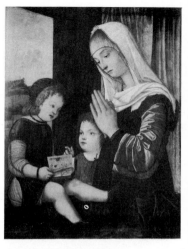

198 Carpaccio: *The Virgin and Child with St John*. Städelsches Kunstinstitut, Frankfurt

enthusiastic followers of Saint-Simon, whose secretary, Olinde Rodrigues, was their cousin, and, like so many others of this socio-mystical sect, they had taken a very active and lucrative part in the commercial and industrial life of France. Their huge fortune dates from the last decade of Louis-Philippe's reign, when – in association with the Rothschilds, with whom they later had a bitter feud – they developed the railway system of north-eastern France. In 1852 they founded the Crédit Foncier, which virtually transformed the whole commercial life of the country, and they were involved in countless other ventures. Together with their relatives they controlled fifty companies with a capital of five milliard francs during their heyday under the Second Empire. When in 1859 they inaugurated with a lavish reception their great mansion in the Faubourg Saint-Honoré, 'Emile Pereire stood planted inside the door, stocky, with his thumbs in his waistcoat; and to everyone who came to compliment him he said loudly with self-conscious pride: "I know there's too much gilt." '[67]

The house was decorated by all the up-and-coming artists of the day, such as Bouguereau and Cabanel,[68] and, a few years later, a well-informed English observer of the French artistic scene commented that 'the power of money over art has never been stronger than it is now', and that 'in a certain intelligible sense' it was the bankers and speculators, a Rothschild or a Pereire, who painted the pictures in the Salons, for pictures were painted for their tastes, and their tastes were well known.[69] In the great picture galleries hung a series of prodigious paintings by modern, but already consecrated, masters, such as Ingres (Plate 195) and Delacroix (Plate 196).[70] The Goncourt brothers, in whom the Pereires brought out all the never very latent anti-Semitism, report Isaac's son as saying: 'I buy modern pictures because it's safer. And then they'll go up in price. For instance, we did well out of buying Ary Scheffer's *Margaret at the Fountain* (Plate 197). He died soon after. The sooner they die, these fellows, the better.'[71] This is grotesque parody, for the Old Masters constituted an even more important part of the collection, but it is true that there is an uncannily predictable element about their purchase of these the moment they became fashionable.

The vogue for fifteenth-century Italian art, for instance, was by no means as smart in France as in England, but inevitably they had their picture attributed to Botticelli, as well as a beautiful signed Carpaccio (Plate 198). There were great pictures by the French

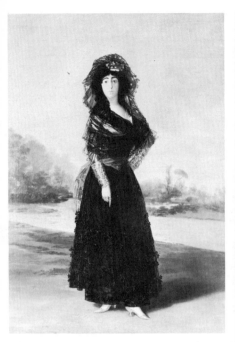

199 Goya: *The Duchess of Alba.* Hispanic
Society of New York

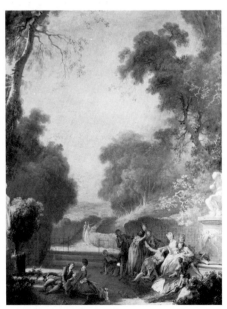

200 Fragonard: *A game of hot cockles.*
National Gallery of Art, Washington

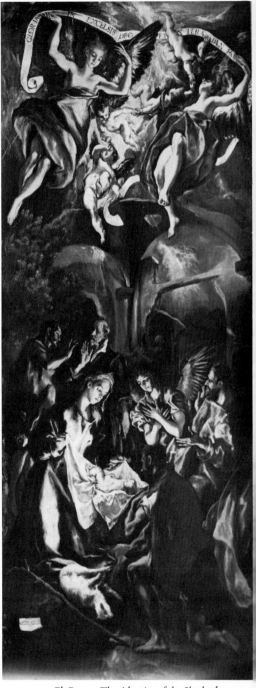

201 El Greco: *The Adoration of the Shepherds.*
Bucharest Museum

eighteenth-century masters, Boucher, Fragonard (Plate 200), and others, while among the Spaniards, there was not just the requisite Murillo, but also a Velazquez, a magnificent Goya (Plate 199), and several other pictures plausibly attributed to him, and – at one time – no less than twelve putative El Grecos, which certainly included a number of masterpieces (Plate 201). About these the Goncourts were characteristically malicious:[72] 'We hear of a magnificent collection of pictures for sale in Spain,' the brothers quote Isaac's son as telling them, 'costing four hundred thousand francs. We buy it. We send the packer who deals with the Louvre pictures – that's another fifty thousand francs for travel expenses. They arrive: absolutely hideous, all rubbish – always Christ on the Cross, church pictures. We put them all in the stables, and do you know what we do with them? When we have a mine or a factory somewhere, we at once send one of these pieces of trash to the local church, so that the curé will agree to allow the labourers to work on Sundays.' There is a grain of truth in the story. When Isaac Pereire wished to stand for the Senate, he offered El Greco's *Crucifixion with Donors* (Plate 202) to his constituency, the town of Prades in the Pyrenees, only to find – ironically enough – that local anti-clericalism led to it's being hidden away.[73] The Dutch pictures included a supposed late Rembrandt from the Fesch collection, and works by Hals (Plate 203) and Vermeer (Plate 204).

The intense fascination of the Pereire collection (which was largely dispersed following their financial crash towards the end of the Second Empire) lies not merely in the beauty of its contents, but in its determined pursuit of rising stars among the Old Masters. Like

202 El Greco: *The Crucifixion with Donors.* Louvre, Paris

203 Frans Hals: *Portrait of a woman.* Kunsthistorisches Museum, Vienna

204 Vermeer: *The Geographer.* 205 Vermeer: *View of Delft.* Mauritshuis, The Hague
 Städelsches Kunstinstitut, Frankfurt

some lion-hunting society hostess, the Pereires knew exactly whom to take up – and whom to drop. The Italian seventeenth century is out ('Dieu merci! ce n'est plus la mode' commented Thoré); the Dutch have changed: Rembrandt, Hals, Vermeer, but also Peter de Hoogh, Hobbema and Cuyp; old favourites, such as Berchem and Wouwermans are there, but in smaller quantities than in earlier collections of such splendour.

There can be no doubt that the particular nature of the Pereire collection was due to the fact that it was largely formed for them by the great historian and critic Théophile Thoré,[74] who – it must sadly be admitted – wrote about it a somewhat sycophantic article which tends to run counter to some of his most sincerely held views. This marks a crucial moment in the history of art collecting – the moment when the art historian-dealer takes over from the artist-dealer as the arbiter of taste. Another such figure, Sir John Charles Robinson, probably the greatest expert of the nineteenth century on Italian Renaissance drawings and sculpture, was soon to build up the spectacular collection of Sir Francis Cook;[75] Giovanni Morelli, the father of 'scientific' connoisseurship, was to perform the same function for Sir Henry Layard;[76] and it seems hardly necessary to stress the role of the young Bernard Berenson in the formation of Mrs Gardner's collection in Boston, or other similar instances nearer our own time. But in the middle of the nineteenth century the phenomenon was still a relatively new one, and it would indeed be hard to find a more bizarre relationship than that between the multi-millionaire Pereires and the radical Théophile Thoré. They had, however, met in Saint-Simonist circles in the 1830s, and had remained on friendly terms ever since, despite their very differing fortunes.

Thoré, of course, is the archetypal hero of this book. His 'rediscovery' of the almost forgotten Vermeer, the zeal with which he pursued him all over Europe, the brilliance with which he reconstructed his career, and the faith with which he always maintained what has now generally been accepted (though it never was in Thoré's own lifetime) that Vermeer ranks with the very greatest of all painters – all this makes him an exemplary figure, and, familiar though the outlines of the story are, they must be traced once again because they reveal so much about the mechanism of the whole process of 'rediscovery'.[77]

Born in 1807, Théophile Thoré (Plate 206) spent the 1830s combining art criticism and left-wing politics until 1840, when he was imprisoned for a year for sedition. After his release he continued to write reviews of contemporary art, while at the same time he took to dealing in the Old Masters. His sympathies were strongly with the Romantics, above all with the landscape painter Théodore Rousseau (Plate 153), and though they differed on almost everything else, he shared with Baudelaire the conviction that Romanticism should never imply a withdrawal from contemporary life.[78] Delacroix signified life; Ingres, the cult of form for its own sake and political indifference.[79] Similarly, his love of the Old Masters was actively affected by his left-wing ideals. Italian art, he asserted, was enslaved to Christ and Apollo; Dutch art was the art of man.[80] Elsewhere he wrote that it was vital to distinguish, as writers did not usually bother to do, between the Flemish and Dutch schools: 'Rubens belongs with the defeated and slaves; Rembrandt with the victors and free. . . . The character of Dutch art in general is to be found in life, in *living life*, man, his customs, his occupations, his joys and whims. . . . This is no longer a mystical art, embracing old superstitions, a mythological art, reviving old symbols; a princely, aristo-cratic and consequently exceptional art, consecrated exclusively to glorifying the tyrants of human kind.'[81] He describes the Dutch seventeenth century, freeing itself from the shackles of religion and tyranny as a 'new strange society . . . as is today the young, prot-estant and democratic society of America'.[82] Dutch painting was not for him, as it still was for most people, a minor – though infinitely attractive – school, full of delightful little masters and one awkward genius, Rembrandt. It was, rather, an uncharted extension of the human spirit, morally as superior to the great Italians, as, for Rio, Lord Lindsay, Ruskin, and so many others, the early Italians were to the later Renaissance and Baroque masters. To that extent Thoré's interpretation of the Dutch ran strikingly parallel to the revival of interest in early Florentine art.[83]

Painters who had of course (unlike the early Florentines) long been admired with enthusiasm, but somewhat shamefacedly, were characterized in new terms which gave them an altogether different dimension: Cuyp was a 'calviniste rigide'; of Jan Steen, 'excellent catholique du reste . . . l'épopée . . . va plus loin que le caractère d'un peuple, elle touche au fond même de l'humanité', and he was to be compared with Shakespeare, Molière, and Balzac; Terborch was a 'vrai gentleman', to be ranked almost with Rem-brandt among the very greatest artists.[84] Against these were Berchem, 'maître falsifié', who had lost all his individuality in Italy, and Both, Poelenburg, Lairesse, Van der Werff, 'sought after by all the princes. But princes can make mistakes – in painting.'[85]

Among all the Dutch masters of the highest rank, however, there seems – to our eyes – to be one who would not be susceptible to treatment along these committed and humanis-tic lines (Plate 207). Yet it is to Vermeer that Thoré's name is most indissolubly linked.[86] Thoré tells us that when he was in Holland on business in 1842, he was struck by the *View of Delft* (Plate 205) in the Royal Museum, but that he had never heard of the artist when he looked up the name in the catalogue.[87] Although he saw and admired two other Vermeers on a later visit, it was not until he was forced into exile in 1849 that he began to pursue the artist with fanatical zeal, talking about him to his friends – and during the 1850s and 1860s, a number of French travellers to Holland, as well as English and German connoisseurs, began to comment on Vermeer[88] – publishing tantalizing and enthusiastic references to him in the many articles that he wrote, as his expertise on Dutch art became more and more widely noted, culminating eventually in the masterly monograph (which first

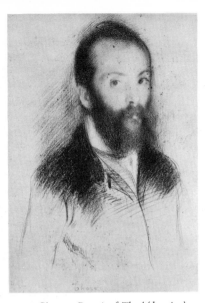

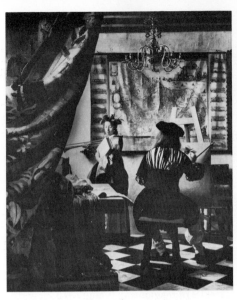

206 Gigoux: *Portrait of Thoré* (drawing).
 Musée des Beaux-Arts, Besançon

207 Vermeer: *Allegory of Painting*.
 Kunsthistorisches Museum, Vienna

appeared in the *Gazette des Beaux-Arts*) of 1866.

Seven years earlier Thoré had returned to France under the amnesty of 1859. When he called on his old friends there was nothing but mutual disappointment. 'Millet and Rousseau are really terrible,' he commented,[89] 'I found them like rocks, it's impossible to change their ideas, they sit there like two fakirs, and nothing makes them modify a single one of their ideas.' Despite this, I do not think that it was so much the immobility of his old

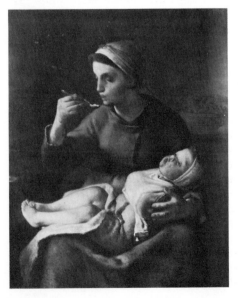

208 Millet: *Femme faisant manger son enfant*
 (exhibited in Salon of 1861, and criticized
 by Thoré). Musée des Beaux-Arts, Marseilles

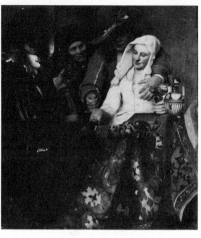

209 Gustave Doré: *Illustration to Canto XXXII of Dante's 'Inferno'* (the preliminary drawing for this was exhibited in the Salon of 1861 and aroused great enthusiasm from Thoré)

210 Vermeer: *The Procuress.* Gemäldegalerie, Dresden

friends that disturbed him as the painting that confronted him, and that he compared nostalgically with the situation as it had been before he left France. On the face of it, he ought to have been pleased with what he found. French painting had evolved, as he had always wanted it to evolve, from the Romantic past to the Realist present, from Christ and Apollo to man (Plate 208). Yet, as one reads Thoré's comments on the works of Courbet and Millet, one cannot help noticing that, for all his genuine admiration for their work and understanding of their qualities, his praise is usually more dutiful than enthusiastic. He did not basically like what he thought of as their lack of fire and passion, and he writes with greater spontaneity of the neo-Romantic melodramatics of Gustave Doré (Plate 209) than of them.[90] Despite his strictures on Millet and Rousseau, it was, to some extent, he who had not changed. He retained his early romanticism, and somehow wanted to see it combined with a new realism. His friends felt just as uneasy about him, as he did about them. Millet accused him of being 'more like a learned cataloguer, interested only in dates and so on, than a man moved by painting'.[91]

The catalogue was, of course, of Vermeer, and his monograph on the artist was, though not the first, certainly an early example of the kind of *catalogue raisonné* with critical introduction which is standard today. But it was anything but objective. Thoré was determined to turn his beloved Vermeer into a painter of the human condition, and it was because Rembrandt was the most humane of Dutch painters, rather than because he was persuaded by any purely 'visual' evidence, that Thoré claimed that Vermeer was a follower of Rembrandt. This bias leads him, for instance, to compare one of the most remarkable of his discoveries, Vermeer's *Procuress* (Plate 210), which – as he himself found, after climbing up a ladder to examine it at close quarters[92] – is signed and dated 1656, with Rembrandt's *Syndics* (Plate 211) which – as he also knew – is signed and dated 1661 and 1662, and to suggest that the not very convincing compositional similarities between them reflect the influence of Rembrandt. And again and again he compares the 'expressive physiognomies

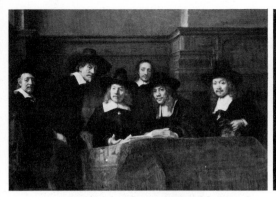

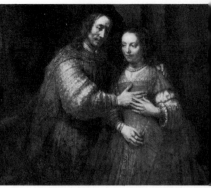

211 Rembrandt: *The Five Syndics of the Amsterdam Cloth Hall, 'The Staalmeesters'*. Rijksmuseum, Amsterdam

212 Rembrandt: *The Bridal Couple, called 'The Jewish Bride'*. Rijksmuseum, Amsterdam

and profoundly human naïveté' of Rembrandt and Vermeer in a manner that would be perplexing in so perceptive a connoisseur, were it not for the fact that his motives are so clearly apparent.

In fact, Thoré did *once* come very near to seeing a different, non-humanist Vermeer, more akin to the painter who has appealed to later art lovers. But ironically he did this when commenting on a picture that we now know to have been painted not by Vermeer, but by a late eighteenth-century imitator of the Dutch golden age (Plate 214). Looking at this in 1860, Thoré wrote, 'for Vermeer, light itself is the subject; all the rest is only a pretext or an accessory, *even the human figure* [my italics]. When he has achieved his light effect, his picture is complete.'[93] But this is the only time that he lets slip any hint of the direction in which later discussion of Vermeer was to move as early as the next generation[94] and culminate in Proust's 'precious Chinese work of art of a quite self-sufficient beauty.'[95]

I mention this not in any way to try to diminish Thoré's towering achievement in 'rediscovering' Vermeer, which is indeed one of the great epics of art-historical research and imagination, but because I do disagree with two claims that have been made for that achievement. The first insists that Thoré's 'discovery' of Vermeer was profoundly influenced by his sympathy with contemporary art, and that – in the usual tendentious phrase – 'it is no coincidence' that this discovery, as likewise his almost equally striking reappraisal of Frans Hals, to which I can only refer in passing, was made in the age of Courbet and Manet. I believe, on the contrary, that Thoré's Vermeer, and even his Hals, were created in opposition to the most 'advanced' trends in the art of his own time. As a man of deep sensibilities, he was much more sympathetic to the painting of Manet than were most critics of his generation, but he always disliked his 'sort of pantheism which thinks no more of a head than a slipper, which sometimes bestows even more importance on a basket of flowers than on a woman's face', or, as he wrote on another occasion, 'beneath these brilliant costumes the people themselves are rather lacking in character'.[96] For Thoré, Hals was just the opposite: above all, a highly expressive naturalist.[97] Both Manet and Thoré helped to rediscover and were highly moved by Hals, but they saw very different things in him, and if Manet was (as is sometimes claimed in a silly phrase) the first modern painter, then Thoré was (in an equally silly phrase) the last, and possibly the greatest, old-fashioned art historian.

The second claim was originally made for Thoré in a hostile spirit by Millet and has been repeated with admiration by later commentators. The monograph on Vermeer, it is suggested, represents a triumphant example of objective historical methodology of the kind we are taught to admire today.[98] I hope that I have already shown that such an approach was alien to Thoré's whole temperament, in which a sense of precise scholarship was more than counterbalanced by the most powerful emotions and ideals.

To what extent was a general, uncommitted art history possible in the early nineteenth century? In 1834, the year that Thoré wrote his first extensive series of articles on art, there was published in Paris a little book designed to uphold every principle against which he was to devote his energies: the absolute superiority of Italian over Northern art, the beneficent power of the monarchy, and so on. In itself it is of no value or interest, but its engagingly ambitious title catches our attention: *The History of Italian Painting from Prometheus to our own days*.[99] Already it must have sounded quaint and archaic, recalling the whimsical sub-title of some late Renaissance treatise, and in any case it was a poor substitute for (as well as being a last feeble reflection of) the authoritative *History of Italian Painting from the revival of the fine arts until the end of the eighteenth century* by the Abate Luigi Lanzi, which had first been published in the fateful year 1789, and which was translated into French, English and German in the 1820s and 30s.[100]

Though finding no room for Prometheus, and though abiding by the neo-classical beliefs common to his age, Lanzi had – with some help from advisers and correspondents – tried to look with steady concentration at the main works of every Italian painter between Cimabue and Tiepolo. Within a few years another Italian, Domenico Fiorillo (who wrote in German), had made the same sort of attempt for the art of all Western Europe. Both men seemed to be aware that they were turning back to an epoch of history that had ended, and both made some perceptive remarks and acute judgements which were long

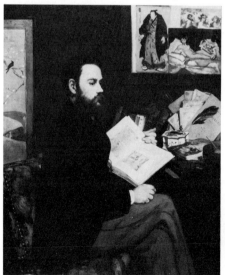

213 Manet: *Portrait of Emile Zola*. Louvre, Paris

214 Dirk Jan van der Laen: *The house in the country*. Staatliche Museen, Berlin–Dahlem

215 Schinkel: *The Berlin Museum*. From *Sammlung architektonischer Entwürfe*

plagiarized by all historians of the arts. But as the 'revivals' got under way, their books inevitably began to lose authority at both ends of the spectrum. Lanzi's brief and measured paragraph on Orcagna, for instance, could provide the sheer information (or, rather, misinformation) for those who now proclaimed him to have been one of the very greatest of all artists – but not the histrionic tone of voice required; while as early as 1806 Fiorillo's account of eighteenth-century French painting was under attack for omitting (the still living) Hubert Robert and underestimating (the barely dead) Greuze.[101]

Completion in fact was impossible, and the scholarly monograph was on the way, in Germany above all, where as early as 1813 the University of Göttingen appointed an art historian to its staff:[102] Von Rumohr's bleakly named *Italienische Forschungen* of 1827–31 and Passavant's *Rafael von Urbino und sein Vater Giovanni Santi* of 1839 were quickly recognized in France and England as marking completely new departures in the study of painting[103] – rigorous scholarship was lifted out of the depths of mindless chronicles and applied to critical evaluation; anecdotal legend was replaced by genuine biography, the study of social and stylistic influences and a *catalogue raisonné*.

Neither book was written by a 'professional' art historian, but in both Paris and London there were constant proposals, constantly rejected, that art history should be taught at the universities, in addition to the general courses on aesthetics which, in France, were well established and influential.[104] But the most important contribution made in the nineteenth century to our knowledge (rather than appreciation) of Italian painting was to come from outside the university.

The meeting in Germany in 1847 between Joseph Archer Crowe, then an English painter and ambitious Grub Street journalist aged thirty-two, and Giovanni Battista Cavalcaselle, 'about seven years my elder, with black hair and beard, a coloured complexion, Italian, an artist',[105] led in time to a series of joint books which remain the earliest in date still to merit regular consultation. The story of the collaboration between the somewhat brash and increasingly reactionary Crowe and the timid yet patriotic insurgent Cavalcaselle is a fascinating one which caused speculation, controversy and bitterness at the time, and has still not been entirely resolved.[106] It is too long to be told here, but it does, however, need to be stressed that the crucial importance of their *New History of Painting in Italy from*

216 Schinkel: *The Berlin Museum (interior).* From *Sammlung architektonischer Entwürfe*

the Second to the Sixteenth Century, first published in 1864–6, lay partly in the conflicting yet complementary temperaments of the two men. This book, and others by them, attempted (as, I have suggested, Le Brun had done in another field some three-quarters of a century earlier) to break away from the exclusively Great Man theory of art history, and to acknowledge instead that there had been many more artists at work in Italy than could be found recorded in the catalogues of the museums or private collections of the day. It is tempting to see this as an inevitable step in the long march forward of art history – and something of the kind was presumably bound to happen one day. In the event, however, the actual circumstances were more banal. Cavalcaselle suffered from that distressing complaint which involves an inhibiting reluctance to commit oneself on any major artistic question. Crowe had no such problems: he liked the idea of big books on big artists – Raphael, Titian, Leonardo, Michelangelo. Their collaboration led to a fruitful compromise, but the concept of a neutral uncommitted art history, conscientiously exploring the foothills with the same energy as the mountain peaks, was certainly due to the pathological timidity of Cavalcaselle.[107]

Such studied neutrality and reluctance to engage in value judgements was all very well in a series of books which would be read by a limited public, but when presented visually it could arouse the most intense passions. In the eighteenth century plans had repeatedly been put forward for the creation of a museum to be laid out on purely historical principles,[108] but the issue had not been serious, as most museums were still essentially private collections, and their contents were, however arranged, generally agreeable to the average visitor. But the purchase by the Prussian state of the complete collection of Edward Solly in 1821 suddenly brought the problem to the fore, because most of the pictures were of a kind with which the public was entirely unfamiliar, even after those considered too bewildering had been disposed of elsewhere.[109] The architect Karl Friedrich Schinkel was sent round Europe to seek inspiration for the museum in which he was to house these and the very different pictures that had been acquired from the Giustiniani collection, but it is hardly surprising that he should have found nothing of much relevance.[110] The Temple of Art that he finally constructed (Plates 215, 216) represented almost as much of a new departure as did its contents.[111] At first, largely under the influence of Rumohr, it was decided

that each school was to be hung along strictly chronological lines: the Florentines from Giotto to Zuccarelli, and similarly with artists from elsewhere.[112] Later, in the words of the museum's first director Gustav Waagen, it was felt that 'this mode of exhibition adheres too strictly to the standing point of the connoisseur of the history of art', and in 1844 he rearranged the entire collection so that all the Italian schools were hung together, though still, of course, in chronological sequence. Eventually, yet further modifications were made.

Waagen's international contacts (fully as much as the acquisition of the Solly collection) made his arrangement of the Berlin Museum of absorbing interest to the whole of Europe. Though he was much mocked in private,[113] we find him everywhere, and especially in England, sitting on committees, handing out advice, arranging exhibitions, writing articles, cataloguing collections, and spreading his high-minded views about painting. And constantly the same question arose: what was the point of an art gallery? 'The principal and essential purpose is, in our opinion, this,' Schinkel and Waagen had written:[114] 'to awaken in the public the sense of fine art as one of the most important branches of human civilization. . . . All other purposes must be subdued to this. Among these the first is to give an opportunity to artists for manifold study; only after that comes the interest of the scholar, and finally and lastly the museum will facilitate the acquisition of information on the history of art among all and sundry.'

But the idea that a public gallery should be a glorified art school died hard, especially in the more utilitarian society of England. When in 1836, there was an export crisis of the kind which is now familiar, Waagen was therefore asked how the purchasing policy of the National Gallery could help to remedy the feeble design of manufactured goods. The answer came back much as it might have done a century earlier:[115] Concentrate on the High Renaissance, 'for the works of such masters have a great influence in forming the taste in the best manner . . . but in order to understand and still better appreciate the great masters, you must commence with those who immediately preceded them and who taught them. . . . There should also be a few specimens of the earlier masters, and [I would] give a history of the early art, and trace it through the masters in the time of Raphael.' Cautious words indeed from a man in charge of the greatest collection of 'primitives' in Europe, but less cautious than those of Edward Solly, who had once owned those 'primitives'. 'If the National Gallery is to be a complete historical collection,' was his contribution to the debate,[116] '[then] of course it must commence from the time of Giotto; but I should not think it advisable to commence in that way; I should think the preferable way would be to commence with the very best masters, those who had brought it to the greatest state of perfection, and then go up to the source as well as come down to the present time. I do not think the public would take that interest if we were to commence with Cimabue and Giotto, but we might commence with Raphael and the other great masters of that period.'

Waagen and Solly were right to feel that the public of other cities would not willingly put up with the austerities of early Italian art: as late as 1862 an authoritative French student[117] of the museums of Italy wrote that he 'must protest again against the demands of art historians. To listen to them one should follow chronological order and furnish museums with canvases the only merit of which is their extreme antiquity.' Of course, he acknowledged, some of the early masters such as Masaccio, Bellini, Mantegna, Van Eyck, Memling, Massys, Dürer and Pinturicchio had real talent; but – he complained – was it not

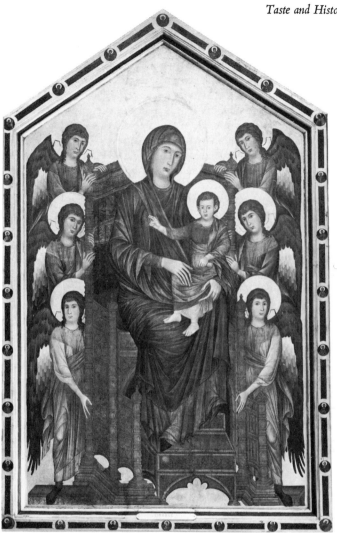

217 Cimabue: *Madonna and Child with angels*. Louvre, Paris

painful when leaving the room containing the masterpieces in the Louvre to run into Cimabue's dreadful *Madonna and Child with angels* (Plate 217) – a picture that had been acquired for the Museum half a century earlier by Vivant-Denon?

What about the decadence of art? Here too Waagen was ready with his advice: 'Even the richest gallery requires only a small number of the best pictures of the following masters', he wrote in 1853,[118] giving a fairly inclusive list of the Italian painters who followed the generation of the Carracci pupils. His advice seems to have been taken, though only a generation or so later, and it naturally hit most strongly those museums which had been created out of seventeenth and eighteenth-century royal collections. In two vigorous articles of 1909 and 1912, one of them called *The Invisible Louvre*, the great art historian

Louis Dimier complained that 'today we are scarcely allowed to know any longer that Bologna had a school of the Carracci, that Rome had famous painters in the seventeenth century, and Naples flourishing studios during the period of the Spanish viceroys', and he published at the same time a remarkably interesting list of all the pictures that had been taken down from the walls of the Louvre some twenty years earlier. Dimier was a profound Catholic,[119] but his ringing call for a serious and sympathetic revaluation of Italian seventeenth-century painting was made in the name of history and taste rather than in that of the Jesuitry that John Addington Symonds had feared.

Certainly the museums of the nineteenth century failed in their duty of giving the public an opportunity to make up its own mind about Taste – just as do the museums of today, as will be acknowledged by anyone who has ever wanted to look at those pictures held by them which do not conform to current text-book interpretations of nineteenth-century art. But was this their duty? Many people felt, on the contrary, that it was the function of a museum to instruct rather than to inform, to impose Taste rather than to question its foundations. A museum was not, it was often explained, a library: on the contrary, in the words of one particularly virulent controversialist,[120] 'the establishment of a National Gallery is a formal recognition on the part of the government which undertakes it of the powerful influence which the fine arts were intended by Providence to exercise on mankind. The only way by which a Legislature can render this influence effective is by exempting, as far as possible, the principles of sound taste and genuine art from the caprices and fluctuations of fashion. The selection, therefore, of works of art is a question of national importance.'

We can end with a vivid indication of this attitude by eavesdropping on yet another committee into the conduct of the National Gallery in London. The year is 1857, and Ruskin is being questioned:[121] 'You have much to do with the education of the working classes in Art. As far as you are able to tell us, what is your experience with regard to their liking and disliking in Art – do comparatively uneducated persons prefer the Art up to the time of Raphael, or down from the time of Raphael – we will take the Bolognese School, or the early Florentine School – which do you think a working man would feel the greatest interest in looking at?' To which came the answer: 'I cannot tell you, because my working men would not be allowed to look at a Bolognese picture.'[122]

5 Spreading the News

R USKIN'S WORKING MEN who, in 1857, were 'not allowed to look at a Bolognese picture' were unfortunate because we happen to know that in that very year, a Bolognese picture, Annibale Carracci's '*The Three Maries*' (Plate 52), was the most popular picture in England, and in the course of a few months had been looked at and admired by more people – including working people – than had yet seen it in its entire history. Although I shall describe the circumstances in which this took place on a later page, it is worth even now making the obvious comment that changes in taste affect different people at different times in different ways.

Accessibility is essential, but not of itself enough: the frescoes of Piero della Francesca, the altarpieces of Rogier van der Weyden, were seen – and ignored – for centuries. Museums may help to draw attention to specific works of art, but we have observed that museums are themselves largely the products of the forces that have been considered so far. No one, for instance, relying on what he could see in any English museum could possibly have developed a taste for early Italian, or eighteenth-century French, art before 1850 at the earliest.[1]

Exhibitions may, on the other hand, attract more attention: their temporary status, and the publicity they inspire, can be of far-reaching importance; and, although auctioneers' rooms had, for more than a hundred years, fulfilled many of the functions of the temporary exhibition,[2] it is not until 1815 that we find – in London – the first of the non-commercial, changing displays of foreign Old Masters which are now so familiar to us;[3] thereafter, indeed, scarcely a year passed without some occasion of the kind, and the Old Master exhibition came to be recognized as something of an English speciality.

They were held at first in the rooms of the British Institution, an organization which had been founded ten years earlier to encourage contemporary English art, and the directors, who were very conscious of the possibility of conflict between old and new, foreign and British, went out of their way to explain how valuable the sight of so many masterpieces would be to living painters[4] – for no National Gallery was yet in being. Like all subsequent exhibitions at the Institution, this one too was made up of loans from private owners – men who belonged essentially to what I have called the 'Orleans generation', brought up on eighteenth-century canons of taste. Although as the years passed they were naturally joined by a new generation of collectors, it is true to say that until 1848 no member of the public would have been aware from the exhibitions that any other canon could exist.[5] As splendid (but chaotically attributed) Poussins followed Correggios, and Teniers clustered next to Wouvermans (Plate 218), the aesthetic map remained reassuringly unchanged.

In 1848 the visitor may have received something of a shock. In the middle room was what the directors described as 'a novelty to which they cannot but refer, namely, a series of Pictures from the times of Giotto and Van Eyck'[6] – a loose timespan that was very loosely applied, but that did allow for the inclusion of a few early pictures of real quality and interest.[7] It has recently been emphasized[8] that the artists who were about to launch the Pre-Raphaelite Brotherhood on the world showed no curiosity about the occasion,

and as they themselves had not yet instigated that revulsion from the 'primitives' about which I wrote in chapter 3, the exhibition was uncontroversial,[9] but it was to be many years before there was any similar opportunity to see earlier art on view in London – with one very important exception. Year by year, Lord Ward, an immensely rich peer whose love of beauty not only encouraged him to build up one of the finest collections in England,[10] but also led him to make the Baudelarian gesture of stripping his wife and admiring her naked body covered with lavish jewellery,[11] would display his latest purchases in a public gallery called the Egyptian Hall. The combination of aristocracy, a possible breath of scandal and pictures such as Fra Angelico's *Last Judgement* (Plate 219) may well have encouraged, among the fifty thousand visitors a year, a taste for early art which could not otherwise have been satisfied.[12]

Outside London the situation was different. In Manchester, where Thomas Agnew, the most influential dealer of the time,[13] was persuading newly-rich factory owners to invest in modern pictures (the distasteful concept of investment was openly acknowledged), a gigantic art exhibition – the greatest ever seen – was held in 1857[14] under the inspiration of three Germans: the Prince Consort, the ubiquitous Dr Waagen, and George Scharf (the brilliant connoisseur, son of a Bavarian tradesman). In four months nearly a million and a half visitors passed under arches inscribed with the words TO WAKE THE SOUL BY TENDER STROKES OF ART and A THING OF BEAUTY IS A JOY FOR EVER (Plate 220), and saw what virtually amounted to nine separate museums – of paintings by ancient, and modern masters; British portraits; historical miniatures; ornamental art; sculpture; watercolours; drawings and engravings by the Old Masters; photography.[15]

Thoré begins his account of the exhibition as follows: 'Let us imagine that the Louvre had suddenly and by magic been created yesterday, and that because of some accident it was to be dispersed tomorrow. . . . The collection of pictures [on view] in Manchester is about on a level with the Louvre. The Spanish school, the Northern primitives, the German, Flemish, and Dutch pictures are even more numerous and finer. The English

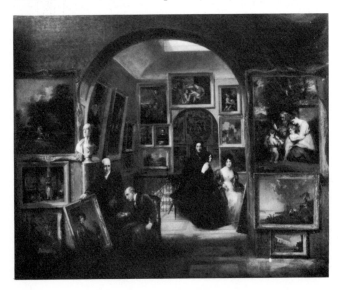

218 Scarlett Davis: *An exhibition in the British Institution*, 1829. Birmingham City Museum and Art Gallery

Fra Angelico: *The Last Judgement*. Staatliche Museen, Berlin–Dahlem

school can be seen only there. Only as regards the great Renaissance Italians does the Louvre surpass Manchester. All this, collected yesterday, will be dispersed tomorrow.'[16] Thoré's estimate is reasonably accurate. Although the established masters were there in force, it was the unfamiliar works that really attracted the connoisseurs: there were as many pictures attributed to Bellini as to Gerard Dou; nearly twice as many putative Van Eycks as Correggios; more Memlings than Ostades; as many Mantegnas as Berchems. Nothing like this had been seen before. Was it accident or design? 'What in the world do you want with Art in Manchester? Why can't you stick to your cotton spinning?' asked one duke when approached for a loan,[17] and it was clear enough even at the time that some of the greatest collectors had not lent, so that the organizers had to rely extensively on the new generation which had begun buying long after the Napoleonic upheavals.[18] But whether the eventuality had been foreseen or not, a vast public was suddenly introduced to the delights of Bartolo di Fredi and Sano di Pietro – the names as well as the pictures. Predictably enough that public was uninterested. Everyone agreed – the experts rather gloomily – that the most popular picture of all was Annibale Carracci's *'The Three Maries'*,[19] thus confirming the judgement of James Barry when the picture had first been exhibited with all the others from the Orleans collection in 1798.[20]

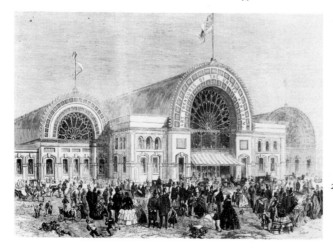

220 *The Art Treasures Exhibition, Manchester*, 1857. From the *Illustrated London News*, 1857

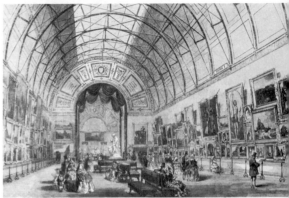

221 Murillo: *The Good Shepherd* (a contemporary photograph of the picture belonging to the Rothschild Collection, exhibited at Manchester in 1857)

222 *The Art Treasures Exhibition, Manchester, 1857 (interior).* From the *Illustrated London News,* 1857

The attitude of the 'man in the street' is expressed with great candour by Nathaniel Hawthorne, who devoted six weeks to a thorough study of the exhibition.[21] Discouraged at first – and how one sympathizes with him! – by the enormous mass of what was to be seen (Plate 222), he gradually acknowledged that 'positively I do begin to receive some pleasure from looking at pictures', and, after nearly a fortnight, he is able to record, 'I am making some progress as a connoisseur, and have got so far as to be able to distinguish the broader differences of style as, for example, between Rubens and Rembrandt'. At the end of his last visit, he recognizes that 'pictures are certainly quite other things to me, now, from what they were at my first visit', but when we look at the details of what impressed him, we find that not one single work of early art (on which the organizers had lavished so much care) is even mentioned, and that what impressed him most were Murillo's *The good Shepherd* (Plate 221), 'the loveliest picture I ever saw', and Dou's *Woman cleaning a Saucepan* (Plate 223). In the Dutch seventeenth-century masters he was dazzled by 'such life-like representations of cabbages, onions, turnips, cauliflowers, and peas. . . . Even the photograph cannot equal their miracles; and I doubt if even the microscope could see beyond the painter's touch.'

For the élite, on the other hand, the star of the exhibition was probably Botticelli's *Mystic Nativity* (Plate 61),[22] and as it was the élite who won the day, it was about a hundred years before extensive coverage was to be given again to the Bolognese masters of the seventeenth century, let alone the Murillos and Dous that so appealed to Hawthorne. For the dealers and the very rich the most attractive section of the exhibition seems to have been that devoted to English historical portraits – certainly, it was very soon after this that there developed that over-riding enthusiasm for Gainsborough, Reynolds, and other eighteenth-century masters that was to last until the 1920s.

The variety of responses stimulated by the Manchester exhibition was possible partly because, unlike any existing museum, it really did provide an erratic, but enormously generous, display of Old Masters of all kinds from early Byzantine to Goya.

In Paris, where Old Master exhibitions were far fewer than in England,[23] the effect of the more important ones was to concentrate, rather than to disperse, taste. Although it involves stretching the use of the word exhibition to include here a brief discussion of Louis-Philippe's Galerie Espagnole, this does in fact seem to be the right context in which to refer to it.[24] It is true that when the King of the French sent the Baron Taylor to Spain in 1835 to collect Spanish pictures for him, the general expectation was that these would belong permanently to the nation, and that no one could possibly foresee that, only thirteen years later, they would be returned to a deposed Louis-Philippe in person by 'the stupid French Republic with its excessive respect for property' (in the words of Baudelaire writing to Thoré).[25] None the less, the stream of publicity that was poured out about the dangers of the mission, the romantic allure of Spain itself, the King's inaugural visit by flaming torchlight – all this gave the Spanish Gallery many of the distinguishing features of an exhibition.

Spanish pictures – especially Murillos of course – were to be found in a fairly large number of private collections, above all those of the banker Aguado and of Marshal Soult;[26] and they seem to have been accessible enough to those really interested, and (in the case of the latter) to those likely to make a big enough offer. Indeed, the news that Soult was disposing of some of his Murillos to the English reached Taylor soon after he had embarked on his mission, and he exploded in a frenzy of indignation:[27] 'Men who would sell their country must have advised this anti-patriotic, iniquitous action . . . pictures paid for in French blood.' It certainly spurred him on to try and acquire more, and better,

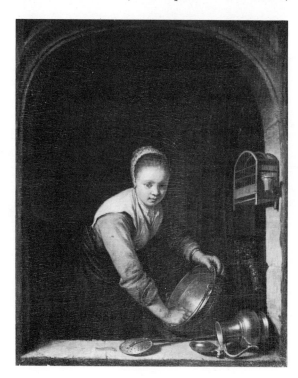

223 Dou: *Woman cleaning a saucepan* . Royal Collection (reproduced by gracious permission of Her Majesty the Queen)

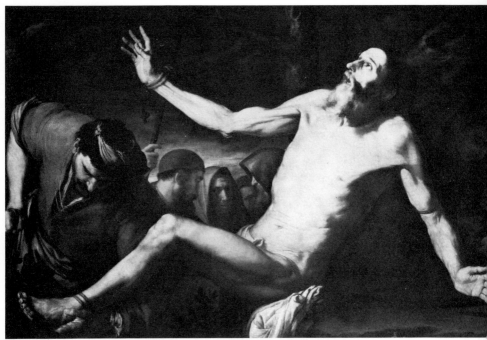

224 Ribera: *The Martyrdom of St Bartholomew*. Musée des Beaux-Arts, Grenoble

225–6 Zurbarán: *St Francis in meditation*. National Gallery, London, and lithograph
in *L'Artiste*, 1ère série, Tome XIV, 1837 (2), p. 336

227 Goya: *Two Women with a letter*. Musée des Beaux-Arts, Lille

228 El Greco: *Lady in a fur wrap* (formerly known as 'Portrait of the Artist's Daughter'). Stirling Maxwell collection, Pollok House, Glasgow

Murillos for France, but in general there seems to have been no clear guidance as to what he should get; he picked up anything that was available (and much was available as a result of the secularization of convents and monasteries); and in the end he returned with an extraordinary hotch-potch, much of it clearly indifferent in quality. But the effect of this, by far the most spectacular addition to the Louvre since the Napoleonic wars, was naturally overwhelming. There were more than four hundred pictures spread over five rooms: the first, devoted to twenty-eight Riberas, which included his *Martyrdom of St Bartholomew* (Plate 224); the second, to some eighty-one Zurbaráns; the third contained nineteen doubtful pictures attributed to Velazquez. In the fourth and largest room were thirty-eight Murillos, twenty-one Alonso Canos, ten Valdes Leals; and, in the last room, were chiefly masters of the sixteenth century.

Despite the enormous excitement aroused by the Galerie Espagnole[28] we can only use the word 'discovery' in connection with it in the most cautious spirit. I agree with recent authors on the subject that, in general, the pictures shown confirmed existing attitudes to Spain rather than stimulated new ones.[29] The painter Jules Breton, who later wrote, in his much-quoted evocation of the gallery, 'there remains with me as it were a dream, terrifying and mysterious, of savage ecstasies, dark piety lit up by flashes of lightning and the feel of the cloister and the Inquisition',[30] was echoing a literary stereotype that was already in existence well before 1838; though it was no doubt reinforced by the accidental factor that major works of the highest quality by Velazquez, which would have given a very different impression of Spanish culture, were unavailable.[31] In the absence of these, Zurbarán proved to be the main attraction, but, significantly, it was his most tense (and, in many ways, uncharacteristic) picture (Plate 225) – rendered even more so in reproduction (Plate 226)–that was made to typify his whole oeuvre. It is, on the other hand, difficult to see why anyone should have found Goya's *Two Women with a Letter* (Plate 227) reminiscent of the Inquisition, and perhaps it is just because of this that Goya was almost entirely ignored.[32]

The case of El Greco was different. One picture, and one picture only, intoxicated the public: the so-called *Portrait of the Artist's Daughter* (Plate 228) – a 'Titien chez les fauves'

229 El Greco: *The Baptism of Christ.*
Hospital de San Juan Batista, Toledo

230 Chardin: *La Pourvoyeuse.* Louvre, Paris

one is tempted to say – and this only made the contrast with his other works more blatant and caused them to be attributed to a wilful and perverse desire for originality, or to madness (defective eyesight was to come later). And yet a few poets and critics were deeply impressed as well as puzzled, for to them El Greco represented an extreme case of the Romantic artist, 'qui dans son extravagance même fit toujours preuve d'un si grand sentiment d'art'.[33] Champfleury thought of writing a book about 'l'étrange Théotocopuli',[34] but though this came to nothing, he did include El Greco, along with Tintoretto, Rembrandt, and – significantly – Delacroix, among his group of 'tormented' painters, who were, by their very nature, superior to such 'calm' masters as Veronese, Rubens, and Le Brun.[35] Baudelaire and Thoré, Delacroix's most ardent champions, were both stimulated, and Delacroix actually bought an El Greco, though it is not clear exactly when he did so.[36] Théophile Gautier, who went to Spain in 1840, wrote, 'few pictures interested me more than his. Even the worst always have something unexpected and surging out of the ordinary which surprises one and makes one dream. . . . He has a depraved energy, an unhealthy power which betray the great painter mad with genius.'[37] Stirling-Maxwell, who was probably inspired by his careful study of the Galerie Espagnole to pay particular attention to El Greco when he went to Spain, wrote of one of his pictures there (Plate 229), 'he might have painted it, by the fitful flashes of lightning, on a midsummer night, from models dressed only in floating ribbands'.[38] From the future admirer of Blake words like this might be interpreted as constituting enthusiastic praise – such would certainly have been their significance for critics half a century later.[39] But in fact Stirling-Maxwell, who was deeply sensitive to the 'realistic' side of El Greco's painting, intended them to be read in an entirely pejorative sense. Gautier too was unable to admire in fact what he approved

of in theory. The point is worth stressing. In our age of art historians we are accustomed to any amount of 'discoveries' being made from among the artists of the past by men to whom the experiments of contemporary painting are deeply repugnant. But for Gautier, and the Romantic critics, it was often easier to accept the daring innovations of their own generation than the comparatively anti-conformist artists of the past. What, in any case, almost no one recognized was that El Greco, Ribera, Zurbarán, and others could be 'discovered' in a more fruitful manner than so much extravagant language suggests: Millet and Courbet – to name only the two greatest painters who acknowledged the impact of the Galerie Espagnole on their development – revealed its influence in a whole series of masterpieces devoid of any allusion to monks, the Inquisition or tormented extravagance.

Occasional Old Master exhibitions were certainly held in Paris – I have already referred to the showing of some pictures by Le Nain, Watteau, Fragonard, Géricault, and other masters in 1848 – but it was not until 1860 that there was held one comparable in scale to the annual displays at the British Institution in London. In that year there opened in Paris a loan exhibition of more than three hundred pictures and drawings, the overwhelming majority dating from the age of Watteau to that of the pre-Revolutionary David – though a drastic reorganization of the exhibition some half way through its run makes it impossible to be certain exactly what was on view at any given moment.[40] It was held in rooms adjoining the property of the greatest of all European collectors of eighteenth-century French art, the fourth Marquess of Hertford, who lent a number of his own pictures. Most of the lenders were, however, of the relatively modest type discussed in the last chapter: Dr La Caze, for instance, and also M. Laperlier,[41] an official in the War Office who spent much of his life in Algeria and who had been initiated by the painter Bonvin in 1849 into an overwhelming love of Chardin (Plate 230), who was represented by at least twenty-two pictures – the greatest number yet assembled anywhere, and the first time that the general public had ever had the chance to see a substantial selection of his work; or again Eudoxe Marcille, who with his brother Camille, had inherited from his father (yet another amateur painter) an admiration for eighteenth-century artists, above all Prud'hon (Plate 231), but extending also to Chardin, Greuze, and other masters.[42] It is not, of course, true that such men were the only ones to have built up striking collections of eighteenth-century French art by this time or to have lent to the exhibition. Quite apart from Lord Hertford himself who sent several superlative Bouchers (Plate 232) to make up a total of sixteen on show,

231 Prud'hon: *The Assumption of the Virgin* (the same composition—but not the same picture—as that exhibited in 1860). Wallace Collection, London

232 Boucher: *The setting of the sun*. Wallace Collection, London

Napoleon III's half-brother, the Comte de Morny, an omnivorous collector and *marchand-amateur*[43] lent Fragonard's *The Swing* (Plate 233), which was later to become one of the most famous pictures of the whole century, to join twenty-six other pictures by this artist at the exhibition, and the Rothschilds already owned Watteaus and Paters.

Yet the situation changed radically after 1860. Thoré in a series of sensitive and acute review articles[44] pursued once again his old, rather nationalist, line, stressing also the naturalism, and even the potentially left-wing elements, in the art of Watteau – 'before him people painted princesses, and he painted shepherdesses' – but his words must have sounded increasingly hollow, and his line was explicitly disowned by the editor of the *Gazette des Beaux-Arts* where his articles appeared.[45] It was the international moneyed aristocracy that was now to take up the eighteenth century in strength, and to turn it once again into what it had originally been and has since remained, a symbol of luxury, refinement, and fantasy. Before the exhibition of 1860, even the keenest advocates of eighteenth-century French art felt that Paters and Lancrets were over-valued,[46] but at Lord Pembroke's sale two years later bankers such as Edouard Fould and the Pereire brothers paid two or three times more for these very artists than anything that had hitherto been dreamed of.[47] Although Chardin remained accessible to the modest collector for a generation or so more, the days when men such as La Caze, Marcille, and Walferdin could pick up their Bouchers and Fragonards cheaply had gone for ever.

The sight of original pictures in a private collection, a church, a palace, a museum, or a temporary exhibition; arranged by chronology, by nationality, or by caprice; belonging to a clergyman, a socialist, an aristocrat, or a scholar – all these factors can affect responses to the pictures more than is readily admitted. But, until recently, the opportunity to see original pictures in any of these circumstances was relatively limited, and the overwhelming mass of the population – even that part of the population specifically concerned with art – had to be content with reproductions and the written word. The effects of both these indirect forms of communication in guiding general taste can hardly be overestimated, and nineteenth-century connoisseurs were well aware of the fact. As each of a series of new techniques – lithography, wood engraving, steel engraving, photography, and so on – was invented, the debates concerning its relative merits *vis-à-vis* the others became more intense. This makes it impossible to avoid some reference, however brief, to the nature of the problems raised.

The most ambitious attempt made in the nineteenth century to reproduce works of art was inspired by the French statesman Adolphe Thiers, who in 1834, when he was minister of the interior, began to commission large-scale copies in oil of the major frescoes of Raphael and Michelangelo.[48] His rather desultory programme was taken up and expanded with enthusiasm, and a driving sense of purpose, for some three years after 1870, in order – it has been plausibly suggested[49] – to check the growing tendency of art students to break away from the Italian Renaissance masterpieces (virtually all of which it was hoped to reproduce) in search of 'unfinished' Impressionist novelties. The aim was thus a conservative one, and though it has been persuasively argued[50] that the copies that were commissioned of Piero della Francesca's frescoes in Arezzo may have played their part in stimulating the classic genius of Seurat, it is almost certain that by the 1870s, when they were made, more tourists – and, even, more art students – could have had access to the originals than to the copies in the Ecole des Beaux-Arts.

In any case, long before modern research into the topic, which has rightly become

233 Fragonard: *The Swing*. Wallace
Collection, London

234 *The Interior of the Arena Chapel, Padua, with
Dante and Giotto*. Chromolithograph pro-
duced for the Arundel Society, from a
watercolour by Mrs Higford Burr, 1856.
Ashmolean Museum, Oxford

popular in recent years,[51] it was recognized that all forms of hand-made copies, whether in watercolours, in oils, or in some form of printing, involved the distorting intervention of the copyist.[52] Quite apart from the question of cheapness, this was one reason why photography was at first welcomed with enthusiasm even by those who, on other grounds, would be most likely to disapprove: 'Among all the mechanical poisons that this terrible 19th century has poured upon men, it has given us at any rate *one* antidote, the Daguerreotype,' Ruskin wrote to his father from Padua in 1845.[53] 'It's a most blessed invention, that's what it is. . . . It is such a happy thing to be able to depend on *everything* – to be sure not only that the painter is perfectly honest, but that he can't make a mistake.' The trouble was that, even if not able to make a mistake (and we would not accept even this assumption today), there were also many other, and much more desirable, things that the camera was not able to do. As late as 1868 the *Art-Journal* pointed out, 'Photography applied to paintings possesses both advantage and disadvantage over the art of the engraver', and emphasized that, as a means of actually conveying what was in a picture, engraving or lithography were still more satisfactory than photography.[54] As regards monumental frescoes in dimly lit Italian churches the choice hardly arose. The Arundel Society, which had been founded in London in 1848 for the express purpose of reproducing for its members such examples of (mainly early) art which were everywhere falling into decay, relied entirely on various kinds of engraving.[55] Watercolour copies were exhibited in its private premises, and as from 1856 chromolithographs began to replace the earlier wood engravings which were issued to members. These could give a tolerable idea of the interior as a whole (Plate 234) as well as a suitable atmosphere in the form of Dante and Giotto at work together, and despite a vast amount of often bitter controversy, they could satisfy many difficult critics: in 1856, Rossetti, who never went to Italy, met Mrs Burr, 'about 32,

refined and very nearly beautiful, energetic withal to an extraordinary degree in Ruskin's style, but quite mild and feminine – ten hours at the top of a ladder to copy a Giotto ceiling being nothing to her. She has been travelling all over Italy with Layard and they together have given one one's first real chance of forming a congruous idea of early art without going there'[56] – revealing words from one of the original Pre-Raphaelite Brotherhood.

The relatively clear definition of early art certainly made it more susceptible to this sort of treatment than would have been, let us say, a Baroque sketch; and though in issues of this kind it is impossible to decide priorities, there can be no doubt that, at least until the last quarter of the nineteenth century, the sheer mechanics of reproduction favoured the 'primitives', much as the enlarged photograph of a small detail has in our own period encouraged a taste for rough textures and loose brush strokes.

It was not, in any case, until the 1880s that photo-mechanical techniques of reproduction in books and journals became feasible, and what was probably the most useful (as opposed to scholarly or elegant) of all popular art publications of the nineteenth century relied exclusively on wood engravings which were often crude and schematic. I am referring to the *Histoire des Peintres de Toutes les Ecoles*, which was edited by Charles Blanc, a man of somewhat mediocre talents but incomparable energy, brother of the strongly Socialist Louis. Among his numerous ups and downs in the French art world he was the first editor of the *Gazette des Beaux-Arts*, and later the first and only director of the short-lived Musée des Copies. Separate fascicules of the *Histoire* were issued at short intervals throughout the

235 [Charles Blanc]: *Histoire des Peintres*, detail of the article on Vermeer.

1850s, and they not only covered an enormous amount of ground, but also made available, in simplified form, the very latest researches of historians and scholars to a vast public. It is worth pointing out that it was in this cheap and popular publication that there appeared the first article ever to be devoted entirely to Vermeer (Plate 235), though Thoré (who himself wrote some of the issues) unquestionably inspired it through his many references to the artist in detailed catalogues of Dutch, Belgian, and German collections, which were published before his full-scale monograph of 1866.[57]

Art journals, which originated in Germany in the eighteenth century,[58] proliferated in England and France throughout the nineteenth,[59] though their lives were often pathetically brief, as can be seen from the brave preface to the *Annals of the Fine Arts* for the year 1819: 'The *Annals* have now reached the third volume, in spite of the opposing influence of the Royal Academy. This is a volume more than any other work solely devoted to art has ever before attained in this country, and it is a most gratifying proof that there are some, and those too of high rank and talent, who approve the principles upon which it is conducted.' None the less, it was forced to close down within five years, and it was not until the advent of the aggressive *Art-Union* in 1839 that there appeared a monthly journal which both carried weight, and managed to combine a substantial circulation with long life.[60]

In France, the superbly illustrated *L'Artiste*, which was founded in 1831 and survived until 1904,[61] was more readable, more eclectic, and also more gossipy – sometimes, in its later years, carrying the commonplace to the verge of the trivial. Only with the creation of the *Gazette des Beaux-Arts* in 1859 did the art historian join the archaeologist (and dealer) in acquiring a vehicle of real authority, distinction, and wide circulation. Such a vehicle would hardly have been possible even fifteen years earlier, as the first issue itself emphasized in pointing to the impact on the public of art exhibitions in London, Paris, and Manchester.[62]

In these specialized or more fashionable magazines, and in the many pages devoted to the arts in such outstanding journals of opinion as the *Revue des Deux-Mondes* or the *Athenaeum*, wrote not merely the connoisseurs, whose names have often cropped up in the pages of this book, but the many more popular authors who helped to spread the news of their achievements: Mrs Jameson, a one-time governess, jilted wife, and commentator on Shakespeare's heroines, 'who knows as much about art as the cat' according to Ruskin,[63] but who, none the less, was probably second only to him in furthering the cult of the 'primitives'; or Arsène Houssaye, yet another theatrical impresario whose influential taste in the arts deserves recording, for he whipped up a somewhat frothy enthusiasm for the eighteenth-century masters, whose 'rediscovery' he liked to claim for himself; or – but the list could be extended indefinitely.

It was, however, the guidebooks, rather than the journals, which must really have influenced in the most effective way imaginable what the public saw;[64] gradually ruining the tourist trade in Bologna, as the harassed 'Eclectics' succumbed to the attacks of Rio and Ruskin, and, no doubt, improving the train services to Padua and Pisa as pilgrims flocked to study 'Christian Art'. As far as the English-speaking public was concerned, two individuals dominated the scene until the 1870s when the first translations of Baedeker began to make a serious impact. Commenting on his father's visit to Italy in 1836, Wilkie Collins wrote twelve years later:[65] 'And, finally, Madame Stark's "Handbook" – then the same "guide, philosopher, and friend" of tourists in Italy that Murray's is now – was consulted and re-consulted as the future Delphic oracle of the party, from the morning of the

departure to the evening of the return,' and the words do indicate the crucial change that came over Italian travel during the space of only a few years.

Mariana Starke, who was born in about 1762, passed her early years in India, where her father held a military post, and on coming to England she made something of a name for herself as a playwright.[66] From 1792 to 1798 she lived in Italy, and witnessed the upheavals there caused by the revolution and foreign invasion. These she described in two volumes of *Travels in Italy*, first published in 1800, in which her histrionic background is apparent in the number of exclamation marks used to describe the pictures and sculptures she particularly admired. From the start these *Travels* were intended to serve partly as guidebooks, for along with a somewhat hectic descriptive style is included much concrete information about posting, prices, shops, surgeons, and so on in Germany and France, as well as in Italy.

When peace returned to the Continent, a new edition appeared, under the title *Letters from Italy*, and although most of the original form was retained, there could now no longer be any doubt that the volumes were intended more as a guide for others than as a record of personal experiences. Its success was prodigious, and it was metamorphosed again and again, under a series of similar, though not identical, titles, being published in Paris, Leghorn, and elsewhere, and including information about a growing range of countries. Moreover, the exclamation marks were now systematized, and fulfilled the purpose later served by stars in Baedeker, Michelin, and other guides. They thus allow us a remarkable glimpse into what the conventional traveller might be expected to admire. Mariana Starke, essentially of the eighteenth century, was slow to change her tastes. In 1815 only five pictures in the Louvre received two exclamation marks (three, and sometimes four, were reserved for certain pieces of antique sculpture): Dou's *Dropsical Woman* (Plate 67), Correggio s *Jupiter and Antiope*, Murillo's *Madonna and Child*, Raphael's '*Madonna of François Ier*', and Titian's *Christ crowned with Thorns*. And although between 1815 and 1825, the Campo Santo (Plates 117, 118) changes from being 'the most elegant building at Pisa' to 'the most beautiful edifice at Pisa', at no time between 1802 and 1839[67] does she move beyond her original opinion of the paintings within it, 'which, however deficient in many respects, cannot but yield pleasure to those who wish, on their entrance into Italy, to view the works of the Revivers of an art afterwards carried to such exquisite perfection'.

A rare concession is made to new tastes in the edition of 1825 by two references in passing (though one has an exclamation mark) to the work of the Beato Giovanni Angelico in S. Marco in Florence. This was retained in the final edition of 1839; and the visitor to that church and convent only three years later must therefore have received something of a shock to be told roundly, in a newly published guidebook, that 'the traveller [to Italy] should consider this building as one of the main objects for which he visits Florence' – and all because of the Fra Angelicos, which have just been described in pages of rapturous prose.[68]

These pages occurred in the first of the celebrated guidebooks published by the firm of John Murray to be devoted to Italy. It was written by Sir Francis Palgrave, who in 1823 at the age of thirty-five, had renounced simultaneously his Jewish religion and his name of Cohen, and who, after many years of historical, literary, and antiquarian studies, was knighted in 1832. His *Handbook for Travellers in Northern Italy* was published anonymously ten years later, and, for the historian of taste, it must count as one of the most influential books ever written despite the fact that Palgrave himself was replaced for subsequent editions. It would be as exhausting as tedious to refer to all the travellers we know of who followed Palgrave's itinerary, echoed his language, and – occasionally – disagreed with his

236 Guido Reni (attributed to): *Portrait of a young girl* (formerly thought to be Beatrice Cenci). Galleria Nazionale d'Arte Antica, Palazzo Corsini, Rome

judgements. And those judgements were ruthlessly opposed to anything that Mariana Starke had ever ventured to suggest even in her most advanced moments: the fifteenth century was to be admired, and art following the death of Michelangelo was simply ignored (and not attacked with that ferocity so vehemently displayed by Ruskin a few years later). Essentially, Palgrave gave wide circulation to views that Bernard Berenson was still proclaiming more than a hundred years after the first publication of the *Handbook*.

He knew what he was doing: 'Since the death of Mrs. Starke, her popular work has, owing to the rapid change of circumstances, become in a measure antiquated for the districts before mentioned [Tuscany and Northern Italy].' Mrs Starke had died just four years earlier, and the only change of circumstances that had occurred was Palgrave's own contribution to, and awareness of, a new attitude to early (and late) Italian art: the ravishingly luminous frescoes by Pietro da Cortona in the Palazzo Pitti, and by Luca Giordano in the Palazzo Medici-Riccardi, which had enraptured Mariana Starke had not (fortunately) disappeared – but no place was found for them in the new guide. For Palgrave's intentions were firm: 'The principle of describing not what *may* be seen, but what *ought* to be seen, has been strictly followed by the author of the present work.' But despite the stern, almost schoolmasterly, tone of this warning, it is perhaps a relief to find that anecdotes and personal touches abound, for to end this discussion some reference must be made to the tone of voice adopted by nineteenth-century writers on the arts.

Indeed, although the word comes last, it should, perhaps, have been treated first, because there can be little doubt that the new language of art criticism which was developed in the nineteenth century played as significant a role in determining the direction of public taste as the sight of any original work or reproduction.

What we would now classify as non-aesthetic associations have, of course, always influenced what the public sees and admires, whether it be the miracle-working Madonnas of the Middle Ages or an attractive but second-rate portrait formerly attributed to Guido Reni[69] (Plate 236) which, in the first half of the nineteenth century, enjoyed a degree of adulation fully as genuine as that now accorded the *Mona Lisa*[70] – chiefly because of the

237 Leonardo da Vinci: *The Last Supper*. Copy by André Dutertre in chalks, tempera and wash. Ashmolean Museum, Oxford

(mistaken) belief that it represented the tragic Beatrice Cenci, executed in 1589 for having instigated the murder of her cruel, debauched, and incestuous father.

But I want to discuss something else which, though difficult to define, should become recognizable as soon as a few examples are given. The origins of a new tone of voice certainly derive from aesthetic theories that were worked out well before the second half of the eighteenth century, but only then is it first regularly applied to individual pictures, as distinguished from Art in general, classical statuary, and natural landscape. Basically, two factors are involved: the use of a very heightened emotional language and the practice of reading into works of art the interests and feelings of the spectator.[71] Whether used separately or in conjunction, both techniques had the effect of bringing a wide public into far closer contact with painting than had ever been the case before; and both resulted from the arrival on the artistic scene of writers – of fiction, of verse, of theology – who had hitherto been little interested in trying to interpret the visual arts.

In 1810, for instance, the Milanese painter Giuseppe Bossi wrote a long, elaborate, intelligent, and not very readable account of Leonardo's *Last Supper*, which can here be profitably illustrated in two reproductions because their juxtaposition throws light on problems which have been discussed earlier in this chapter, and because the question of recording this much damaged work has always been a matter of acute interest, and never more so than during the early years of the nineteenth century.[72] There is, first, the very

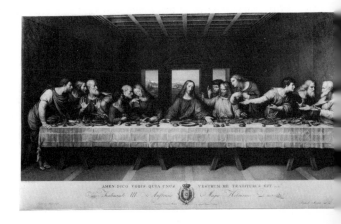

238 Leonardo da Vinci: *The Last Supper*. Engraving by Raphael Morghen

239 J. Ruisdael: *The Jewish Cemetery.*·
Gemäldegalerie, Dresden

careful drawing by André Dutertre (Plate 237), commissioned in 1789 by Louis XVI, but only completed five years later when the King had already been guillotined; and there is the engraving by Raphael Morghen published in 1800 after the fresco had suffered still further injury from the French troops who had recently invaded Italy, an engraving which was soon afterwards credited with having 'renovated the fame of Leonardo's work'[73] (Plate 238). Just seven years after Bossi's seminal monograph (which had followed his own copy, in oils, of the mural),[74] two great writers – Goethe and Stendhal – published magnificently evocative plagiarisms of it, acknowledged by the former, and concealed by the latter. Bossi had been among the first of many writers to give an overtly psychological interpretation of the actions and expressions of the different apostles, and Goethe developed this theme in his succinct and masterly essay.[75] But Stendhal, by seizing on one tiny phrase in Bossi's lengthy book, radically reinterpreted Leonardo's masterpiece in his infuriating, but enthralling, *History of Painting in Italy.* Leonardo, he writes, had to represent the affecting moment when Jesus – '*to consider him only as a young philosopher surrounded by his disciples on the eve of death*' [my italics] – tells them tenderly, 'Verily I say unto you, that one of you shall betray me', and he continues: 'So loving a soul must have been deeply touched, realizing that among the twelve friends whom he had chosen; with whom he was hiding to avoid persecution; whom he had wanted to reunite that day for a brotherly meal (as a symbol of the reunion of hearts and universal love which he wanted to establish on earth); that among these there should be a traitor who was to hand him over to his enemies for a sum of money.' Christ, in other words, has been humanized well before Renan's epoch-making biography, and Leonardo's mural represents friendship betrayed – a situation to be paralleled, in one form or another, in the lives of most people, and never more so than in the wake of Napoleon's rise and fall.[76]

Most of the great nineteenth-century writers are more rhetorical in their subjective interpretations of art; none more so, of course, than Ruskin, who, like Stendhal, but with infinitely greater perception and feeling, frequently uses the insights of other writers as the starting point for his own superlative evocations – evocations which, with their mixture of plangent tenderness and ruthless bullying, made the visual arts significant to a wide public in a way that had never been known before.

The subjective approach (and by using this word I do not mean to imply false or inadequate) could make pictures interesting in a quite new manner. Already before Goethe in 1816 wrote of Ruisdael's *Jewish Cemetery* (Plate 239), 'even the tombs in their ruined

condition point to the past beyond the past; they seem to be the tombs of themselves'[77] (a comment as rational as beautiful when applied to this particular picture), it had been suggested that it was of the very essence of Ruisdael's paintings to emanate a 'sweet melancholy' even when they showed subjects which carried no such tragic associations as the *Jewish Cemetery*. Instances can no doubt be traced earlier, but the first known to me in which Ruisdael is treated in this spirit occurs in one of a series of essays by the painter Jean-Joseph Taillasson,[78] which were published in book form in 1807 at the height of the Empire, two years before the death, at the age of sixty-three, of this impoverished survivor from the earlier, heroic days of neo-classicism.[79] I am glad that this should be the case because it allows me at least to mention a writer, whose own somewhat desiccated (but occasionally beautiful) paintings (Plate 240) would never suggest that he was one of the most perceptive – and certainly the most independent – art critics of the early nineteenth century; a man who, one feels again and again, could suddenly look at an Old Master with fresh eyes, and discard the prejudices of a century of theorizing and dogmatism; who could write defiantly of Rembrandt not only that 'we should be delighted that he did not leave Holland' to go to Italy, as most critics had regretted, but that 'he proves that nobility does not depend so much on [correctness of] form as on the feeling which gives life to form'.[80] Here indeed was a new approach, and this is confirmed by his comment that 'although today it may perhaps be a crime to talk of Watteau . . . our grateful grandchildren will one day restore his great reputation'.[81] Taillasson's essay on Watteau, in fact, constitutes the first significant criticism of the artist to appear since the articles written by his friends not long after his death – and it is far more subtle than most of these. In one sentence he opens up a whole new vista: 'He often brings to mind that pleasant philosophy . . . which . . . [makes us], with glass in hand, console ourselves, as best we may, for the brevity of life.' But at least another generation had to pass before the conviction developed that Watteau's paintings were melancholy.[82]

And by then melancholy was everywhere. Rio discovers it in the Madonnas of Botticelli (Plate 241) 'whose faces are nearly always veiled in sadness',[83] and indeed the real

240 Taillasson: *Spring*. Bowes Museum, Barnard Castle

241 Botticelli: *The Virgin and Child with Angels* ('*Madonna della Melagrana*') (detail). Uffizi, Florence

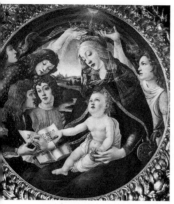

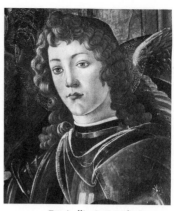

242 Botticelli: *Madonna of the Magnificat*. Uffizi, Florence

243 George Du Maurier: *Nincompoopiana*. From *Punch's Almanack for 1881*

244 Botticelli: *St Barnabas altarpiece* (detail). Uffizi, Florence

message conveyed by this enormously influential, extreme Catholic reactionary, so deeply indebted to German scholarship and aesthetics, is not so much the spirituality of early Italian art, which he so insistently maintains, as an almost *fin-de-siècle* withdrawal from active life, above all from the life of the town with its hideous corruption lying in wait on all sides – a withdrawal, ideally, into a landscape by Cima da Conegliano (Plate 248), 'where the colour is so fresh and alive, the water so transparent, the birds and the trees are treated with so much love'.[84]

Catholicism, in fact, probably plays a greater part in changing the tone than the content of the new emotional criticism: there is the young German W. H. Wackenroder who, though a Protestant himself, writes in 1797, under the pseudonym of a Catholic lay brother, 'art galleries should be temples where in calm and silent humility and in a solitude which elevates the heart we may admire great artists as the highest creatures among mortal beings';[85] there is the radical Ultramontane Lamennais, condemned by the Church for his excessively democratic opinions, and who indeed went so far as to ask the rhetorical question, 'Do you not see under the exterior form the appropriate inner life of each of the animals of Paul Potter (Plate 249)?'[86] And in this context we may surely be allowed to include the Oxford don Walter Pater who, as an undergraduate, had shocked a friend by exclaiming, 'What fun it would be to be ordained and not to believe a single word of what you are saying',[87] and eleven years later implied that this was much the same sort of dilemma that had faced the Virgin in Botticelli's *Madonna of the Magnificat* (Plate 242) with the difference that he now saw the situation as tragic: 'The young angels, glad to rouse her for a moment from her dejection, are eager to hold the inkhorn and support the book; but the pen almost drops from her hand, and the high cold words have no meaning for her'; – how many of Pater's aesthete disciples, toying with the idea of joining the Catholic church, brought up on novels and sermons about religious 'doubts', must have looked at the picture with a quite new intensity.[88]

In Toledo, a generation later, Maurice Barrès[89] (Plate 251), whose violent, authoritarian Catholicism never altogether suppressed the egoism and sadistically inclined aestheticism of his earliest youth, disposed in a few phrases of earlier ideas about El Greco: ' "Madness," says the sacristan', as on his first day in the city they looked together at El Greco's *Burial of the Count of Orgaz* (Plate 250), 'and many connoisseurs may echo his words. But I, from the

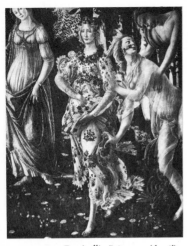

245 Botticelli: *Primavera* (detail). Uffizi, Florence

246 Beardsley: *Sandro Botticelli.* Reproduced by Vallance

247 Beardsley: *Hermaphroditus.* Reproduced in *The Early Work of Aubrey Beardsley*

very first moment, felt myself in contact with a strange and powerful soul,' and as he examines the later works (Plate 253), the fascination grows. Gradually, El Greco is enrolled into that select band of artists and writers, so prominent at the end of the nineteenth century, whose convictions, whose creative powers, and whose frequent perversities of style, made of them, in their own eyes, more authentic Catholics than was the Pope himself. Barrès was determined to point out that El Greco was not a 'romantic' painter of the type that would be familiar to his readers. Nor was it any use complaining, he pointed out of the *Burial*, that the heavenly scene above the mourners detracted from the painting as a serious work of art: that would be the equivalent of saying, 'I would like Joan of Arc, if it were not for her voices!' The apparently irrational is the essential element of the picture. It is no use complaining, either, that the Heaven promised to us by El Greco is cold and

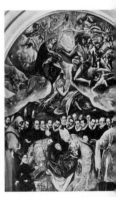

248 Cima da Conegliano: *St Jerome in a landscape*. National Gallery, London

249 Potter: *Cows in a meadow*. Rijksmuseum, Amsterdam

250 El Greco: *The Burial of the Count of Orgaz*. S. Tomé, Toledo

spectral, and that once there we will turn into larvae instead of splendid butterflies. That is its point. El Greco rejects the means of physical seduction and takes us to a place where we are freed of the pleasures of the senses. 'People have said he is mad. *Attention*, he is just a Spanish Catholic!'

I must run the risk of repetition and emphasize yet again that I am not, at this stage, discussing the phenomenon of 'rediscovery' as such. Long before the appearance in 1911 of Barrès' sensationally named *Greco, or The Secret of Toledo*, the Spanish art historian Manuel Cossío had begun his studies on the artist which were to lead to the first fundamental monograph – and Barrès himself took most of his raw material from this.[90] I am, rather, trying to explain the acceptance, by what we may call the general aesthetic consciousness, of artists who were not widely familiar – or who were too familiar through the constant repetition of old stereotypes. In this context the part played by the poet, the novelist, or the dilettante could be fundamental. But it could also be erratic and irresponsible.

'Before a Botticelli I am mute,' says young Prigsby in Du Maurier's caricature as early as 1881 (Plate 243).[91] But almost no one else was. How often in the 1890s do we come across a 'decadent' Botticelli, whose 'dangerous angels sometimes opened the door on to blameable territory' (Plate 244),[92] or whose nymph in the *Primavera* (Plate 245) 'with her vampire face – for she is a vampire and perhaps worse – kept [us] in a state of anguish, fever, and frenzy through the ambiguity of her sex'?[93] In his extreme youth Aubrey Beardsley once told a friend that every artist reveals his own personality in all his works; inevitably – given the climate of the time – he was challenged to draw an imaginary portrait of Botticelli based on his interpretation of the pictures;[94] equally inevitably the resulting head (Plate 246) is barely distinguishable from that of his drawing of *Hermaphroditus* (Plate 247). And even when this phase had passed, we find a critic in 1913 calling on the example of Botticelli to rescue modern painters from the materialism of the Impressionists.[95]

As a historian of his reputation had already pointed out well before this, Botticelli had

251 Zuloaga: *Portrait of Maurice Barrès with Toledo in the background*. Musée Historique Lorrain, Nancy

252 Bartolommeo Veneto: *Portrait of a woman*. Städelsches Kunstinstitut, Frankfurt

not only been rediscovered; he had been recreated: 'Is it really possible that he was so very like us?'[96] And John Addington Symonds put the point neatly enough when he shocked the young Roger Fry by saying, 'of course we are all very thankful to Botticelli for having inspired those fine pages of Walter Pater'.[97]

In other cases a virtually unknown artist could, through the charged descriptions of an author of genius, be given a few years at least of hectic celebrity. In 1903, yet another French Catholic novelist, Huysmans, found himself in Frankfort, disgusted above all by the Jews, who were more offensive than Jews elsewhere just because they did not have the decency to look like Jews.[98] To escape contamination he went to the picture gallery, where he was consoled by an early Flemish *Madonna and Child*, 'so tenderly sad that one can attribute to her every kind of anguish, every kind of apprehension' – including, as Huysmans emphasizes, the anguish of being surrounded by so many Jews. But there too was an anonymous courtesan picture (Plate 252) of a type by no means unfamiliar in early sixteenth-century Venetian painting. For Huysmans, however, she 'sums up in her own person all the ferocity, all the luxury, all the sacrilege of the Renaissance. . . . She is sibyl and witch, prostitute and dancer,' and so on. It would be interesting to see the statistics of the number of visitors to the Frankfort museum over the subsequent few years, but meanwhile we need only record that although 'Bartolommeo Veneto' can be shown to have painted many fine pictures, Huysmans' 'rediscovery' of him has not really outlived the ambience in which it was made.

By the 1880s the credit for having 'rediscovered' an Old Master was as keenly sought as the foresight for having launched a new one: Edmond de Goncourt, a great master of the new language of art criticism which has been discussed in earlier pages, claimed (falsely) to have 'rediscovered' the eighteenth century; Champfleury, more justifiably (and more repetitively) claimed to have 'rediscovered' Le Nain, and he and Thoré dedicated monographs to each other; if we are to believe Ruskin – and in this case we should not[99] – early Italian art and Tintoretto had been ignored until he began to write about them; even the diffident Pater was anxious to point out that 'a large part of my Renaissance studies had previously appeared in Reviews or Magazines, among others that on Botticelli, which I believe to be the first notice in English on that old painter. It preceded Mr. Ruskin's lectures on the subject by I believe two years.'[100]

The old hierarchies had been irrevocably subverted. By a happy coincidence it was in the very last year of the nineteenth century that a critic was moved to write in the *Art-Journal*, 'We of the present day are somewhat apt to speak with a want of due respect of the art criticism of a not very distant past which held high in esteem the work of artists whom we now pass over with as much indifference as, but a few years since, were treated the creations of those earlier schools we now revere. At the same time while there is little likelihood of a near future setting aside the general judgement of modern criticism on the art of the past, it behoves us not to display anything approaching the temper of our fathers, as we too may be tempted into committing as many errors as they, in overlooking merit which a more broadminded catholicity of taste should place in a category apart from classified schools and epochs.'[101]

How easy it is to proclaim general principles, how difficult to face concrete realities! This critic was fighting what he (and, probably, what the readers of the *Art-Journal*) must have thought of as a daring and gallant battle on behalf of Giovanni Battista Tiepolo – nearly thirty years after the Metropolitan Museum in New York had bought the first of

253 El Greco:
 Pentecost.
 Prado, Madrid

254 Bouguereau: *The Proposal*.
 Metropolitan Museum
 of Art, New York

255 Gérôme: *Pygmalion and Galatea*.
 Metropolitan Museum
 of Art, New York

its many superb works by the artist.[102] Yet could he even remotely have anticipated our current preoccupation with Caravaggio, let alone with the minor followers of Caravaggio?[103]

But though we too find it easy enough to accept the theory, and more troubling to face the fact, as early as 1884 at least one French critic had acknowledged that, given the right circumstances, artists such as Ary Scheffer, Paul Delaroche, Léon Cogniet, and Camille Roqueplan, who had then fallen into total oblivion, would once again be appreciated.[104]

It will not have escaped anyone's attention that, nearly a century later, this is exactly what is happening, and that we are at present in the early stages of a 'rediscovery' fully as far-reaching as any that I have discussed in the course of this book. Indeed, this book itself has been actively stimulated at every point by what I have been able to observe of the reinterpretation of so-called (and, often, wrongly so-called) Academic or Official art of the nineteenth century in England and in France. I have, I hope, been able to benefit by comparing the past with the present: the roles played by dealers, private collectors, exhibitions, and museums, both in the United States and in Europe; the element of snobbery and 'camp'; the growing number of specialized studies – and barely a week goes by without students proposing subjects for research which less than ten years ago would have been dismissed as frivolous, involving as they do the investigation of artists who were then treated with ignorant contempt; the rise in prices; the claims that contemporary painters have played a vital role in the whole process; the half-blind groping as we try to sort out the 'good' from the 'bad' academics – is Couture, perhaps, the Ghirlandaio or Perugino of the nineteenth century, and who is the 'Francesco da Imola'?; even the political connotations: a recent letter to the *New York Times* from the leading historian of 'academic art' pointed out, 'the present generation . . . desires to explore our common assumptions about academic art, just as it wishes to question the policies emanating from government and the university'.[105] Such an attitude should cause less surprise to those who have

observed 'left-wing' support for Boucher and Fragonard in the years preceding 1848.

And there has been the opposition. Even while writing this book, I have come across an article by one of the world's leading authorities on Impressionism which strongly attacks the Metropolitan Museum for exhibiting 'Rosa Bonheur's highly expendable *Horse Fair*, a majestic exercise in futile dexterity. Together with Bastien-Lepage's kitschy *Joan of Arc*, Pierre Cot's titillating *Storm*, Bouguereau's insipid *Proposal* (Plate 254), and not one but two insufferable Géromes (Plate 255) . . . paintings which should be preserved [in the store rooms] as evidence of the bad taste of a bygone era and of the cynicism of our days which treats them as though they were works of art'[106] – the sentiment, almost the very words themselves, will be familiar to readers of this book. So too will this passage from an article written by a French critic which appeared at much the same time: 'It is no coincidence' – that handy and tendentious phrase – 'that one of the first to realize the possibilities offered by Pop Art was also one of the ablest students of neo-classicism. . . . Today, the dams are down. In the Metropolitan Museum, Gérome hangs beside Corot, and Regnault next to Courbet. Bouguereau is exhibited more often than Degas. Regarded as comic foils only a few years ago, the Salon artists are now hailed as brethren, theses are being written about them. Tomorrow the Louvre will be theirs. The "Age of Neo-Classicism" is part – an especially splendid one – of what might be called Academia's revenge.'[107]

It is always easier to study the past than the present, and while sharing in the justified excitement that must accompany any investigation of nineteenth-century painting – that territory which is as unexplored in our own day as was the art of the Middle Ages or the Rococo to any but the expert some century and a half ago – I must confess to a considerable degree of unease at the implications of the problems I have been discussing.

This book is intended to be a footnote to history and not to aesthetic theory, but it would be absurd to claim that the two can be compartmentalized so easily. It is surely the case that history itself can – at certain moments – only be understood at the price of a certain abdication of those value judgements which art lovers (rightly) esteem so highly. And although it is possible to avoid the quicksands of total aesthetic relativism by postulating that widening horizons and deeper knowledge will eventually lead to the creation of new and more soundly based standards, it is none the less true that every convincing rediscovery has – to use a repugnant but self-explanatory expression – involved the acquittal of many 'guilty' artists in order to free the few candidates who are worthy of serious reconsideration. Whose heart has not sunk at the sight of walls hung with depressing rows of battered 'primitives' chosen with – so it seems to the modern eye – a depressing lack of discrimination? Our reappraisal of the nineteenth century is now proceeding with such speed (and such happy results) that it becomes increasingly difficult – and increasingly meaningless – to apply to it conventional expressions of admiration or distaste based on criteria which already seem out-dated. It would not, in any case, surprise me if the illustration with which I began this book in order to demonstrate a moment in the History of Taste (Plate 2) were, before very long, to be considered, in the words of a critic writing about it in 1841, as an example of 'a masterly work which is by no means inferior to the prototypes left to us by Italy'.[108]

Notes

Introduction

1 Farington, II, p. 180: 8 January 1804. Mr Howard Colvin has pointed out to me that the king was referring to James Wyatt's 'Gothic or Castellated Palace', which was begun in 1801, left unfinished in 1811, and pulled down in 1827–8; see Colvin, vol. VI, pp. 356–7.

2 Rosenthal, 1897, pp. 19–20.

3 Story, I, p. 296. Linnell's portrait of Peel is now in the National Portrait Gallery, London.

4 Buchanan, I, p. 102.

5 See Schneider.

6 Evidence of Richard Ford to the National Gallery Select Committee, 1852–3, para. 3941. Ford was evidently confusing the non-existent Francesco with Innocenzo (Francucci) da Imola, the Raphaelesque painter, interest in whom had been stimulated by three lectures read to the Academy in Bologna by Pietro Giordani in 1812.

7 For the most remarkable study yet made of

changing attitudes to one architectural style (the Gothic), see Frankl.

8 For the controversy over the authenticity and importance of the Elgin Marbles, see the *Report from the Select Committee . . . on the Earl of Elgin's Collection . . . 1816.*

9 Quoted by Schneider, p. 230.

10 Shee, 1809, pp. 119–20.

11 For a very interesting discussion of changing attitudes to the *Apollo Belvedere,* see the (unpublished) Oxford D.Phil thesis by Dr Jon Whiteley, 'The Revival in Painting of Themes inspired by Antiquity in Mid-Nineteenth Century France', 1972, pp. 75 ff. I am very grateful to Dr Whiteley for allowing me to make use of this thesis.

12 Viollet-le-Duc, p. 135.

13 Henry James, I, pp. 10, 96, and 125.

Chapter One

1 *Art-Union*, 1 January 1842, p. 9.

2 Baudelaire: Salon de 1846 – *Oeuvres*, p. 894.

3 *Art-Union*, 1 January 1842, p. 9.

4 Charles Blanc: *Ecole Française*, III (Delaroche); H. Lemonnier. I am most grateful to Mr Norman Ziff for his generous help in answering my many queries concerning Delaroche.

5 Another extremely famous painting of this kind, but with a far more committed Catholic programme, was Friedrich Overbeck's *Triumph of Religion in the Arts* (Städelsches Kunstinstitut, Frankfurt, Plate 8), begun in 1833, four years before Delaroche started work on his mural. Unlike

Delaroche's painting, Overbeck's highly tendentious treatment of his theme aroused controversy concerning the artists selected – see Andrews, pp. 68–9 and 126–7 with illustrations and bibliography. Delaroche was himself responsive to the early Italian art which inspired Overbeck and the Nazarenes – see Halévy.

6 See especially Vitry, who gives a dated list of the busts of artists commissioned for the Louvre.

7 *Art-Union*, 1 January 1842, p. 9.

8 Vitet, 1841, p. 568.

9 See, as one example among many, the (generally hostile) discussion by Etienne Huard in the *Journal*

des Artistes, 1841, pp. 353–61. He suggests that the figure of Fra Angelico was inspired by a Zurbarán monk.

10 Royal Archives, Windsor, quoted by the gracious permission of Her Majesty the Queen: RA Vic. Add. H 2, p. 491. Short histories of the monument are given in the *Handbook* and by P. A. Bezodis. I hope to publish a long account in the near future.

11 *Art-Journal*, 1854, p. 187 and 1856, p. 8.

12 I deduce this from an inspection of the very complete records concerning the construction of the Albert Memorial in the Royal Archives at Windsor. Mr Bezodis, to whose help I am much indebted, has reinforced my impression that 'negative evidence' supports the view that Armstead himself must have chosen the names of the painters represented. Certainly this assumption was made at the time. In commenting on the podium of the Musicians, the *Art-Journal*, 1874, p. 88 noted that 'it must have cost the sculptor no little research into the annals of music, especially those of a long time past, to trace out the men most worthy of being commemorated in his work.' The *Handbook* is silent on the subject, but in discussing the recently deceased Sir Charles Eastlake, it mentions that 'his services, in making the preliminary arrangements with the different sculptors and other artists, were most invaluable to the Executive Committee'.
Many years ago Steegman had already pointed out that 'for a contemporary evaluation [of the Prince's activities in the artistic field], the bas-reliefs on the Albert Memorial contain several buried clues' (1950, p. 318). Unfortunately they remain very buried.

13 Royal Archives, Windsor, quoted by the gracious permission of Her Majesty the Queen: RA Vic. Add. H 2, pp. 354, 945, 1266, 1270, 1433.

14 Armstead's scrap books concerning the Albert Memorial are in the Library of the Royal Academy, London. I am much indebted to the librarian for allowing me to inspect these.

15 See an article on the subject by Haskell to be published in the *Revue de l'Art* during the course of 1975.

16 Barry, 1783, pp. 161 ff., with a very combative and interesting discussion concerning his choice of artists. It should be noted that Barry's print after his mural does not give a faithful reproduction of all the details.

17 With which it was frequently compared – see *Kensington News*, 9 July 1870; *The Times*, 2 July 1872; *Saturday Review*, 3 January 1874, etc.

18 The *Builder*, 27 July 1872, was particularly enthusiastic about Armstead's contribution to the podium, but it criticized the absence of Soane, Schinkel, Perrault and others from the list of architects portrayed: these, together with the Sculptors, were the work of J. B. Philip.

18a Boyer d'Agen, pp. 99–100.

19 Eastlake, 1870, p. 52 and p. 118.

20 Lady Eastlake, II, p. 90.

21 Walpole, p. xxiv.

22 Ruskin, 1972, p. 140 (9 July 1845).

23 An early and vigorous advocate of the practice was William Blake. His habit of 'knocking down and putting up' is to be found in many of his writings, but nowhere more succinctly than in the unique surviving copy of an advertisement leaf for the *Descriptive Catalogue* of his well-known exhibition of 1809: 'In this Exhibition will be seen real Art, as it was left us by Raphael and Albert Durer, Michel Angelo, and Julio Romano; stripped from the Ignorances of Rubens and Rembrandt, Titian and Correggio' (reproduced by Keynes, p. 69).

24 C. R. Leslie says that after a lecture by Constable in 1836 denouncing 'Both and Berghem, who, by an incongruous mixture of Dutch and Italian taste, produced a bastard style of landscape, destitute of the real excellence of either', one of the audience, a gentleman possessing a fine collection of pictures, said to him 'I suppose I had better sell my Berghems', to which Constable replied, 'No sir, that would only continue the mischief. *Burn them*.' (Referred to in Constable, p. 56.)

25 The history of Giorgione's *Tempesta* is as difficult to reconstruct as its iconography, but as it is of the greatest interest to the student of taste it is worth investigating here in as much detail as possible. As is well known Michiel (the so-called *Anonimo Morelliano*) describes it in the Vendramin collection in 1530; thereafter (except for one brief confirming reference in 1569) it is totally forgotten for centuries.
In 1817 Byron wrote some rapturous stanzas in *Beppo* (xii–xiv) about a painting attributed to Giorgione in the famous Manfrin collection in

Venice, of which the only lines directly relevant here are:

'Tis but a portrait of his Son, and Wife,
And self; but *such* a Woman! Love in life!

Thereafter, a picture known as the *Family of Giorgione* was duly enthused over by every tourist to the city. But what was this picture? In an extremely ingenious footnote (to a rather weird article) Calvesi demonstrates two things: (i) that, however enthusiastic, such tourists were extraordinarily vague when describing what they saw – which would be odd were they looking at so idiosyncratic a composition as the *Tempesta*; (ii) that the one visitor, before Burckhardt in 1855, who does discuss, with a bare minimum of detail, the *Family of Giorgione* does so in terms which make its identification with the *Tempesta* wholly impossible. On the other hand, Burckhardt's own equally brief description in the first edition of his *Cicerone* ('a real genre painting, a youthful picture with a fine landscape') does very strongly indicate that he was referring to the *Tempesta*. Therefore, concludes Calvesi, there were *two* pictures known as the *Family*, of which the 'real one' seen by Byron and others before Burckhardt, was disposed of some time in the late 1840s or early 1850s (when the collection was indeed being partly dispersed) to be replaced by the *Tempesta*, acquired from some unknown source and promptly christened the *Family of Giorgione* so as not to disappoint lovers of Byron.

The theory has one considerable merit: there certainly were two very different pictures called the *Family of Giorgione*, and the Manfrin servants were probably on the casual side as to which one they decided to tell visitors was the famous picture they had come to see. But, as Calvesi could not know, at least for a time (and probably since the end of the eighteenth century) they were both in the collection together. One of the pictures, almost certainly the one admired by Byron and most tourists, is a *Triple Portrait* (Plate 22), now at Alnwick and attributed in most recent literature to a follower of Titian (for its purchase by the fourth Duke of Northumberland, probably in 1856, as the *Family of Giorgione*, see Murray's *Handbook* . . . 1864, p. 204). The other was the *Tempesta*, which only left the Manfrin collection in 1875.

We know that the two pictures hung in different rooms in the Palazzo in 1851 from a manuscript inventory of that year, now in the library of the National Gallery in London: in the 'Stanza Segnata B' is no. 28 – Giorgione: *Tre mezze figure* [i.e. the Alnwick picture] valued at 2,500

napoleons; in the 'Stanza Segnata E' is no. 17 – Giorgione: Sua Famiglia [i.e. the *Tempesta*] valued at only a hundred napoleons! Moreover, this is confirmed by an unpublished letter in the same library from Edward Cheney, dated 7 May 1851, which appears to refer both to a *A portrait by Giorgione* (*celebrated in Beppo*) *of a woman and child – very beautiful* [presumably the *Tempesta*] and to *the three heads by Giorgione* [presumably the Alnwick picture], which latter he recommended the National Gallery to buy.

I am very grateful for the help of Miss Pamela Eyres, the librarian, and of Mr Michael Levey, the director, in my consultation of these documents in the National Gallery which, although they do not solve all the problems concerned (when and where did Manfrin buy either picture?), do prove beyond doubt that the *Triple Portrait* was far more highly esteemed than the *Tempesta* – which is surely the reason why the Duke of Northumberland acquired it. To make matters more confused it may be added that entirely different pictures bearing the name the *Family of Giorgione* sometimes turn up in other nineteenth-century collections.

For changing conceptions of another painting by Giorgione, see Haskell, 1971.

26 [Roger de Piles], p. 80. Damon, in this dialogue, is presumably referring to De Piles' own championship of Rubens. The general attitude (though not, of course, the specific instance) should be compared to that of Félibien writing in 1666 (*Entretiens*, 1705, I, p. 129): 'Afin de ne vous pas ennuyer en m'arrestant à plusieurs Peintres Italiens dont les ouvrages ne se voyent plus, et qui mesme ont esté comme effacez par ceux qui ont paru depuis, je vous diray peu de chose . . . de Philippe Lippi' – quoted by Teyssèdre, p. 56.

27 Le Brun: *Galerie*, I; Discours Préliminaire, p. iii: 'C'est sur ces derniers que je veux parler, c'est de ces hommes qui, restés inconnus de leur vivant, et même après leur mort, ont besoin, pour reprendre la place qu'ils auraient dû occuper parmi leurs rivaux et leurs contemporains, que leurs tableaux n'échappent point aux regards d'un curieux empressé de les chercher, et capable de les apprécier.

'Plusieurs peintres ont été *découverts* ainsi: que l'on me passe cette expression.'

28 By far the fullest account of Le Brun's career is that by Emile-Mâle, who refers to much of the earlier literature devoted to him. See also A. P. de Mirimonde, 1956.

29 Le Brun: *Catalogue d'objets rares et curieux . . .* [Lugt 7152].

30 *ibid.* The comparison between Chardin and Rembrandt was made at various times during the 1750s and 1760s – for examples see Wildenstein, 1933, pp. 87–8 and 122. It must, of course, be remembered that the name of Rembrandt did not then carry the same implications as it was to later.

31 Vigée-Lebrun, *Lettre IV*; for an equally hostile account see Mme Ancelot, p. 22.

32 See Gallet.

33 See the interesting letter of thanks written to him by Greuze on behalf of the painters of Paris published in *Nouvelles Archives de l'Art Français*, 1874–5, p. 435.

34 His *Almanach historique et raisonné . . .* of 1776 represents his first venture into the field of criticism. Some years ago M. André Jammes (to whom I am much indebted) showed me a copy of the Salon catalogue for the year 1800 annotated 'par moy Le Brun commissaire [du musée?]' Le Brun found Meynier's *Telemachus leaving the Island of Calypso* 'le meilleur tableau du Sallon', but on the whole his sympathies (very briefly expressed – 'bien', 'charmant', 'deliscieux', etc.) appear to have been given to painters of genre subjects.

35 See the many references to Le Brun in the collection of documents about David assembled by Daniel and Guy Wildenstein.

36 Sensier, pp. 15–17. Michel's widow joined the general chorus of denunciation of Le Brun, claiming that her husband had hated him 'quoiqu'il fût souvent forcé d'être son compagnon de plaisirs.'

37 See *Magasin Encyclopédique*, 1803, I, pp. 543–6.

38 See *Bulletin de la Société de l'Histoire de l'Art Français*, 1941–4, p. 105.

39 See his letter of 24 September 1800 published in *Nouvelles Archives de l'Art Français*, 1872, pp. 431–7. The history painters he named were: David, Menageot, Gérard, Vincent, Girodet, Prud'hon, Regnault, Carle Vernet, Meynier, Guillon Lethière. To these he added, on his own initiative, Fabre, Guérin, and Gauffier.

40 See Le Brun: *Précis historique . . .*

41 See Gould, 1965, pp. 25–6 and Le Brun's own many pamphlets, letters, etc., recorded by Emile-Mâle.

42 See Lapauze, 1903, pp. 367–8; 8 Nivos lan 3eme (28 December 1794).

43 See Lapauze, 1903, p. 273 – 13 germinal l'an II (2 April 1794).

44 In an undated letter to the 'Général Premier Consul', published by Vauthier, pp. 342–3, who says that elsewhere Le Brun, 'homme à la conscience large', referred to twenty-three journeys outside France.

45 M. *** [Le Boeuf]. *Catalogue raisonné . . . 8 Avril 1783* [Lugt 3550].

46 In a later publication, which appeared after Napoleon had proclaimed himself Emperor, Le Brun once more changed his mind about the effects of royalty on artists, and referred with enthusiasm to the roles of Pericles, Leo X, François I, Louis XIV, and – above all – 'Napoléon le Grand, qui déjà offre, lui seul, plus d'artistes habiles que L'on en a vu sous plusieurs règnes' – Le Brun: *Choix des Tableaux*, Paris 1810, Discours Préliminaire, pp. ix–x.

47 Le Brun: *Galerie . . .*, II, p. 49.

48 Le Brun: *Choix des Tableaux*, Paris 1810, Discours Préliminaire, p. vi.

49 These inadequacies are reported by Frédéric Quilliet, a somewhat unscrupulous adventurer, who acted as Le Brun's accomplice in Spain – see Rouchès, 1930 and 1931.

50 See the interesting account of Le Brun in Lipschutz, who gives ample coverage to such publications.

51 Le Brun: *Choix des Tableaux*, Paris 1810, p. 22.

52 See, for instance, Previtali, and Pevsner and Lang.

53 Why Le Brun should have attributed the work of Sebastian Vrancx (Plate 43), a seventeenth-century Flemish artist of the very kind with which he was most familiar, to Van der Weyden remains a mystery for us – but was surely not for him.

54 Le Brun: *Galerie*, I, p. 4.

55 Le Brun: *Choix des Tableaux*, Paris 1810, p. 24.

56 In his monograph on Vermeer (see chapter IV), Thoré noted a few comments in early nineteenth-century sale catalogues, and added a fully justified '(*sic!*)' to the claim by the dealer Paillet in the Van Leyden sale catalogue of 1804 [Lugt 6852] that 'les amateurs doivent se contenter aujourd'hui de

quelques portraits d'artistes de la main de cet auteur, dont les productions ont toujours été regardées comme classiques'. This was in reference to the *Concert* now in the Gardner Museum, Boston. A more interesting and puzzling allusion to a supposed Vermeer, which seems to have escaped attention, concerns a picture which passed through a Paris sale on 25 January 1802 [Lugt 6352], also conducted by Paillet. The provenance is not indicated, but the description of the painting (no. 106) corresponds very closely indeed to the *Mistress and Maid* in the Frick Collection, New York, except that the composition is reversed, the colour of the cloth on the table is green rather than blue, and that a mirror is included among the

objects on the table. Nor are the measurements identical. Paillet specifically refers to Le Brun's praise of Vermeer.

57 Le Brun: *Recueil de gravures au trait*, II, p. 87.

58 Meltzoff, 1942, p. 150.

59 See Buchanan, II, p. 305. Le Brun's name turns up quite frequently in the memoirs of the period. Mme de Souza, for instance, seems to have relied on his opinions about contemporary pictures and Old Masters, and wrote to the Countess of Albany that Le Brun considered that Fabre's portrait of the Countess was 'painted by an angel' – see Pélissier, pp. 148 and 160.

Chapter Two

1 Reprinted in Schlegel, vol. IV. See also the English version by E. J. Millington, itself an interesting document of nineteenth-century taste.

2 Goethe, 1970, p. 72.

3 Apart from Perugino, who (as the master of Raphael) had always remained something of an exception in the general neglect of early Italian painters, very few 'primitives' were exhibited in the Louvre before July 1814 (when Napoleon had already abdicated for the first time) – see Blumer. Mantegna's *Madonna della Vittoria* (which was closely associated with French history) was removed to Paris from Mantua in 1797, as also was his altarpiece for S. Zeno from Verona. Van Eycks and Memlings (and a Gerard David) were plundered from Flanders and (later) from Danzig. Indeed, during most of the Empire, Northern 'primitives' would have been more prominent in the Musée Napoléon than their Italian counterparts.

4 For the reappraisal of early Northern art, see Sulzberger 1961.

5 For the first, and by far the most vivid, account of the dispersal of the Orleans collection, see Buchanan, I, pp. 1–216.

6 Mary Berry, II, p. 87.

7 James Barry described the pictures (*Works*, II, pp. 61–140) but without conveying any feeling that the event in itself was an extraordinary one.

8 See Hazlitt, 'On the Pleasures of Painting' in *Works*, vol. VIII, p. 14.

9 Farington, II, p. 130: 8 August 1803: 'His Majesty talked abt Patronage and the state of the Arts in this country, – and sarcastically abt Noblemen being picture dealers', and see also an article in the *Annals of the Fine Arts for 1817*, London 1818, p. 203, which quotes the King as having said, 'I know not how it is, but I never sent a *gentleman* in a public capacity to Italy, but he came back a *picture-dealer*'. The *Annals* returns constantly to this theme. Among English 'gentleman dealers' of the period should be included Arthur Champernowne, the Reverend Holwell Carr, Sir Simon Clarke, George Hibbert, Sir Gregory Page Turner – and there were many more.

10 The most extraordinary of these dealers was the minor artist Bonnemaison, some of whose activities in these years can be tracked down in Penrice, pp. 15 ff. His zeal as a restorer for the Musée Napoléon is said to have shocked David among many others (Passavant, I, p. 174), and he later enjoyed a highly successful career as keeper of the Duchesse de Berry's pictures (Angrand, pp. 157–9). He was a nephew of the well-known harp maker Sebastien Erard, who also dealt very extensively in pictures and moved between Paris and London, though I have only found evidence that he did so during the short-lived Peace of Amiens in 1802–3. Erard's son-in-law was Alexis Delahante, an extremely well-known dealer in England, a friend of Lawrence and of many other

prominent figures; but of all this dynasty he alone seems to have been an exile during the Napoleonic period and not to have returned to France until the Restoration (see Penrice, p. 28, and also Whitley, 1928). In 1810 Le Brun managed to sell to English dealers and collectors many of the pictures he had acquired in Italy and Spain (Buchanan, II, p. 251), and other examples could be given of such transactions at the height of the wars.

11 See Roehn, pp. 98–100, and his obituary in *L'Artiste*, 1834 (2), Iᵉʳᵉ série, tome 8, p. 296, and Neil MacLaren, 1960, p. 309. Le Brun, who says that the price for which the picture sold in London was £4,000, was quick to point out (1810, p. 57) that 'ce prix ne doit pas être regardé comme une base, mais une fantaisie'.

12 These letters, addressed to his partner Mr Stewart, are in the National Library of Scotland, Edinburgh, and I am extremely grateful to Mr Hugh Brigstocke, who is at present preparing them for publication, for drawing my attention to them. As this edition has not yet appeared, in future notes I refer to them as Buchanan: *Letters*. For Buchanan, see – as well as his own book and these letters – the obituary in the *Art-Journal*, 1864, pp. 131–2, Herrmann 1972, and Colin Clark.

13 Buchanan, II, pp. 86–7.

14 Buchanan: *Letters*, 11 June 1802.

15 See Dictionary of National Biography.

16 Farington, II, p. 72: 13 January 1803.

17 Rev. E. D. Clarke, pp. 99–100.

18 As can be seen from his interesting notes on his own collection in the library of the Victoria and Albert Museum, London, Reserve V 19. See also Waagen, 1838, II, pp. 201–7.

19 A large number of the Buchanan letters are concerned with the seventh Earl of Wemyss (1723–1808) – see especially those of 23 December 1803, 22 February 1804, 5 and 19 March 1804, 4 May 1804. For a more up-to-date and more balanced view of his collecting see [Wemyss], and Carritt.

20 Buchanan: *Letters*, 27 January 1804.

21 Buchanan: *Letters*, 9 February 1803.

22 Buchanan: *Letters*, 26 May 1802.

23 Buchanan: *Letters*, 2 February 1804.

24 Buchanan: *Letters*, 11 February 1804.

25 Buchanan: *Letters*, 24 February 1804.

26 For one instance, see Buchanan: *Letters*, 31 January 1804: 'You know West has a good deal to say either for or against pictures of *high value*, as the Poussin, or Parmigianino, when they come into the market – the only way I am convinced of obtaining *his* interest is by bribery and corruption, but this must be done in a very delicate way.'

27 Buchanan: *Letters*, 24 February 1804: 'When you see Cosway you may say I had got a Drawing I mentioned to him long ago by Rubens, which I shall send him by the first opportunity. You may likewise say that I am no Collector of Drawings myself, which may be an apology for giving it him so readily.'

28 Buchanan: *Letters*, 8 May 1804.

29 Buchanan, II, p. 9.

30 A very brief list of a few of the most prominent artistic advisers of the day – themselves often significant collectors – and their clients will indicate how important was their role in the formation of contemporary taste: Sir Thomas Lawrence, R.A. (John Julius Angerstein), Richard Cosway, R.A. (Marquis of Stafford), Henry Tresham, R.A. (William Beckford and Sir Richard Worsley), Henry Walton, R.A. (Lord Fitzwilliam). The tradition was, of course, a very old one, and in the previous generation Sir Joshua Reynolds had acted in a similar capacity for the Duke of Rutland, and Jacob More for Lord Abercorn.

31 Levey, p. 298.

32 By far the best known of these was the Liverpool historian of the Medici, William Roscoe (1753–1831), who played an active part in English public and cultural life – for his collecting of 'primitives' see Michael Compton, who also discusses others interested in the field at this time. Although Roscoe acquired some outstanding masterpieces, notably Simone Martini's *Child Christ discovered by his Parents in the Temple* and Ercole Roberti's *Pietà* (both in the Walker Art Gallery, Liverpool) he himself never went to Italy and his interest in early pictures was a purely historical one.

33 The Camuccini collection was bought in 1856, twelve years after the artist's death, by the fourth Duke of Northumberland, and – along with many of the pictures themselves – there remains at Alnwick a complete manuscript inventory. Apart from the *Feast of the Gods* now in Washington, the

most famous picture to attract early nineteenth-century visitors was Claude's *Seaport* (Röthlisberger, I, p. 124), which is still at Alnwick – see, for instance, A. Constantin, pp. 237–9. This picture was bought from the Barberini collection in 1798; a year earlier Camuccini and his brother had, in partnership with the English dealer Alexander Day, bought the *Feast of the Gods* and Titian's *Bacchus and Ariadne* in London (see Gould, 1959, p. 104 and Walker, pp. 78–9). A letter from James Irvine to Buchanan of 22 December 1804 (Buchanan, II, p. 159) makes it clear that at that date Camuccini was still closely associated with English dealers, though he had quarrelled with Sir Simon Clarke. In 1826 the papal administration investigated the Camuccini collection in order to draw up a list of the pictures for which an export licence should be refused (Beaucamp, II, p. 567). Camuccini seems to have allowed fairly easy access to the collection (Constantin *cit.*), but to have disliked copies being made of the pictures (Malins, p. 94). Though he is said to have tried to persuade the Pope to buy the collection as a whole (Falconieri, p. 282), he clearly remained very much a *marchand-amateur*, and an obituary in the *Bulletin de l'Alliance des Arts* (1844–5, tome III, p. 107) claims that 'il vendait beaucoup de vieux tableaux, qu'il restaurait et *droguait* avec infiniment d'adresse'.

34 See Fausto Lechi, pp. 10 ff. for full documentation of this remarkable episode.

35 For the career of Costabili (1756–1841), see Padovani, pp. 143–54, and the preface to the sale catalogue of his library (to be dispersed in Paris as from 18 February 1858) published in Bologna in 1858. It is most regrettable that his pictures were not catalogued until 1838 (by Laderchi), for the great majority of them date from the fifteenth century, and it would be particularly interesting to know when Costabili purchased these and hence to what extent he was a pioneer in the appreciation of early masters. Clearly, local pride was one determining factor in his acquisition of works by Tura, Costa, and other painters of the Ferrarese school; but there were also many 'primitives' from other parts of Italy, and certainly by Laderchi's time the collection was thought of as having specifically 'pre-Raphaelite' and 'purist' connotations.

36 See Corrado Ricci, 1907.

37 Beaucamp, I, p. 306.

38 The literature on French looting (as opposed to 'legal' confiscation) in Italy is vast, but has never been brought together or seriously investigated. For one episode at Verona, see Bourrienne, I, pp. 182–8, and for a number of other instances, Beaucamp, I, pp. 262, 288–90 and elsewhere.

39 Letter from Mme de Souza to the Countess of Albany, 10 April 1811, in Pélissier, p. 96. This was Cardinal Giuseppe Andrea Albani (1750–1834), son of the Prince of Soriano and Donna Marianna Cybo Malaspina, who spent much of the Napoleonic period in France – see *Dizionario Biografico degli Italiani*.

40 Buchanan, II, pp. 1–3.

41 For Alquier's Italian pictures, which passed into the Chaix d'Est Ange collection, see Joseph du Teil. The 'Michelangelo' is discussed at length by Garnault, pp. 154 ff. Steinman thought highly of it, but de Tolnay – the latest authority to discuss it – considers it to have been a copy. Its present location is not known to me.

42 See Collot's sale catalogue of 29 March 1855 [Lugt 22330], with quotations from letters addressed to him by Seroux d'Agincourt; also Lamy. The 'Leonardo' *Salome*, from the Barberini collection, is probably the picture – or a version of it – attributed to the studio of Cesare da Sesto in the National Gallery, London [2485]. The Poussin is in the Petit Palais, Paris.
 General Moreau was more successful, though evidently less interested, than Alquier or Collot in obtaining important pictures, for he owned for a time Guercino's *Vocation of St Luigi Gonzaga* (Wrightsman Collection) which he expropriated from the Theatine Church at Guastalla in 1805, and then (when he was recalled to Paris) left behind to his successor, General Junot – see Fahy, p. 118.

43 Van der Tuin, p. 59.

44 The *commissaire* Reboul seems to have had particularly close contacts with English dealers, though it is admittedly very difficult to be certain exactly when he was in contact with them – see Passavant, I, p. 248, but also Gould, 1962 for an alternative provenance for the Raphael; and [Mahon] *Guercino*, p. 56, no. 23. Similarly, from Spain, Raphael's *Madonna della Tenda* (Munich) is said to have been brought to London by means of a French *commissaire* – see Passavant, I, p. 278.

45 Bertie Greathead, p. 124.

46 This *Crucifixion* (National Gallery, London) was sold to Fesch in 1818 from the church of S.

Domenico in Città di Castello – a town remarkably generous with its art treasures (Gould, 1962, pp. 158–9).

47 During his visit to Paris in 1802 Schlegel described a number of Lucien's pictures in some detail.

48 For a general life of Lucien, see Piétri, who discusses his collecting (not always quite accurately) on pp. 155 and 180–1. Apart from the volume of engravings, we also have an account of the sale and list of his pictures drawn up by Buchanan in 1815 (II, pp. 269–87), but much disappointment was aroused (Hazlitt, XVIII, pp. 84–9) when Lucien withdrew some twenty of the most famous paintings. Similarly, many years later at the sale of his great-uncle Cardinal Fesch, Lucien's son made himself equally unpopular by buying in many of the leading masterpieces.

49 See [Mongan]: *Ingres*, nos. 11 and 33.

50 See Marmottan, 1901, pp. 284 ff. for some interesting documents relating to Lucien's portraits by Fabre, and the engravings of his collections.

51 [Lucien Bonaparte], 1812.

52 Although it cannot as yet be proved, it seems much more likely that the Spanish paintings recorded in Lucien's catalogue were acquired on this visit, rather than – as suggested by Lipschutz (p. 42) on the basis of an article of 1843 – through Marshal Sebastiani.

53 Boyer, pp. 225–34.

54 See letter from Irvine to Buchanan of 30 June 1804 – in Buchanan, II, p. 154.

55 See Salerno. Not all the pictures went to Berlin, and it is not always possible to follow the full details of Bonnemaison's handling of the affair.

56 Buchanan, II, p. 301. Buchanan, who could not have seen the Fesch collection or the ones referred to in the following note, makes an exception for those of the Empress Josephine and of Talleyrand, 'both of whom may be considered as public characters'. It is unlikely that Vivant-Denon would have so considered Josephine, for she caused infinite trouble to the organizers of the Musée Napoléon by tending to consider as her personal property what they thought of as belonging to the State: the most spectacular example of such behaviour occurred in 1807 when General Lagrange, following a practice popular with officers keen to

ingratiate themselves at court, 'gave' her thirty-six masterpieces from the gallery at Cassel which Vivant-Denon had requisitioned for the Museum. Napoleon let her have her way, and in the end the main loser was the Elector of Hesse, for the pictures were in 1815 acknowledged to be her private property (she sold them to Tsar Alexander I) and hence were not restored to him when the Museum was dismantled – see Chatelain, pp. 179–81, Saunier, pp. 78–9, de Mirimonde 1957, and Grandjean.

Talleyrand's collection of Flemish and Dutch pictures was formed by Le Brun, and was sold in 1817 (after intrigues worthy of its owner) to Buchanan through Bonnemaison – see Buchanan, II, pp. 345–8.

57 Two further collections of Old Masters (as defined by conventional late eighteenth-century taste) were formed in Italy during this period, and must be recorded here. Both belonged to men who not only spent many years in the peninsula (as opposed to marauding soldiers), but who were also in the circles of the Bonaparte family. Prince Eugène de Beauharnais (1781–1824), the Emperor's stepson and Viceroy of Italy, acquired a large number of pictures for himself and for his friends (such as Mme de Souza – see Pélissier, p. 89), as well as for the Brera, while he was in Milan. Some of these were of the highest quality and importance, such as Guercino's *St Jerome* (Moscow) and Guido Reni's *Assumption* (private collection, Switzerland), from the famous Sampieri collection in Bologna which, in 1811, he and the State bought in association (see Ricci, pp. 36 and 86; [Mahon] *Guercino*; and Pepper, p. 475); but unfortunately the first illustrated Beauharnais catalogue was not published until many years later when the pictures belonged to his son, the Duke of Leuchtenberg (the title given to Eugène by Bonaparte). As this catalogue is totally reticent about provenances, it is difficult in the present state of our knowledge to be sure which pictures were acquired by Eugène during his years of power. Hubert gives brief, but excellent, indications of the tastes of the various members of the Bonaparte family in Italy.

The distinguished painter François-Xavier Fabre (1766–1837), who succeeded Alfieri as the lover of the Countess of Albany and who spent thirty years in Florence, was closely associated with Lucien Bonaparte, whose portrait he painted. In 1825 he made the first of two donations of his pictures to his native town of Montpellier, where they still remain in the museum named after him. The gift

was composed of two hundred and twenty-four paintings (as well as drawings and sculptures), but as we know that he went on buying until his death, here too it is difficult to be sure to what extent he was able to take advantage of his connections with the Napoleonic regime to further his acquisitions, which, although sometimes of high quality, are of course not to be compared with those of this patron Lucien.

58 Beaucamp, I, pp. 239 and 270.

59 Beaucamp, I, p. 319; and II, pp, 575 ff. for references to his pictures.

60 See Gere, and Scheller.

61 Buchanan, II, p. 18. For the inventory of Godoy's pictures in 1808, see Guzmán. It is not at all clear from this which pictures, apart from the Correggio, were taken by Murat.

62 For the 'Alba' Madonna in Washington, and the Rubens *Triumph of the Eucharist* canvases from Loeches (formerly Grosvenor collection, now in the Louvre and Sarasota), see Passavant, I, pp. 149 and 183; and Buchanan, II, pp. 222 ff. Even by the standards of the time the removal of these pictures against the will of the local population, through a combination of French bayonets, English money, and Danish diplomatic immunity, seems outstandingly squalid, though Buchanan recounts the whole episode with considerable pride. Bourke also exported to England two small landscapes with figures by 'Velazquez', now in the Lansdowne collection, and attributed by Lopez-Rey (nos. 163-4) to a 'lesser follower'. See also Mrs Jameson: *Private Galleries . . .*, p. 313.

63 For all this, see the material very usefully assembled by Lipschutz.

64 Soult's depredations were attacked by his own countrymen, and (most savagely) by Ford.

65 Buchanan, II, p. 205.

66 Buchanan, II, p. 229.

67 See letter from Lawrence to Penrice of 10 January 1810 – Penrice, pp. 11-12.

68 See the biography of Seroux d'Agincourt attached to the first volume of the completed book.

69 This is the whole burden of Previtali's well documented book. It needs to be stressed that although many scholars are now deeply interested in the problem, there is as yet no full-scale study of the 'rediscovery of the primitives' (Previtali's survey is mostly confined to Italy and ends with the eighteenth century), though there are some useful articles dealing with the reputations of individual painters or specific collectors, on which I have relied heavily, as will be apparent from my List of Books Consulted. Venturi's *Il Gusto dei Primitivi* is a stimulating essay on some aspects of the subject from a very individual point of view, but certainly not a history. It is from a weary recognition of this fact, rather than from any true conviction, that writers who touch on the problem continue to refer to the two articles by Von Klenze and Borenius, which were useful pioneering works and which contain much interesting information, but which are by now so out of date as to be actively misleading.

70 Seroux d'Agincourt: *Discours Préliminaire*, Chapitre III.

71 For a summing-up of the controversy, and a bibliography concerning it, see Stubblebine, pp. 30-42, who suggests that the date 1221 was in fact painted in (much later, when the altarpiece itself was refurbished) to record the death of St Dominic, and the establishment of the Dominican Order in Siena, which both occurred in that year.

72 Seroux d'Agincourt, II, *Peinture*, p. 101.

73 For a general survey of French interest in early Italian art, see Chastel.

74 After an earlier visit before 1775, in 1785 he replaced Vivant-Denon as secretary of the embassy in Naples – Richer, p. 85. For Cacault, see the entry in the *Dictionnaire de Biographie Française* with some references to other literature. Richer is the most useful source for his museum and collecting, because he includes full quotations from other accounts. The Musée Rolin at Autun owns fifteen very affectionate letters from Cacault and his brother to Amaury Duval, the diplomat, artistic functionary, literary editor, and scholar. They date from between 1793 and 1808, and although most of them were sent from Italy, they include virtually no significant information about the collection.

75 Richer, pp. 127-8.

76 Richer, pp. 75 and 125. The sculptor François Lemot, who was a friend of Cacault, bought the castle at Clisson. See also Quatremère de Quincy, 1817.

77 Cacault was born in 1742 and died in 1805. It is unfortunately impossible to know when and where he bought his twelve hundred pictures, which – we

are told (Richer, p. 101) – he assembled over a period of thirty years. Richer also claims (p. 127) that he owned almost as many again, but that these were seized by the English with a vessel taking them to France, and were sold in London in 1805. Cacault was advised by the artist Wicar – whom he much admired – in his purchases (Beaucamp), and it seems virtually certain that his 'primitives' were not bought until his Roman stay of 1799–1801. Writing very much later about this period, the artist Granet (Chapitre VI) said of Cacault that he was 'grand amateur de tableaux. Il en avait dans son hôtel une grande quantité qu'il avait achetés à bas prix. Il suffisait qu'ils eussent été peints par de vieux peintres italiens pour qu'ils fussent admirables à ses yeux.'

78 His pictures are now in the museum at Nantes, but unfortunately no adequate modern catalogue of that museum has been published.

79 One very notable instance is that of General Miollis, the cultivated officer who had had erected a statue of Virgil at Mantua, and who as Governor of Rome entertained splendidly at his official residence, the Villa Aldobrandini – see Auréas. Mme Récamier mocked him for thinking that *Corinne* was the name of a town in Italy, but although he seems to have been much taken in by dealers, his love of art was clearly a strong one. He relied much on the advice of the French painters Granet, and Wicar (Beaucamp, II, pp. 434, 445 ff., 452 ff.), who drew his portrait, sold him pictures, and catalogued his collection – see [Miollis], but Miollis also had the imagination to commission Ingres' *Tu Marcellus eris* (Toulouse), landscapes by Didier Boguet, etc. I have so far been unable to identify a single one of his three hundred and ninety Old Masters, but it is obvious that the star names, such as Raphael, Poussin, and Guido Reni, were copies – and frequently acknowledged as such. On the other hand, his Italian Baroque paintings, attributed to such artists as Francesco de Mura, Giaquinto, Trevisani, and Tiepolo, who were little thought of at the time, may well prove to be authentic if they can be traced. Miollis seems to have had no interest whatsoever in early Italian pictures which could be bought easily and cheaply at the time. One would dearly like to have overheard the conversations about art that he enjoyed having with his frequent visitor Seroux d'Agincourt.

80 [Artaud de Montor], 1808. See also Previtali for this whole circle of collectors, as well as the painter Paillot de Montabert, who seems to have

been the first man (in 1812) actually to have praised the 'primitives' at the expense of Raphael.

81 *Magasin Encyclopédique*, 1811, tome IV, p. 449.

82 Not that d'Armagnac despised the Titians, Murillos, Van Dycks, etc., as can be seen from his sale catalogues of 1836 and 1857 [Lugt 14418 and 23376]. His Rogier van der Weyden 'Miraflores altarpiece' (Berlin) was attributed at the time to the more popular Memling, and was sold in 1836 – for full details of the provenance, see Davies, 1972, p. 214. The authentic Memling Floreins altarpiece (Louvre) remained in his possession until his death.

83 Virtually all that follows comes from the remarkable series of articles by Herrmann, 1967–8, although it will be seen that I sometimes differ in the conclusions that I draw from his impressive researches.

84 This seems to me to be virtually proved by the following question and answer at the Select Committee on Arts and Manufactures, 1836, para. 1826:

[*Chairman*] From what you state, I suppose you have travelled a great deal with a view of studying and purchasing pictures abroad?
[*Mr Edward Solly*] The greater portion of these pictures were purchased for me by agents, who upon sending me documents proving where the pictures were taken from, and being approved of by the committee at Berlin (for I purchased under the advice of the principal connoisseurs and professors of the art at Berlin), the pictures were then retained; but I have travelled so as to be well acquainted with the Louvre and the Dresden gallery in particular.

85 *Arts and Manufactures*, 1836, paras. 1824–77, and especially 1841–8.

86 For the Boisserée collection, see Firmenich-Richartz, and for Goethe's response, see Andrews, p. 16.

87 Aders' name turns up frequently in nineteenth-century biographies and memoirs – Gilchrist, Crabb Robinson, Passavant, Waagen, etc. As far as I know, the first modern writer to stress his importance was Geoffrey Grigson. Virtually everything that has yet been discovered about him is included in M. K. Joseph's very useful compilation, on which I have relied heavily. Many of Aders' pictures are now in the National Gallery, London. After his sale a number were acquired by the

surgeon Joseph Henry Green (1791–1863), who had studied in Germany, and been in touch with Tieck and Bunsen. He was especially close to Coleridge.

88 The recent biography by Chatelain refers to many earlier accounts, though not the valuable one in Gould, 1965.

89 Harmand, p. 162.

90 It is true that a great many of these, as well as his magnificent prints, were bought by him before he was appointed director of the French Museums.

91 The chief sources of our information concerning Denon's collection of pictures consist of the [sale] catalogue of 1826, drawn up by A. N. Pérignon [Lugt 11164], and the *Monuments des Arts du Dessin* of 1829, which includes some reproductions of paintings among the drawings, sculptures, and objects of all kinds. No modern study exists of the collection, though it is always referred to in accounts of Denon, nor is this the place to undertake one. But the pictures referred to in my text are Pérignon, no. 6 [as Antonello], Memling: *Portrait of a Medallist* (Musée des Beaux-Arts, Antwerp); no. 41, Fra Angelico: Two panels of *The Annunciation* [described as *Visitation*] (Edsel Ford collection, Detroit - Pope-Hennessy, 1952, p. 197 and fig. xxxvi as 'ascribed to Fra Angelico'); no. 65 [as Breughel le Vieux], Bruegel the Younger?: *Wedding dance* (one of the many versions, conveniently listed in the catalogue, of the picture in the John G. Johnson collection, Philadelphia, pp. 15–16); no. 153, Fragonard: *Sacrifice to a rose* (private collection, Wildenstein, 1960, no. 497); no. 50 [as Jean-Baptiste Tiepolo], Domenico Tiepolo: *Education of the Infante of Spain at Parma* (London, formerly Bischoffsheim

collection – Morassi, nos. 286–7); no. 187, Watteau: *Gilles* (Louvre).

92 Chatelain, p. 51.

93 Boyer, pp. 12 and 185–6; Blumer.

94 Harmand, pp. 161–3, and the *Monuments des Arts du Dessin.*

95 Dibdin, II, pp. 453–68, for a very interesting account of the collections, and the fact that on one occasion there were twenty-two English visitors at a time!

96 Lady Morgan, II, 1818, pp. 98–113, for a very full account.

97 *Monuments des Arts du Dessin . . .*, I, pp. 21–5.

98 The four magnificently illustrated volumes of the *Monuments des Arts du Dessin . . .*, which were published in 1829 (four years after Denon's death), were produced by his nephew Brunet-Denon, himself a remarkable collector who bought in some of the best pictures at the sale of his uncle's possessions (*L'Artiste*, 1835 (I), tome 9, p. 142), and Amaury Duval. There is some correspondence between the two men about the publication among the Amaury Duval papers in the Musée Rolin, Autun (K⁸ 30), and a full investigation of these might prove rewarding. The text of the *Monuments* probably reflects Denon's general ideas, but it is quite inadequate in conveying his flair and insights as recorded for us by his many visitors.

99 Frances Lady Shelley, I, p. 128: 5 August 1815.

100 Dibdin, II, pp. 457–9. The picture, which Dibdin reproduces, was in fact the Memling: *Portrait of a Medallist* in Antwerp – see note 91.

Chapter Three

1 Lamy, tome 39, p. 175.

2 D'Agincourt, tome III, p. 131; quoted Previtali, p. 172.

3 See the report by Joachim Le Breton, secrétaire perpetuel of the Classe des Beaux-Arts of the Institut, published in the *Magasin Encyclopédique*, 1809, tome 5, pp. 315–35. The pictures by Ingres were the *Baigneuse de Valpinçon* and the *Oedipe et le Sphinx* (both in the Louvre). See also Lapauze, 1924, II, p. 85.

4 See Le Breton's report in *Magasin Encyclopédique*, 1812, tome 6, pp. 5–45.

5 In 1834 Horace Vernet reported from Rome that 'la tendance qui se manifeste serait plutôt un retour vers le goût primitif du Giotto et du Beato Angelico. Si elle n'est pas poussée jusqu'à l'imitation suivie, cette tendance ne peut que garantir des erreurs qu'on reproche au romantisme.' But, by a curious irony in view of the attacks to which he had been subjected as a young man, Ingres found

himself a year later deploring the interest in early art shown by the students of the Academy in Rome – see Schneider, pp. 301 and 309.

6 See especially Rosenblum, chapter IV, 'Towards the *Tabula Rasa*'.

7 See, for instance, the comments by Léon Lagrange in his review of the Salon of 1864 (*Gazette des Beaux-Arts*, 1864, xvi, p. 506): 'Le public (nous ne parlons pas de la critique) aime à greffer des noms nouveaux sur des noms anciens. Vous dites M. Moreau, il vous répond Mantegna. Vous dites M. Manet, il vous répond Goya. Vous dites M. Ribot, il vous répond Ribera. Et voilà des hommes jugés ... la responsabilité des défauts de M. Moreau passe toute entière à Mantegna, et Goya devient le bouc émissaire des sottises de M. Manet.'

8 For this journey and its results see the interesting article by Marcia R. Pointon.

9 Phillips – see especially preface (of 1833), pp. x–xi, and Lecture I (of 1827), pp. 33–44.

9a It had been expressed most effectively by the artist, dealer, and collector William Young Ottley, who had been deeply interested in early Italian art since the last decade of the eighteenth century (see Previtali, Gere, Waterhouse). In an introductory message 'To the Lovers of Art', accompanying his *A Series of Plates* of 1826, he wrote: 'In respect of the three great requisites of *invention*, *composition*, and *expression*, and for the *foldings of the draperies*, the best productions of these periods may even now be studied with profit, and those of *Giotto*, especially (as the editor has had occasion to observe at some length in the work before mentioned) abound in examples in which, by the employment and ingenious distribution of the figures, the intended subject is developed with a degree of perspicuity seldom equalled, and perhaps never surpassed, by painters of later times.' Ottley is here referring back to his own superlative *Italian Schools of Design*, which, though published in complete form only in 1823, had in fact begun to appear in 1808. Phillips specifically acknowledged the importance of Ottley's book.

10 Uwins, I, p. 181 and II, pp. 330–1

11 Cunningham, II, p. 170.

12 Cunningham, II, pp. 369 and 374.

13 Wilkie Collins, II, p. 86.

14 The only biography of Lady Callcott is by Gotch, and is of little relevance in this context. But her own books vividly convey her astonishingly perceptive responses to art, as – still more – do her unpublished papers which Mr Christopher Lloyd, who is at present editing them, has kindly shown to me.

15 See Callcott: *Essays*, chapter V. As the unpublished travel journals on which these essays were based date from 1827–8, it can be seen that she was even more exceptional among connoisseurs of the time than might otherwise appear.

16 See his sale catalogue of 8–11 May 1845 [Lugt 17780].

17 Waagen, 1838, I, pp. 154–5.

18 I am grateful to Mr Christopher Lloyd for showing me a copy of this interesting letter of 24 February 1821, in the John Murray archives, London.

19 These are the last words of Lady Callcott's *Continuation*.

20 Waagen, 1838, I, p. 155.

21 For the Eastlakes see the important forthcoming book by Professor David Robertson, who has kindly allowed me to read it in typescript, and the brilliant chapter in Steegman, 1950, as well as Lady Eastlake's *Journals*, her many uncollected articles, and her introduction to the second (and posthumous) volume of her husband's *Contributions*.

22 As early as 1826 Flaxman had planned to give a lecture at the Royal Academy recommending the students to study the 'fine prints from the paintings in the Campo Santo' by Lasinio, which – a full generation later – played their part in detonating the Pre-Raphaelite explosion. Ill health prevented his delivering it – see Flaxman, pp. 14 and 249.

23 For a very useful survey of this phenomenon see Melchiori.

24 See Gombrich, 1971, p. 24, who points out that, in his distaste for Bernini and the Baroque, even Winckelmann was ready to express a certain qualified and reluctant admiration for both the 'primitive' and Michelangelo, though he is not here specifically referring to early Italian painting.

25 See, for instance, Martin Archer Shee, p. 76.

He himself was to become president of the Royal Academy, and writing in 1809 he says: 'In this view it is, that, with great deference to the high authority of Reynolds, the Author would have been disposed to hesitate, before he recommended the Taste of Michael Angelo to the particular cultivation of the English School Buonaroti is a blazing star, too excentric in its orbit, to direct us safely in the navigation of Art.'

26 Reynolds. Discourse XII, pp. 218–20.

27 Flaxman. *Lectures*, no. x (Modern Sculpture).

28 See Irwin.

29 J. Romney, p. 107. Romney's letter dates from 1775.

30 As opposed to drawings, etc. Flaxman, however, does sometimes adopt a 'primitive' style. The two artists of this generation whose art owes most to Michelangelo, Barry (1741–1806) and Fuseli (1741–1825) differed somewhat in their attitudes to early Italian art. Fuseli's contempt was whole-hearted, whereas Barry 'reverenced' Cimabue, and saw in Masaccio 'many particular things very nearly perfect'. (*Works*, I, p. 180). Later, the two contemporaries Ottley (1771–1836) and Humbert de Superville (1770–1849) both combined a highly sensitive study of primitives with a passion for Michelangelo – see Previtali: *Disegni di D. P. Humbert de Superville*, 1964.

31 Keynes, pp. 28–9. Much later Rodin was to be deeply inspired by the combined influences of medieval sculpture and Michelangelo.

32 [Duppa]. *Miscellaneous Observations . . .*, p. 195.

33 Wilkie Collins, I, pp. 255–6.

34 Pointon, p. 346.

35 Gotch, pp. 263–4, and Levey, p. 297.

36 Mrs Bray, p. 72.

37 Passavant, II, p. 231.

38 Although it is true that there was a great deal of violent opposition to what was often called the 'Louis XIV style' in interior decoration at this time – see, for instance, the evidence given in 1836 to the Select Committee on Arts and Manufactures. Waagen's attitude to this style changed with the years. In 1838 he wrote of the Earl de Grey's collection: 'The apartments in which the collection is distributed are very magnificently decorated in the absurd style of the age of Louis XV, which has

lately come into vogue in England. This taste proves that the English often aim more at a rich and splendid, than at a noble and beautiful effect' (II, p. 393). In 1854, this becomes merely: 'The apartments in which this collection is distributed are very magnificently decorated in the style of the age of Louis XV' (II, p. 85). The style has been fully discussed by Winslow Ames.

39 See, for instance, its comment on an auction of modern English pictures in 1849: 'highly gratifying it is to find that, in the majority of instances, these have realised prices as good as most pictures by the . old masters bought which have lately been submitted to competition. True, the buyers may not be of the same class, for we missed from the sale rooms, on the occasions referred to, the noble collector or his agent, whom fashion, or taste, yet keeps from paying homage to his fellow-countrymen, and from showing his appreciation of it by giving the work of English artists a place in his aristocratic mansion. It is the middle classes chiefly by whom our school is patronised: many of these are gathering round them galleries of Art which, at some future day, will rank as high as any of past times, and in monetary value will be as marketable.' *Art-Journal*, 1849, p. 251.

40 'It is but fitting that our public gallery of Art should not only equal, but surpass, every other in Europe.' *Art-Journal*, 1858, p. 184. The word 'fitting' in this context is entirely typical of the self-assured tone of mid-Victorian journalism.

41 *Art-Union*, 1844, p. 195.

42 *ibid.*, p. 286.

43 *Art-Journal*, 1847, p. 142.

44 *Art-Journal*, 1858, p. 217.

45 *ibid.*, p. 350.

46 *Art-Journal*, 1859, p. 229. In 1826 Cicognara had called Orcagna 'il Michelangelo del XIV Secolo' – *Antologia*, III, p. 163. Ten years later Rio referred with admiration to the 'terrorisme mystique' of the Dantesque inspiration in Orcagna, 'le Michelange de son siècle'. See Rio, II, 1836, p. 82.

47 *Art-Journal*, 1856, p. 227.

48 *Art-Journal*, 1854, p. 34.

49 Mrs Bray, pp. 79–80.

50 Eastlake's attitude to the modern Pre-Raphaelites is not easy to fathom, but in her auto-

biography (published by her daughter in 1899) Mary Howitt wrote (II, p. 72): 'When Millais, in 1851, exhibited at the Royal Academy his "Mariana in the Moated Grange" . . . the then recently-appointed President of the Royal Academy, Sir Charles Eastlake, privately said it was the last year that the Hanging Committee would admit this outrageous new school of painting to their walls.'

51 See his evidence to the Select Committee on the National Gallery, para. 6472.

52 *Art-Journal*, 1859, p. 132.

53 See Select Committee on National Gallery, paras. 9050–7.

54 Quoted by Sandby, II, p. 253.

55 See 'To the Lovers of the Fine Arts', preface to *A Series of Plates*: 'It is well known of painting, that art began to decline soon after it had attained its greatest excellence; that before the middle of the sixteenth century a comparatively corrupt style was more or less prevalent in almost every part of Italy. . . . Hence it appears fair to infer, that there must have been something in the system of study and processes of the early Florentine masters, and in the principles by which they were governed, which was of a nature to lead to genuine excellence, and rendered them *safe teachers of their art*; but that in the novel principles and methods which were by degrees introduced by artists of later periods there was something *fallacious*.'

56 *Art-Journal*, 1858, p. 355. Interestingly enough, in 1849 – before its campaign against the Pre-Raphaelites got under way – the *Art-Journal* had reviewed Rossetti's *Girlhood of the Virgin Mary* (his first exhibited picture) at the Hyde Park Gallery in a somewhat similarly 'progressive' spirit: 'This picture is the most successful as a pure imitation of early Florentine art that we have seen in this country. The artist has worked in austere cultivation of all the virtues of the ancient fathers. . . . Thus, with all the severities of the Giotteschi, we find necessarily the advances made by Pietro della Francesca and Paolo Uccello, without those of Masolino da Panicale' (p. 147). From the standpoint of the art historian the reasoning is muddled, to say the least, but the implications are clear enough.

57 W. P. Bayley in the *Art-Journal*, 1860, pp. 131–2.

58 J. Beavington Atkinson in the *Art-Journal*, 1860, p. 133.

59 Dyce, pp. 11–12. Dyce, who himself owned a small picture of a *Madonna appearing to a kneeling youth*, once attributed to Raphael (rejected by Dussler, p. 61), put his ideas into practice by helping to build up the private collection of Captain Stirling M.P. in Renfrewshire – see Waagen, 1854, III, p. 314. This contained a number of fifteenth-century pictures, some of them of high quality.

60 J. Beavington Atkinson in *Art-Journal*, 1859, p. 309.

61 *ibid.*

62 From a review in the *North British Review*, November 1847, pp. 20–1, of Lord Lindsay.

63 Frith, II, pp. 87–8.

64 In 1807 – see Cunningham, I, p. 148.

65 For a useful summing up see Bruno Foucart. The controversy has extended to the editing of his papers which makes serious consultation of them a tiresome business. The essential sources are the three volumes of the *Inventaire Général des Richesses d'Art de la France*, and the three volumes of Courajod, as well as the various editions of Lenoir's own catalogues.

66 On 30 October 1793 – see *Inventaire*, II, p. 102; and, for a similar occasion on 9 April 1794, *ibid.*, p. 148.

67 Foucart, p. 228.

68 Michelet's wonderfully evocative account of the Musée des Monuments Français was published in his *Histoire de la Révolution Française*, livre XII, chapitre VII.

69 Childe-Pemberton, II, p. 562 – Letter to Sir William Hamilton of 26 January 1798.

70 *Magasin Encyclopédique* [1799], tome 6, p. 549.

71 Unfortunately it is not yet possible to draw up a full inventory of the Earl-Bishop's pictures. For the most recent authoritative study of his patronage, see Brinsley Ford, 1974, pp. 426–34.

72 See the letter signed Philantique, dated Iᵉʳ Ventôse, l'an 3ᵉᵐᵉ de la République – published by Lapauze, 1903, pp. 395–6.

73 Schnapper, pp. 155–7, shows, however, that though it had no doubt been intended to include Le Brun, he was in fact omitted – a sign that his prestige was diminishing.

74 By this rather rhetorical expression I mean to

suggest that the triumph of David had a far more damaging effect on the appreciation of French eighteenth-century history painting than of such artists as Watteau, Fragonard, or Chardin, who continued to find some admirers almost without interruption.

75 Bergeret, p. 335.

76 For a very useful survey of the whole field, see Simches; and also Cutler.

77 See the references to this collection in Thoré's *Bulletin de l'Alliance des Arts*, III, 25 December 1844, p. 179, and *ibid.*, 10 February 1845, pp. 242–3, and Cypierre's sale catalogue of 10 March 1845 [Lugt 17668].

78 See *Bulletin de l'Alliance des Arts*, IV, 10 May 1846, pp. 369–71.

79 For this attractive friend of Gautier, Flaubert, De Nerval, Hugo, and other important contemporary figures, and his role in promoting an interest in Tiepolo and Guardi, see the reference in Haskell, 1967, pp. 481–97.

80 Gault de Saint-Germain, 1819, pp. 63 and 106. In his *Trois Siècles . . .*, of 1808, Gault de Saint-Germain had already written of Fragonard as one of the leading artists of the eighteenth century (pp. 232–3). He was also a most enthusiastic admirer of Chardin, Hubert Robert, and Jules Vernet.

81 Viardot was much mocked for this – see the comments by Hédouin in the *Bulletin des Arts*, Vème année, tome V, p. 185, and by Champfleury, 1850, pp. 39–40.

82 Writing of this period, the art dealer Charles Roehn noted that 'la plus grande révolution qui s'opéra alors dans le monde des tableaux, ce fut le goût instantané qui se déclara pour les Wateau . . .; les Pater, les Lancret, sur les tableaux desquels rejaillit un reflet de la vogue du maître, augmentèrent de valeur; quelques uns de leurs ouvrages passèrent sous le nom de Wateau. A ce moment il n'était si petit amateur qui ne voulut posséder un tableau de ce maître; aussi la phrase d'usage dans le monde artistique était celle-ci: Avez-vous vu mon Wateau. Cette secousse commerciale influa sur toutes les peintures dont le style avait quelques rapports avec celui de ce maître.' (pp. 79–80).

83 Delpech: *Examen raisonné . . .*, pp. 5–11.

84 Stendhal: *Salon de 1824*, p. 143.

85 *Journal des Débats*, 21 October 1824. I owe many of these references to Dr Jon Whiteley, for whose constant help I am very grateful. It would be simple to assemble many more criticisms making the same point. For the general attitude of Delécluze, see Baschet.

86 *Journal des Débats*, 22 March 1845.

87 *Journal des Artistes et des Amateurs*, 3eme année, Ier volume, 1829, pp. 236–7.

88 Either Paillet or H. Delaroche in their accounts of the picture in the Claude Tolozan sale of 23 February 1801 [Lugt 6204], p. 48.

89 See Haskell, 1967, pp. 481–97, and (not mentioned there) the very interesting article by Jules Buisson.

90 See Haskell, 1967, pp. 58–61.

91 In fact Leroi, though a biting critic of academic art, had no sympathy for the Impressionists either.

92 This is suggested by Simches, p. 16, on the basis of a (somewhat abbreviated) quotation from *L'Artiste* of 1836. In fact the full relevant passage from the article (in my copy of a journal which constantly raises textual problems of the most tiresome complexity) reads as follows: 'notre aristocratie est partagée entre l'un et l'autre [Renaissance and eighteenth-century styles]. Dans la Chaussée d'Antin, la *Renaissance* est plus en faveur; les salons de MM. Rothschild et Aguado ont donné le ton. Le genre des Watteau et des Boucher domine dans le faubourg Saint-Germain.' (*L'Artiste*, 1836 (1), Iere série, tome XI, p. 5.) Though it is, in fact, difficult to infer very much from this (the more so, as the Renaissance is oddly described as 'cette alliance bizarre, mais non sans charme et sans fécondité, de l'art grec et des fantaisies arabes'), there may be an implied distinction between the artistocracies of money and of birth. But the main point is the capriciousness of the anti-medieval reaction of the late 1830s. None the less, although proof is lacking, I accept Mr Simches's conjecture that the return to power during the Restoration of the old nobility which, like the Bourbons, 'had learnt nothing and forgotten nothing' may well have played a significant part in reviving a taste for the rococo.

93 *Journal des Débats*, 31 July 1849.

94 The condition was not observed. For Walferdin's offer see Wildenstein, 1960, pp. 38 ff. *L'Artiste* (Veme série, tome III, 1849, p. 73) described

him as 'un vieux républicain de l'ancienne roche', and by 1867, Thoré (in *Paris-Guide*, I, p. 544) says that he owned two to three hundred paintings, and seven to eight hundred drawings by Fragonard. See also Roger Portalis.

95 The exhibition was the third one to be organized by the Association des Artistes Peintres, Sculpteurs, Architectes, Graveurs et Dessinateurs, which had been founded by the Baron Taylor in December 1844 (Maingot, p. 86). The most informative review of the exhibition is that by Clément de Ris in *L'Artiste*, 1848, pp. 177–80 and pp. 193–6, who was very critical of many of the pictures, but who ends his first article: 'Nous le répétons, c'est incontestablement à Géricault et à Rousseau que l'exposition de cette année devra son succès.' In an interesting article in *L'Illustration*, 5 February 1848, pp. 359–62, the critic A.J.D. also deplores the quality of many of the pictures shown, but goes out of his way to attack the government's administration of the arts.

96 Michelet. *Journal*, I, p. 682: 2 February 1848. Michelet's great panegyric of Géricault was written (but not actually delivered) for his course of lectures at the Collège de France in 1847–8 – see Klingender. I am most grateful to Dr T. J. Clark for showing me his notes on the reputation of Géricault in 1848. Two more pictures attributed to him were exhibited at the Bazar Bonne-Nouvelle. In later years Michelet was to write an important and memorable account of Watteau – see Haskell, 1972. Too much political tendentiousness must not, however, be read into the exhibition, as a study of the catalogue quickly reveals: a drawing of Robespierre by Gautherot was no doubt more than compensated for by a Greuze 'portrait du jeune Dauphin (Louis XVII)'.

97 Of which only the one illustrated here can be identified with any certainty.

98 'A.J.D.' in *L'Illustration* – see note 95. In a later issue, *L'Illustration* (1848) reproduced Chardin's *Garçon cabaretier*.

99 See Paul Mantz.

100 Léon Gozlan in *L'Artiste*, 2eme série, tome I, 1839, p. 156.

101 Champfleury, 1860, p. 179; and for the revival of the Le Nain in general, see Meltzoff, 1942.

102 Thoré, 1848. As early as 1836, Thoré (for

whom, see chapter 4), who was at this time a violently left-wing journalist as well as an art critic, had first sketched out his equation between radicalism, the rococo and national glory. In an article published in that year, he deplored the weak representation of French eighteenth-century masters in the Louvre, and made the point that 'sous Louis XV, les artistes n'ont guère produit que pour la royauté. Au moins, la *nation*, qui a succédé à Louis XV, devrait-elle avoir cet héritage.'

103 See Klingender.

104 The general background to this aspect of nineteenth-century taste is brilliantly illuminated by Fried in his otherwise unconvincing article on Manet, though I think he post-dates the phenomenon.

Proudhon and Champfleury are the great exceptions to the widespread left-wing admiration for eighteenth-century art, but Proudhon's views on the Old Masters are interesting in connection with another ideological battle that raged throughout much of the nineteenth century: the controversy over 'art for art's sake'. For him the art and the epoch of the Renaissance were characterized by lack of principles. This, inevitably, led to a 'culte idolâtrique de la forme' (pp. 78–9). For Edgar Quinet, on the other hand, the assumed disintegration of religious faith in Italy in the fifteenth and sixteenth centuries led to 'poetry, art, beauty', which were essentially based on a new interest in human life: 'la madone est descendue de son siège sacerdotal . . . le Christ lui-même est devenu, sous le pinceau de Michel-Ange, un autre Jules II, un pape irrité et militant' (pp. 310 ff.). Many years earlier, a writer in *L'Artiste* (1837, Iere série, tome XIII, p. 14) had contrasted the devout Catholicism of Cimabue and Raphael, and the Republicanism of David, with the lack of any serious beliefs in contemporary society.

For an interesting account of French nineteenth-century attitudes to the Middle Ages, see Dakyns.

105 But, it must be stressed once again, the many anonymous contributors to the *Art-Journal* did not all speak with one voice, and opinions diametrically opposed to those quoted here may certainly be found in its pages.

106 *Art-Journal*, 1858, p. 350.

107 *Art-Journal*, 1859, p. 229.

108 *Art-Journal*, 1858, p. 360.

109 Rio's wife was English and his personal con-

tacts with England were numerous. Although he acknowledged the extreme importance of German thinkers on his own artistic ideas, there is no doubt that it was through his book that the idea of 'Christian art' became so well known in England. Montalembert's dithyrambic account of Fra Angelico was first published in book form in 1839, along with a review of Rio, a starred guide to the Catholic schools of painting in Italy (Sassoferrato was the only painter of the seventeenth century to earn any), and other essays. Significantly, in view of what is said later in this chapter, when his articles on art were reprinted in 1861, they included also (pp. 366–84) an open letter of 1844, written in the most fluent – and biting – English 'addressed to a reverend member of the Camden Society on Architectural, Artistical, and Archaeological Movements of the Puseyites', which mocked all Anglican interest in church decoration as 'but an empty pageant, like the tournament of Eglinton Castle, separated from the reality of Catholic truth and unity'.

110 This attitude to art, which was to prove of the highest importance in conditioning taste, is particularly associated with Ruskin's writings in the late 1840s and early 1850s – in *The Seven Lamps of Architecture*, and the magnificent denunciation of the Vendramin tomb (in SS. Giovanni e Paolo) in *The Stones of Venice*: 'Who, with a heart in his breast, could have stayed his hand as he drew the dim lines of the old man's countenance – unmajestic ones, indeed, but at least sancified by the solemnities of death – could have stayed his hand, as he reached the bend of the grey forehead, and measured out the last veins of it at so much the zecchin?' (*Works*, IX, p. 52). But in 1842 the Reverend William Faber, then still an Anglican, had been gratified to discover that the Certosa of Pavia was richly and elaborately decorated even where the human eye could not see it – *Sights and Thoughts*, p. 163. Gibbon, on the other hand, had merely been 'astonished' at the labour and expense involved in carving details in Milan cathedral which would virtually never be seen – Gibbon, p. 46.

111 See, especially, the Reverend John W. Burgon, M.A. In the words of the *Dictionary of National Biography*, Burgon, who spent much of his combative life in Oxford, was 'a high churchman of the old school, he was as opposed to ritualism as he was to rationalism, and every form of liberalism he abhorred'. But he had a real love of art and

archaeology, and some of his descriptions of modern life in Rome are vivid and sympathetic.

112 For an exceptionally vigorous exponent of some of these attitudes, see the account of his foreign travels by Henry Alford, the Dean of Canterbury. He is by no means always able to stick to his declared intention (p. 35) of not railing at 'the *chefs-d'oeuvre* of Italian art in their own country . . . because they are not in the English Gothic style'. Alford is deeply moved by early art, is satisfied that 'a mass of reds and blues and sprawling limbs' by some unnamed seventeenth-century painter demonstrates that 'through all this degradation must the Roman Catholic mind have passed' (p. 230), and finally concludes that 'Foreigners lack *gumption*'.

113 Burgon, p. 109.

114 Seymour, pp. 135–44.

115 Many of Wiseman's articles, most of which originally appeared in the *Dublin Review*, were reprinted in three volumes in 1853. He also lectured on the arts.

116 See especially his entertaining and important review article 'Italian Guides and Tourists' of 1836, reprinted in 1853.

117 For his life, see Ward.

118 See *Remarks on Lady Morgan's statements regarding St. Peter's Chair preserved in the Vatican Basilica*, first published in Rome in 1833, and reprinted in *Essays* twenty years later.

119 Faber's meaning is not in doubt, but his scholarship is somewhat erratic. He denounces Italian architecture 'from Bernini [1598–1680] to the miserable Maderno [1556–1629]'. His travel book is on the sanctimonious and humourless side ('It has to be regretted that French wickedness has almost always been picturesque'), but – as so often in nineteenth-century English literature – the tension that he experiences between his instinctive aesthetic emotion and his sense of duty can be moving in its impact. His denunciation at La Spezia of Shelley, that 'low, unprincipled scoundrel, not a romantic', who had none the less given him so much pleasure, is characteristic of his attitude to the arts, and Venice inspires him to real eloquence.

120 Bowden, p. 179.

121 Bowden, p. 258.

122 Ferrey, p. 127.

123 Ferrey, p. 126, for his letter to Lord Shrewsbury, written in May 1847.

124 Ward, I, p. 356.

125 Ferrey, p. 161.

126 As Newman wrote in a letter of 1848: 'If Mr. Pugin persists, as I cannot hope he will not, in loading with bad names the admirers of Italian architecture [i.e. Renaissance and Baroque], he is going the very way to increase their number. He will not be *put down* without authority which is infallible. And if we go to authority, I suppose Popes have given a greater sanction to Italian than to Gothic' – XII, p. 213.

127 Though the circumstances in which these acquisitions were made is not clear.

128 For a brief outline of the career of the Reverend Fuller Russell (1814–84), see Boase: *Modern English Biography*, and Crockford, 1876 and 1884.

129 For Fuller Russell's tendencies in early life and his relationship to the Oxford Movement, see Liddon, I, pp. 400–8, and II, pp. 141–5.

130 See John Fuller Russell, B.C.L.: 'The Ancient Knight or Chapters on Chivalry', London 1849: 'But chivalric imagination still waves its magic wand over us. We love to link our names with the heroic times of Europe . . . etc. etc.' (p. 192).

131 See Waagen, 1854, II, pp. 461–4, and IV,

1857, p. 284; and also his sale catalogue of 18 April 1885 [Lugt 44815].

132 Beresford-Hope is a familiar figure to all students of the English ecclesiastical and architectural scene of the nineteenth century, and it would be far beyond the scope of this book to describe his activities in any detail. The outlines of his career can be found in the *Dictionary of National Biography*, and there is a highly entertaining account of his life by H. W. and I. Law. Although Beresford-Hope is particularly associated with the patronage of architecture, it is worth pointing out that he bought Overbeck's *Incredulity of St Thomas*, now in a Swiss collection (Andrews, p. 70), and employed William Dyce.

133 Waagen, IV, 1857, pp. 189–92.

134 Dennistoun, II, p. 166. Dennistoun, who was one of the earliest writers in the English language to appreciate the greatness of Piero della Francesca, uses extremely cryptic terminology in his discussion of 'the principles and history of what is now generally known under the denomination of CHRISTIAN ART'. I am, however, inclined to believe that the passage here quoted refers less to Catholic converts than to the Puseyites. For Dennistoun's views on art, and his collecting, see Brigstocke.

135 Symonds: *The Catholic Reaction*, II, pp. 402n, and 408. The whole passage contains a stimulating discussion on taste.

Chapter Four

1 It would be wholly impossible here to list even the principal figures concerned, but four of the more impressive collections may just be noted to give some indication of the scale of aristocratic involvement with the arts during the Regency and early Victorian periods, and the quality of the 'conventional' pictures which continued to flow into England.

Of the third Marquess of Lansdowne (1780–1863), who enjoyed a highly successful career in public life as a reforming minister, Mrs Ruskin wrote to her father in 1852 that he was 'fonder in reality of the Arts than politics, and aspires more to be a Maecenas [*sic*] than a Charles Fox' (Lutyens, p. 304). Waagen confirms his 'elevated and cultivated taste, such general knowledge of the

subject [art], as is very seldom met with, not only in England, but in general' (Waagen, 1838, II, p. 257), and repeatedly describes the splendid collections he built up for himself at Lansdowne House in London, and Bowood in the country (1854, II, pp. 143–53; III, pp. 146–67, etc.). During his lifetime, his pictures and sculpture were also described by Passavant (I, pp. 195–7 and pp. 309–13), Mrs Jameson (pp. 287–338), and in the *Art-Union* (1847, pp. 329–31 and 359–60). He started buying in 1808, and among his most prized possessions was Rembrandt's *Mill* from the Orleans collection (Washington), Salvator Rosa's *Self-portrait* (London), and splendid paintings by Raphael, Bronzino, Murillo, and other masters, some still with the family.

The fourth Duke of Northumberland (1792–1865) in 1856 bought almost the entire collection that had been formed by the Italian painter Vincenzo Camuccini and his brother (see chapter 2). The greatest masterpiece was the *Feast of the Gods* by Bellini and Titian (Washington), but there were many other pictures – mainly seventeenth-century Italian – of superb quality (see Waagen, 1857, IV, pp. 465–74 and the exhibition catalogue *Noble Patronage*, 1963). The Duke harked back to an eighteenth-century tradition by employing leading Italian architects and craftsmen to design Renaissance interiors in his medieval castle of Alnwick in order to house his pictures adequately.

Though not himself of aristocratic descent, the exceedingly rich R. S. Holford (1808–92), who inherited his fortune in 1838, married into the aristocracy (Anne Lindsay, a cousin of Lord Lindsay). He built a palace in the centre of London (the *Art-Journal* commented in 1856, p. 304, 'an untitled Englishman with refined taste and ample means is a king without the trouble of crown and sceptre') and a huge country house in Gloucestershire. Waagen described his collection in 1854 (II, pp. 192–222) and 1857 (IV, p. 101), and there have been many subsequent accounts, most notably by R. H. Benson, his son-in-law. He was 'catholic in his range . . . exacting in his choice' and preferred 'the fulness of summer to the colder springtime of Art', but 'had no sympathy with the cult of the crude or the decadent' (R. and E. Benson, p. viii). His collections were sold in 1927, and his holdings of medieval manuscripts have led to his being described as the 'Ideal Connoisseur' (Munby, pp. 147–50).

One of the least studied English collectors of the first half of the nineteenth century is W. J. Bankes (1787–1855), a great traveller and close friend of Byron, on whose advice he bought the famous *Judgement of Solomon*, sometimes attributed to Giorgione, which is still in the family collection at Kingston Lacy, as are magnificent pictures by Velazquez, Reni, Rosa, and others which were acquired by Bankes during the many years he spent living in Spain, and above all Venice to which he had been driven by his sexual indiscretions at home – see V. Bankes.

In case all this should give too rosy a picture of the general situation, it is worth recalling the comment made by the banker, poet, and collector Samuel Rogers on Lord Holland (1773–1840), who lived in Italy for some years between 1793 and 1796, and later assumed a dominant role in London society: 'Painting gives him no pleasure, and music

absolute pain' (Thomas Moore, IV, p. 48).

2 For help in studying the Baring family and collections I am very grateful to Professor Christopher Platt, Mr T. L. Ingram, and Mr Christopher White.

3 For the outlines of Sir Francis Baring's career, see the *Dictionary of National Biography*, and the frequent references in Farington, which suggest the scale and nature of his social life.

4 Buchanan, I, p. 21.

5 It is very difficult to be certain which exactly were the Dutch pictures bought by Sir Francis Baring himself. Mrs Jameson claims (p. 4) that he acquired the best pictures at the Geldermeester and Countess of Holderness sales in 1800 and 1802, but this is by no means sure. He did buy some paintings – by Berchem, Mieris, and Steen – at the Greffier Fagel sale (London 1801, Lugt 6269), and we know from Farington (III, p. 258) that at the sale of Boydell's Shakespeare Gallery he bought pictures by Opie, Northcote, and Peters.

6 See Passavant, I, pp. 277–85.

7 Apart from the early sources, see Oliver Millar, pp. 26–9.

8 See Buchanan, II, p. 251, and the list published in Appendix II of [Northbrook].

9 Waagen, 1838, III, pp. 27–46.

10 See, above all, Waagen, 1838, II, pp. 265–86, and the *Art-Union*, 1847, pp. 122–7 for details of his superb collection.

11 See P. H. Emden, pp. 35–6.

12 See *Art-Union*, 1847, pp. 275–7.

13 See [Northbrook], Appendix I.

14 Though not the last. In 1847 Lord Ward bought the Bisenzo collection in Rome; for the Duke of Northumberland's purchase of the Camuccini pictures in 1856, see note 1; Lord Hertford continued to buy on a royal scale until his death in 1870, when he was succeeded by his illegitimate son, Sir Richard Wallace, who in 1871, acquired *en bloc* the collections of the Comte de Nieuwerkerke.

15 See [Northbrook].

16 The original papers of the Burlington Fine Arts Club, and of the various informal societies that led up to it, are in the library of the Victoria and Albert Museum. Most of the more significant

material is referred to in the important account of the club by R. H. Benson (*The Holford Collection* ..., 1924, pp. 19–28), and in the *Burlington Magazine*, 1952, pp. 96–8. On the whole, more time was devoted to 'objets d'art' than to pictures. Although we know the names of the members and of the collections visited and discussed, the essentially informal and social nature of the club naturally involved no keeping of specific records of what was said on any occasion. But the wide membership, and very varied works of art looked at, need to be emphasized.

There was in Paris during the 1870s and 80s what appears to have been a rather more restricted dining club of art collectors organized by Count Jacques-Victor de la Béraudière ('dont le goût passait, à juste titre, pour le plus épuré de Paris') on the first Thursday of each month (Eudel, v, pp. 221 and 402), and there were many more associations of the kind about which we know little, though their importance in the formation of taste must certainly have been considerable.

17 For Selvatico and his background, see Venturi, pp. 135–8, and Paola Barocchi, who reprints many of the essential documents.

18 Selvatico, pp. 572–6.

19 *Art-Journal*, 1856, p. 340 – in a discussion of a *Fête Champêtre* belonging to Queen Victoria.

20 National Gallery, Committee of Evidence, paragraph 6472.

21 Quoted in [La Tour], pp. 95–6.

22 For a discussion of this, see Steegman, 1947.

23 Lindsay, pp. xiv–xv.

24 As early as 1810 Benjamin Robert Haydon had compared the Elgin Marbles to Giotto (Diary, I, p. 166). Later Rio commented on their similarity to Benozzo Gozzoli's frescoes in the Medici chapel – 1836, p. 202. Though this was far less apt, it may well have remained in Coutts Lindsay's mind.

25 This was quoted in *Apollo*, 1965, p. 255. I am most grateful to Mr Hugh Brigstocke for checking the original manuscript of this letter among the Lindsay papers in the John Rylands Library, Manchester. Mr Brigstocke tells me that it is dated 28 March 1842, and was written from Florence to Lindsay's future mother-in-law, Mrs Anne Lindsay. For a highly stimulating essay on the reputation of Piero della Francesca, see Longhi, 1963, pp. 116–69.

26 The literature on La Caze (1798–1869) is extensive. For recent reappraisals and new information, see Sylvie Béguin and Claire Constans, written in connection with the memorable exhibition held in the Louvre in 1969 to commemorate the centenary of his bequest of all his pictures to the museums of France.

27 See the vivid account of him in Chennevières, IV, pp. 120–3.

28 Burty, 1879, p. 147.

29 For an interesting account of the collection of François Marcille, see *Les Beaux-Arts*, 1844, II, pp. 188–90.

30 Goncourt, I, p. 600 – 8 May 1859.

31 Reiset. *Notice des tableaux* ... Reiset was himself a great collector, keeper of drawings at the Louvre, and friend of Ingres. Chennevières (III, pp. 90–104) describes him as 'le plus parfait expert de peintures et de dessins que la France ait connu depuis Mariette', but Viel-Castel has a (characteristically) bitter account of him (II, pp. 53 and 209). Reiset sold his small but superb collection of paintings to the Duc d'Aumale in 1879.

32 Rochefort, the political revolutionary and art lover, writes interestingly about La Caze (I, pp. 116–18), who – so he claims – was the first to 'discover' Hals. Rochefort also says that La Caze used to 'complete' his Chardins, and that he refused to buy Rembrandt's *David playing the harp before Saul* (now in the Mauritshuis, but recently doubted by Gerson, p. 602).

33 It is worth pointing out that the account of La Caze's collection in *L'Annuaire des Artistes*, 1861, pp. 117–22, stresses the fact that it 'se compose d'oeuvres de toutes les écoles, choisies avec le sentiment de l'art, et non avec le goût exclusif qui, en ce moment, gouverne le plus grand nombre de nos amateurs. ... Aussi juge-t-il de la peinture au point de vue de l'artiste, sans se préoccuper de l'opinion du commun des collectionneurs, toujours un peu mondains dans leurs acquisitions.'

34 Chennevières, III, pp. 30–51.

35 Although it is impossible to read any account of French cultural life in the nineteenth century without coming across the figure of the Baron

Taylor (1789–1879), there is unfortunately no adequate biography of him. Maingot gives only the bare outlines of his career.

36 Although, as will be seen in the next chapter, the attributions of a very high proportion of the pictures in the Galerie Espagnole have been questioned (and were so at the time), at least six of the eight El Grecos exhibited were authentic – and masterpieces. It is true that four of these were portraits, which were more easily acceptable to current taste, but there were 'difficult' pictures as well, such as the *Adoration of the Shepherds* (Bucharest). Eight El Grecos are few compared to eighty 'Zurbaráns', but when Baron Taylor bought them, the artist was only just becoming talked about even in Spain (de Salas, 1941), and in France he was as yet completely unknown. As for Goya, he was already familiar in the circles in which Taylor moved, but only as an etcher, and here too Taylor's selection of eight paintings was an impressive and varied one.

37 Taylor probably owned the *Annunciation* (Budapest), attributed by Wethey to the workshop of El Greco (II, p. 169, x–18), no. 23 in his sale catalogue of 24–6 February 1880 [Lugt 39926]. Most of Taylor's Old Masters were acknowledged to be copies and were apparently of little interest. Chennevières (III, p. 45) recorded having seen 'a few unimportant pieces by El Greco which, . . . among the armour and a thousand other records of his travels, decorated the high walls of the rooms he occupied for so long in the Rue de Bondy'.

38 Apart from Ford's masterly *Handbook*, see the important catalogue of the *Richard Ford in Spain* exhibition, London 1974, which contains references to his collecting.

39 11 January 1832; published by Prothero, p. 77.

40 National Gallery Select Committee, 1853, paras 5405 and 5408. The questioner was Mr Vernon, and Lord Overstone, after replying: 'I would rather not enter into a discussion upon that question', later added: 'I cannot for a moment listen to the idea that the Spanish school is a school from the study of which nothing is to be gained.'

41 *Art-Journal*, 1853, pp. 176–7.

42 These may have been among the many easel paintings by Goya that the *Bulletin de l'Alliance des Arts* of that year, 1842 (pp. 94–6) rather surprisingly claimed were being bought by Englishmen.

43 For Stirling-Maxwell's collection, see Waagen, IV, pp. 448–53; Enriqueta Harris; Alexander A. Auld; and the handbook to the Stirling-Maxwell collection, Pollok House, published by the Corporation of Glasgow. Mr Hugh Brigstocke is at present working on the family papers, and has kindly answered a number of my queries.

44 It was bought by the Rt Hon. Henry Labouchère (later Lord Taunton), the Whig politician, who had a fine collection of pictures of all schools, and who showed a special predilection for imposing Spanish masterpieces – Goya's *Forge* and El Greco's *Vincenzo Anastagi* (both in the Frick Collection), and Zurbarán's *Battle with the Moors at Jerez* (Metropolitan Museum), which also came from Louis-Philippe's Galerie Espagnole.

45 The *Adoration of the Name of Jesus* in the National Gallery, London. Among the portraits was the so-called 'El Greco's daughter' (*Portrait of a Lady in a fur wrap*, now in Pollok House), which, as we shall see in the next chapter, was one of the stars of Louis Philippe's collection.

46 Gilchrist, 1863 (the first edition), which gives a catalogue of Blake's paintings and drawings with the names of their owners.

47 The notebook is now in the British Museum, and in 1973 was edited in facsimile by David V. Erdman and Donald K. Moore.

48 Notably his brother, William Michael, and presumably Swinburne, who in 1867 wrote an enthusiastic critical study of Blake.

49 See the preface by William Bell Scott to the catalogue of the Blake exhibition organized by the Burlington Fine Arts Club in that year.

50 The Pierpont Morgan Library owns a most interesting album, containing forty-six drawings and watercolours by English artists, which once belonged to Cheney – see an account of this, which was kindly brought to my attention by Miss Felice Stampfle, in the *15th Report to the Fellows*, 1967–8, New York 1969. The most extensively represented artist is T. H. Cromek, a fascinating exhibition of whose works (many of them from the Cheney collection) was held at Colnaghi's, London 1972 – see the catalogue. The Morgan Library also owns twelve interesting letters to Cromek from R. H. Cheney, Edward's brother, with whom he was always very close.

51 Especially Rawdon Brown.

52 This, the following quotation, and much of the information about Cheney (1803–84) given here, comes from the fine memoir of him by his (liberal) friend Monckton Milnes (later Lord Houghton), to whom there are some interesting letters from Cheney in the Library of Trinity College, Cambridge, kindly drawn to my attention by Dr A. N. L. Munby.

53 Lugt. *Marques de Collection*, no. 444.

54 For Cheney's collection, see Waagen, IV, pp. 170–5, the Christie sale catalogues of 29 April 1885 [Lugt 44875] and 4–5 May 1905 (his great-nephew Francis Capel-Cure), also Knox, Byam Shaw, and Morassi.

55 Though Cheney was, in fact, a learned man, and many collectors, both public and private, looked to him for advice. He gave evidence to the Select Committee on the National Gallery in 1853, and his letter to the gallery about the possible purchase of pictures from the Manfrin Collection has already been referred to (chapter 1, note 25).

56 See letter from Effie Ruskin of 26 April 1852 published by Mary Lutyens, p. 301. The book contains constant references to him.

57 See the figures published in the *Art-Union* (1839, p. 104) which had access to the customs' records; thus, 1833: 7050; 1834: 7459; 1835: 7591; 1836: 10421; 1837: 6637; 1838: 6484. These figures do not include pictures imported from France.

58 This was the portrait (no. 195), now described as 'style of Neufchâtel', which was bought as a Holbein. It was reproduced in the *Illustrated London News*, VII, 1845, p. 89, as Miss Celina Fox kindly pointed out to me.

59 This is the implication of chapter 5 'The Old Masters, 1815–1884', of Reitlinger, who none the less provides a great deal of interesting information about taste in this period.

60 There has been no detailed modern study of this astonishing collection, though there are two informative articles (by Thuillier, and Carrington), mostly about the pictures now at Ajaccio. The only full-length biography of the cardinal, by the Abbé Lyonnet, was published in 1841, two years after his death at the age of 76. It is very useful, but the general tone of reverence makes some of its contents a little suspect, though even the devoted Abbé is occasionally disturbed by Fesch's methods of acquisition. The *avant-propos* to the 1844 cata-

logue by the *commissaire-expert* Georges draws on Lyonnet, but adds a great deal of new information. There are two main difficulties in studying the collection: the identification of the pictures themselves, concerning which much remains to be done, though the detailed entries of the catalogue are very helpful; and, secondly, their provenances, which are never given. The reason for this is probably a simple one. The auction was held in Rome, and export regulations forbade the removal from the papal states of any important pictures which could not be shown to have been brought to the city from outside. It was therefore in the interests of the auctioneer to suggest that as many as possible of the paintings had been acquired by the cardinal *before* he settled finally in Rome, following the downfall of his nephew Napoleon: these pictures he marked with an asterisk in the catalogue, and there is reason to believe that he was generous with these. Some checks can be made: there are, first, the cardinal's exceedingly interesting account books, published in 1922–3 by the Abbé Vanel (and I am most grateful to Professor Ternois for procuring copies of this rare publication for me), but they unfortunately only cover the years 1799–1802; secondly, there are a large number of descriptions of the hospitable cardinal's various residences over a period of several decades. Beginning (to the best of my knowledge) with English visits to Paris during the Peace of Amiens – Bertie Greathead, Opie, etc. – and increasing greatly in numbers after Waterloo when the Palazzo Falconieri was a regular tourist attraction – Lawrence, Lady Morgan, Thomas Moore, etc. – these can give us a few clues (admittedly often only negative ones) as to when some of his more important acquisitions were made. I hope to investigate the whole collection at much greater length on another occasion.

61 Fesch himself had already sold some of his pictures on various occasions, but it was not until 1841 that the first full catalogue was drawn up – full, in the sense that most (though not, apparently, all) of the pictures were listed: but only in the most summary manner. It was this that called forth the mockery of the *Bulletin de l'Alliance des Arts* (1842, I, pp. 4–5). About fifteen hundred of the less important pictures were sold in the intervening years, but the really significant auction did not take place until 1845.

62 William Coningham, about whom I intend to write a full study elsewhere.

63 That of the Comte Alexandre de Pourtalès-Gorgier (1776–1855), the Protestant son of a Swiss banker. See the interesting accounts of his huge collections – 'on sait avec quelle discretion les portes ... étaient ouvertes: les intimes, quelques rares savants, obtenaient le droit de contempler ses merveilles' – in a series of articles in the *Gazette des Beaux-Arts* in 1864–5. See also J. J. Dubois.

64 The Reverend Walter Davenport-Bromley (1787–1863) bought more than forty pictures at the Fesch sale, and it was there that he began his large-scale purchasing which led to his building up one of the most distinguished collections in England of early Italian painting. See Waagen (III, 1854, pp. 371–80 and IV, 1857, pp. 166–8) and his sale catalogue of 12–13 June 1863 [Lugt 27402].

65 I am particularly grateful to M. Pierre Rosenberg for letting me have a copy of a list of all the purchasers at the Fesch sale. The great majority were dealers, usually buying for individual collectors, such as Laneuville who, among other pictures, bought Poussin's *Dance to the Music of Time* (Wallace Collection) for Lord Hertford. About a hundred pictures were bought in by Fesch's great-nephew, the Prince de Canino (Lucien Bonaparte's son), who very soon afterwards sold most of them to Lord Ward.

66 For a useful summary of the activities of Emile (1800–75) and Isaac (1806–80) Pereire, see Zeldin, pp. 54–5 and 82, with references. See also P. H. Emden, pp. 144–60.

67 See Chapman, pp. 94, 167, and 244.

68 Much of the decoration, which was highly praised by Théophile Gautier (*Bouguereau*, pp. 14–16), still survives in the Chancery of the British Embassy in Paris (the former Hôtel Pereire).

69 P. G. Hamerton, p. 2.

70 Our main information about the Pereire collection comes from Thoré's article of 1864, reprinted as a separate brochure in the same year, and the sale catalogue of 6–9 March 1872 [Lugt 32968]. However, some pictures may have been acquired after Thoré's article, and not all the pictures were sold in 1872 – Ingres' *Baigneuse de Valpinçon* for instance, appears in neither publication, and was acquired by the French State in 1879. Moreover, an anonymous sale of 30–31 January 1868 [Lugt 30187] contained a large number of Pereire pictures, though also some (I believe) from

other sources. In addition, Isaac's son, Henri, continued to buy pictures long after the dispersal of the main collection of his father and uncle (see, for instance, Eudel, II, pp. 37 and 245). M. André Pereire, who has recently presented a number of pictures to the Louvre, kindly tells me that he has no family papers which would clear up some of the problems which are still outstanding.

71 Goncourt, I, p. 1156: 1 November 1862. On the other hand, Drumont, the most extreme anti-Semite of the nineteenth century, not only had rather a soft spot for the Pereires, but went out of his way to emphasize the sincerity of Isaac's love of art – II, p. 350. This is probably explained by the fact (kindly told me by Mr John Gross) that Drumont worked for ten years on *La Liberté*, a paper owned by the Pereire brothers.

72 Goncourt, I, p. 1156: 1 November 1862. The picture collection in Spain was that of the Urzaiz.

73 Barrès, pp. 121–2.

74 In his great monograph on Vermeer, Thoré writes, 'J'ai eu le plaisir, non seulement d'admirer ses tableaux dans les musées et les galeries, mais d'en conquérir plus d'une douzaine, les uns que j'ai fait acheter par mes amis MM Pereire, Double, Cremer, etc., les autres que j'ai achetés pour moi-même'. The anonymous author of an account of the Pereire sale in *L'Artiste* (1871–2, pp. 144 ff.) says: 'On sait que le conservateur ordinateur de la galerie Pereire avait été Théophile Thoré, alias William Burger – on pouvait donc en toute assurance se hasarder à cette vente, à moins qu'il ne soit pas reconnu que les critiques d'art ne sont pas des connaisseurs.'

75 Sir John Charles Robinson (1824–1913) would deserve extensive treatment in any full account of Victorian taste and collections. His training as an art student in Paris and his wide ranging travels on the Continent enabled him to acquire a first hand and unusually profound knowledge of European arts and crafts of every kind – drawings, sculpture, paintings, ceramics, etc. – which he put to good use. As curator of the Museum of Ornamental Art in Marlborough House and in various other related posts he helped to build up the superb collection of Italian sculpture now in the Victoria and Albert Museum (see Pope-Hennessy, 1964, I, pp. vii–xi), and his catalogue of the Raphael and Michelangelo drawings in the Ashmolean Museum, Oxford, is perhaps the single most important contribution to scholarly connoisseurship made by an Englishman in the nineteenth

century. But he was a difficult man, who plunged headlong into a series of violent controversies, and in 1867 he lost his official posts (though in 1882 he was made – a singularly unsuccessful – Surveyor of the Queen's Pictures). It was explained that 'no personal imputation was intended beyond the statement that whilst travelling at the public expense he had sometimes purchased works of art for himself and for his friends'. He certainly had. As one of the founders of the Burlington Fine Arts Club, he was in close touch with many leading collectors, and he put his expertise at their service. Apart from the remarkable collections of Sir Francis Cook (for which, see Robinson, 1885, and Borenius) and John Malcolm of Poltalloch, he was also closely associated with those assembled by the marine engineer Robert Napier, and by the merchant banker and railway director Matthew Uzielli – for both of which he wrote the catalogue – and, no doubt, many others. He himself owned remarkable pictures of all schools, and the appraisal that he wrote of El Greco in 1868 (whose *Christ driving the money changers from the Temple* he later presented to the National Gallery in London) is probably the most balanced and certainly the most enthusiastic that had by then appeared anywhere in print: 'As a painter or colourist . . . he is entitled to rank with Titian, Paul Veronese, Tintoretto, Rubens, Velasquez, and Reynolds; that is, on a level in this particular respect with the greatest representative names in art.' (Robinson: *Memoranda*, p. 39.)

76 As has been pointed out recently by Fleming.

77 A great deal has been written about every aspect of Thoré's career, and I have drawn on the obvious published sources (Blum, Grate, Marguery, Thuillier, etc.) and the very full bibliography in the tantalizingly incomprehensible Morawska. For the sake of convenience I refer to him as Thoré throughout, even though in later years he signed his books and articles W. Bürger, under which name they are listed at the end of this book.

78 See especially his open letter to Théodore Rousseau used as a preface to his *Salon de 1844.*

79 See his strictures on Ingres: 'l'amour exclusif de la forme, l'indifférence absolue sur tous les mystères de la vie humaine, le scepticisme en philosophie et en politique, le détachement égoiste de tous les sentiments communs et solidaires' in *Salon de 1846*, and elsewhere.

80 *Musées*, II, p. x.

'81 *Musées*, I, pp. 319–26. It should be added that, like all the greatest critics, Thoré was by no means always consistent in his attitudes. His passionate admiration for Velazquez (expressed in his own writings, and also in his notes to a French translation of Stirling-Maxwell) is difficult to reconcile with his distaste for 'a princely, aristocratic and consequently exceptional art, consecrated exclusively to glorifying the tyrants of the human kind'. Nor did he suffer under any misapprehension as to the greatness of Rubens himself.

82 *Musées*, I, p. ix.

83 Other critics were gaining a deeper understanding of Dutch art at much the same time – see Van der Tuin, who quotes (pp. 68–9) from Louis Vitet writing in 1860 that 'la peinture hollandaise . . . n'est plus un jeu d'enfants, une oeuvre de dexterité, une sorte de chinoiserie; c'est de l'art grand et fort, de l'art qui touche, émeut et parfois meme élève l'âme'. But I suspect that the loquacious and prolific Thoré was responsible for much of the change of attitude implied in this and similar quotations from other authors.

84 *Musées*, I, pp. 118–19.

85 *Musées*, I, p. 145. But Thoré was not always so hostile, and sometimes spoke warmly of Jan Both (*Musées*, II, p. 95). Constable's attitude has already been discussed – see chapter 1, note 24.

86 See, above all, Meltzoff 1942; and Blum, who reprints Thoré's monograph which was first published in the *Gazette des Beaux-Arts* in 1866, though he had already made lengthy contributions to the knowledge of Vermeer in earlier writings.

87 Although the picture had belonged to the royal collection since 1825, as far as I know only two foreign comments had been made on it in print before Thoré's visit in 1842 – and both by Englishmen. The great dealer and connoisseur John Smith refers to it as a 'superb picture' among those he lists by the scholars and imitators of Gabriel Metsu (part IV, p. 110), and George Agar Ellis writes of it (p. 46) as 'a very good view of Delft'.

88 Maxime Du Camp, Théophile Gautier, Charles Blanc, Paul Mantz, and the Goncourt brothers all spoke highly of Vermeer before Thoré's monograph, but it was he who probably drew their attention to the artist. Waagen and Eastlake were also early enthusiasts.

89 Marguery, p. 300.

90 See, for instance, his *Salon de 1861* (I, p. 105): 'M. Doré est un nouveau venu dans l'école, et presque le seul qui y marque par un certain génie. Reconnaissons-le donc maître aussi, – à nos risques et périls', and *Salon de 1863* (I, p. 370): 'Dans la nouvelle génération d'artistes, je ne crois pas qu'il y en ait un seul à qui puisse s'appliquer ce mot de génie, si ce n'est peut-être en un certain sens et dans une certaine mesure, à Gustave Doré.'

91 Marguery, p. 301.

92 *Musées*, II, p. 79.

93 *Galerie Suermondt*, pp. 34–41, especially p. 38. This particular emphasis on light is strikingly similar to Le Brun's characterization of a (real) Vermeer.

94 See, for instance, Henry Havard writing in 1883 (II, pp. 214–15): 'Beaucoup d'entre ces personnages ne figurent là, en effet, que comme des taches heureuses. Ce sont des notes agréables dans un concert adorable de tonalités fines, délicates, fondues, enveloppées. . . . Ils ne commandent pas le reste; rien ne leur est subordonné; chaque ton local, au contraire, a sa valeur propre et son accent voulu, et, s'ils jouent un rôle important dans cette mélodieuse symphonie, c'est par la tache qu'ils font, et non par l'idée qu'ils expriment.'

It needs to be pointed out that this somewhat 'abstract' view not only of Vermeer, but of Dutch art in general, has a very long history, and, in its attempt to reconcile high taste with apparently trivial subject matter, proved to be as important as Thoré's more humanist approach. Throughout the eighteenth and nineteenth centuries there were comments to the effect that, in the somewhat clumsy and repetitive words of the artist William Collins writing in 1817, 'it is the painter who in reality enjoys and admires their works. . . . Most of the Dutch pictures are composed of subjects gross, vulgar, and filthy; and where this is not the case with the subjects, the characters introduced are such as to degrade the human species below the level of the brute creation . . . yet, notwithstanding these objections to them, they are most profoundly skilled in the great technical beauties and difficulties of the Art, and are accordingly highly valued by the artist. As these merits, however, can only be tested by the enlightened and initiated, persons who belong to neither class must buy the Dutch pictures for purposes unconnected with a legitimate admiration of painting' (Wilkie Collins, I, pp. 112–13).

On an infinitely higher level of culture and sophistication, this is the principal message of Fromentin's superb *Les maîtres d'autrefois*, first published in the *Revue des Deux-Mondes* in 1876, though he is not concerned with the 'gross, vulgar and filthy subjects', which gave rise to such puzzled reactions in earlier years, and though, as has often been pointed out, he fails to show any real appreciation of Vermeer. Indeed, the consequences of this book were somewhat equivocal as far as the fortunes of Vermeer were concerned, for the great Dutch artist was keenly admired both by the charming, but minor, painter François Bonvin, who was also a receptive reader of Fromentin (see Foucart's edition, and Moreau-Nélaton, p. 85), and by the Impressionists against whom Fromentin's book was primarily directed – see Pissarro, November 1898, p. 461: 'Comment te décrire les portraits de Rembrandt, les Hals, et cette *Vue de Delft* de Van der Meer, chefs-d'oeuvre qui se rapprochent des impressionnistes?'

95 For Proust's attitude to Vermeer, which played so central a part in his life and his art, see Chernowitz, Huyghe, Hélène Adhémar, and unpublished Oxford D.Phil. thesis by David Wakefield.

96 See Thoré: *Salon de 1868*, II, pp. 531–3, and *Salon de 1863*, I, p. 424. It is worth contrasting this with his comments on Rembrandt's *Jewish Bride* (Plate 212) – *Musées*, II, p. 10. He insists that in this painting, which Thoré took to be unfinished, Rembrandt had from the very first given life to his human characters, and that only after that stage would he have filled in the accessories which were of relative indifference. This, he claims, was in direct contrast with the practice of most contemporary painters, who planned the whole picture simultaneously and with equal emphasis, 'donnant à un accessoire insignifiant la même valeur qu'aux figures qui sont le vrai motif de la composition' – the very fault, in other words, with which he was later to reproach Manet (Plate 213).

97 See Frances Jowell – to whom I am most grateful for showing me an advance copy of this interesting article. It is worth adding that, although as Mrs Jowell rightly stresses, Smith did not include the paintings of Hals in his great *Catalogue Raisonné*, he had – according to his grandson – considered admitting him, along with 'Breughel, Elsheimer . . . and several others; and his work [was] slightly listed; but, as his pictures were not then estimated at their present high standard, his works were not included' (*Connoisseur*, March 1903, pp. 214–15).

98 Such an approach was ingeniously demonstrated in the forgeries of Van Meegeren, who painted those Caravaggesque Vermeers which 'must have existed' but were inconveniently thin on the ground; it has been more honourably vindicated in the 'rediscovery' of Georges de La Tour.

99 See Huard.

100 See the bibliographical references in Schlosser, p. 510. As early as the 1770s Lanzi had begun to acquire early Italian paintings for the Uffizi.

101 See T. C. Bruun-Neergard.

102 Fiorillo – see Waetzoldt, II, p. 287. The first professorship seems to have been Waagen's appointment to the chair at Berlin in 1844.

103 See, among many other responses, Eastlake's review of Passavant, reprinted in *Contributions*, I, pp. 180–271.

104 In England, see, for instance, the conclusion of the Select Committee into Arts and Manufactures, 1836, p. vii: 'It is with regret that Your Committee notice the neglect of any general instruction even in the history of art at our universities and public schools; an opinion noticed long ago by Mr. Burke, and obvious to every reflecting mind.' The issue was nearly always related to practical instruction in the arts, and the raising of standards in design. For France, see Hautecoeur.

105 Crowe, p. 65. Unfortunately his autobiography, which is very long winded, finishes with the year 1860, but he gives a lively account – from his own point of view – of the collaboration between Cavalcaselle and himself.

106 The most recent – and balanced – account, with extensive references to earlier literature on the subject, is provided by Moretti. This needs to be followed up with a full study of the massive Crowe and Cavalcaselle archives in the library of the Victoria and Albert Museum, London. Even a cursory examination of these reveals beyond any doubt that Crowe also was a competent draughtsman and knowledgeable scholar.

107 For French developments in these years, also much concerned with important archival research, see the *Bulletin de la Société de l'Histoire de l'Art Français* of 1972, which commemorates the centenary of the foundation of the Society.

108 The history of museums is too vast a subject to be discussed here, except in so far as it directly relates to the main problems raised by this book. For a very brief, but useful, survey see Seling.

109 See Herrmann, 1967–8.

110 See Ettlinger.

111 The somewhat earlier Dulwich gallery, though specially designed for pictures, was a private building intended to house an essentially traditional collection; Klenze's Glyptothek at Munich, begun in 1816, was conceived as a public museum from the start, but its contents were to consist exclusively of sculpture.

112 For this whole question see Waagen's important article of 1853.

113 Ruskin found him 'a most double dyed ass' (21 November 1843 – in *Diaries*, I, p. 249); William Wetmore Story thought that he was 'the stupidest old plodder I have heard; nothing at all did he give us but a series of facts, and in the most mumbling, slovenly manner' (letter to J. R. Lowell, 30 January 1850 – James, I, p. 214); Rossetti referred to his 'lying dulness' (letter to William Allingham, 23 July 1854 – *Letters*, I, p. 208); Crowe said that he was so 'near sighted that he could not judge of a picture unless he almost touched it with his nose' (pp. 399–400). With the exception of this last opinion, all these judgements are inspired, at least in part, by an 'aesthetic' reaction against the new positivist art history. Lady Eastlake was kinder in her patronizing way. She found him 'an intelligent, clever and witty old gentleman, full of mimicry and drollery and better bred than most Germans' (I, p. 249).

114 Quoted by Seling, p. 44.

115 Arts and Manufactures, I, paras. 84–5.

116 Arts and Manufactures, II, para. 1841.

117 Lavice, pp. xxxvi–xxxvii.

118 *Art-Journal*, 1853, p. 122.

119 See the very interesting preface by Henri Zerner to the recent selection of Dimier's writings.

120 Morris Moore in a letter to *The Times*, 19 November 1846, republished in Verax. Moore was a connoisseur and dealer, much of whose life centred round the attribution of one picture, the *Apollo and Marsyas*, now in the Louvre as a Perugino. His violently abusive attacks on all those who disagreed with his opinion that it was a Raphael (he had bought it in 1850 for seventy

guineas as a Mantegna) were collected by him in a volume, published in Rome in 1885, with the melodramatic sub-title 'A European Scandal' – Haskell, 1978. Though sometimes tedious, his letters, pamphlets, and so on, provide a useful corrective to those who maintain that such febrile connoisseurship only arose in the age of Duveen and Berenson.

121 Report of the National Gallery Site Commission, para. 2451.

122 After this bold opening Ruskin continues with a somewhat ambiguous phrase which makes it difficult for us to tell how far he himself has been responsible for preventing his working men from looking at Bolognese pictures, and how far the 'exceeding refinement of their minds' has had that desirable effect on its own.

Chapter Five

1 It was in 1850 that the Hon. W. T. H. Fox-Strangways presented his early Italian pictures to the University of Oxford (as opposed to previous gifts to his college of Christ Church) – see the forthcoming catalogue by Christopher Lloyd.

2 For art exhibitions before the nineteenth century, see Koch.

3 The word 'foreign' needs to be stressed, because the first Old Master exhibition of the British Institution, held in 1813, had been devoted to the works of Sir Joshua Reynolds, followed by one in the following year which showed pictures by Hogarth, Gainsborough, Zoffany, and Richard Wilson. For the background to these exhibitions see Whitley, 1928, and, for the pictures shown, Graves.

4 The prefaces to the catalogues of the earlier exhibitions, in which these points are frequently made, were reprinted in *An Account of All the Pictures* . . ., 1824.

5 M. K. Joseph, p. 26, proves that the collection of early Flemish pictures belonging to Karl Aders was exhibited at the Suffolk Street Gallery in 1832, but this seems to have attracted little attention. It is significant that the well-informed Whitley has no reference to it.

6 See the preface to 'Catalogue of Pictures . . . with which the proprietors have favoured the Institution, June 1848.'

7 A number of these were lent by an interesting and early collector of Italian 'primitives' the Reverend John Sanford – for whom see Nicolson.

8 Andrews, p. 79.

9 Indeed it was highly praised in the *Art-Union* (1848, p. 225), for 'In their works the progression of Art may be studied up to its fullest development; they amply prove that it was truly progressive, and did not at once burst into the utmost perfection it has achieved'.

10 For Lord Ward (1817–85), who was elevated to the Earldom of Dudley in 1860, and his collecting of art, see Waagen, 1854, I, p. 35, and II, pp. 229–38; also *Tübingen Kunstblatt*, 5 August 1847, and his sale catalogue of 25 June 1892 [Lugt 50974], as well as note 12 below.

11 See Lady Cardigan, pp. 45–6. The reference is to Lord Ward's first wife. His second, whom he married in 1865, also seems to have suffered from his capricious aestheticism. According to her obituary in *The Times* (4 February 1929) 'for fourteen years this queen of beauty lived in something like a gilded cage, from which, however, there was no wish to escape. Lord Dudley, a man of cultured taste and many accomplishments, was benevolent and bountiful, but whimsically despotic. He insisted on his wife's wearing full dress, even at the remotest shooting lodge in the Highlands; he loaded her with gorgeous jewels . . . he gave her everything – always except any measure of responsibility.'

12 For the Egyptian Hall, see *Survey of London*, vol. XXIX, The Parish of St James, Westminster, part 1, London 1960, pp. 266–70 and, for accounts of these exhibitions, see *Art-Journal*, 1851, p. 149, and 1852, p. 198.

13 See *Agnews*, and also a long article in the *Art-Journal*, 1861, p. 319, and innumerable references in the press of the time, some of them recorded by Redford. The phenomenon of industrial, particularly Lancashire, collecting of modern art was noted by every observer: in 1857, the *Art-Journal* was able to gloat (p. 8): 'We have lived to see the

fulfilment of our dearest hopes – Art patronage diverted from (so-called) old masters into the healthy channel of contemporary art', though later it was to become somewhat disillusioned as it found these purchasers taking too enthusiastically to the speculative aspects of collecting which the *Journal* itself had so often recommended.

14 For a most interesting appraisal of the exhibition, see Steegman, 1950, pp. 233 ff.

15 Apart from two editions of the shilling 'Catalogue of the Art Treasures of the United Kingdom collected at Manchester in 1857', there are very many contemporary publications of all kinds discussing various sections of the exhibition.

16 *Trésors d'art*, pp. v–vi. Charles Blanc also published an account of his impressions in book form, and there are innumerable reviews in the English and foreign periodicals and newspapers of the time, some of which are tabulated in the 'avertissement de l'éditeur' of the second edition of Bürger (Thoré), Brussels 1860.

17 See *A Handbook to the Gallery of British Paintings*, p. 3.

18 Thoré (p. 16) says that almost the only ones to abstain were 'la noble maison de Sutherland et le duc de Devonshire, Lord Ashburton et Lady Peel', and Hawthorne, pp. 561–2 reports that 'it is said that the Tory nobility and gentry have contributed to it much more freely and largely than the Whigs'.

19 See *Illustrated London News*, 1857, p. 239; Thoré, p. 97; Hawthorne, p. 563.

20 Barry had then written (*Works*, II, p. 69): 'For all the parts of the art, the highest as well as the lowest, it is certainly amongst the most excellent of the old pictures now existing: the most exquisite judgement will only confirm, and cannot out-go the feelings of the most uncultivated people in the admiration of this picture' – prophetic words.

21 Hawthorne, pp. 545–63 (22 July–6 September 1857).

22 See 'Pre-Raph' in *Art Treasures Examiner*, p. 75.

23 See the catalogue of the 'Exposition Retrospective' organized in 1866 by the Union Centrale des Beaux-Arts appliqués à l'Industrie, and the comments on this exhibition in the *Gazette des Beaux-Arts*, 1866, p. 573 and the *Art-Journal*, 1866, pp. 221–2.

24 For by far the fullest account of the steps leading up to the formation of the Galerie Espagnole, see Guinard 1967.

25 See letter of *c.* 20 June 1864 – *Correspondance*, II, p. 386.

26 See Lipschutz, *passim*, and especially pp. 123–37 for the Galerie Espagnole.

27 Guinard, 1967, p. 177.

28 To which, in 1842, were added two hundred and twenty more Spanish pictures bequeathed to the King by the English collector Frank Hall Standish.

29 Lipschutz, p. 196, and Guinard in *Hommage à Ernest Martinenche*: 'loin d'avoir crée en France la curiosité pour la peinture espagnole, on peut dire que la Galerie de Louis-Philippe est née de cette curiosité'. But he makes an exception for Zurbarán.

30 Jules Breton, p. 175.

31 At the time critics claimed that only one of the pictures in the Galerie Espagnole attributed to Velazquez was probably by him (Guinard, 1967, p. 284). Even this, the *Adoration of the Shepherds*, in the National Gallery, London (no. 232), is now given, very doubtfully, to 'the School of Seville' – MacLaren, 1952, p. 60.

32 It is also important to remember that the very fact that Goya already enjoyed a high reputation as an etcher of the most bizarre kind positively acted against the appreciation of his more 'straightforward' paintings, though the ones in the Galerie Espagnole were of very high quality.

33 Paul Mantz, reviewing Roger de Beauvoir 'Les Arts en Espagne' in *L'Artiste*, IVème série, 184 t, tome I, p. 107.

34 Meltzoff, 1942, p. 284.

35 Champfleury, 1850, pp. 37–8.

36 Wethey, II, no. 80 – a small reduction of the *Espolio* in Toledo Cathedral.

37 Gautier, p. 172, and see Guillaumie-Reicher, pp. 414–19.

38 Stirling, I, p. 286. Richard Ford, whose responses to El Greco were as mixed as those of every other writer at the time, but who knew the artist from his work in Spain and not the Galerie Espagnole, made the revealing comparison: 'He was often more lengthy and extravagant than

Fuseli, and as leaden as cholera morbus' (*Handbook*, III, p. 1147).

39 This point is made by Meltzoff, *Le Nain*, p. 284, though it will be seen that I do not altogether agree with his interpretation of Gautier's response to El Greco.

40 The exhibition was organized by the dealer François Petit, and the catalogue was written by the influential critic and connoisseur Philippe Burty who, however, acknowledged that he gave only those attributions made by the owners themselves. It was held at 26, Boulevard des Italiens, the premises of Louis Martinet, an extremely interesting theatrical impresario, and organizer of independent exhibitions (among them the memorable one of works by Manet in 1865), whose career was somewhat similar to that of the Baron Taylor – see *Notice-Préface au catalogue de la vente au profit de Mme Martinet*, 17–18 May 1887 [Lugt 46592]. I am grateful to Mrs Linda Whiteley for her help over this exhibition, which, like that of 1848, was also held in aid of an artists' benevolent society. Among the more interesting reviews, see those by A.-J. Du Pays in *L'Illustration*, 29 September 1860; by Théophile Gautier in *Le Moniteur Universel*, 5 September 1860; and, above all, by Thoré (see note 44).

41 For Laperlier, see, above all, the informative article by Burty in *L'Art*, 1879, who mentions that his loans to the exhibition are those indicated in the catalogue as belonging to 'M. ★★★'; Lord Hertford's are described as from the 'Collection d'un amateur'.

42 François Marcille has already been referred to – see chapter 4, note 29. For his son Camille see the preface by Paul de Saint-Victor to his sale catalogue of 6–9 March 1876 [Lugt 36232], and the article by Georges Duplessis; and for Eudoxe, see *Annuaire des Artistes*, 1862, pp. 128–38, and Henry de Chennevières. There are abundant contemporary references to the collections of all three men in journals and newspapers.

43 Morny's activites as an art collector are as complex to unravel as any of the other pursuits involving hedonism and finance with which he was associated. Amidst a mass of sale catalogues and controversial literature, either sycophantic or bitterly hostile, see the balanced judgement of Chennevières, IV, pp. 123–7, who says that he was 'pas très sûr de son propre goût', but that 'en fin gourmet de la haute vie, [il] s'était dit de bonne heure que la plus brillante enseigne de toute maison vraiment aristocratique de la vieille Europe était une collection de tableaux, et cette collection il avait voulu l'avoir, et, pour en réunir chez lui les plus précieux morceaux, il avait pris conseil des plus délicats collectionneurs ses amis, ou des experts les plus raffinés; c'est ainsi qu'il s'était adressé tantôt aux sûrs avis de M. Reiset, tantôt aux très habiles négotiations des Stevens.' Certainly, many masterpieces, including world-famous pictures by Terborch, Watteau and Courbet, passed through his hands at one time or another.

44 In the *Gazette des Beaux-Arts*, 1860. Fried relies heavily on these for his account of the cultural background to the early Manet, but (as I have already indicated) I believe that they constitute essentially an elaborate repetition of ideas that Thoré had suggested many years before.

45 *Gazette des Beaux-Arts*, 1860, tome VII, p. 257.

46 Including Thoré himself in the above-mentioned articles.

47 For the impact of Lord Pembroke's sale and the relative absence of Chardins from the great plutocratic collections, see (as well as contemporary sale-room reports, etc.) the two important articles in *The Times Literary Supplement* of 1 June 1960, pp. 409–11, and 14 May 1970, pp. 537–8. For Chardin's impact on smaller collectors and contemporary artists, see John W. McCoubrey.

48 Thiers had, in fact, been preceded as regards the Raphael frescoes by Catherine the Great and the Duke of Northumberland in the eighteenth century.

49 See Boime, 1964, for the whole venture.

50 See Longhi, p. 160.

51 By far the most interesting and imaginative treatment of the whole topic is by Ivins. See also the more specialized studies by Sulzberger, 1958, and E. F. Van der Grinten. I am grateful to M. André Jammes, Professor Aaron Scharf and Miss Tanya Ledger for help over these problems.

52 Stendhal was especially intrigued by this problem: 'Le quai Voltaire est peuplé d'estampes qui représentent la *Madonna della Seggiola* (que Waterloo a rendue au palais Pitti). Les amateurs distinguent deux gravures de ce tableau célèbre: l'une de Morghen, l'autre de M. Desnoyers. Il y a une certaine dissemblance entre ces estampes, c'est ce qui fait la différence des *styles* de ces deux artistes. Chacun a cherché d'une manière particu-

lière l'imitation du même original' – *Promenades dans Rome*, 20 September 1827 (*Voyages en Italie*, p. 648).

53 15 October 1845 – *Ruskin in Italy*, p. 225.

54 *Art-Journal*, 1868, p. 195, reviewing 'The Pictures by the Old Masters in the National Gallery, photographed by Signor L. Caldesi'.

55 See unpublished Oxford D. Phil. thesis (1978) on the Arundel Society by Tanya Ledger, to whom I am very grateful for much help.

56 Letter written in 1856 to William Allingham – in *Letters*, I, p. 298. Layard was the moving spirit behind the Arundel Society at this time.

57 It is very curious that (as Frances Jowell has pointed out to me) Hals was included in the *Flemish* school – despite Thoré's participation in the venture.

58 The earliest one of which I know is *Miscellaneen artistischen Inhalts*, edited by Johann Georg Meusel, which appeared at six-monthly intervals at Erfurt, the first volume being published in 1779.

59 For the English and French material see the invaluable bibliographies by Helene E. Roberts and Gustave Lebel.

60 For the origins of this journal see the memoirs of S. C. Hall, its first editor, I, pp. 338–63, and also Anthony King, who emphasizes (p. 109) that the journal though supporting all its aims, had 'no financial or formal connection with the [Art-Union] Society'.

61 See Damiron.

62 *Gazette des Beaux-Arts*, 1859, I – Introduction.

63 In a letter to his father of 28 September 1845, *Ruskin in Italy*, p. 216. But although it is true that Mrs Jameson was no connoisseur, her iconographical work on *The Legends of the Saints* (1848), *The Legends of the Monastic Orders* (1850), and similar subjects has survived far more satisfactorily than most mid-nineteenth century writing on the arts. Moreover, her guides to the London collections (for which, see Herrmann, 1966) remain invaluable source books, and through her close contacts with Ottilie von Goethe she played a significant role in encouraging the study of German culture in England. Her (not very distinguished) articles on Italian artists began to appear in the *Penny Magazine* in 1843, the same year that Ruskin published the first volume of *Modern Painters*.

64 Fortunately, this important subject is at last being tackled seriously with the preparation by Mr Giles Barber of a bibliography of 'English language guidebooks to the Continent of Europe before 1870' and I am extremely grateful to him for allowing me to see the work he has done on this so far. In addition to the overall guides to which I so briefly refer here, it of course needs to be remembered that most European towns of any consequence published their own handbooks, which were no doubt also read by the more diligent travellers (who, however, only very rarely seem to refer to them in their correspondence, journals, etc.), and a study of these too would be of great value for the charting of changes in artistic taste in the nineteenth century. A start has been made with the three-volume catalogue by Antonio Pescarzoli of the Luigi Vittorio Fossati Bellani collection. See also the most interesting discussion in Hale, pp. 122–9.

65 Wilkie Collins, II, p. 69.

66 For the outlines of her career see the *Dictionary of National Biography*.

67 This was the date of the last and posthumous edition – Mariana Starke died in 1838.

68 Murray's Handbook, 1842, p. 533.

69 Hardly a visitor to Rome fails to be moved by the 'Guido Reni' portrait which, for obvious reasons, had a particularly strong appeal for novelists, such as Balzac, Dickens, Hawthorne, and many more.

70 For an extremely interesting (and entertaining) article on the cult of the *Mona Lisa*, see George Boas, whose pioneering work fails, however, to mention that Vasari can never actually have seen this portrait, about whose technique he writes with such enthusiasm.

71 I am most grateful to Mr Alex Potts, who has had long discussions with me on this subject, and who has brought to my attention much interesting material, some of which is referred to in this and other notes.

The most famous instance of heightened emotional language is probably that used by Winckelmann in his description of the *Apollo Belvedere* in 1764, though already in 1700 François Raguenet had written of this statue that 'on n'est pas étonné que les Payens ayent adoré ces sortes d'Images', and that 'l'Apollon, par son air de

grandeur, vous enléve, vous pénétre, & vous fait sentir les traits & les éclats d'une majesté plus qu'humaine qu'il répand, pour ainsi dire, tout autour de lui' (pp. 296–303). By 1809 Archer Shee was mocking this sort of approach: 'Winckelmann gives what he calls a description of the Apollo, in which he works hard, "To be himself the great sublime he draws" (Pope). He indeed labours in such a poetical ecstasy, that he almost "assumes the God", and seems half inclined to rival the object of his enthusiasm, not only in his personal dignity, but in his prophetic character. In a happy strain of discriminative criticism, which has made him the oracle of travelling connoisseurs, and the manual of picture-dealers, he points out a variety of expressions, as incompatible with each other, as inconsistent with that unity and simplicity of character, which is the peculiar excellence of ancient Art. ... The tortures produced by the serpents, are nothing compared with those Laocoon suffers from the Connoisseur' (pp. 112–13 and 122). But such jibes could do nothing to put an end to an epidemic that spread from the *Apollo* to all forms of art.

72 The question of copies after the *Last Supper*, and the particular significance of the one by Dutertre, have recently been discussed by Heydenreich, who also refers to his own and other earlier contributions to the subject.

73 Goethe, 1821, introduction by Noehden, p. xxxii.

74 Bossi's full-scale copy on canvas was commissioned by Eugène de Beauharnais, and painted between 1807 and 1809. It was kept in the Castello Sforzesco in Milan, and destroyed during the war.

75 Goethe's famous 'Observations' were originally published in *Über Kunst und Altertum*, 1817, no. III, *Werke*, XII, pp. 164–8. The first English edition was translated with an Introduction and notes by G. H. Noehden in 1821.

76 I am grateful to Dr David Wakefield for helpful discussions on this issue. For the question of Stendhal's sources for his interpretation of the *Last Supper* in his *Histoire de la Peinture en Italie*, see the edition by Paul Arbelet, pp. 224–34. For an exhaustive account of Stendhal's own annotated copy of Bossi's monograph, see C. Cordié.

77 Goethe's 'Ruysdael als Dichter' was first published in *Morgenblatt für gebildete Stände*, Tübingen, in 1816 – see *Werke*, XII, pp. 138–42.

78 Taillasson, pp. 45–50, for his essay on Ruisdael, which is deeply imbued with the spirit of Jean-Jacques Rousseau.

79 See the memoir of Taillasson by Bruun-Neergard published in the *Magasin Encyclopédique*, 1810, tome I, pp. 310–14, and for a recent discussion (with references to earlier literature) of his most important picture, *Timoleon and the Syracusans* (Tours) of 1796, Robert Rosenblum, pp. 92 ff.

80 Taillasson, pp. 129–35. The idea that Rembrandt would have lost at least as much as he would have gained by studying in Italy was not itself wholly new, but I know of no critic before Taillasson who was so ready to discard conventional opinions about the incorrectness of his forms.

81 Taillasson, pp. 39–45.

82 For a discussion of mid nineteenth-century views of Watteau as a melancholy painter, see Haskell 1972, and Posner.

Another great enthusiast for Watteau at this period was the Rouen painter C. Lecarpentier, who, however, accepts the traditional eighteenth-century view that although he was 'd'un caractère mélancolique et atrabilaire', his paintings 'inspirent une folle gaieté'. None the less, Lecarpentier ends his essay on the artist by claiming that his works 'will always be esteemed by men of taste despite changes in fashion' (II, pp. 211–20). Lecarpentier is equally enthusiastic about Fragonard ('né au pays délicieux où chanta Petrarque, il en eut la grâce et ce sentiment délicat qui prête à tout un charme inexprimable. On croit voir couler sans cesse au milieu de ses tableaux la source enchanteresse de Vaucluse sous milles formes différentes' - II, pp. 279–83) and many other artists who were little written about at the time.

83 Rio, 1836, p. 128 – referred to by Levey, p. 299.

84 Rio, 1836, p. 489.

85 Wackenroder, I, p. 79 – the sentiment was echoed some years later by Goethe in his *Dichtung und Wahrheit* when recalling the impression made on him by his first visit to the Dresden Gallery in 1768: 'akin to the emotion upon entering a House of God' (Book VIII) – see *Werke*, IX, p. 320.

86 Lamennais, tome III (1840), livre 8, ch. v, p. 240.

87 See Wright, I, p. 188.

88 Pater, 1873, p. 47. Botticelli's reputation in

nineteenth-century England has been charted by Michael Levey, who emphasizes the impact on Pater of Swinburne's review of an exhibition of drawings in the Uffizi in 1868, two years before the publication of Pater's own epoch-making essay. The interpretation of Botticelli as a doubter was partly instigated by the attribution to him (both by Vasari and by nineteenth-century historians) of the 'heretical' altarpiece of the *Assumption of the Virgin* (National Gallery, London, no. 1126, 'ascribed to Botticini').

89 Barrès first went to Spain in 1892, and though we know from references in his *Carnets* that El Greco must have impressed him on this tour, it was not until his second visit in 1907 that he planned his book on the artist. Julius Meier Graefe, whose *Die spanische Reise* of 1910 also played a major part in establishing the reputation of El Greco, went to Spain for the first time in 1908 – see Moffett, pp. 103–7.

90 As Barrès himself acknowledged. Although Cossío's substantial monograph was only published in 1907–8, he had begun writing about him with considerable enthusiasm more than twenty years earlier – see p. xv.

91 *Punch Almanach*, 1881, reproduced by L. Ormond, p. 265.

92 Huysmans – quoted by Praz, p. 399.

93 Jean Lorrain: *Monsieur de Bougrelon*, p. 31. This novel is a rich mine for those in search of late nineteenth-century rubbish about art – and other things as well. Needless to say, El Greco comes in for his share of ecstatic writing, as does the smile of the *Mona Lisa*, 'quel poème de férocité perverse et royale . . . etc., etc.' See many other instances in Praz.

94 See Vallance.

95 Laurence Binyon, pp. 24 ff. The whole introductory essay, 'Botticelli's significance for modern art', is of great interest for the historian of taste.

96 See Rosenthal. Herbert Horne was almost alone in being able to escape from the homosexual, aesthetic ambience in which his responses to Botticelli originated, to produce the superb and scholarly biography of the artist which has not yet been surpassed.

97 Letter to Basil Williams, from Venice, in May

1891 – see *Letters*, I, p. 146. The letter is enthralling in its complex implications for the reputation of Botticelli at this period. Fry was irritated by Symonds adding 'with what I think was hardly good taste in one who is so obviously a rival, "That is the worst thing I've yet said about Botticelli".' As early as 1877 Symonds thought the honours paid to Botticelli had been 'somewhat exaggerated' (III, p. 249), and he must have been one of the first men in Europe to be intrigued by (and to muse on) the rediscovery of Botticelli which 'in the last century and the beginning of this . . . would have passed for a mild lunacy'. He wrote evocatively, but not with complete sympathy, about him, and he could not 'bring myself to accept Mr. Pater's reading of the Madonna's expression'; indeed, he and Pater rather despised each other for all their similarities of temperament and taste (see Grosskurth, pp. 157–8). As for Roger Fry, he found that 'defending Botticelli is not at all what I am naturally keen on now', while in 1898 a reading of Pater provoked from him the fascinating comment: 'It is a pity he makes so many mistakes; but the strange, and for a Morelli-ite disappointing, thing is that the net result is so very just' – *Letters*, I, p. 171.

98 Huysmans, 1905, reprinted 1967.

99 See, for instance, 'Praeterita', para. 180, in *Works*, XXXV, p. 156.

100 Pater: *Letters*, p. 41: 28 November 1881.

101 Carew Martin, 1899, pp. 334–8.

102 *The Investiture of Bishop Harold* (71.121) – a sketch related to the fresco in the Kaisersaal at Würzburg. For a general discussion of Tiepolo's reputation in the nineteenth century, see Haskell, 1967, pp. 481–97. Although private collectors had been interested in him for many years, the first exhibition of paintings by him was apparently held in May 1894 in Venice to celebrate the second centenary of his birth. The first brief monograph, by Henry de Chennevières, followed in 1898, and it was not until 1909 and 1910 that the substantial works by Molmenti and Sack were published. As far as England was concerned, Cheney's pioneering collection had been wholly forgotten. In 1891 Roger Fry wrote that 'Tiepolo is a great revelation to me; I had never heard of him before' (*Letters*, I, p. 147). John Addington Symonds' very fine essay on Tiepolo was first published in *In the Key of Blue* in 1893.

103 For the revival and subsequent reputation of Caravaggio, see Joffroy.

104 Eudel, IV, pp. 239–44.

105 See Albert Boime: 'Academic Yes, Decadent No', letter to *New York Times*, 28 September 1969.

106 John Rewald: 'Should Hoving be de-accessioned?' in *Art in America*, vol. 61, January 1973, pp. 24–30.

107 Pierre Schneider. 'The Age of Neo-Classicism: Notes on a Frozen Ideology' in *Encounter*, February 1973, pp. 59–63.

108 *L'Artiste*, 1841, IIeme série, tome 7, p. 354.

Books and Articles consulted

The following list is composed only of published works referred to in the course of this book: it is in no sense intended to constitute a bibliography covering the whole field. The editions of books cited are those which I have used, and are not necessarily the earliest. The use made of unpublished material is recorded in the relevant notes.

lhémar, Hélène. 'La vision de Vermeer par Proust, à travers Vaudoyer', *Gazette des Beaux-Arts*, 1966, pp. 291–302.

[Agar Ellis, George]. *Catalogue of the principal pictures in Flanders and Holland, 1822*, London, privately printed, 1826.

Agnew, Geoffrey. *Agnew's 1817–1967*, London 1967.

[Albert Memorial]. *Handbook to the Prince Consort National Memorial*, published by the authority of the Executive Committee, London 1872.

Alford, Henry. *Letters from Abroad*, London and Cambridge 1865.

Ames, Winslow. *Prince Albert and Victorian Taste*, London 1968.

Ancelot, Mme. *Les Salons de Paris – foyers éteints*, Paris 1858.

Andrews, Keith. *The Nazarenes – A Brotherhood of German Painters in Rome*, Oxford 1964.

Angrand, Pierre. *Le Comte de Forbin et le Louvre en 1819*, Paris 1972.

Antologia (di G. P. Viesseux) – *gli scritti d'arte*, per cura di Paola Barocchi, 4 vols., Florence 1975.

[Artaud de Montor]. *Considérations sur l'état de la peinture en Italie, dans les quatre siècles qui ont précédé celui de Raphael . . .*, deuxième édition, Paris 1811.

[Artaud de Montor]. *Peintres primitifs – collection de tableaux rapportée d'Italie et publiée par M. le Chevalier Artaud de Montor, membre de l'Institut, reproduite par nos premiers artistes, sous la direction de M. Challamel*, Paris 1843.

Art-Union, a monthly journal of the Fine Arts, 1839–48, after which year it is called *Art-Journal*.

[Arts and Manufactures]. *Report from the Select Committee on Arts and their connexion with Manufactures; with the minutes of evidence, appendix and index*, ordered by The House of Commons, to be Printed, 16 August 1836.

Auld, Alexander A. 'Some purchases by William Stirling of Keir', *Scottish Art Review*, XII, no. 3, 1970, pp. 18–22.

Auréas, Henri. *Un général de Napoléon: Miollis*, Paris 1961.

Bankes, Viola. *A Dorset heritage, the story of Kingston Lacy*, London 1953.

Barocchi, Paola. *Testimonianze e polemiche figurative in Italia: L'Ottocento – Dal Bello ideale al Preraffaelismo*, Messina-Florence 1972.

Barrès, Maurice. *Greco, ou le secret de Tolède*, Paris 1966.

Barry, James. *An Account of a series of Pictures, in the great room of the Society of Arts, Manufactures, and Commerce, at the Adelphi*, London, printed for the author, 1783.

Barry, James. *The Works*, 2 vols., London 1809.

Baschet, Robert. *E.-J. Delécluze, témoin de son temps, 1781–1863*, Paris 1942.

Baudelaire, Charles. *Correspondance*, texte établi, présenté et annoté par Claude Pichois avec la collaboration de Jean Ziegler, 2 vols., Paris (Pléiade), 1973.

Baudelaire, Charles. *Oeuvres complètes*, Paris (Pléiade), 1961.

Beaucamp, Fernand. *Le peintre lillois Jean-Baptiste Wicar (1762–1834) – son oeuvre et son temps*, 2 vols., Lille 1939.

Béguin, Sylvie, and Constans, Claire. 'Hommage à Louis La Caze (1798–1869) au Musée du Louvre', extrait de *La Revue du Louvre*, no. 2, 1969, pp. 1–20.

Benson, R. and E. *Catalogue of Italian pictures at 16 South Street, Park Lane, London and Buckhurst in Sussex collected by Robert and Evelyn Benson*, London, privately printed, 1914.

Benson, R. H. *The Holford Collection illustrated with one hundred and one plates selected from twelve illuminated manuscripts at Dorchester House and one hundred and seven pictures at Westonbirt in Gloucestershire*, London, privately printed, 1924.

Benson, R. H. *The Holford Collection – Dorchester*

House, 2 vols., Oxford 1927.

Bergeret, P.-N. *Lettres d'un artiste sur l'Etat des Arts en France, considérés sous les rapports politiques, artistiques, commerciaux et industriels*, Paris 1848.

Berry, Miss. *Extracts of the Journals and Correspondence of Miss Berry from the year 1783 to 1852*, edited by Lady Theresa Lewis, 3 vols., London 1865.

Bezodis, P. A. *Survey of London*, vol. 38, to be published for the Greater London Council, London 1975.

Binyon, Laurence. *The Art of Botticelli – an essay in pictorial criticism*, London and Glasgow 1913.

Blanc, Charles. *Les Trésors de l'Art à Manchester*, Paris 1857.

Blanc, Charles. *Histoire des Peintres de toutes les écoles: Ecole Française*, 3 vols., Paris 1862-3.

Blum, André. *Vermeer et Thoré-Bürger*, Geneva 1946.

Blumer, Marie-Louise. 'La mission de Denon en Italie (1811)', *Revue des Etudes Napoléoniennes*, vol. 38, 1934, pp. 237-57.

Boas, George. 'The Mona Lisa in the History of Taste', *Journal of the History of Ideas*, vol. 1, 1940, pp. 207-24.

Boime, Albert. 'Le Musée des Copies', *Gazette des Beaux-Arts*, 1964, pp. 237-47.

Boime, Albert. 'Academic Yes, Decadent No', letter to *New York Times*, 28 September 1969.

[Bonaparte, Lucien]. *Choix de Gravures à l'eau forte, d'après les peintures originales et les marbres de la galerie de Lucien Bonaparte – cent quarante deux gravures*, London 1812.

Borenius, T. 'The Rediscovery of the Primitives', *Quarterly Review*, CCXXXIX, April 1923, pp. 258-70.

Bossi, Giuseppe. *Del Cenacolo di Leonardo da Vinci*, Milan 1810.

Bouguereau, W. *Catalogue illustré des oeuvres*, Paris 1885.

Bourrienne. *Mémoires* (vol. 1, pp. 182-8: *Dilapidations en Italie*), 10 vols., Paris 1831.

Bowden, John Edward. *The Life and Letters of Frederick William Faber D.D., Priest of the Oratory of St. Philip Neri*, London 1869.

Boyer d'Agen. *Ingres d'aprés une Correspondance inédite*, Paris 1909.

Boyer, Ferdinand. *Le Monde des Arts en Italie et la France de la Révolution et de l'Empire*, Turin 1969.

Bray, Mrs. *Life of Thomas Stothard, R.A.*, London 1851.

Breton, Jules. *Nos peintres du siècle*, Paris, n.d. [1899].

Brigstocke, Hugh. 'James Dennistoun', *Connoisseur*, 1973, pp. 90-7 and 240-9.

[British Institution]. *An Account of all the pictures exhibited in the rooms of the British Institution, from 1813 to 1823, belonging to the Nobility and Gentry of England: with remarks, critical and explanatory*, London 1824.

Bruun-Neergard, T. C. 'Corrections et Additions pour un ouvrage de M. Fiorillo', *Magasin Encyclopédique*, 1806, vol. 3, pp. 332-59.

Buchanan, W. *Memoirs of Painting, with a chronological history of the Importation of Pictures by the Great Masters into England since the French Revolution*, 2 vols., London 1824.

Buisson, Jules. 'Jean-Baptiste Tiepolo et Dominique Tiepolo', *Gazette des Beaux-Arts*, 1895, II, pp. 177-86 and 293-304.

Bürger, W. [see also under Thoré, Théophile]. *Musées de la Hollande: Amsterdam et La Haye – Etudes sur l'école hollandaise*, Paris 1858 (referred to in Notes as *Musées*, I).

Bürger, W. *Musées de la Hollande, II, Musée Van der Hoop, à Amsterdam et Musée de Rotterdam*, Paris 1860.

Bürger, W. 'Exposition de tableaux de l'Ecole Française Ancienne tirés de collections d'amateurs', *Gazette des Beaux-Arts*, 1860, VII, pp. 257-77 and 333-58.

Bürger, W. *La Galerie Suermondt à Aix-la-Chapelle*, Brussels 1860.

Bürger, W. 'Galerie de MM. Pereire', *Gazette des Beaux-Arts*, 1864, XVI, pp. 193-213 and 297-317.

Bürger, W. *Trésors d'Art en Angleterre*, third edition, Paris 1865.

Bürger, W. *Van der Meer de Delft*, Paris 1866. Reprinted by André Blum (q.v.).

Bürger, W. *Salons – 1861 à 1868, avec une préface par T. Thoré*, 2 vols., Paris 1870.

Burgon, Rev. John W. *Letters from Rome to friends in England*, London 1862.

Burke, Edmund. *A Philosophical Enquiry into the Origin of our Ideas of the Sublime and Beautiful*, edited with an introduction and notes by J. T. Boulton, London 1958.

Burty, Philippe. 'Laurent Laperlier', *L'Art*, vol. XVI, 1879, pp. 147-52.

Byam-Shaw, James. 'The Biron Collection of Venetian Eighteenth Century Drawings at the Metropolitan Museum', *Metropolitan Museum Journal*, vol. 3, 1970, pp. 235-58.

Callcott, Maria. *Description of the chapel of the Annunziata dell'Arena; or Giotto's Chapel in Padua*, London 1835.

Callcott, Mrs. *Essays towards the history of painting*, London 1836.

Callcott, Lady. *Continuation of Essays towards the History of Painting*, London 1838.

Calvesi, M. 'La Tempesta di Giorgione come ritrovamento di Mosè', *Commentari*, 1962, pp. 226–55.

Cardigan and Lancastre, Countess of. *My Recollections*, London 1915.

Carrington, Dorothy. 'Cardinal Fesch, a Grand Collector', *Apollo*, 1967, pp. 346–57.

Carritt, David. 'Pictures from Gosford House', *Burlington Magazine*, 1957, pp. 343–4.

Champfleury. *Essai sur la vie et l'oeuvre des Le Nain Peintres Laonnois*, Laon 1850.

Champfleury. 'Nouvelles Recherches sur la Vie et l'Oeuvre des Frères Le Nain', *Gazette des Beaux-Arts*, 1860, II, pp. 173–85, 266–77, 321–32.

Chapman, J. M. and Brian. *The Life and Times of Baron Haussmann – Paris in the Second Empire*, London 1957.

Chastel, André. 'Le goût des "Préraphaélites" en France', in catalogue of the exhibition *De Giotto à Bellini*, Paris 1956.

Chatelain, Jean. *Dominique Vivant Denon et le Louvre de Napoléon*, Paris 1973.

Chennevières, Henry de. 'M. Eudoxe Marcille', *Gazette des Beaux-Arts*, 1890, 3ᵉᵐᵉ période, vol. IV, pp. 217–35 and 296–310.

Chennevières, Ph. de. 'Souvenirs d'un Directeur des Beaux-Arts' (extrait de *l'Artiste*), 5 parts, Paris 1883–9.

Chernowitz, Maurice Eugene. *Proust and Painting*, New York 1944.

Childe-Pemberton, William S. *The Earl Bishop – The Life of Frederick Hervey, Bishop of Derry, Earl of Bristol*, 2 vols., London 1924.

Clark, Colin. 'In search of Buchanan', *Scottish Art Review*, XII, 4, 1968, pp. 27–9.

Clarke, Reverend Edward Daniel. *The Life and Remains*, London 1824.

Collins, Wilkie. *Memoirs of the Life of William Collins, Esq., R.A., with selections from his Journals and Correspondence*, 2 vols., London 1848.

Colvin, H. M. (general editor). *History of the King's Works*, vol. VI, 1973 (by J. Mordaunt Crook and H. M. Port).

Compton, Michael. 'William Roscoe and Early Collectors of Italian Primitives', *Liverpool Bulletin*, No. 9, Walker Art Gallery Number, 1960–1, pp. 26–51.

Constable, John. *Discourses*, compiled and annotated by R. B. Beckett, Suffolk Records Society, vol. XIV, 1970.

Constantin, A. *Idées Italiennes sur quelques tableaux célèbres*, Florence 1840.

Cordié, Carlo. 'Le Annotazioni di Stendhal al "Del Cenacolo di Leonardo" di Giuseppe Bossi' reprinted in *Ricerche Stendhaliane*, Naples 1967, pp. 207–58.

Cossío, Manuel B. *El Greco, edición definitiva al cuidado de Natalia Cossío de Jimenez*, Barcelona 1972.

Courajod, Louis. *Alexandre Lenoir, son journal et le Musée des Monuments Français*, 3 vols., Paris 1878.

Crockford's Clerical Dictionary, 1876 and 1884.

Crowe, Sir Joseph. *Reminiscences of thirty-five years of my life*, London 1895.

Cunningham, Allan. *The Life of Sir David Wilkie*, 3 vols., London 1843.

Cutler, Maxine G. *Evocations of the Eighteenth Century in French Poetry 1800–1869*, Librairie Droz, Geneva 1970.

Dakyns, Janine R. *The Middle Ages in French Literature 1851–1900*, Oxford 1973.

Damiron, Suzanne. 'La Revue "L'Artiste": Histoire administrative, présentation technique. Gravures romantiques hors texte', *Bulletin de la Société de l'Histoire de l'Art Français*, 1951, pp. 131–42.

Davies, Martin. *National Gallery Catalogues – The Earlier Italian Schools*, London 1951.

Davies, Martin. *Rogier van der Weyden*, London 1972.

Delpech, M. S. *Examen raisonné des ouvrages de peinture, sculpture et gravure, exposés au Salon du Louvre en 1814*, Paris 1814.

Dennistoun, James. *Memoirs of the Dukes of Urbino, illustrating the arms, arts, and literature of Italy, from 1440–1630*, 3 vols., London 1851.

Dibdin, Rev. Tho. Frognall. *A Bibliographical Antiquarian and Picturesque Tour in France and Germany*, 3 vols., London 1821.

Dimier, Louis. 'Un mot sur l'Ecole Napolitaine', *Les Arts*, March 1909, pp. 19–32 and September 1909, pp. 18–29.

Dimier, Louis. 'Le Louvre Invisible', *Les Arts*, August 1912, pp. 2–22.

Dimier, Louis. *L'Art Français, textes réunis et présentés par Henri Zerner*, Paris (Miroirs de l'Art) 1965.

Drumont, Edouard. *La France Juive*, 32nd edition, Paris, n.d.

Dubois, J. J. *Description des tableaux faisant partie des collections de M. le C^te de Pourtalès-Gorgier*, Paris 1841.

Duplessis, Georges. 'La collection de M. Camille Marcille', *Gazette des Beaux-Arts*, 1876, 2^ème période, XIII, pp. 419–39.

[Duppa, Richard]. *Miscellaneous Observations and Opinions on the Continent*, London 1825.

Dussler, Luitpold. *Raphael – a critical catalogue of his Pictures, Wall-Paintings and Tapestries*, London 1971.

Dyce, William. *The National Gallery – its formation and management considered in a letter addressed, by permission, to H.R.H. the Prince Albert, K.G.*, London 1853.

Earland, Ada. *John Opie and his circle*, London 1911.

Eastlake, Charles Lock. *Contributions to the Literature of the Fine Arts*, London 1848 (referred to as Eastlake, I).

Eastlake, Charles Lock: *Contributions to the Literature of the Fine Arts, second series – with a memoir compiled by Lady Eastlake*, London 1870 (referred to as Eastlake, II).

Eastlake, Lady. *Journals and Correspondence*, edited by her nephew Charles Eastlake Smith, 2 vols., London 1895.

[Elgin]. *Report from the Select Committee of the House of Commons on the Earl of Elgin's Collection of Sculptured Marbles*, London 1816.

Emden, Paul H. *Money Powers of Europe in the Nineteenth and Twentieth Centuries*, London 1937.

Émile-Mâle, Gilberte. 'Jean-Baptiste-Pierre Le Brun (1748–1813) – son role dans l'histoire de la restauration des tableaux du Louvre', *Mémoires de la Fédération des Sociétés Historiques et Archéologiques de Paris et de l'Ile-de-France*, VIII, 1956, pp. 371–417.

Ettlinger, L. 'A German Architect's visit to England in 1826', *Architectural Review*, 1945, vol. 97, pp. 131–4.

Eudel, Paul. *L'Hôtel Drouot et la Curiosité*, 9 vols., Paris 1885–91.

Faber, Frederick William. *Sights and Thoughts in Foreign Churches and among Foreign Peoples*, London 1842.

Fahy, Everett, and Watson, Sir Francis. *The Wrightsman Collection, vol. V: Paintings, Drawings, Sculpture*, New York 1973.

Falconieri, Carlo. *Vita di Vincenzo Camuccini*, Rome 1875.

Farington, Joseph. *The Farington Diary*, edited by James Greig, 8 vols., London 1922–8.

Félibien, M. *Entretien sur les vies et sur les ouvrages des plus excellens peintres anciens et modernes*, new edition, 5 vols., London 1705.

Ferrey, Benjamin. *Recollections of A. N. Welby Pugin, and his father, Augustus Pugin; with Notices of their works, with an appendix by E. Sheridan Purcell, Esq.*, London 1861.

Firmenich-Richartz, E. *Die Brüder Boisserée*, Jena 1916.

Flaxman, John. *Lectures on Sculpture*, new edition, London 1865.

Fleming, John. 'Art Dealing and the Risorgimento – I', *Burlington Magazine*, 1973, pp. 4–16.

Ford, Brinsley. 'The Earl-Bishop: an eccentric and capricious patron of the arts', *Apollo*, 1974, pp. 426–34.

Ford, Richard. *A Hand-Book for Travellers in Spain and readers at home . . .*, London 1845 (reprinted in 3 vols. by Centaur Press, London 1966).

Ford, Richard. *The Letters*, edited by Rowland E. Prothero, London 1905.

[Richard Ford in Spain]: a loan exhibition, with introduction by Denys Sutton and catalogue by Brinsley Ford, Wildenstein Gallery, London 1974.

Foucart, Bruno. 'La fortune critique d'Alexandre Lenoir et du premier musée des monuments français', *L'Information d'Histoire de l'Art*, 14^ème année, 1969, no. 5, pp. 223–32.

Frankl, Paul. *The Gothic: Literary sources and interpretations through eight centuries*, Princeton 1960.

Fried, Michael. 'Manet's Sources – Aspects of his Art, 1859–1865', *Art Forum*, March 1969, pp. 28–79.

Frith, W. P. *My Autobiography and Reminiscences*, 3 vols., 3rd edition, London 1887.

Fromentin, Eugène. *Les Maîtres d'autrefois*, présentation et notes de Jacques Foucart, Paris 1965.

Fry, Roger. *Letters*, edited, with an introduction, by Denys Sutton, 2 vols., London 1972.

Gallet, Michel. 'La maison de Madame Vigée-Lebrun, Rue du Gros-Chenet', *Gazette des Beaux-Arts*, 1960, pp. 275–84.

Garnault, Dr Paul. *Les Portraits de Michelange*, Paris 1913.

Gault de Saint-Germain, P.-M. *Les Trois Siècles de la Peinture en France*, Paris 1808.

Gault de Saint-Germain, P.-M. *Choix des Productions de l'Art les plus remarquables exposées dans le Salon de 1819*, Paris [1819].

Gautier, Théophile. *Voyage en Espagne*, Paris 1879.

Gere, John. 'William Young Ottley as a collector of drawings', *British Museum Quarterly*, vol. XVIII, no. 2, June 1953, pp. 44–53.

Gerson, H. (revised by). *Rembrandt – The complete edition of the paintings*, by A. Bredius, London 1969.

Gibbon, Edward. *Journey from Geneva to Rome. His Journal from 20 April to 2 October 1764* – edited by Georges A. Bonnard, London 1961.

Gilchrist, Alexander. *Life of William Blake, 'Pictor Ignotus'*, 2 vols., London 1863.

Goethe, J. W. von. *Werke*, 14 vols., Hamburg (Christian Wegner Verlag), 1949–60.

Goethe, J. W. de. *Observations on Leonardo da Vinci's celebrated picture of The Last Supper*, translated from the German, and accompanied with an introduction and a few notes, by G. H. Noehden, Lld D., F.R.S., etc. London 1821.

Goethe. *Italian Journey*, London (Penguin), 1970.

Gombrich, E. H. *Ideas of Progress and their Impact on Art*, The Cooper Union School of Art and Architecture, 1971.

Goncourt, Edmond et Jules de. *Journal – Mémoires de la Vie Littéraire*, 4 vols., Paris 1956.

Gotch, R. B. *Maria, Lady Callcott*, London 1937.

Gould, Cecil. *National Gallery Catalogues – The sixteenth-century Venetian School*, London 1959.

Gould, Cecil. *National Gallery Catalogues – The sixteenth-century Italian Schools (excluding the Venetian)*, London 1962.

Gould, Cecil. *Trophy of Conquest: The Musée Napoléon and the creation of the Louvre*, London 1965.

Grandjean, Serge. *Inventaire après décès de l'Impératrice Joséphine à Malmaison*, Paris 1964.

Granet, F. M. *Vie de Granet – écrite par lui-même et publiée dans 'Le Temps'*, 28 September–27 October 1872; ms. in Bibliothèque Doucet, Paris.

Grate, Pontus. *Deux critiques d'art de l'époque romantique*, Stockholm 1959.

Graves, Algernon. *A Century of Loan Exhibitions, 1813–1912*, London 1913–15 (reprinted in 3 vols., Bath 1970).

Greathead, Bertie. *An Englishman in Paris – 1803*, edited by J. P. T. Bury and J. C. Barry, London 1953.

Grigson, Geoffrey. *Samuel Palmer – The visionary years*, London 1947.

Grinten, E. F. van der. 'Consistent formal distortions and peculiarities in 19th century art historical reproductions: Iconologia formalis', *Nederlands Kunsthistorisch Jaerboek*, no. 15, 1964, pp. 247–60.

Grosskurth, Phyllis. *John Addington Symonds – A biography*, London 1964.

Guillaumie-Reicher, Gilberte. *Théophile Gautier et l'Espagne*, Paris, n.d.

Guinard, Paul. *Dauzats et Blanchard peintres de l'Espagne romantique*, Paris 1967.

Guinard, Paul. 'Zurbarán et la "découverte" de la peinture espagnole en France sous Louis-Philippe', *Hommage à Ernest Martinenche*, Paris, n.d.

Guzmán, Juan Pérez de. 'Las colecciones de cuadros del Príncipe de la Paz', *La España Moderna*, año 12, núm 140, pp. 95–126.

Hale, J. R. *England and the Italian Renaissance*, London 1963.

Halévy, F. 'Notice sur la vie et les ouvrages de Paul Delaroche', *Annuaire des Artistes et des Amateurs*, publié par M. Paul Lacroix, 1860, pp. 213–39.

Hall, S. C. *Retrospect of a Long Life from 1815 to 1883*, 2 vols., London 1883.

Hamerton, P. G. *Painting in France after the decline of Classicism*, London 1869.

Handbook to the Gallery of British Paintings in the Art Treasures Exhibition – being a reprint of critical notices originally published in 'The Manchester Guardian', London 1857.

Harmand, C. *Manuel de l'Amateur des Arts dans Paris, pour 1824*, Paris 1824.

Harris, Enriqueta: 'Sir William Stirling-Maxwell and the History of Spanish Art', *Apollo*, 1964, pp. 73–7.

Haskell, F. 'Tiepolo e gli artisti del secolo XIX', *Civiltà Europea e Civiltà Veneziana* (edited by V. Branca), *Sensibilità e razionalità nel Settecento*, I, pp. 481–97, Florence 1967.

Haskell, F. 'Francesco Guardi and the nineteenth century', *Problemi Guardeschi*, pp. 58–61, Venice 1967.

Haskell, F. 'Giorgione's *Concert Champêtre* and its admirers', *Journal of the Royal Society for the Encouragement of Arts, Manufacture and Commerce*, 1971, pp. 543–55.

Haskell, F. 'The Sad Clown: some notes on a 19th century myth', *French 19th century painting and literature* (edited by Ulrich Finke), pp. 2–16, Manchester 1972.

Haskell, F. 'Un martyr de l'attribution: Morris Moore et l'*Apollon et Marsyas* du Louvre', *Revue de l'Art*, 1978, pp. 77–88.

Hautecoeur, Louis. 'L'Histoire de l'Art en France', *Revue de l'Art*, 1–2, 1968, pp. 127–8.

Havard, Henry. 'Johannes Vermeer, dit Van der Meer de Delft', *Gazette des Beaux-Arts*, 1883, I, pp. 389–99, and II, pp. 213–24.

Hawthorne, Nathaniel. *The English Notebooks*, edited by Randall Stewart, New York and Oxford 1941.

Haydon, Benjamin Robert. *The Diary* (edited by W. B. Pope), 2 vols., Cambridge, Mass., 1960.

Hazlitt, William. *The Complete Works*, edited by P. P. Howe, 21 vols., London 1930–4.

Herrmann, Frank. 'Mrs. Jameson's "Companion to the most celebrated private galleries of art in London"', *Connoisseur*, 1966, vol. 162, pp. 31–5 and 102–6.

Herrmann, Frank. 'Who was Solly?', *Connoisseur*, 1967, vol. 164, pp. 229–34; vol. 165, pp. 12–18 and pp. 153–61; vol. 166, pp. 10–18; 1968, vol. 169, pp. 12–17.

Herrmann, Frank. *The English as Collectors*, London 1972.

Heydenreich, Ludwig H. *The Last Supper*, London 1974.

Horne, Herbert. *Alessandro Filipepi, commonly called Sandro Botticelli, Painter of Florence*, London 1907.

Houghton, Lord. 'Edward Cheney – In Memoriam', *Miscellanies of the Philobiblon Society*, vol. xv, 1877–84, pp. 1–18.

Howitt, Mary. *An Autobiography*, edited by her daughter Margaret Howitt, 2 vols., London 1889.

Huard, E. T. *Histoire de la Peinture Italienne, depuis Prométhée jusqu'à nos jours*, Paris 1834.

Hubert, Gérard. *La Sculpture dans l'Italie Napoléonienne*, Paris 1964.

Huyghe, René. 'Vermeer et Proust', *Amour de l'Art*, 1936.

Huysmans, J. K. *Trois Primitifs*, Paris 1967.

Ingres. Catalogue of exhibition held at the Petit Palais, Paris 1967–8.

Inventaire Général des Richesses d'Art de la France – Archives du Musée des Monuments Français, Paris 1ère partie, 1883; 2ème partie, 1886; 3ème partie, 1897.

Irwin, David. 'Flaxman's Italian Journals and Correspondence', *Burlington Magazine*, 1959, pp. 212–17.

Ivins, William M. *Prints and Visual Communication*, New York 1953.

James, Henry. *William Wetmore Story and his friends – from letters, diaries, and recollections*, New York 1903 (reprinted London, Thames and Hudson, n.d.).

Jameson, Mrs. *Companion to the most celebrated private galleries of art in London*, London 1844.

Joffroy, Berne. *Le dossier Caravage*, Paris 1959.

John G. Johnson Collection. Catalogue of Flemish and Dutch Paintings, Philadelphia 1972.

Joseph, M. K. 'Charles Aders', *Auckland University College Bulletin*, no. 43, English series no. 6, 1953.

Jowell, Frances Suzman. 'Thoré-Bürger and the Revival of Frans Hals', *Art Bulletin*, 1974, pp. 101–17.

Keynes, Geoffrey. *Blake Studies – Essays on his life and work*, 2nd edition, Oxford 1971.

King, Anthony. 'George Godwin and the Art Union', *Victorian Studies*, VIII, 1964, pp. 101–30.

Klenze, Camillo von. 'The Growth of Interest in the Early Italian Masters', *Modern Philology*, IV, October 1906, pp. 207–68.

Klingender, F. D. 'Géricault as seen in 1848', *Burlington Magazine*, 1942, pp. 254–6.

Knox, George. *Catalogue of the Tiepolo Drawings in the Victoria and Albert Museum*, London (H.M.S.O.), 1960.

Koch, Georg Friedrich. *Die Kunstausstellung – Ihre Geschichte von den Anfängen bis zum Ausgang des 18. Jahrhunderts*, Berlin 1967.

Laderchi, C. *Descrizione della Quadreria Costabili*, 2 vols., Ferrara 1838–9.

Lamennais, F. *Esquisse d'une Philosophie*, 4 vols., Paris 1840–6.

Lamy, M. 'La découverte des primitifs italiens au XIXᵉ siècle: Seroux d'Agincourt (1730–1814) et son influence sur les collectionneurs, critiques et artistes français', *Revue de L'Art ancien et moderne*, vol. 39, 1921, pp. 169–81, and vol. 40, 1921, pp. 182–90.

Landon, C. P. *Vies et Oeuvres des peintres les plus célèbres de toutes les écoles*, 25 vols., Paris 1813–20.

Lapauze, Henry (editor). *Procès-verbaux de la Commune Générale des Arts de Peinture, Sculpture, Architecture et Gravure . . . et de la Société Populaire et Républicaine des Arts . . . publiés*

intégralement pour la première fois, Paris 1903.

Lapauze, Henry. *Histoire de l'Académie de France à Rome*, 2 vols., Paris 1924.

La Tour, Georges de. Catalogue of exhibition held in Paris, May–September 1972.

Lavice, A. *Revue des Musées d'Italie – catalogue raisonné des peintures et sculptures exposées dans les galeries publiques et particulières et dans les églises*, Paris 1862.

Law, Henry William and Irene. *The Book of the Beresford Hopes*, London 1925.

Lebel, Gustave. 'Bibliographie des Revues et Périodiques d'Art parus en France de 1746 à 1914', *Gazette des Beaux-Arts*, 1951, I, pp. 5–64.

Lebrun, J.-B.-P. *Almanach historique et raisonné des architectes, peintres, sculpteurs, graveurs et ciseleurs*, année 1776 et année 1777, Geneva (Minkoff reprint) 1972.

Lebrun, J.-B.-P. *Galerie des Peintres Flamands, Hollandais et Allemands*, Paris, vols 1 and 2, 1792; vol. 3, 1796.

Lebrun, J.-B.-P. *Précis historique de la vie de la Citoyenne Le Brun peintre. . . . A Paris, gratis – An deuxième de la République Française, Une et Indivisible.*

Lebrun, J.-B.-P. *Catalogue d'objets rares et curieux, provenant du Cabinet et fond de Marchandises . . . par cessation de commerce* [Lugt 7152], Paris 1806.

Lebrun, J.-B.-P. *Recueil de gravures au trait, à l'eau forte et ombrées d'après un choix de tableaux de toutes les écoles, recueillis dans un voyage fait en Espagne, au Midi de la France et en Italie, dans les années 1807 et 1808*, 2 vols., Paris 1809.

Lebrun, J.-B.-P. *Choix des Tableaux les plus capitaux de la rare et précieuse collection recueillie dans l'Espagne et dans l'Italie, par M. Lebrun, dans les années 1807 et 1808*, Paris 1810.

Lebrun, Mme Vigée. *Souvenirs*, 2 vols., Paris, n.d. [1869?].

Lecarpentier, C. *Galerie des Peintres Célèbres, avec des remarques sur le genre de chaque maître*, 2 vols., Paris 1821.

Lechi, Fausto. *I quadri delle Collezioni Lechi in Brescia – storia e documenti*, Florence 1968.

Lemonnier, Henry. 'La peinture murale de Paul Delaroche à l'Hemicycle de l'Ecole des Beaux-Arts', *Gazette des Beaux-Arts*, 1917, vol. XIII, pp. 173–82.

Levey, Michael. 'Botticelli and Nineteenth-Century England', *Journal of the Warburg and Courtauld Institutes*, vol. 23, 1960, pp. 291–306.

Liddon, Henry Parry. *Life of Edward Bouverie Pusey*, 4 vols., London 1893–7.

Lindsay, Lord. *Sketches of the History of Christian Art*, 3 vols., London 1847.

Lipschutz, Ilse Hempel. *Spanish Painting and the French Romantics*, Harvard University Press, 1972.

Longhi, Roberto. *Piero della Francesca*, Florence 1963.

López-Rey, José. *Velázquez – a catalogue raisonné of his oeuvre*, London 1963.

Lorrain, Jean. *Monsieur de Bougrelon*, Paris 1897.

Lugt, Frits. *Les Marques de Collections de Dessins et d'Estampes . . .*, Amsterdam 1921.

Lugt, Frits. *Répertoire des Catalogues de Ventes Publiques intéressant l'art ou la curiosité*, 3 vols. published, The Hague, 1938, 1953, 1964.

Lutyens, Mary. *Effie in Venice – Unpublished letters of Mrs. John Ruskin written from Venice between 1849–1852*, London 1965.

Lyonnet, Abbé. *Le Cardinal Fesch archevêque de Lyon, primat des Gaules, etc., etc.*, 2 vols., Lyon and Paris 1841.

MacLaren, Neil. *National Gallery Catalogues – The Spanish School*, London 1952.

MacLaren, Neil. *National Gallery Catalogues – The Dutch School*, London 1960.

[Mahon, Denis]. *Il Guercino – catalogo critico dei dipinti*, Bologna 1968.

Maingot, Eliane. *Le Baron Taylor*, Paris 1963.

Malins, Edward. *Samuel Palmer's Italian Honeymoon*, London 1968.

Mantz, Paul. *Salon de 1847*, Paris 1847.

Marguery, H. 'Un pionnier de l'histoire de l'art: Thoré-Bürger', *Gazette des Beaux-Arts*, 1925, I, pp. 229–45; 295–311; and 367–80.

Marmottan, Paul. *Les Arts en Toscane sous Napoléon – La Princesse Elisa*, Paris 1901.

Martin, Carew. 'The last of the Venetian masters: Giovanni Battista Tiepolo', *Art-Journal*, 1899, pp. 334–8.

McCoubrey, John W. 'The Revival of Chardin in French Still-Life Painting, 1815–1870', *Art Bulletin*, 1964, pp. 39–53.

Melchiori, Giorgio. *Michelangelo nel Settecento Inglese – un capitolo di storia del gusto in Inghilterra*, Rome 1950.

Meltzoff, Stanley. 'The Rediscovery of Vermeer', *Marsyas*, II, 1942, pp. 145–66.

Meltzoff, Stanley. 'The Revival of the Le Nains', *Art Bulletin*, 1942, pp. 259–86.

Michelet, Jules. *Journal* (vol. I, 1828–48), ed. by Paul Viallaneix, Paris 1959.

Millar, Oliver. *Introduction to Exhibition of Dutch*

Pictures from the Royal Collection, London
1971–2.

[Miollis]. *Indicazione delle sculture, e della Galleria de'
quadri esistenti nella Villa Miollis al Quirinale*,
Rome 1814.

Mirimonde, A. P. de. 'Les opinions de M. Lebrun
sur la peinture hollandaise', *Revue des Arts*,
6ème année, vol. IV, 1956, pp. 207–14.

Mirimonde, A. P. de. 'Les dépenses d'art des
Impératrices Joséphine et Marie-Louise',
Gazette des Beaux-Arts, 6ème période, vol. 50,
1957, pp. 89–107.

Moffett, Kenworth. *Meier-Graefe as art critic*,
Munich 1973.

[Mongan, Agnes]. *Ingres Centennial Exhibition
1867–1967*, Harvard University 1967.

Montalembert, Le Comte de. *Du Vandalisme et du
Catholicisme dans l'Art*, Paris 1839.

Montalembert, Le Comte de: *Mélanges d'Art et de
Littérature*, Paris 1861.

[Moore, Morris]. *The Abuses of the National Gallery
with the letters of 'A.G.', of 'The Oxford
Graduate'; The Defence of Mr. Eastlake, in 'The
Daily News,' etc., etc., and Remarks upon
them. By Verax. To which are added, Observa-
tions on The Minutes of the Trustees of The
National Gallery, including Mr. Eastlake's
Report. By Verax*. London (William Pickering,
177 Piccadilly), 1847.

Moore, Morris. *Raphael's 'Apollo and Marsyas' – A
European Scandal*, 2nd edition, Rome (Tipo-
grafia Tiberina) 1885.

Moore, Thomas. *Memoirs, Journal, and Correspon-
dence*, edited by the Right Honourable Lord
John Russell M.P., 8 vols., London 1853.

Morassi, Antonio. *A Complete Catalogue of the
Paintings of G. B. Tiepolo*, London 1962.

Morawska, Hanna. *Kłopoty Krytyka: Thoré-Bürger
Wśród Prądów Epoki (1855–1869)*, Wrocław–
Warsaw–Crakow 1970.

Moreau-Nélaton, Etienne. *Bonvin raconté par lui-
même*, Paris 1927.

Moretti, Lino. *G. B. Cavalcaselle: Disegni da
antichi maestri – catalogo della mostra*, Venice/
Verona 1973.

Morgan, Lady. *France*, 4th edition with additional
notes; 2 vols., London 1818.

Morgan, Lady. *Italy*, a new edition, 3 vols.,
London 1821.

Munby, A. N. L. *Connoisseurs and Medieval
Miniatures, 1750–1850*, Oxford 1972.

[Murray's]. *Handbook for Travellers in Northern Italy*,
London 1842.

[Murray's]. *Handbook for Travellers in Durham and
Northumberland*, London 1864.

[National Gallery]. *Report from the Select Committee
on the National Gallery with Minutes of
Evidence, Appendix, and Index, 1852–3.*

[National Gallery.] *Report of the National Gallery
Site Commission, together with the Minutes,
Evidence, Appendix, and Index*, 1857.

Newman, John Henry. *Letters and Diaries*, edited
by Charles Stephen Dessain, 26 vols. published
1961–73 ff.

Nicolson, Benedict. 'The Sanford Collection',
Burlington Magazine, 1955, pp. 207–14.

Noble Patronage. An exhibition devoted to the
activity of the Percy family, Earls and Dukes
of Northumberland, as collectors and patrons
of the arts, organized by the Department of
Fine Art, The University of Newcastle upon
Tyne, The Hatton Gallery 1963.

[Northbrook.] *A descriptive catalogue of the collection
of pictures belonging to the Earl of Northbrook*,
by W. H. James Weale and Jean Paul Richter,
London 1889.

Ormond, Leonée. *George Du Maurier*, London
1969.

Ottley, William Young. *Engravings of the most noble
the Marquis of Stafford's collection of pictures in
London . . . the executive part under the manage-
ment of Peltro William Tomkins, Esq.*, 4 vols.,
London 1818.

Ottley, William Young. *The Italian School of
Design: being a series of facsimiles of Original
Drawings by the most eminent painters and
sculptors of Italy; with biographical notices of the
artists and observations on their works*, London
1823.

Ottley, William Young. *A Series of Plates engraved
after the paintings and sculptures of the most
eminent masters of the early Florentine school . . .*,
London 1826.

Padovani, Corrado. *La critica d'arte e la pittura
ferrarese*, Rovigo 1954.

*Paris Guide – par les principaux écrivains et artistes de
la France*, 2 vols., Paris 1867.

Passavant, J. D. *Tour of a German Artist in England,
with notices of private galleries, and remarks on
the state of art*, 2 vols., London 1836.

Pater, Walter. *Studies in the History of the Renais-
sance*, London 1873.

Pater, Walter. *Letters*, edited by Lawrence Evans,
Oxford 1970.

Pélissier, Léon-G. *Le portefeuille de la Comtesse d'Albany (1806–1824) – lettres mises en ordre et publiées, avec un portrait*, Paris 1902.

[Penrice.] *Letters addressed to the late Thomas Penrice, Esq., while engaged in forming his collection of pictures 1808–1814*, Yarmouth n.d.

Pepper, D. Stephen. 'Guido Reni's Early Style: His activity in Bologna, 1595–1601', *Burlington Magazine*, 1969, pp. 472–83.

Pescarzoli, Antonio. *I Libri di Viaggio e le guide della raccolta Luigi Vittorio Fossati Bellani*, 3 vols., Rome 1957.

Pevsner, Nikolaus, and Lang, S. 'The Doric Revival' (1948), and 'The Egyptian Revival' (1956), reprinted in Nikolaus Pevsner, *Studies in Art, Architecture and Design – Volume I, From Mannerism to Romanticism*, London 1968.

Phillips, Thomas. *Lectures on the History and Principles of Painting*, London 1833.

Piétri, François. *Lucien Bonaparte*, Paris 1939.

[Piles, Roger de.] *Conversations sur la Connoissance de la Peinture, et sur le Jugement qu'on doit faire des Tableaux*, Paris 1677.

Pissarro, Camille. *Lettres à son fils Lucien, présentées, avec l'assistance de Lucien Pissarro, par Jean Rewald*, Paris 1950.

Pointon, Marcia R. 'The Italian Tour of William Hilton R.A. in 1825', *Journal of the Warburg and Courtauld Institutes*, XXXV, 1972, pp. 339–58.

Pope-Hennessy, John. *Fra Angelico*, London (Phaidon) 1952.

Pope-Hennessy, John, assisted by Lightbown, Ronald. *Catalogue of Italian Sculpture in the Victoria and Albert Museum*, 3 vols., London 1964.

Portalis, Roger. 'La collection Walferdin et ses Fragonard', *Gazette des Beaux-Arts*, 1880, I, pp. 297–322.

Posner, David. ' Watteau melancolique: la formation d'un mythe', *Bulletin de la Société de l'Histoire de l'Art Français*, 1973, pp. 345–61.

Praz, Mario. *The Romantic Agony*, translated from the Italian by Angus Davidson, London 1933.

Previtali, Giovanni. *La fortuna dei primitivi dal Vasari ai neoclassici*, Turin 1964.

Previtali, Giovanni. *Mostra di Disegni di D. P. Humbert de Superville – saggio introduttivo*, Gabinetto Disegni e Stampe degli Uffizi, XIX, 1964.

Proudhon, P. J. *Du principe de l'Art et de sa destination sociale*, Paris 1865.

Quatremère de Quincy. 'Voyage Pittoresque dans le Bocage de la Vendée, ou Vues de Clisson . . . publiées par C. Thiénon, peintre; gravées à l'acqua tinta par Piringer', *Journal des Savants*, 1817, pp. 418–23.

Quinet, Edgar. *Oeuvres Complètes – Tome 6: Les Roumains; Allemagne et Italie, Mélanges*, Paris 1857.

Raguenet, François. *Les Monumens de Rome, ou descriptions des plus beaux ouvrages de peinture, de sculpture et d'architecture qui se voyent à Rome, et aux environs, etc.*, Amsterdam 1701.

Redford, George. *Art Sales. A History of Sales of Pictures and other works of art . . .*, 2 vols., London 1888.

Reiset, F. *Notice des tableaux légués au Musée National du Louvre par M. Louis La Caze*, Paris 1878.

Reitlinger, Gerald. *The Economics of Taste: the rise and fall of picture prices, 1760–1960*, London 1961.

Reynolds, Sir Joshua. *Discourses on Art*, edited by Robert R. Wark, Huntington Library, San Marino, California 1959.

Ricci, Corrado. *La pinacoteca di Brera*, Bergamo 1907.

Richer, Ed. *Voyage à Clisson*, 4th edition, Paris 1823.

Rio, A.-F. *De la poésie chrétienne dans son principe, dans sa matière et dans ses formes; Forme de l'Art*, Seconde Partie, Paris 1836.

Rio, A.-F. *De l'Art Chrétien, nouvelle édition entièrement refondue et considerablement augmentée*, 3 vols., Paris 1861.

Roberts, Helene E. 'British Art Periodicals of the Eighteenth and Nineteenth Centuries', *Victorian Periodicals Newsletter*, Number 9, July 1970.

Robinson, J. C. *Catalogue of the Various Works of Art forming the collection of Matthew Uzielli, Esq. of Hanover Lodge, Regent's Park, London*, London 1860.

Robinson, J. C. *Catalogue of the Works of Art forming the collection of Robert Napier, of West Shandon, Dumbartonshire*, London, privately printed, 1865.

Robinson, J. C. *Memoranda on Fifty Pictures, selected from a Collection of Works of the Ancient Masters. With Notices of some Italian, Spanish, German, Flemish and Dutch Painters*, London, privately printed, 1868.

Robinson, J. C. 'The gallery of pictures by the Old Masters, formed by Francis Cook, Esq., of

Richmond', *Art-Journal*, 1885, pp. 133–7.

Rochefort, Henri. *Les Aventures de ma Vie*, 5 vols., Paris 1896.

Roehn, Ch. *Physiologie du Commerce des Arts, suivie d'un traité sur la Restauration des Tableaux*, Paris 1841.

Romney, Rev. John. *Memoirs of the Life and Works of George Romney, including various letters, and testimonies to his genius, &c.*, London 1830.

Rosenblum, Robert. *Transformations in late Eighteenth Century Art*, Princeton 1967.

Rosenthal, Léon. *Sandro Botticelli et sa réputation à l'heure présente*. Dijon 1897.

Rossetti, Dante Gabriel. *Letters*, edited by Oswald Doughty and John Robert Wahl, 4 vols. published, Oxford 1965–7.

Röthlisberger, Marcel. *Claude Lorrain – The Paintings*, 2 vols., London 1961.

Rouchès, G. 'Les premières publications françaises sur la peinture espagnole', *Bulletin de la Société de l'Histoire de l'Art Français*, 1930, pp. 35–48.

Rouchès, G. 'Supplément d'information sur Frédéric Quilliet', *Bulletin de la Société de l'Histoire de l'Art Français*, 1931, pp. 90–4.

Ruskin, John. *The Works*, edited by Cook and Wedderburn, 39 vols., London (Library Edition) 1903–12.

Ruskin, John. *The Diaries*, selected and edited by Joan Evans and John Howard Whitehouse, 3 vols., Oxford 1956–9.

Ruskin in Italy: letters to his parents 1845, edited by Harold I. Shapiro, Oxford 1972.

Salas, Xavier de. 'La valoración del Greco por los Románticos Españoles y Franceses', *Archivo Español de Arte*, 1941, pp. 397–406.

Salerno, Luigi. 'The Picture Gallery of Vincenzo Giustiniani', *Burlington Magazine*, 1960, pp. 21–7; 93–104; 135–50.

Sandby, William. *The History of the Royal Academy of Arts from its foundation in 1768 to the present time – with biographical notices of all the members* 2 vols., London 1862.

Saunier, Charles. *Les Conquêtes Artistiques de la Révolution et de l'Empire*, Paris 1902.

Saxl, F. 'Three "Florentines": Herbert Horne, A. Warburg, Jacques Mesnil', republished in *Lectures*, 2 vols., London (The Warburg Institute), 1957.

Scheller, R. W. 'The case of the stolen Raphael drawings', *Master Drawings*, vol. XI, no. 2, 1973, pp. 119–37.

Schlegel, Friedrich. *Kritische Ausgabe seiner Werke*, herausgegeben von Ernst Behler, 12 vols., Zürich 1958–71.

Schlegel, Frederick von. *The Aesthetic and Miscellaneous Works*, translated from the German by E. J. Millington, London 1849.

Schlosser-Magnino, Julius. *La letteratura artistica*, seconda edizione italiana aggiornata da Otto Kurz, Florence-Vienna 1956.

Schneider, René. *Quatremère de Quincy et son intervention dans les arts (1788–1830)*, Paris 1910.

Seling, Helmut. 'The genesis of the Museum', *Architectural Review*, 1967, pp. 103–13.

Schnapper, Antoine. *Jean Jouvenet et la peinture d'histoire à Paris*, Paris 1974.

Selvatico, P. *Storia Estetico-Critica delle Arti del Disegno, ovvero l'Architettura, la Pittura e la Statuaria considerate nelle correlazioni fra loro e negli svolgimenti storici, estetici e tecnici; lezioni dette nella I.R. Accademia di Belle Arti in Venezia*, Venice, 2 vols., 1852–6.

Sensier, Alfred. *Etudes sur Georges Michel*, Paris 1873.

Seroux d'Agincourt, J. B. L. G. *Histoire de l'Art par les monumens, depuis sa décadence au IV^e siècle jusqu'à son renouvellement au XVI^e siècle*, 6 vols., Paris 1823.

Seymour, Rev. M. Hobart. *A Pilgrimage to Rome*, London 1848.

Shee, Martin Archer. *Elements of Art, A Poem; in six cantos; with Notes and a Preface; including strictures on the state of the arts, criticism, patronage, and public taste*, London 1809.

Shelley, Lady. *The diary of Frances Lady Shelley 1787–1817*, edited by her grandson Richard Edgcumbe, 2 vols., London 1912.

Simches, Seymour O. *Le Romantisme et le goût esthétique du XVIII^e siècle*, Paris 1964.

Smith, John. *A catalogue Raisonné of the works of the most eminent Dutch, Flemish, and French painters . . .*, 8 parts, London 1829–42.

Starke, Mariana. *Travels in Italy, between the years 1792 and 1798*, 2 vols., London 1802.

Starke, Mariana. *Letters from Italy . . .*, second edition, 2 vols., London 1815.

Starke, Mariana. *Information and directions for Travellers on the Continent*, 6th edition, 2 vols. in one, Leghorn 1825.

Starke, Mariana. *Travels in Europe, for the use of Travellers on the Continent, and likewise in the Island of Sicily*, 9th edition, considerably enlarged and embellished with a map, Paris 1839.

Steegman, John. 'Lord Lindsay's "History of Christian Art"', *Journal of the Warburg and Courtauld Institutes*, vol. 10, 1947, pp. 123–31.

Steegman, John. *Consort of Taste 1830–1870*, London 1950.

Steinman, Ernst. *Die Portraitdarstellungen des Michelangelo*, Leipzig 1913.

Stendhal. *Histoire de la Peinture en Italie*, texte établi et annoté avec préface et avant-propos par Paul Arbelet, 2 vols., Paris 1924.

Stendhal. 'Salon de 1824', *Mélanges d'Art*, Paris (Le Divan) 1932.

Stendhal. *Voyages en Italie*, textes établis, présentés et annotés par V. del Litto, Paris (Pléiade) 1973.

Stirling, William. *Annals of the Artists of Spain*, 3 vols., London 1848.

Story, Alfred T. *The Life of John Linnell*, 2 vols., London 1892.

Stubblebine, James H. *Guido da Siena*, Princeton 1964.

Sulzberger, Suzanne. 'Les premières reproductions graphiques du rétable de l'Agneau mystique', *Gazette des Beaux-Arts*, 1958, pp. 313–18.

Sulzberger, Suzanne. *La réhabilitation des primitifs flamands 1802–1867*, Brussels 1961.

Symonds, John Addington. *Renaissance in Italy* [including *The Catholic Reaction*] 6 vols., London 1875–86.

Taillasson. *Observations sur quelques grands peintres, dans lesquelles on cherche à fixer les caractères distinctifs de leur talent, avec un précis de leur vie*, Paris 1807.

Teil, Baron Joseph du. 'La collection Chaix d'Est-Ange', *Les Arts*, July 1907, pp. 1–37.

Teyssèdre, Bernard. *L'Histoire de l'Art vue du Grand Siècle*, Paris 1964.

Thiénon, Ch. *Voyage pittoresque dans le bocage de la Vendée; ou vues de Clisson et de ses environs; avec atlas*, Paris 1817.

Thoré, T. [see also under Bürger]. 'A MM les Directeurs du Musée du Louvre', *L'Artiste*, 1836 (i), Ière série, vol. XI, pp. 281–3.

Thoré, T. *Le Salon de 1844*, Paris 1844.

Thoré, T. *Le Salon de 1846*, Paris 1846.

Thoré, T. 'De l'Ecole Française à Rome', *L'Artiste*, 1848, 4ème série, vol. XI, pp. 214–17.

Thuillier, Jacques. 'Les tableaux du Cardinal-oncle', *L'Oeil*, October 1957, pp. 33–41.

Thuillier, Jacques. 'L'Homme qui retrouva Vermeer', *L'Oeil*, May 1960, pp. 51–7.

Times Literary Supplement, 1 July 1960, pp. 409–11: 'The Taste of Angels'.

Times Literary Supplement, 14 May 1970, pp. 537–8: 'Dix-huitième master of cuisines'.

Tolnay, Charles de. 'Note on an unpublished portrait of Michelangelo', *Gazette des Beaux-Arts*, 1949, I, pp. 449–51.

Tuin, H. van der. *Les vieux peintres des pays-bas et la critique artistique en France de la première moitié du XIXᵉ siècle*, Paris 1948.

Uwins, Mrs. *A Memoir of Thomas Uwins, R.A.*, 2 vols., London 1858.

Vallance Aymer. 'The Invention of Aubrey Beardsley', *Magazine of Art*, 1898, pp. 362–8.

Vanel, Chanoine J.-B. 'Deux livres de comptes du Cardinal Fesch', 2nd and 3rd parts, *Bulletin Historique du Diocèse de Lyon*, 1922, no. 4, and 1923, no. 5.

Vauthier, G. 'Denon et le gouvernement des arts sous le consulat', *Annales Historiques de la Révolution Française*, 1911, tome IV, pp. 336–65.

Venturi, Lionello. *Il Gusto dei Primitivi*, Turin 1926 (reprinted 1972).

Verax see under Morris Moore.

Viel Castel, Comte Horace de. *Mémoires sur le règne de Napoléon III*, 6 vols., 3rd edition, Paris 1883–4.

Viollet le Duc, E. *Lettres d'Italie 1836–1837 addressées à sa famille* – annotées par Geneviève Viollet le Duc, Paris (Léonce Laget) 1971.

Vitet, L. 'La Salle des Prix à l'Ecole des Beaux-Arts', *Revue des Deux-Mondes*, 4ème série, vol. 28, 1841, pp. 937–54.

Vitry, Paul. 'Liste des Bustes d'Artistes commandées pour la Grande Galerie et les salles de peinture du Louvre', *Bulletin de la Société de l'Histoire de l'Art Français*, 1930, pp. 137–41.

[Vivant-Denon.] *Monuments des Arts du Dessin chez les peuples tant anciens que modernes, recueillis par le Baron Vivant Denon, ancien directeur des Musées de France, pour servir à l'histoire des arts, lithographiés par ses soins et sous ses yeux.* Décrits et expliqués par Amaury Duval – A Paris, chez M. Brunet-Denon, 4 vols., 1829.

Waagen, G. F. *Works of Art and Artists in England*, 3 vols., London 1838.

Waagen, G. F. 'Thoughts on the new building to be erected for the National Gallery of England, and on the arrangement, preservation, and enlargement of the collection', *Art-Journal*, 1853, pp. 101–3 and 121–5.

Waagen, G. F. *Treasures of Art in Great Britain,* 3 vols., London 1854.

Waagen, G. F. *Supplemental Volume to the Treasures of Art in Great Britain* [here referred to as Waagen, IV], London 1857.

Wackenroder, Wilhelm Heinrich. *Werke und Briefe,* 2 vols., Jena 1910.

Waetzoldt, Wilhelm. *Deutsche Kunsthistoriker von Sandrart bis Rumohr,* 2 vols. in one, Berlin 1965.

Walker, John. *Bellini and Titian at Ferrara,* London 1956.

Wallace Collection. *Pictures and Drawings,* text with historical notes and illustrations, 16th edition, London 1968.

Walpole, Horace. *Aedes Walpolianae,* 3rd edition, Strawberry Hill 1767.

Ward, Wilfrid. *The Life and Times of Cardinal Wiseman,* 2 vols., London 1897.

Waterhouse, E. K. 'Some notes on William Young Ottley's collection of Italian Primitives', *Italian Studies presented to E. R. Vincent,* pp. 272–80, London 1962.

[Wemyss.] *Pictures from Gosford House lent by the Earl of Wemyss and March,* National Gallery of Scotland 1957.

Wethey, Harold E. *El Greco and His School,* 2 vols., Princeton 1962.

Whitley, William T. *Art in England, 1800–1820,* Cambridge 1928.

Whitley, William T. *Art in England, 1821–1837,* Cambridge 1930.

Wildenstein, Daniel and Guy. *Documents complémentaires au catalogue de l'oeuvre de Louis David,* Paris 1973.

Wildenstein, Georges. *Chardin,* Paris 1933.

Wildenstein, Georges. *The Paintings of Fragonard,* London 1960.

Williams, D. E. *The Life and Correspondence of Sir Thomas Lawrence, Kt,* 2 vols., London 1831.

Wiseman, His Eminence Cardinal. *Essays on Various Subjects,* 3 vols., London 1853.

Wright, Thomas. *The Life of Walter Pater,* 2 vols., London 1907.

Zeldin, Theodore. *France 1848–1945, Vol. I: Ambition, Love and Politics,* Oxford 1973.

List of Illustrations

Where the name of a photographer is not indicated in brackets, the print has been supplied by the museum or institution to which the picture belongs.

Chapter One

Index